MARIO TESTINO LET ME IN!

MARIO TESTINO
LET ME IN!

TASCHEN

HONG KONG KÖLN LONDON LOS ANGELES MADRID PARIS TOKYO

In memory of my father

FOREWORD BY NICOLE KIDMAN

I first met Mario Testino in the late summer of 2002 when we did a shoot together for Vanity Fair. We were at a remote beach location in Malibu. It was a perfect sunny, breezy day. There was the usual organized chaos of catering truck and wardrobe and props and lighting equipment and we were bivouacked at a funny beach house with very little room to squeeze all of us in… but there in the midst of the activity was Mario: energetic and calm, somehow, at the same time.

We worked together again this fall 2006, in England, for Vogue. No sun this time, just buckets and buckets of rain. We were on a magnificent country estate, having to jump in and out of the house and a mobile camper between storm fronts. Mario was just the same as I had remembered him from four years before: spontaneous but focused, and very funny.

As an artist he responds instinctively to his environment, it becomes part of his photographs, and you, the subject, become an integral part of the environment. Among his many gifts is the ability to capture something about the sitter's essence, an immediacy, a shared moment. What's more, he makes you feel special, which is a lovely way to feel, especially under the scrutiny of a camera lens.

Ich machte Mario Testinos Bekanntschaft im Spätsommer 2002,
bei einem Shooting für Vanity Fair. Wir waren an einem einsamen
Strandabschnitt in Malibu. Es war ein herrlicher Tag, sonnig und windig.
Es herrschte das übliche organisierte Chaos aus Catering-Trucks,
Garderobe, Requisiten und Scheinwerfern, und wir campierten in
einem witzigen kleinen Strandhaus, in dem kaum alle Platz fanden…
und mitten im Trubel war Mario, energisch und gelassen zugleich, wie
immer er das anstellte.
Im Herbst 2006 arbeiteten wir wieder miteinander, in England, für Vogue.
Diesmal keine Sonne, stattdessen schüttete es. Wir waren auf einem
eindrucksvollen Landsitz und rannten bei jeder Regenpause aus dem
Haus beziehungsweise Campingmobil, ehe uns die nächste Sturmfront
wieder nach drinnen scheuchte. Mario war genauso, wie ich ihn in
Erinnerung hatte: spontan, aber voll konzentriert, und sehr lustig.
Als Künstler spricht er instinktiv auf seine Umgebung an, sie fließt in
seine Fotos ein, und man selbst als Gegenstand der Aufnahme geht in
der Umgebung auf. Eins seiner vielen Talente besteht darin, etwas vom
innersten Wesen seiner Modelle, eine gewisse Unmittelbarkeit, einen
verbindenden Moment festzuhalten. Mehr noch, er gibt einem das
Gefühl, einzigartig zu sein, und das ist ein schönes Gefühl, besonders
unter dem gnadenlosen Auge der Kamera.

VORWORT VON NICOLE KIDMAN

J'ai fait la connaissance de Mario à la fin de l'été 2002, à l'occasion d'une séance de prises de vue pour Vanity Fair. C'était à Malibu, par une superbe journée sur une plage isolée et balayée par une brise délicieuse. Autour de nous régnait le chaos organisé habituel: camion de ravitaillement, garde-robe, accessoires, matériel d'éclairage. Nous bivouaquions dans une drôle de petite maison au bord de la mer, à peine assez grande pour nous contenir tous. Au milieu de cette ruche se tenait Mario, à la fois énergique et calme.

Nous avons à nouveau travaillé ensemble cet automne 2006 en Angleterre, pour Vogue. Pas de soleil, cette fois, mais des torrents de pluie. Nous nous trouvions sur une magnifique propriété à la campagne, nous précipitant hors de la maison avec un camping-car chaque fois qu'il y avait une éclaircie. Mario était exactement le même que quatre ans plus tôt: spontané mais concentré, et toujours très drôle. En tant qu'artiste, il réagit instinctivement à son environnement. Il l'intègre dans ses photos et fait de son sujet, c'est-à-dire de vous, une partie intégrante de cet environnement. Parmi ses nombreux dons, il sait capter quelque chose de l'essence de son modèle, une immédiateté, un moment partagé. En outre, il vous donne le sentiment d'être exceptionelle, ce qui est très agréable, surtout quand vous êtes soumise au regard scrutateur d'un objectif.

PRÉFACE DE NICOLE KIDMAN

MARIO'S HOLLYWOOD BY MICHAEL ROBERTS

Mario Testino reclines on a gilded chaise longue in a corner of his cathedral-size white marble studio. Toying distractedly with the sparkling diamond-studded platinum Leica dangling from his wrist, he listens to a soothing soundtrack of violins and harps as legions of lissom assistants diligently heave wind machines and digital hardware to and fro across the vast acres of Aubusson. "Increeeevil", sighs Mario. Inspired by the sunlight flooding down onto their cherubic curls from the cantilevered skylight, he waves away the liveried footmen holding a gold carved sedan chair ready to take him off to the latest location and decides to stay. Suddenly the doors burst open and a Very Great Star sweeps in, her face a mask of grief. "Oh, Mario, Mario", she sobs, "You haven't photographed me for hours, days, weeks!" Prostrating herself in a pitiful heap of chiffon and sable on the floor she weeps softly into the honey beige carpeting as the music swells to a crescendo.

Without a word Mario puts the Leica to his eye and snaps. Faster and faster. Then he raises another glittering gem-encrusted camera to his other eye and snaps them both in unison. The air is filled with a thousand twinkling flashes, each one affirming the star's placement in the galaxy of stellar entities.

"Mmmm. Increeeevil, no?", Mario says, pointing a languid forefinger towards the digital screen. The Very Grand Star staggers to her feet and recoils in amazement. Gone are the care-worn features of her high anxiety. Gone too are the worry lines etched from troubling over which profile to present to her voracious public. Instead, the woebegone creature who staggered in has been transformed into a movie legend, a thing of Lustrous Allure, Vivacity and Remarkably Few Blemishes. "Oh Mario, Mario", she says, "You are just so . . ." "Increeeevil, no?", cries Mario, leaping onto his prancing white stallion, gathering himself into his shaved mink cape and, with a cavalier wave of his light meter as rose petals fall, galloping off into the brightest of bright pink sunsets. CUT!

That was a scene from 'Too Too Mario', a remarkable musical epic destined for a cinema near you (providing you live in an area with suitable style credentials) in which we discover over several lush hours why Mario Testino is just so very Mario. We are treated to soaring duets ("I love you" "I love you too") sung by Mario and Demi Moore; show stopping harmonies ("You make me look so interesting" "I know") crooned by Mario, Gwyneth, Madonna and many others. We have the occasional reflective soliloquy ("Where's my helicopter?") sung by Mario with one eye on his Blackberry and the other on his luggage, and everything ends with a grand finale ("My heart says take my clothes off but my agent says I shouldn't") chorused by the entire membership of the Hollywood Actors Guild. All of which goes to prove that when the stars want to be in pictures nowadays, they don't call the studios. They call Mario.

I first called Mario many years ago when he was not celebrated solely by his first name. It was the early Eighties and I seem to remember him living in a London squat. A grand squat (something like an abandoned hospital) but a squat nonetheless. He was the budding photographer. I was the erstwhile fashion editor of the English social monthly Tatler. His first glossy magazine shoot was not so spectacular – just a model wearing some Ralph Lauren leaning against a gruesome crumbling wall in a Soho tenement. It was cold, squalid and damp, a far cry from the gold plated, private jetted, tropically heated Marioworld of today. Since then we have run into each other through the years in Tangier, London, Rio, Milan, Paris and New York as the trajectory of his fashion career blazed a trail that inevitably led to L.A., Hollywood and the singularly revealing pictures in this book. What makes them unique? "It's the intimacy", says Mario. "The feeling of total privacy". Thus we have the entire spectrum of Hollywood royalty larking about in their undies (or less) as candidly unembarrassed as alcohol-fuelled students at a slumber party. "There's a certain amount of trust because I'm not going to make them look bad", says Mario. "Some of them may say, 'Oh, stop taking pictures' but I think it's an obligation. I'm allowed to see things that most people are not – so I should show them."

All of which reminds me of the opening scene from 'Too Too Mario'. The megabudget credits whisk us through Winter in Gstaad, Spring in Paris, Summer in Peru and finally alight on Autumn in New York. Central Park. Mario is snapping Demi Moore. Her clothes drop like autumn leaves as she hides behind her super-luxurious leather holdall. "Pleeease, Demi", Mario coaxes "Just a leeetle more skin. Really, it would be increeeevil". "Oh Mario", sighs Demi, thwacking him about the head with her priceless iguana-skin Birkin. "You are awful – but I like you!"

Mario Testino lässt sich auf eine vergoldete Chaiselongue in einer Ecke seiner Studio-Kathedrale aus weißem Marmor sinken. Geistesabwesend mit der funkelnden, diamantbesetzten Platin-Leica tändelnd, die von seinem Handgelenk baumelt, lauscht er der sanften Hintergrundmusik von Violinen und Harfen, während Legionen flinker Assistenten beflissen Windmaschinen und digitale Hardware über fußballfeldgroße Aubussontteppiche schleppen. „Ungraaaulich", seufzt Mario. Inspiriert von dem Sonnenschein, der durch das Oberlicht auf ihre engelhaften Locken flutet, scheucht er mit einer Handbewegung die livrierten Lakaien beiseite, die neben einer Sänfte mit vergoldetem Schnitzwerk bereitstehen, um ihn zur nächsten Location zu befördern, und entschließt sich, zu bleiben. Plötzlich springt die Tür auf, und eine WELTBERÜHMTE SCHAUSPIELERIN kommt hereingerauscht, der die Verzweiflung ins Gesicht geschrieben steht. „Oh, Mario, Mario", schluchzt sie, „du hast mich seit Stunden, Tagen, Wochen nicht fotografiert!" Sie wirft sich als bemitleidenswertes Häuflein Chiffon und Zobel vor ihm zu Boden und weint in den honiggelben Teppichboden, während die Musik zum Crescendo anschwillt.

Ohne ein Wort setzt Mario die Leica ans Auge und knipst. Schneller und schneller. Dann hält er vor sein anderes Auge eine ebenfalls juwelenstarrende Kamera und knipst mit beiden gleichzeitig. Die Atmosphäre ist erfüllt von tausend funkelnden Lichtblitzen, jeder einzelne eine Huldigung an diesen einen, alle anderen überstrahlenden Stern am Hollywood-Firmament.

„Mmmmm. Ungraaaulich, nein?", sagt Mario und deutet mit einem trägen Zeigefinger auf den digitalen Bildschirm. Die WELTBERÜHMTE SCHAUSPIELERIN richtet sich unsicher auf und zuckt vor Verblüffung zurück. Verschwunden die verhärmten, von innerer Unruhe gezeichneten Züge. Wie weggewischt sind die Sorgenfalten von der ewigen, bangen Frage, welches Profil sie dem unersättlichen Publikum präsentieren soll. Das jammervolle Geschöpf, das kurz zuvor hereingewankt ist, hat sich in eine Leinwandgöttin verwandelt, eine strahlende Erscheinung mit berückender Ausstrahlung und erstaunlich makellosem Teint.

„Oh Mario, Mario", sagt sie, „du bist einfach so…" „Ungraaaulich, nein?", ruft Mario aus, schwingt sich auf sein tänzelndes weißes Ross, hüllt sich in einen Hauch von Nerz, winkt unbekümmert mit seinem Belichtungsmesser, während es Rosenblätter regnet, und galoppiert davon in den pinkesten aller Sonnenuntergänge.
SCHNITT!

Das war eine Szene aus „Too Too Mario", einem musikalischen Breitwandepos, demnächst in einem Kino in Ihrer Nähe (vorausgesetzt, Sie leben in einer Gegend die höchsten Ansprüchen an Stil und Geschmack genügt), in dem wir über mehrere schwelgerische Stunden hinweg miterleben dürfen, warum Mario Testino so unvergleichlich Mario ist. Man verwöhnt uns mit schmelzenden Duetten („Ich liebe dich", „Ich dich auch") von Mario und Demi Moore und umwerfendem Harmoniegesang von Mario, Gwyneth, Madonna und zahlosen anderen. Zwischendurch ein nachdenkliches Solo („Wo bleibt mein Hubschrauber?"), das Mario singt, ohne das Blackberry oder sein Gepäck aus den Augen zu lassen, und alles endet im großen Finale („Mein Herz sagt mir, zieh dich aus, aber mein Agent ist dagegen") zu dem sämtliche Mitglieder der Hollywood Actors Guild geschlossen als Chor antreten. Womit bewiesen wäre: Wenn die Stars zum Film wollen, gehen sie heute nicht zu den Studios – sie holen Mario.

Ich holte Mario zum ersten Mal vor vielen Jahren; lange bevor schon allein sein Vorname ein gerühmtes Markenzeichen war. Es waren die frühen Achtziger, und ich meine mich zu erinnern, dass er in einem besetzten Haus in London lebte. Ein weitläufiges Gebäude (sowas wie eine stillgelegte Klinik), aber doch nur ein besetztes Haus. Er war der hoffnungsvolle junge Fotograf. Ich war der Fashion Editor des englischen Society-Magazins Tatler. Sein erstes Foto für ein Hochglanzmagazin war nichts Spektakuläres – ein Model in irgendwas von Ralph Lauren, das in einem Mietshaus in Soho an einer scheußlich maroden Wand lehnte. Es war kalt, verkommen und feucht, alles andere als die vergoldete, tropisch warme und mit Privatjet ausgestattete Marioworld von heute. Seitdem sind wir einander in Tanger, London, Rio, Mailand, Paris und New York über den Weg gelaufen; seine kometengleiche Laufbahn führte ihn zwangsläufig nach LA, Hollywood, und ließ ihn die einmaligen Aufnahmen machen, die sich in diesem Buch finden. Was macht sie so einzigartig? „Es ist ihre Intimität", meint Mario. „Die absolut private Atmosphäre." Und so sehen wir hier die erste Garnitur Hollywoods in Unterwäsche (oder weniger) herumalbern, ungeniert und unbekümmert wie beschwipste Studenten und Studentinnen auf einer Pyjamaparty. „Ich genieße einen gewissen Vertrauensvorschuss, denn ich würde niemals jemanden bloßstellen", erklärt Mario. „Manche von ihnen sagen schon mal: ‚Ach, lass das Fotografieren doch jetzt', aber ich glaube, das ist nicht ernst gemeint. Mir werden An- und Einblicke gewährt, die den meisten anderen vorenthalten bleiben – daher denke ich, ich sollte sie auch zeigen." Das alles erinnert mich an die Anfangsszene von „Too Too Mario." Während die Megabudget-Credits durchlaufen, gleiten wir vom Winter in Gstaad über den Frühling in Paris und den Sommer in Peru hinüber in den goldenen Herbst im New Yorker Central Park. Mario knipst Demi Moore. Ihre Kleidung fällt wie das Herbstlaub, während sie sich hinter ihrer superluxuriösen Lederreisetasche versteckt. „Pleeese, Demi", lockt Mario, „nur noch ein biiißchen mehr Haut. Das wäre ganz entzüüückend." „O Mario", seufzt Demi und gibt ihm einen Klaps mit ihrer unbezahlbaren Birkin Bag aus Eidechsenleder. „Du bist abscheulich – aber ich liebe dich!"

MARIOS HOLLYWOOD VON MICHAEL ROBERTS

Mario est allongé sur une méridienne dorée, dans un coin de son studio en marbre grand comme une cathédrale. Jouant distraitement avec un étincelant Leica en platine incrusté de diamants accroché à son poignet, il se laisse bercer par une douce musique de violons et de harpes tandis qu'une armée d'assistants agiles déplacent des machines à vent et le lourd matériel numérique de-ci de-là à travers des hectares tapissés d'Aubusson. «Incrojaaaable» soupire Mario. Inspiré par les rayons de soleil filtrant par la vaste verrière et inondant leurs boucles angéliques, il congédie d'un geste de la main les laquais en livrée qui se tenaient prêts à l'emmener dans une chaise à porteurs en bois sculpté et doré vers sa prochaine séance de prises de vue. Il a décidé de rester. Soudain, les portes s'ouvrent grand et une Très Grande Star fait irruption, le visage baigné de larmes. Elle sanglote: «Oh Mario, Mario, ça fait des heures, des jours, des mois que tu ne m'as pas photographiée!» Elle s'effondre, prostrée à ses pieds dans un tas de mousseline et de zibeline, hoquetant doucement sur la moquette miel tandis que la musique atteint un crescendo.

Sans un mot, Mario approche le Leica de son œil droit et presse sur le déclencheur. Encore, de plus en plus vite. Puis il lève un autre appareil incrusté de pierreries devant son œil gauche et la mitraille en stéréo. La salle est remplie d'un scintillement de flash, chacun réaffirmant la place de la star dans le firmament des corps célestes.

«Mmmm, incrojaaaaable, non?» susurre Mario en pointant un index languissant vers un écran numérique. La Très Grande Star se relève en titubant puis tressaille en voyant son image. Adieu le masque du désespoir, adieu les traits tirés par l'angoisse à force de ne plus savoir quel profil offrir à son public vorace. La créature tourmentée et chancelante entrée un peu plus tôt s'est métamorphosée en légende vivante, une déesse de l'écran resplendissante, lustrée, pétillante et remarquablement épargnée par le temps.

Elle s'extasie: «Oh, Mario, Mario… tu es tellement…»

«Incrojaaaable, non?» réplique Mario avant de sauter sur son fringant destrier blanc. Il rabat autour de son cou sa cape en vison rasé, salue l'assistance en brandissant son posemètre sous une pluie de pétales de rose puis s'élance vers le lointain dans un coucher de soleil d'un rose flamboyant.

COUPEZ!

C'était une scène de «Trop, trop Mario», une merveilleuse épopée musicale durant plusieurs heures qui sortira bientôt dans une salle près de chez vous (à condition que vous habitiez dans un quartier suffisamment distingué) où vous découvrirez pourquoi Mario Testino est tellement Mario. Vous y entendrez des duos virtuoses («Je t'aime», «Je t'aime aussi»), roucoulés par Mario et Demi Moore; des sérénades inoubliables («Tu me rends tellement intéressante», «Oui, je sais») entonnées d'une voix suave par Mario, Gwyneth, Madonna et bien d'autres; l'occasionnel monologue méditatif «Où est mon hélicoptère?» interprété par Mario un œil sur son portable Blackberry et l'autre sur ses bagages, et le grand chœur final «Mon cœur me dit de poser nu mais mon agent me le déconseille» chanté par l'ensemble des membres de l'Hollywood Actors Guild. Tout ceci prouvant que désormais, quand une star veut un rôle dans un film, elle n'appelle plus le studio mais Mario.

La première fois que j'ai contacté Mario, c'était il y a de longues années, quand on ne l'appelait pas encore par son prénom. C'était au début des années quatre-vingt et il me semble me souvenir qu'il habitait dans un squat londonien. Un squat grandiose (une sorte d'hôpital abandonné) mais un squat quand même. C'était un tout jeune photographe et je dirigeais les pages mode du mensuel mondain anglais Tatler. Son premier reportage pour nous n'avait rien de folichon, juste un mannequin en Ralph Lauren adossé au mur délabré d'un vieil immeuble de Soho. Il faisait froid, gris et humide, aux antipodes de l'univers plaqué or sous un ciel tropical strié de jets privés du Marioland d'aujourd'hui. Depuis, nous nous sommes croisés à Tanger, Londres, Rio, Milan, Paris et New York tandis que sa trajectoire le menait inexorablement vers LA, Hollywood, et les superbes clichés présentés dans ce livre. Ce qui les rend si unique? «Leur côté privé. L'impression de grande intimité» répond Mario. C'est ainsi que nous voyons défiler toutes les têtes couronnées d'Hollywood batifolant en petite tenue (ou moins), aussi naturelles et détendues que des adolescentes éméchées faisant la fête chez l'une d'entre elles. Mario explique: «Mes sujets me font confiance parce qu'ils savent que je les mettrai en valeur. Certains disent parfois ‹Ça suffit maintenant, pose ton appareil› mais c'est plus fort que moi. On me laisse voir des choses que la plupart des gens ne peuvent pas voir, alors il faut bien que je les montre.»

Ce qui me rappelle la scène d'ouverture de «Trop, trop Mario»: pendant le générique de la mégasuperproduction, nous voyons se succéder l'hiver à Gstaad, le printemps à Paris, l'été au Pérou, jusqu'à ce que la caméra se fixe enfin sur l'automne à New York. On est à Central Park, Mario photographie Demi Moore. Les vêtements de la star tombent comme des feuilles mortes tandis qu'elle se cache derrière son fourre-tout atrocement chic. Il la cajole «S'il te plaaaaît, Demi, montre un peu plus de chair. Vraiment, ce sera incrojaaaable». «Oh, Mario!» soupire Demi en lui donnant une tape sur le crâne avec son Birkin en iguane hors de prix. «Tu es un monstre, mais je t'aime bien quand même!».

MARIO À HOLLYWOOD PAR MICHAEL ROBERTS

CONVERSATION BETWEEN MARIO TESTINO AND PATRICK KINMONTH

PATRICK KINMONTH As a photographer you are given extraordinary opportunities and access. So why did you call this book "Let Me In"?

MARIO TESTINO It's true, I am let into all kinds of places to photograph at special moments but I often feel amazed to be there. "Let Me In" is about bringing other people into those moments.

PK So the book is an invitation to party with you. And to go with you where you go.

MT Yes, in a way I see it as a diary written with a camera. This work belongs to a period of about three years. Maybe it's because I have photographed almost everybody in here at least once before, that now, the second or third time around, I feel ready to drop my defenses and so do they. That helps a lot. As a photographer you have to try to find something new to say about the people around you, and they allow me to do that.

PK Are most of these pictures taken around official sittings, before and after work…?

MT Some, but a lot of the pictures are nothing to do with sittings. Many are from parties. Or sometimes I wanted to photograph somebody I was just hanging out with at home or I went over to show him or her something I had done of them and ended up taking more pictures. But often, too, taking spontaneous photographs with a little camera even with no intention of using them can break the ice before a session.

PK I suppose it deals with the photographer's equivalent of the painter's fear of the blank page… the first frame…

MT Sometimes there may be just a couple of frames that seem to work when I look at them later. Very occasionally, if I feel they add an interesting dimension, I propose these photographs to the magazines as well.

PK In that kind of picture you are seeing people at their most real and unconstructed…

MT The only problem is that usually at that stage they are not wearing the right clothes, or are getting undressed or something, so often they really are unusable images with no editorial value as such. But I was interested in putting them together here and seeing how they add up.

PK Some pictures here are rough, out of focus, but they have their own energy. Sometimes their beauty is unconventional but it is still beauty. And together they make up a sort of collage that captures a world…

MT I suppose it has come to a point where most of the people that are in this book trust me when I take a photograph of them. It does not have to be in the context of perfect hair and make-up in the studio. I hope I always put the person in the picture before me, by which I mean that even if the picture is in some way shocking, I am not going to run that picture if the person doesn't look great. People know that when I go to photograph them I would only choose something I consider a good picture afterwards. It's my job.

PK What makes a picture of somebody good for you?

MT I think when it conveys a certain kind of well-being, of exuberance, sensuality, the enjoyment of a moment, collusion, intelligence, humor, a glimpse of that person as they are in private… a lot of things at once. Beauty is so related to your state of mind, to your mood at that particular second…

PK So in these spontaneous pictures you get what you might want to achieve later in a more carefully constructed way? Is it a kind of sketchbook for you?

MT Yes, precisely. I try to take the lessons of these pictures into my work. In fact I often construct my work to look as if I just happened to be there with a camera at the right time. Like most people, I want to hide the work that goes into making pictures, because I love the idea that the beauty of life is all there in a moment, for a split-second: captured in the photograph. And the reality is like that… sometimes you are sitting in a car looking out of the window, you see something beautiful, but by the time you say to your friend, "Look!" it has disappeared. I want to keep those moments.

PK Or find them, even make them.

MT Exactly. But I usually like the unexpected, it often has a newer kind of beauty.

PK It is like a rehearsal that ends up being a performance. And rehearsals are genuinely often more exciting. There is an added element of uncertainty. These photographs are mostly taken with nobody around supporting you, no assistants or your team…

MT Many, not all, of these pictures are taken with automatic cameras. So with them I do not need assistants… I use auto-focus, the camera determines the exposure, and I can concentrate, look and shoot. In fact these cameras ARE my assistants. But my real assistants, and my collaborators, are indispensable to my work. Even if they are not always around when I photograph, and they usually are, they make all my work possible.

PK Sometimes in these pictures you are aware that the person is performing for you, doing something quite extreme, whether it is Robbie Williams putting on a bra or somebody pulling their pants down or showing their body in a provocative way… do you encourage these moments?

MT It is wonderful when they happen, but only if the person is happy to go there. I want to laugh with my friends not at them, and that goes for everyone I photograph. It's about appreciation rather than exposure. I used to go backstage at the shows and I realized that the girls enjoyed doing something just for me. I think it's about the fact that I would never ask anyone to do things that I am not prepared to do myself. They would immediately say to other photographers who might come over "no, no you can't look but you can, Mario". "Let Me In" is also about acknowledging that kind of special compliment. I have also had the chance to go to the party highlights of these years which are the Oscar parties in L.A. given by Graydon Carter of Vanity Fair and the Metropolitan Costume Institute parties in New York given by Anna Wintour of American Vogue. Wherever you look there is somebody fascinating, famous, beautiful, talented and I was lucky enough to be there and able to record some of it. Thankfully they let me in!

PATRICK KINMONTH Als Fotograf stehen Ihnen doch eigentlich alle Türen offen. Warum nennen Sie dieses Buch „Let Me In"?

MARIO TESTINO Es stimmt, als Fotograf komme ich an alle möglichen Orte, um in besonderen Momenten zu fotografieren, aber ich staune oft selbst, dass ich dort bin. Mit „Let Me In" möchte ich andere an diesen Momenten teilhaben lassen.

PK Das Buch ist also eine Einladung, mit Ihnen auf eine Party zu gehen; Sie an diese Orte zu begleiten.

MT Ja, in gewisser Weise betrachte ich es als Tagebuch, wenn auch mit der Kamera geschrieben. Diese Arbeiten stammen aus einem Zeitraum von ungefähr drei Jahren. Alle Menschen, die hier abgebildet sind, hatte ich zuvor schon mindestens einmal fotografiert, und dies ist vielleicht der Grund dafür, dass ich jetzt, wo ich sie zum zweiten oder dritten Mal fotografiere, so weit bin, das Visier runterzulassen, und ihnen geht es genauso. Das hilft einem sehr weiter. Als Fotograf muss man versuchen, immer neue Statements über die Leute um einen herum zu finden, und genau das ermöglichen sie mir.

PK Sind die meisten dieser Fotos im Rahmen offizieller Fototermine entstanden, also vor und nach der eigentlichen Arbeit…?

MT Einige, aber viele Fotos haben damit gar nichts zu tun. Viele entstanden auf Partys. Manchmal wollte ich auch einfach jemanden fotografieren, der zufällig bei mir zu Besuch war, oder ich war bei jemandem, um ihm oder ihr die Ergebnisse einer Fotosession zu zeigen, und daraus ergab sich dann, dass ich noch ein paar Fotos machte. Mit einer kleinen Kamera ein paar Schnappschüsse zu machen, auch wenn man sie gar nicht verwenden will, ist aber auch gut, um bei einem Fototermin das Eis zu brechen.

PK Ich nehme an, es ist bei einem Fotografen wie bei einem Maler, der vor der leeren Leinwand steht… die Angst vor dem ersten Foto.

MT Manchmal finde ich einige dieser Aufnahmen ganz brauchbar, wenn ich sie mir später ansehe. Ab und zu mal, wenn ich finde, dass sie dem ganzen eine weitere interessante Dimension hinzufügen, lege ich sie auch den Magazinen vor.

PK Auf solchen Fotos sieht man die Menschen so echt und unkonstruiert / un-inszeniert wie selten…

MT Das Problem ist, dass sie zu dem Zeitpunkt meistens nicht das richtige anhaben, sich gerade ausziehen oder sonstwas, darum sind die Fotos redaktionell eigentlich nicht zu verwerten. Aber ich fand es interessant, sie hier einmal zusammenzustellen und zu sehen, was dabei herauskommt.

PK Einige der Aufnahmen sind sehr grob, unscharf, aber sie haben eine ganz eigene Energie. Es ist zwar manchmal eine unkonventionelle Schönheit, aber schön sind sie allemal. Zusammen bilden sie eine Art Collage, die eine ganze Welt wiedergibt…

MT Die meisten der in diesem Buch Abgebildeten vertrauen mir mittlerweile, wenn ich ein Foto von ihnen mache. Und das gilt nicht nur unter Studiobedingungen, perfekt geschminkt und perfektes Haar. Ich hoffe doch, dass für mich die Person auf dem Bild immer wichtiger ist als ich. Damit meine ich, selbst wenn das Bild in irgendeiner Weise schockierend ist, kann derjenige sicher sein, dass er darauf toll aussieht, sonst würde ich es gar nicht verwenden. Das wissen die Leute, wenn sie sich von mir fotografieren lassen, dass ich hinterher nur Fotos auswähle, die ich für gut halte. Das gehört zum Job.

PK Wann ist ein Bild von jemandem für Sie gelungen?

MT Ich glaube, wenn es ein gewisses Wohlbefinden rüberbringt, Ausgelassenheit, Sinnlichkeit, das Vergnügen eines Augenblicks, Einverständnis, Intelligenz, Humor, wenn da etwas von der Privatperson aufblitzt… viele Dinge auf einmal. Schönheit ist so abhängig von der Gemütsverfassung, der Stimmung in dieser einen bestimmten Sekunde…

PK Finden Sie mit diesen spontanen Bildern etwas, das Sie eventuell später gestylter und durchkomponierter umsetzen wollen? Ist das für Sie sowas wie ein Skizzenbuch?

MT Ja, ganz genau. Ich versuche das, was ich aus diesen Fotos gelernt habe, in meine Arbeit zu übernehmen. Ich gestalte meine Fotos ohnehin oft so, dass es aussieht, als wäre ich zufällig im richtigen Moment mit der Kamara dabei gewesen. Wie die meisten will auch ich nicht, dass man den Bildern die Arbeit ansieht, die dahinter steckt, weil mir die Vorstellung gefällt, dass in einem Moment die ganze Schönheit des Lebens zum Ausdruck kommt, im Bruchteil einer Sekunde: und auf das Foto gebannt. Die Realität ist ja auch so… manchmal sitzt man im Auto und schaut aus dem Fenster, man sieht etwas Schönes, aber bis man zu seinen Freunden gesagt hat: „Guckt mal!" ist es verschwunden. Ich will diese Momente festhalten.

PK Oder sie finden, sie vielleicht sogar erzeugen.

MT Genau. Aber normalerweise mag ich das Unerwartete, das Schöne darin ist oft einfach frischer.

PK Es ist wie eine Probe, die dann zur Aufführung wird. Und Proben sind oft viel aufregender. Es kommt ein Element der Unwägbarkeit dazu. Diese Fotos entstehen meistens, ohne dass jemand da ist, um Sie zu unterstützen, keine Assistenten oder das Team…

MT Nicht alle, aber viele von diesen Bildern sind mit automatischen Kameras aufgenommen. Darum brauche ich dabei keine Assistenten… Ich benutze Autofocus, die Belichtungszeit berechnet die Kamera, und ich kann mich darauf konzentrieren, hinzusehen und den Auslöser zu drücken. Im Grunde sind diese Kameras meine Assistenten. Aber meine echten Assistenten und Mitarbeiter sind für meine Arbeit unverzichtbar. Sie sind zwar nicht immer anwesend, wenn ich fotografiere, aber meistens sind sie dabei, sie ermöglichen überhaupt erst meine Arbeit.

PK Manchmal sieht man den Bildern an, dass jemand für Sie posiert, vielleicht etwas ziemlich Extremes für Sie macht, ob es nun Robbie Williams im BH ist oder jemand, der die Hose runterlässt oder seinen Körper provozierend zur Schau stellt… ermutigen Sie sie zu so etwas?

MT Es ist wundervoll, wenn so etwas zustande kommt, aber nur wenn es dem oder der Betreffenden auch wirklich nichts ausmacht, so weit zu gehen. Ich lache mit meinen Freunden, nicht über sie, und das gilt auch für jeden, den ich fotografiere. Ich will jemanden nicht bloßstellen, sondern richtig würdigen. Ich bin bei den Shows oft hinter der Bühne gewesen, und ich habe gemerkt, dass die Mädchen Spaß daran haben, bestimmte Sachen nur für mich zu machen. Ich glaube, das liegt daran, dass ich nie von jemandem etwas verlangen würde, dass ich nicht selbst zu tun bereit wäre. Bei anderen Fotografen, die nach ihnen kamen, sagten sie immer gleich: „Nein, nein, nein, ihr dürft nicht gucken, aber du schon Mario". Mit „Let Me In" will ich dieses besondere Kompliment auch zurückgeben. Ich hatte außerdem die Gelegenheit, zu den Party-Highlights in diesem Jahr zu gehen, nämlich den Oscar-Partys in LA, die Graydon Carter von Vanity Fair gibt, und den Partys des Metropolitan Costume Institute, die Anna Wintour von der amerikanischen Vogue veranstaltet. Wohin man schaut, steht jemand, der faszinierend, berühmt, schön, talentiert ist, und ich hatte das große Glück, dort zu sein und einiges davon festhalten zu können. Zum Glück haben sie mich reingelassen!

MARIO TESTINO IM GESPRÄCH MIT PATRICK KINMONTH

PATRICK KINMONTH En tant que photographe, vous avez accès à des événements et des personnalités extraordinaires. Pourquoi alors avoir intitulé ce livre «Let Me In» («Laissez-moi entrer»)?

MARIO TESTINO C'est vrai, on m'ouvre grand les portes pour photographier mes sujets à des moments privilégiés et je suis souvent le premier surpris de me trouver là. «Laissez-moi entrer» s'adresse à tous ceux qui veulent venir avec moi.

PK En somme, ce livre est une invitation à faire la fête avec vous. Et à vous accompagner là où vous allez.

MT Oui, d'une certaine manière, je le vois comme un journal intime écrit avec un appareil photo. Ce travail représente une période d'environ trois ans. C'est peut-être parce que j'avais déjà photographié au moins une fois pratiquement tous ceux qui y figurent que, pour notre deuxième ou troisième rencontre, j'étais prêt à abaisser mes défenses et eux aussi. Cela aide beaucoup. En tant que photographe, je dois trouver quelque chose de nouveau à dire sur les gens autour de moi et ils me laissent faire.

PK La plupart de ces clichés ont été pris avant ou après une séance de pose officielle…?

MT Certains mais pas tous. Beaucoup n'ont rien à voir avec une séance de pose. Il y en a que j'ai pris lors de fêtes, d'autres que j'ai juste eu envie de prendre alors que j'étais tranquillement chez moi avec untel ou untelle. Il est arrivé aussi que je me rende chez un sujet pour lui montrer ses photos et que je finisse par en prendre d'autres. Souvent, je prends des instantanés avec un petit appareil sans intention de les utiliser plus tard, juste histoire de briser la glace avant une séance.

PK C'est sans doute une façon d'exorciser l'équivalent du syndrome de la toile blanche chez un peintre… le premier plan…

MT Quand je les regarde plus tard, il arrive qu'il n'y ait que quelques plans valables. Très rarement, si je considère qu'ils ajoutent une dimension intéressante, je propose également ces instantanés au magazine qui m'a commandé le portrait.

PK Dans ce genre de photos, vous montrez les gens quand ils sont le plus vrais et le moins construits…

MT Le seul problème c'est que, à ce stade de la séance, ils ne portent pas encore les bons vêtements, ou ils sont en train de s'habiller ou je ne sais quoi, si bien que ces images n'ont aucune valeur éditoriale pour le commanditaire. Mais je trouvais intéressant de les assembler pour voir ce que ça donnait.

PK Certaines images sont brutes de forme, floues, mais elles possèdent leur propre énergie. Même quand elles sortent de la norme, elles n'en sont pas moins belles. Présentées ensemble, elles forment une sorte de collage qui capte un univers…

MT Entre-temps la plupart des gens photographiés dans le livre me font confiance. Nous n'avons pas besoin d'être dans un contexte de studio où la coiffure et le maquillage doivent être parfaits. Je fais toujours passer mon sujet avant moi – en tout cas je l'espère – ce qui signifie que même si la photo est, d'une manière ou d'une autre, surprenante, je ne la montrerai pas si la personne dessus n'est pas à son avantage. Les gens savent que, si je les photographie, je ne choisirai ensuite que les bonnes photos. C'est mon boulot.

PK Pour vous, qu'est-ce qui fait qu'une photo est bonne?

MT Quand elle exprime une forme de bien-être, d'exubérance, de sensualité, le plaisir du moment, la connivence, l'intelligence, l'humour, un aperçu de cette personne dans son intimité… c'est beaucoup de choses à la fois. La beauté est tellement liée à votre état d'esprit, à votre humeur à cet instant précis…

PK En d'autres termes, dans ces images spontanées, vous obtenez ce que vous souhaitez accomplir plus tard d'une manière plus minutieusement construite? Pour vous, ce sont des sortes d'esquisses?

MT Oui, exactement. J'essaie de tirer les leçons de ces premières photos pour les incorporer dans mon travail. En fait, je construis souvent mes images de sorte qu'elles donnent l'impression que je me suis trouvé là par hasard au bon moment. Comme la plupart des gens, je veux effacer tout l'effort qui a été nécessaire pour obtenir le résultat final car j'aime l'idée que la beauté de la vie soit entièrement captée dans cet instant précis, cette fraction de seconde où la photo a été prise. Mais dans la réalité… vous êtes assis dans une voiture, regardant par la fenêtre et vous voyez quelque chose de beau. Le temps que vous disiez à votre ami: «Hé, regarde», cela a disparu. Je veux conserver ces moments.

PK Ou les découvrir, voire les fabriquer.

MT Absolument. Mais j'aime généralement l'inattendu, il présente souvent une forme de beauté plus nouvelle.

PK C'est comme une répétition qui finit par être une représentation. Or, les répétitions sont souvent plus excitantes. Il y a un élément supplémentaire d'incertitude. Ces photos sont généralement prises alors que vous n'avez personne pour vous aider, ni assistants ni équipe…

MT Certaines de ces photos, mais pas toutes, ont été prises avec un automatique. Dans ce cas, je n'ai pas besoin d'assistants, j'utilise l'auto-focus, l'appareil détermine l'exposition, je peux me concentrer, regarder et appuyer sur le déclencheur. En fait, ces appareils sont mes assistants. Toutefois, mes vrais assistants et mes collaborateurs me sont indispensables. Même s'ils ne sont pas forcément présents quand je photographie (ils le sont généralement), ce sont eux qui rendent mon travail possible.

PK Parfois, sur ces photos, on sent que le sujet se met en scène pour vous, faisant quelque chose d'extravagant comme Robbie Williams enfilant un soutien-gorge, quelqu'un baissant son pantalon ou exhibant son corps de manière provocante… vous encouragez ces moments?

MT Quand ça arrive, c'est merveilleux, mais uniquement si c'est le sujet lui-même qui choisit d'aller dans cette voie. J'aime rire avec mes amis, pas rire d'eux. Idem pour tous ceux que je photographie. C'est plus une affaire d'appréciation que d'exhibition. Autrefois, j'allais toujours dans les coulisses après les défilés et je me suis rendu compte que les filles aimaient bien faire des choses uniquement pour moi. Je crois que ça vient du fait que je ne demanderais jamais à quelqu'un de faire ce que je ne serais pas disposé à faire moi-même. Quand d'autres photographes approchaient, elles les chassaient «Non, toi, tu ne peux pas regarder, que Mario». «Let Me In» est aussi une manière de prendre acte de ce compliment. Au cours de ces années, j'ai également eu la chance d'être invité à des fêtes fabuleuses comme les réceptions pour les Oscars données par Graydon Carter de Vanity Fair ou les soirées du Metropolitan Costume Institute organisées par Anna Wintour du Vogue américain. Dans ces fêtes, où que vous regardiez, il y a une personne fascinante, célèbre, belle et talentueuse. J'ai eu la chance d'y être et d'en capturer quelques fragments. Dieu merci, ils m'ont laissé entrer!

UNE CONVERSATION ENTRE MARIO TESTINO ET PATRICK KINMONTH

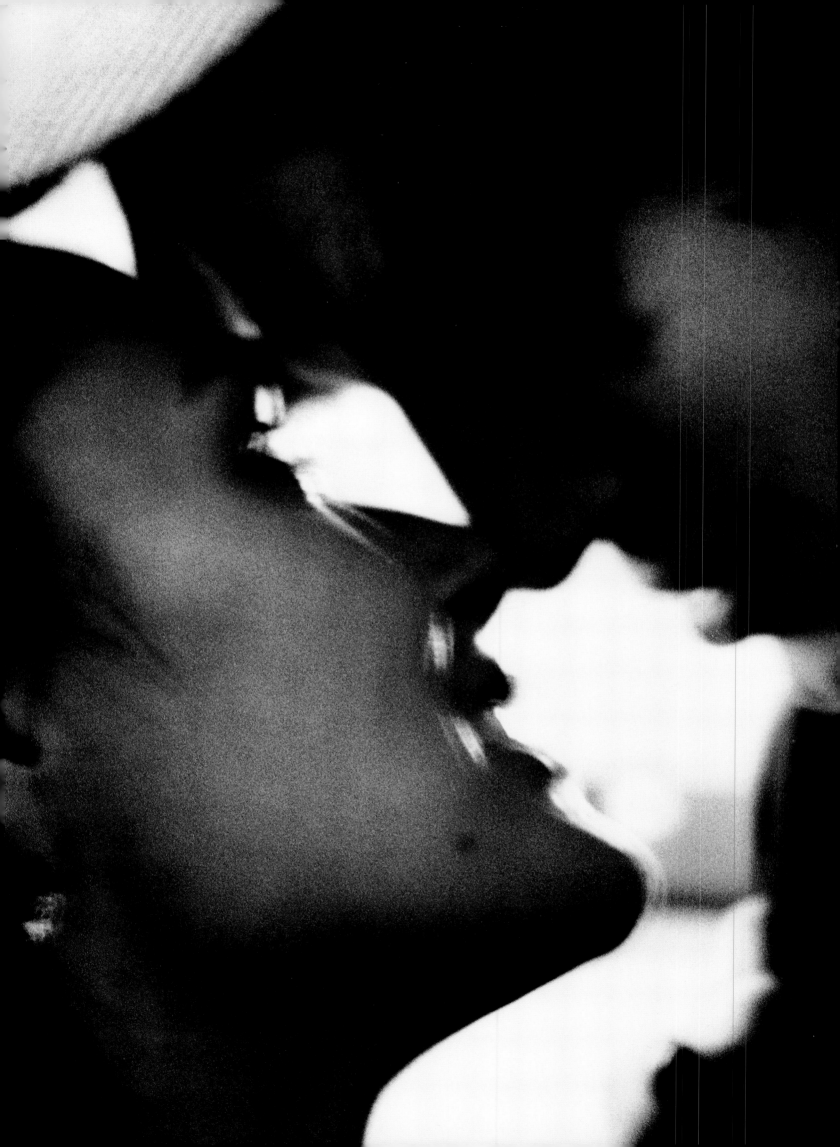

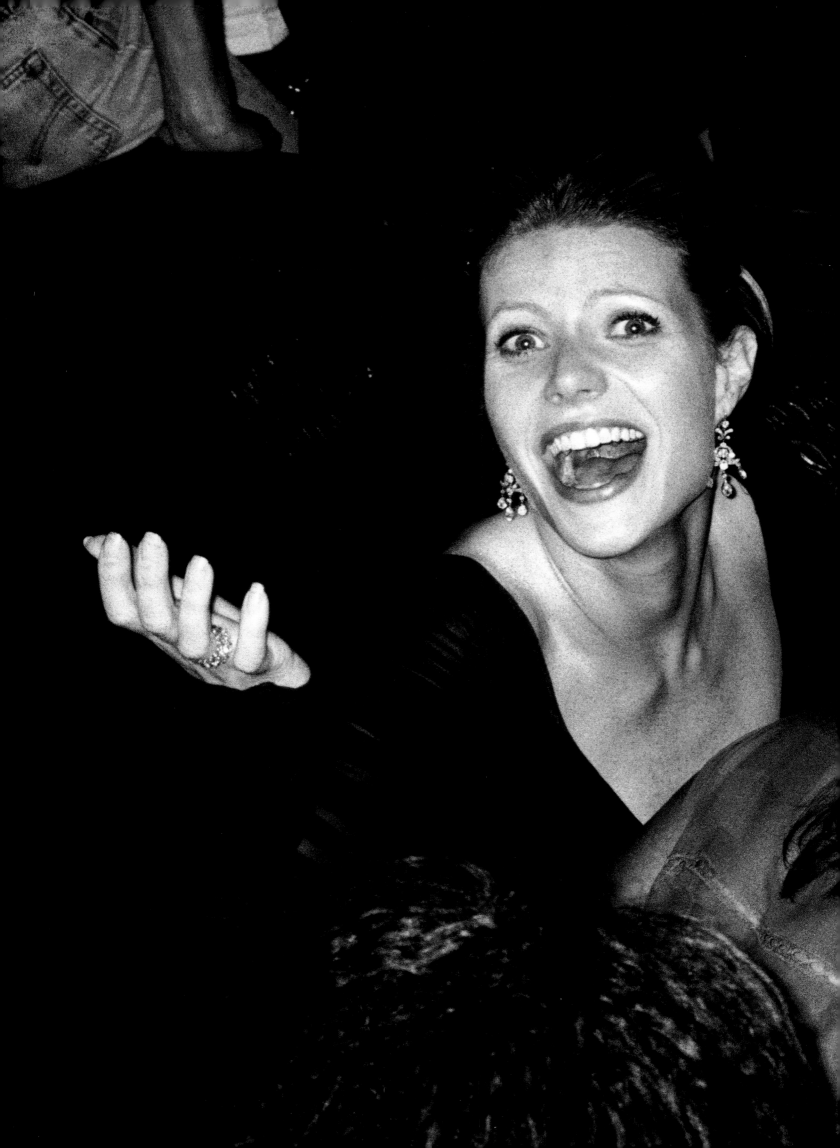

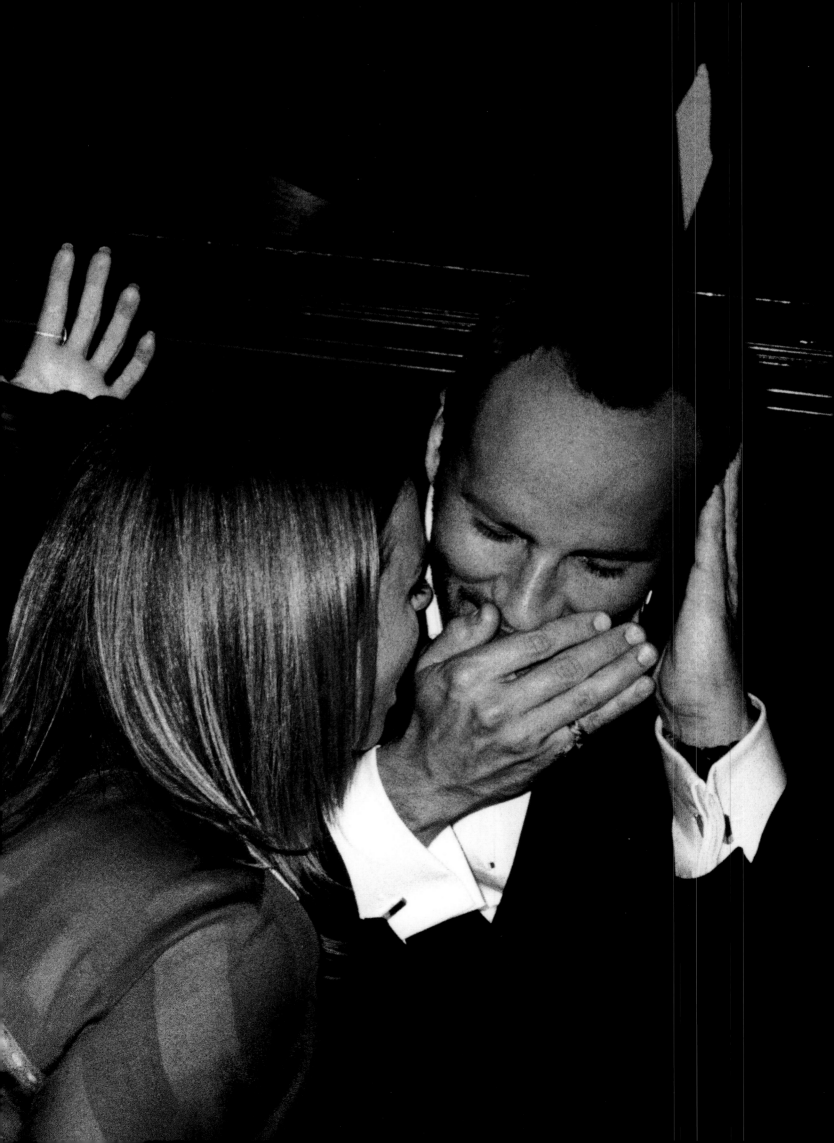

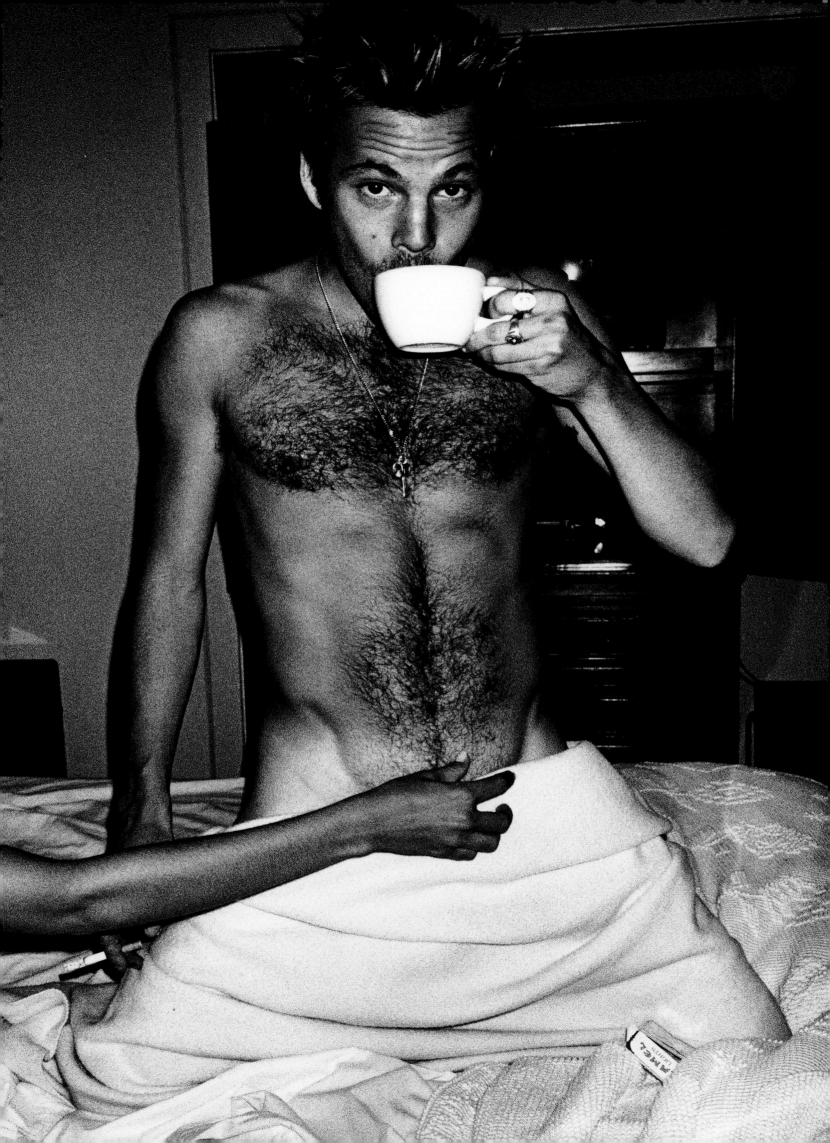

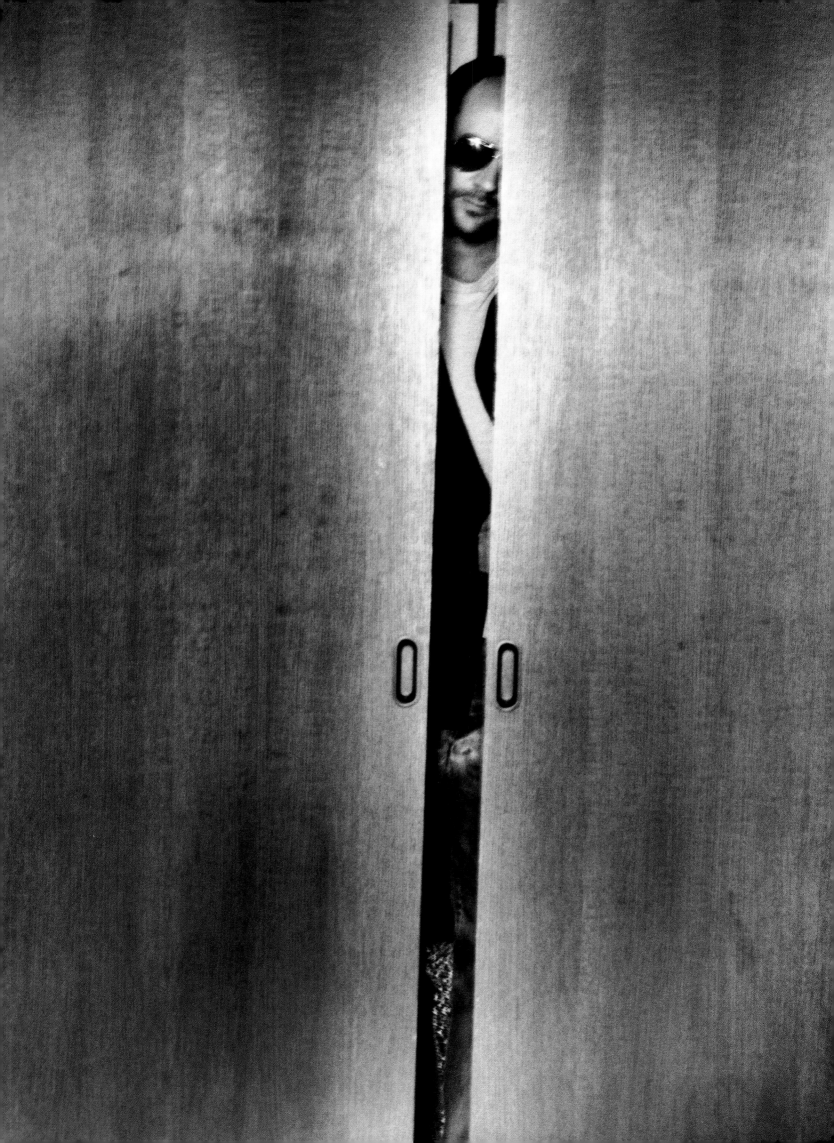

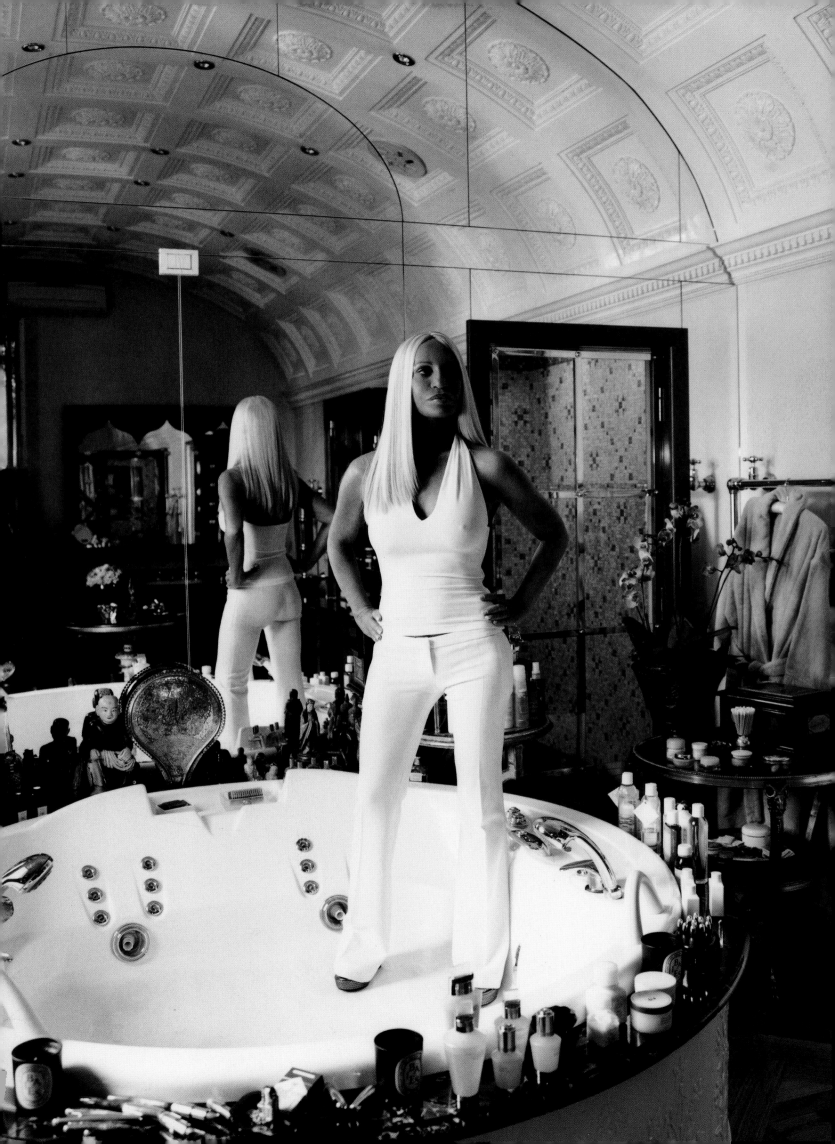

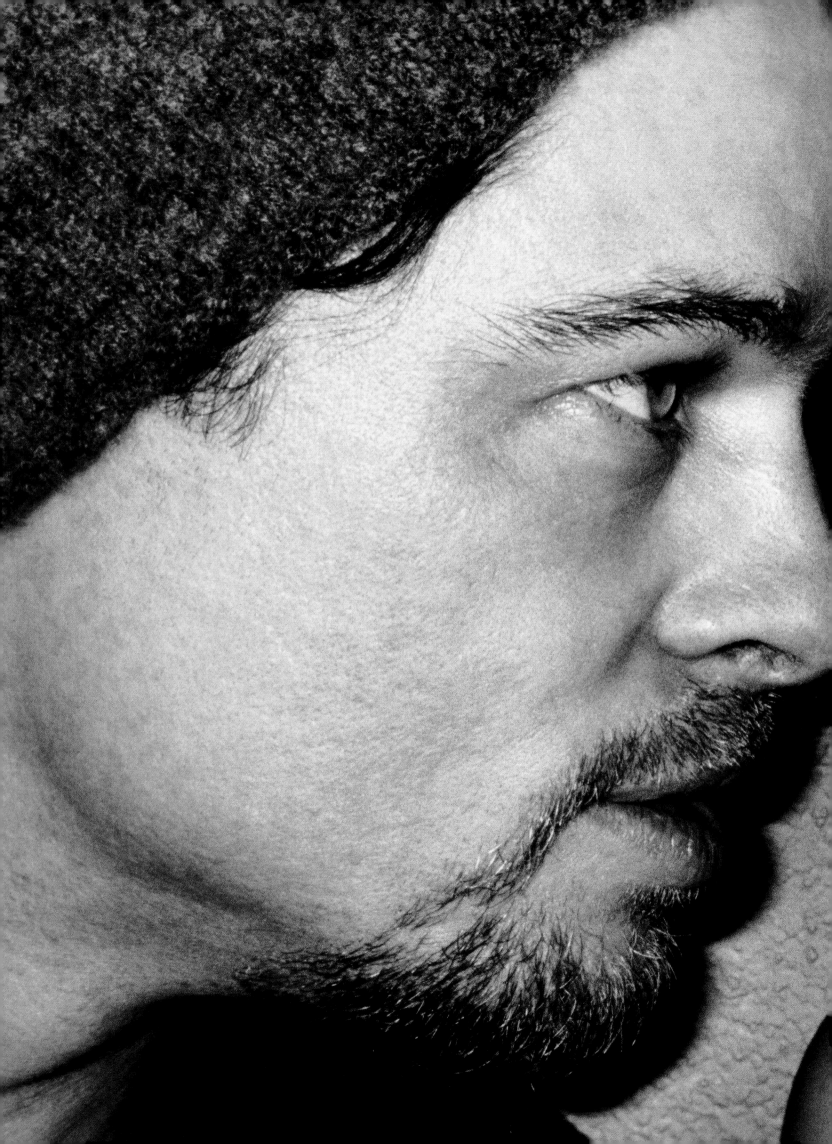

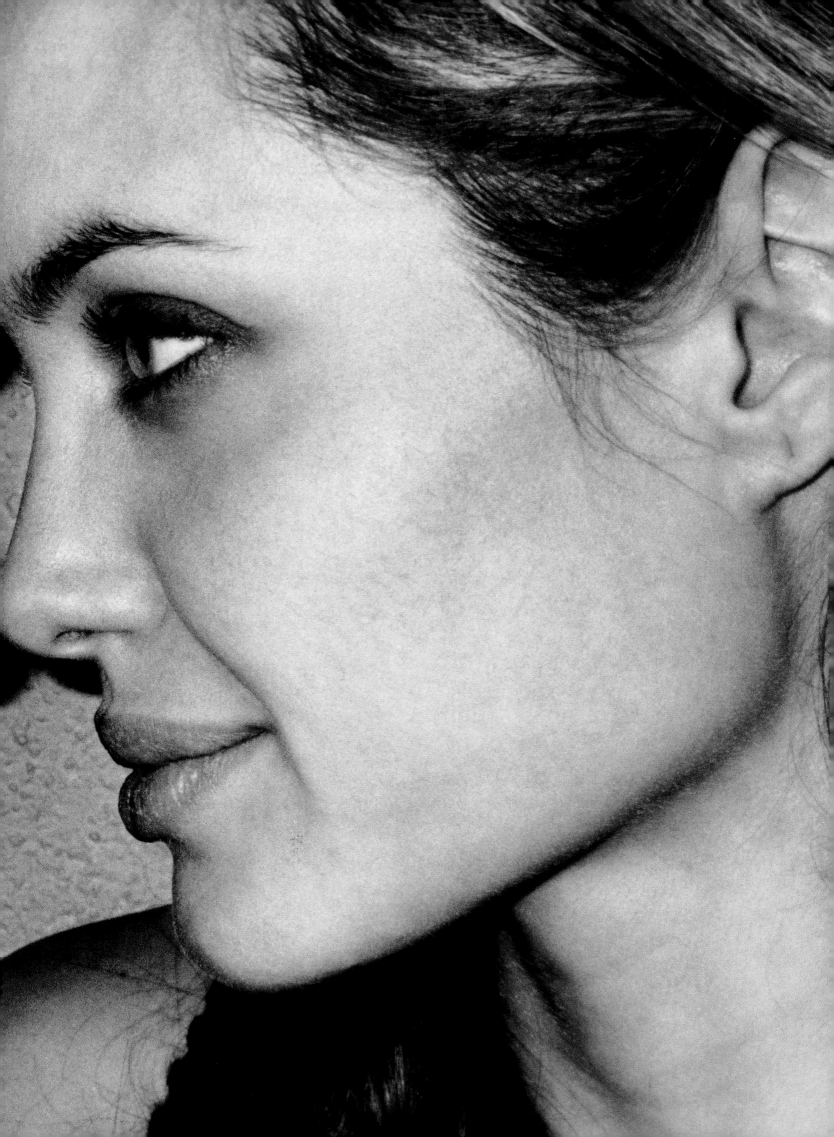

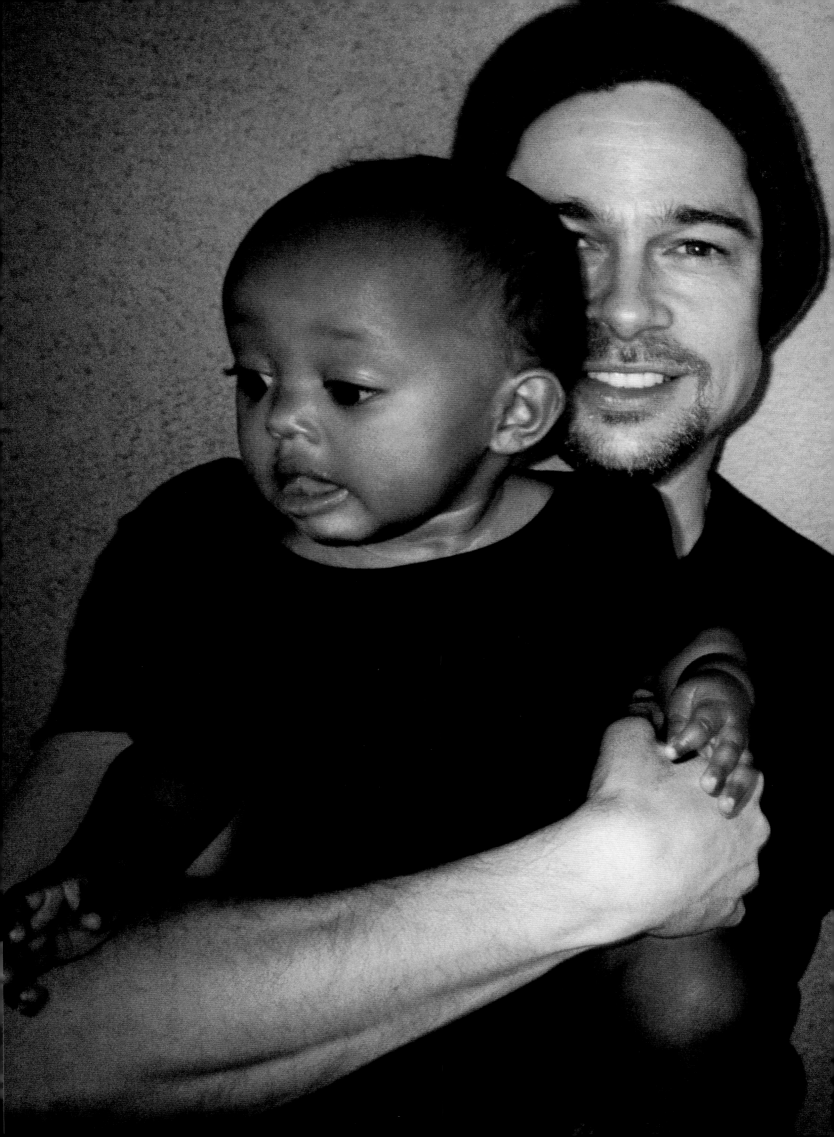

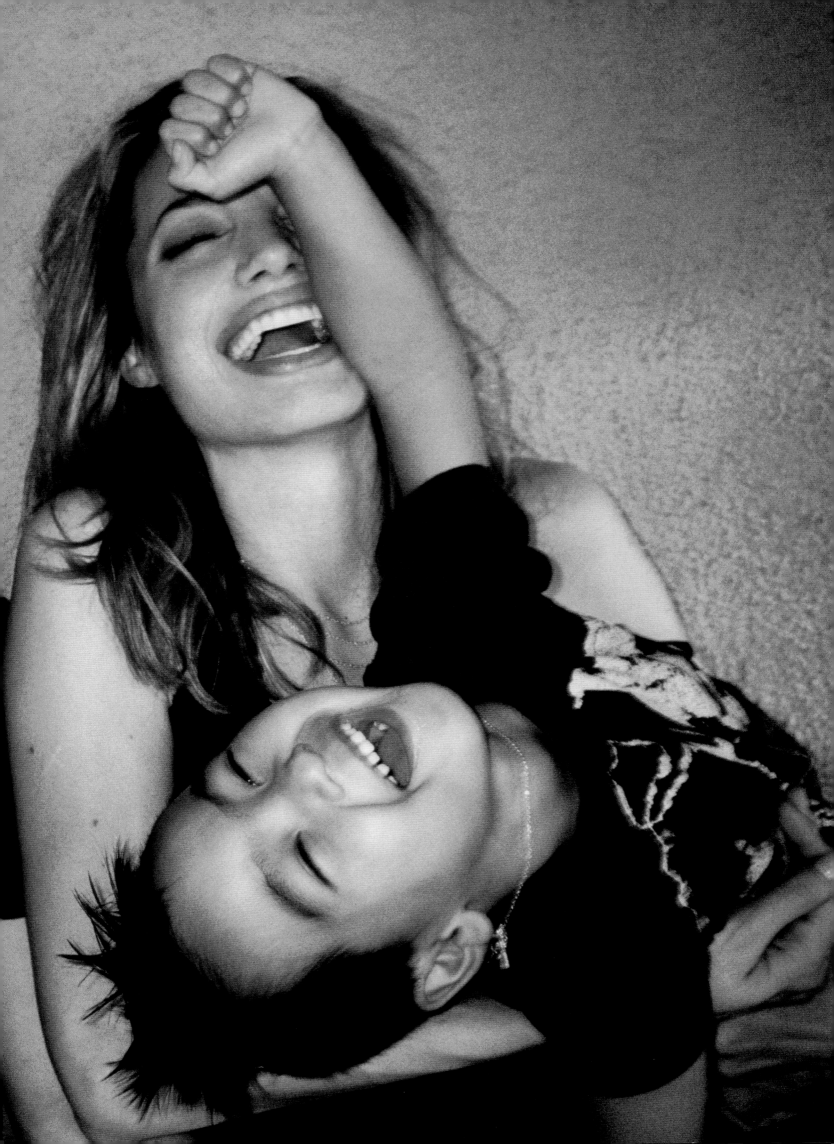

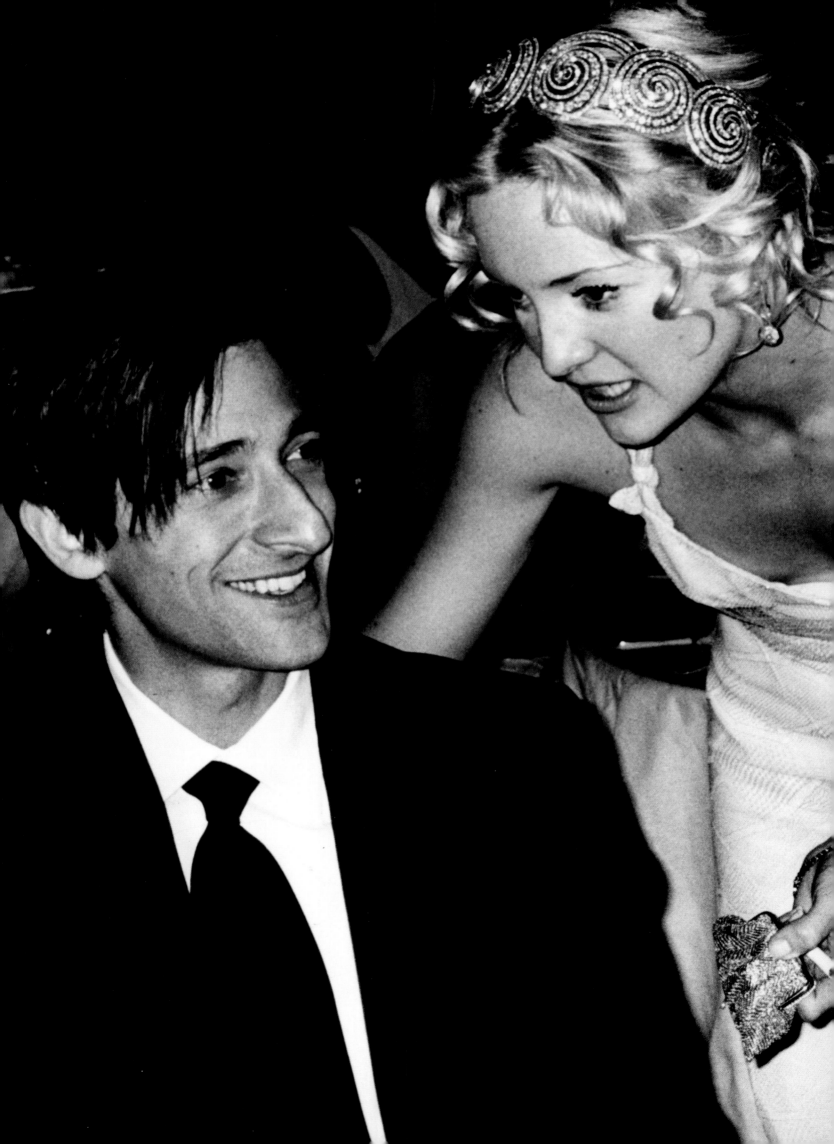

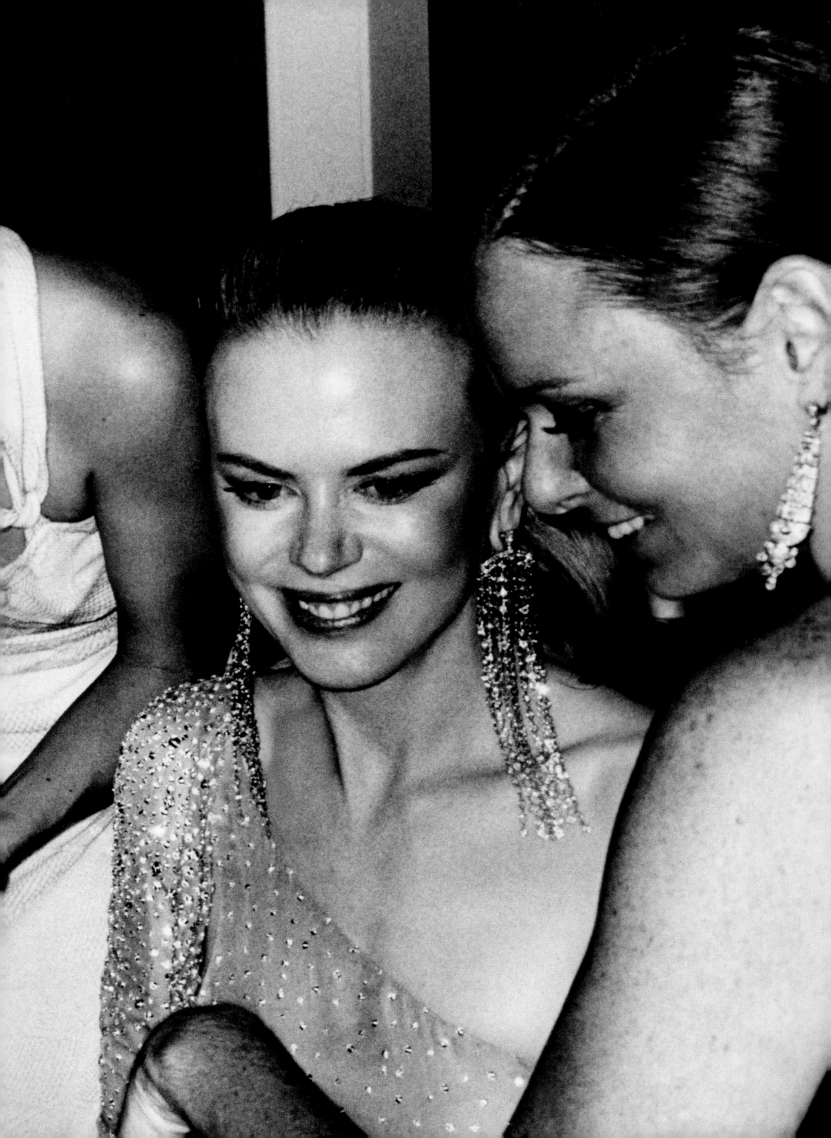

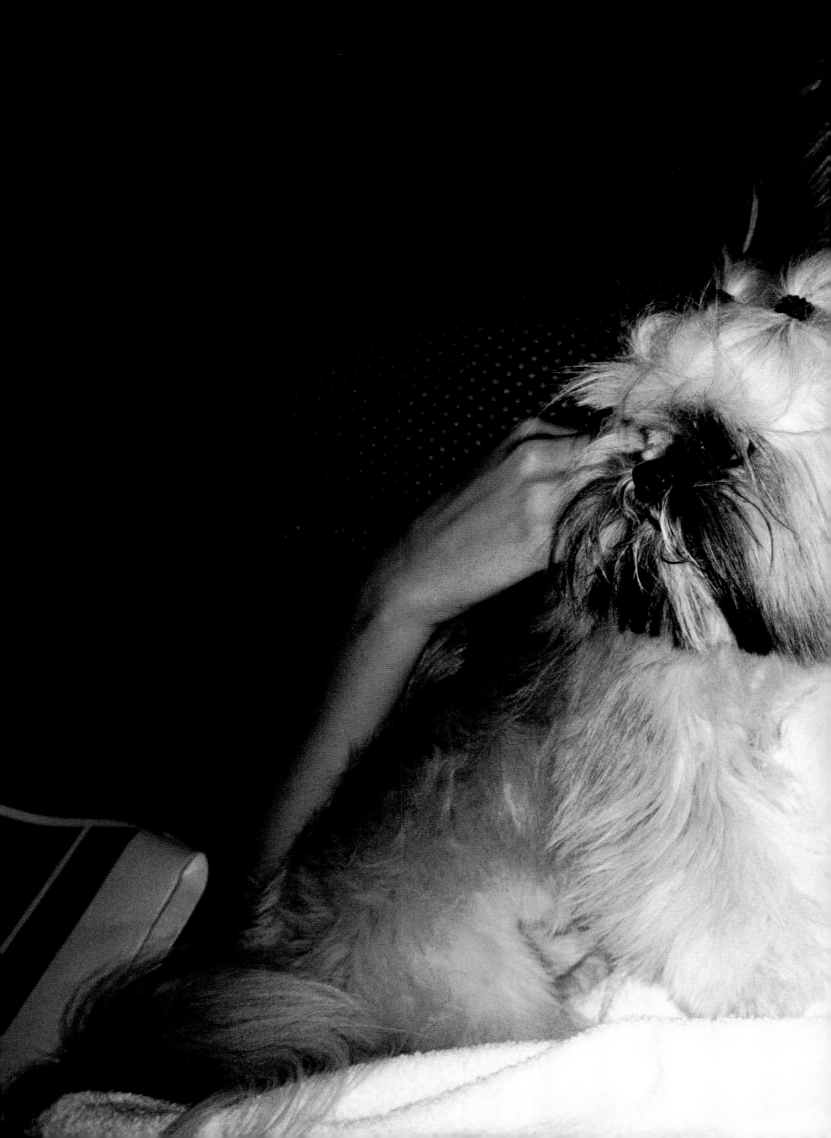

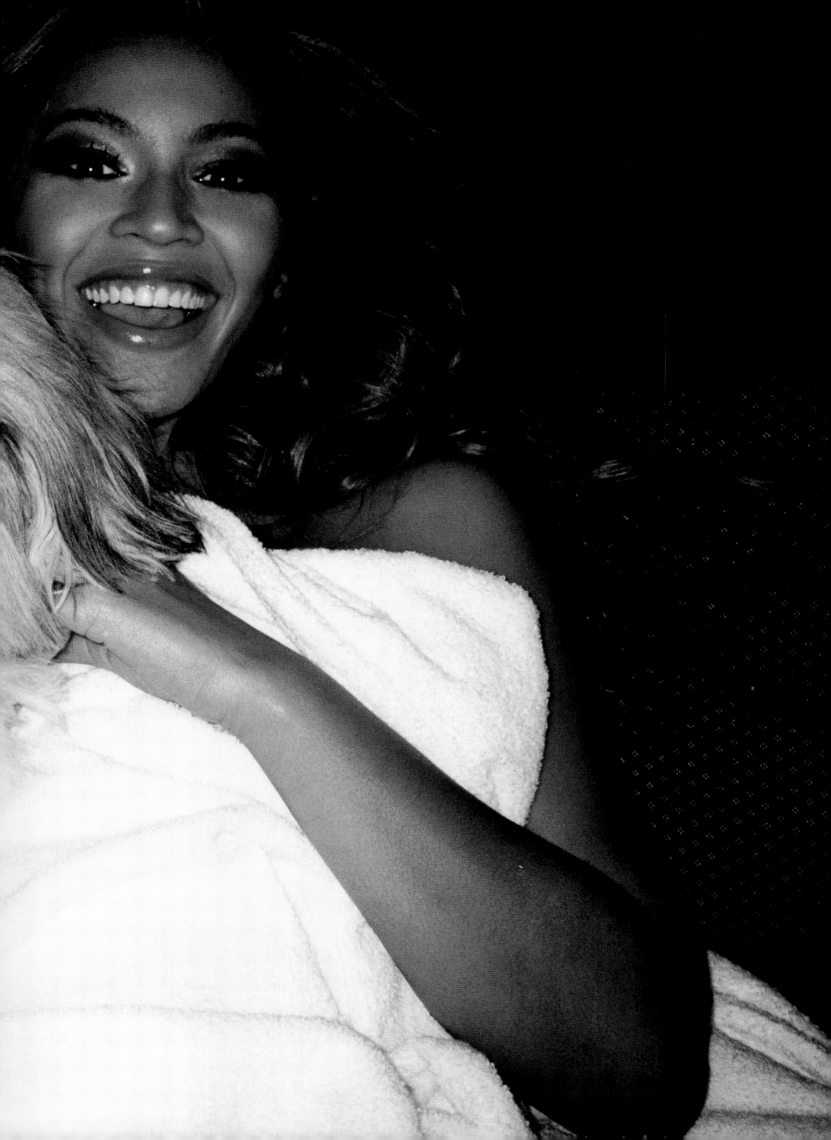

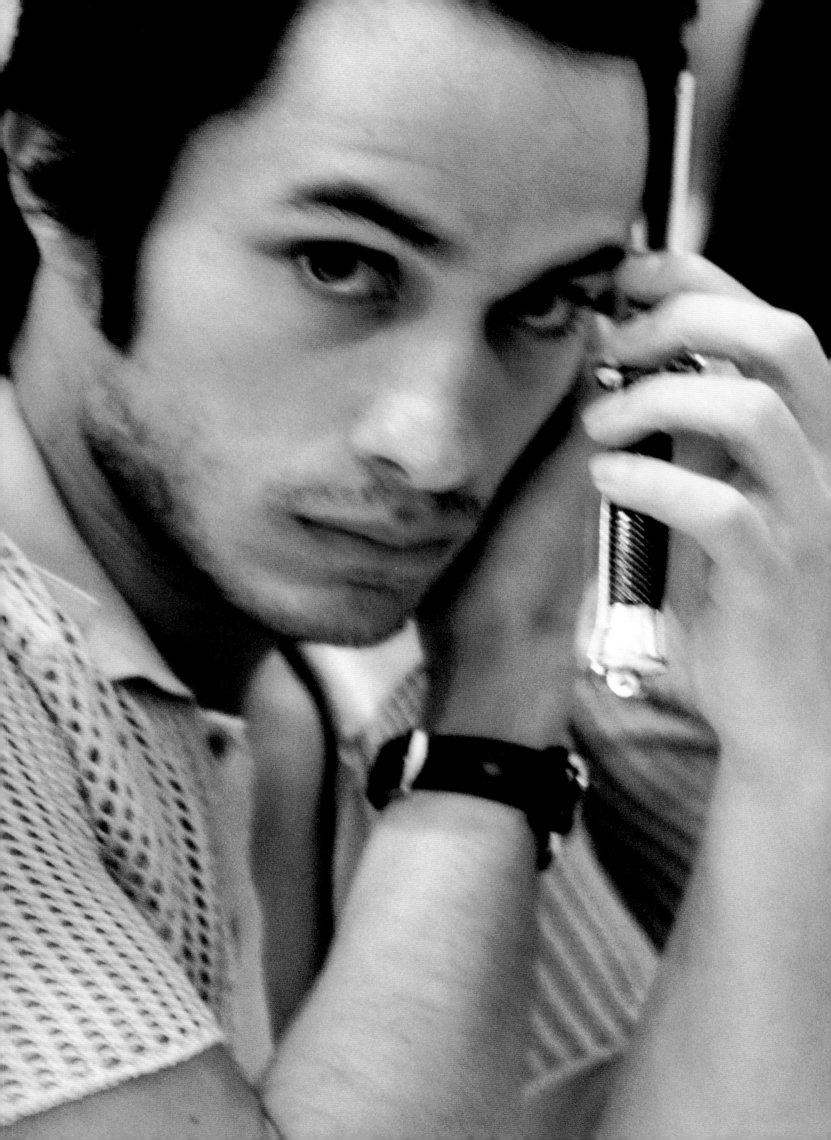

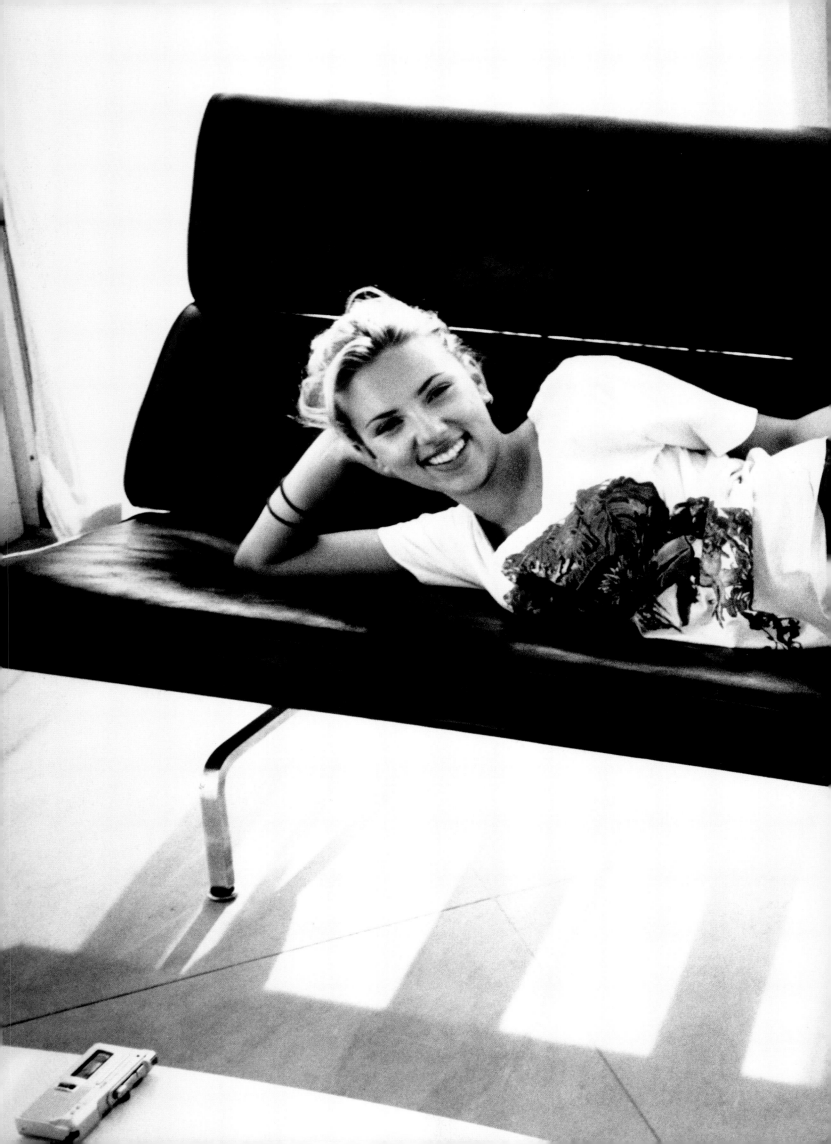

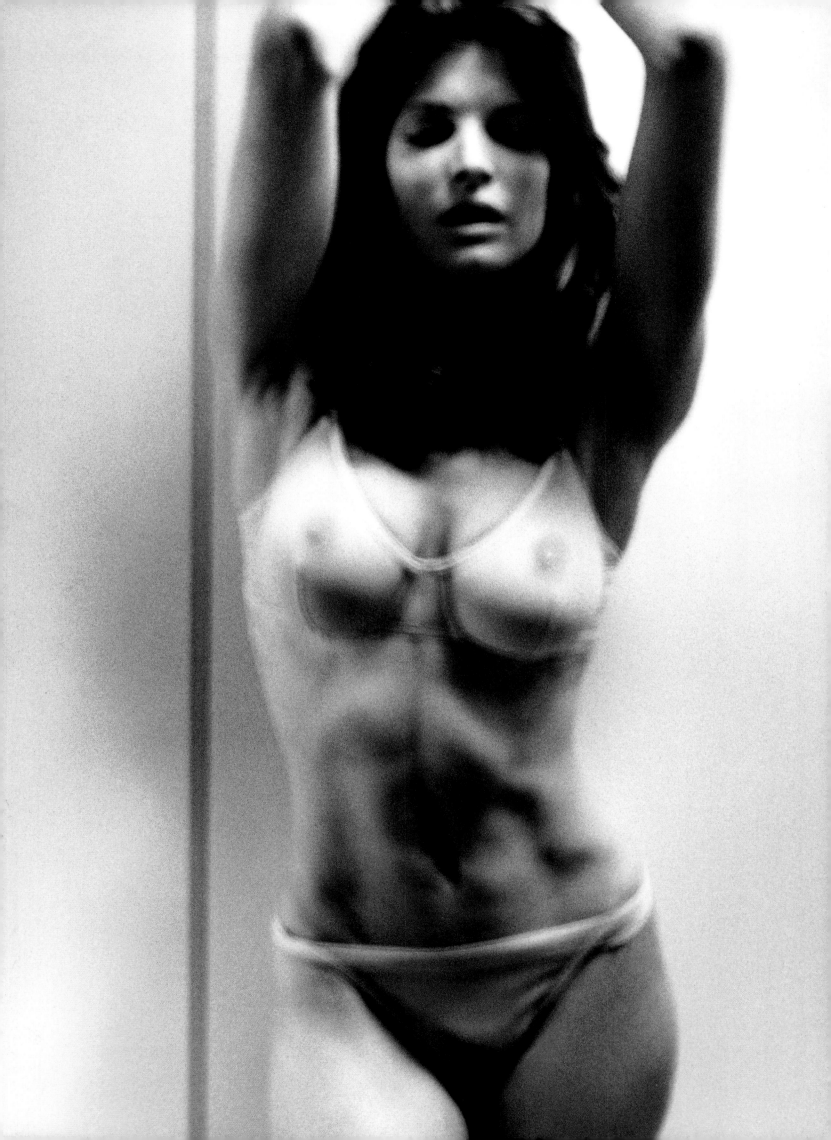

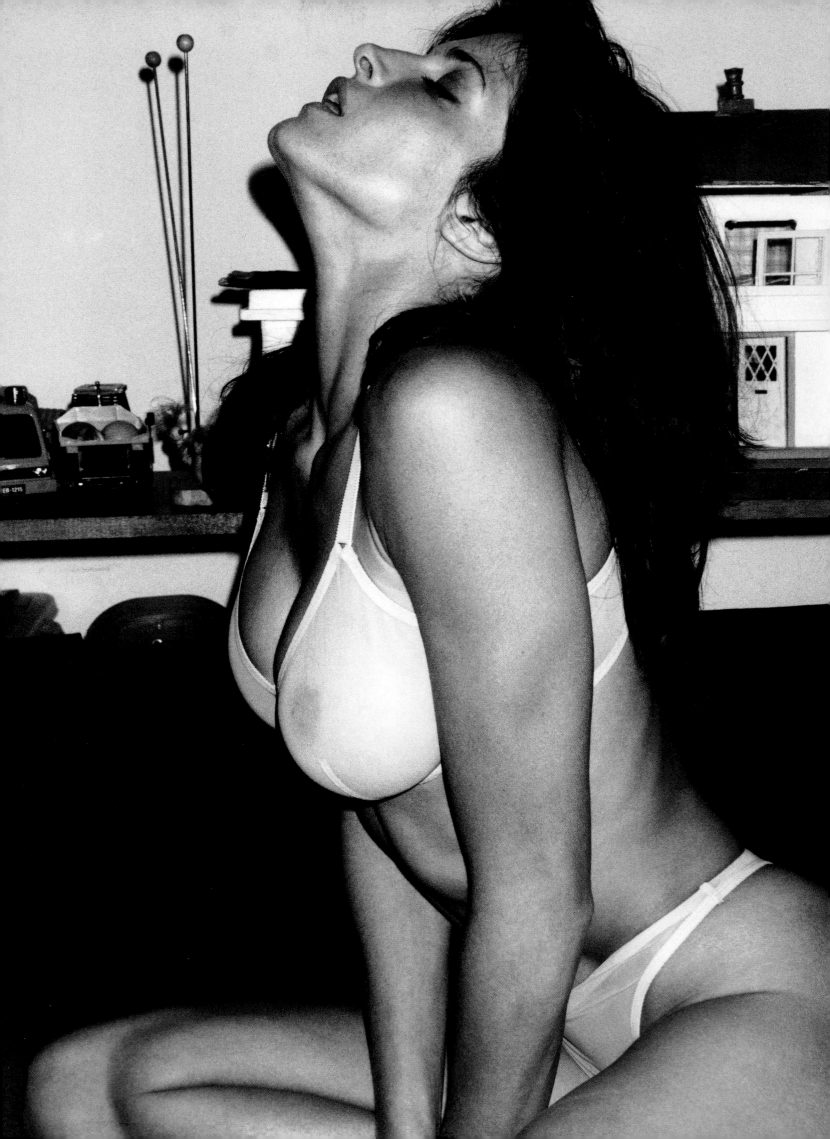

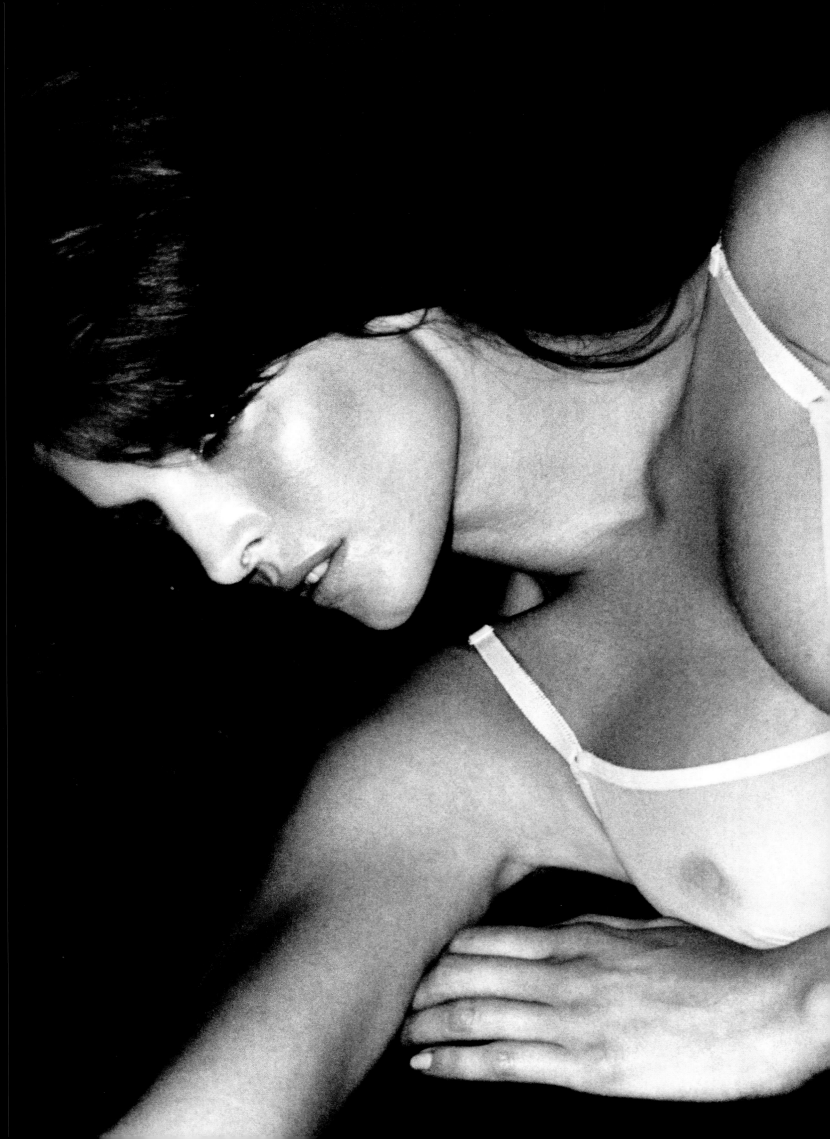

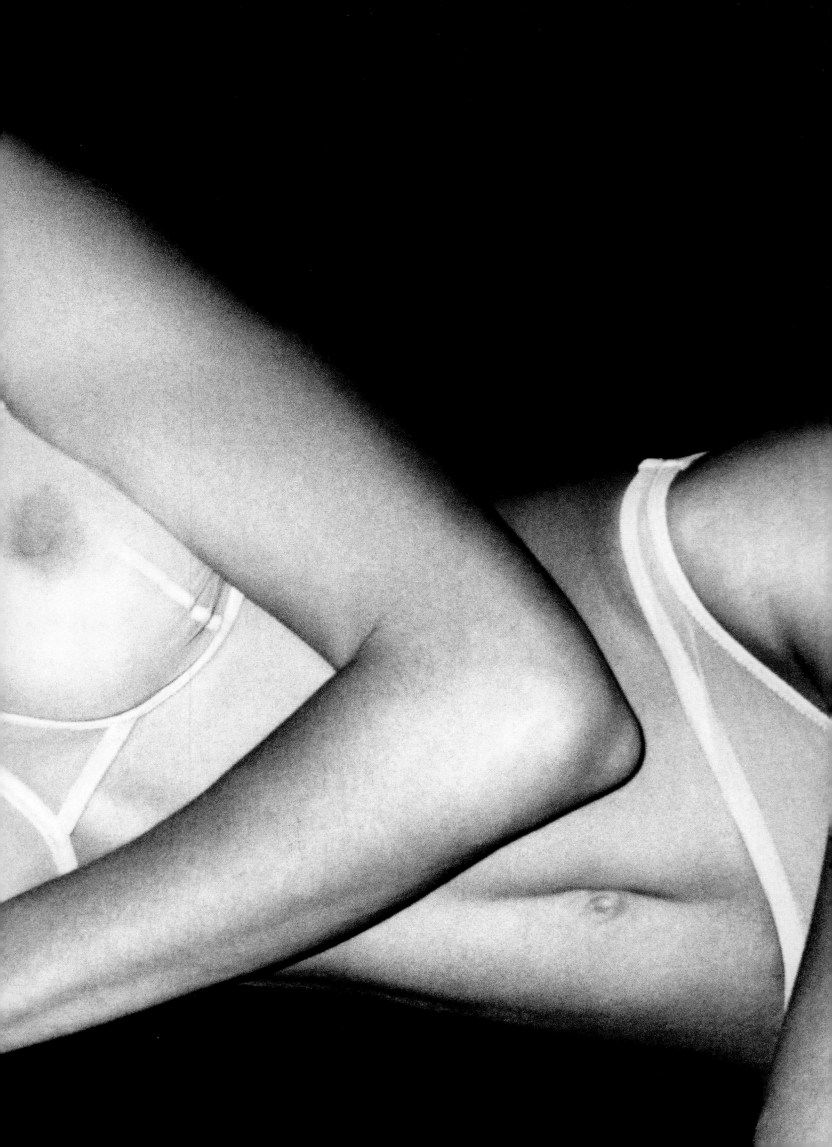

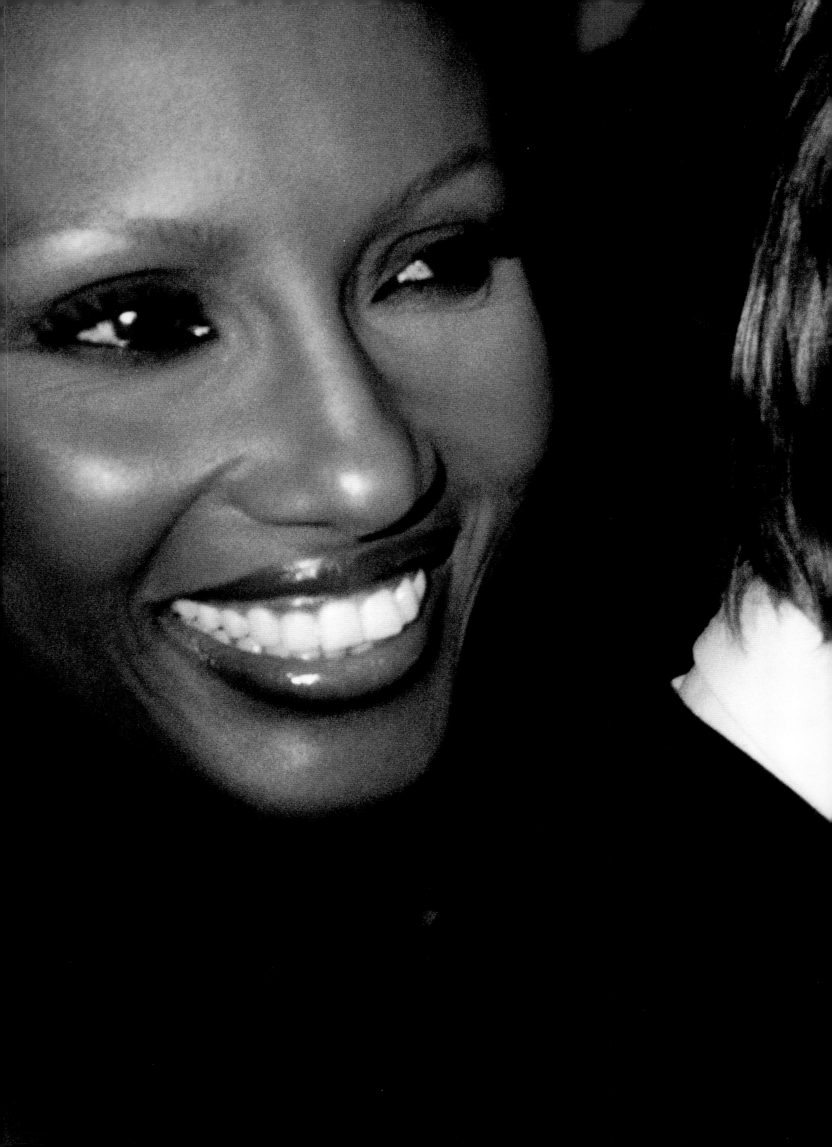

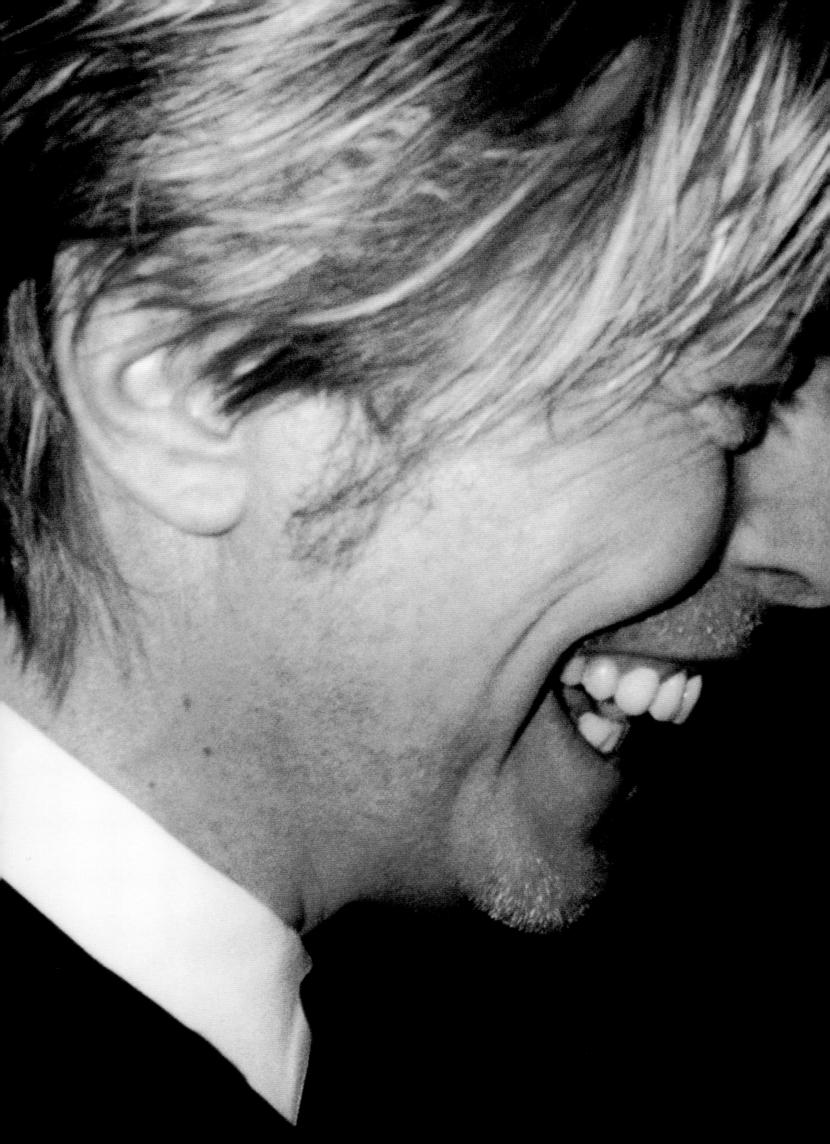

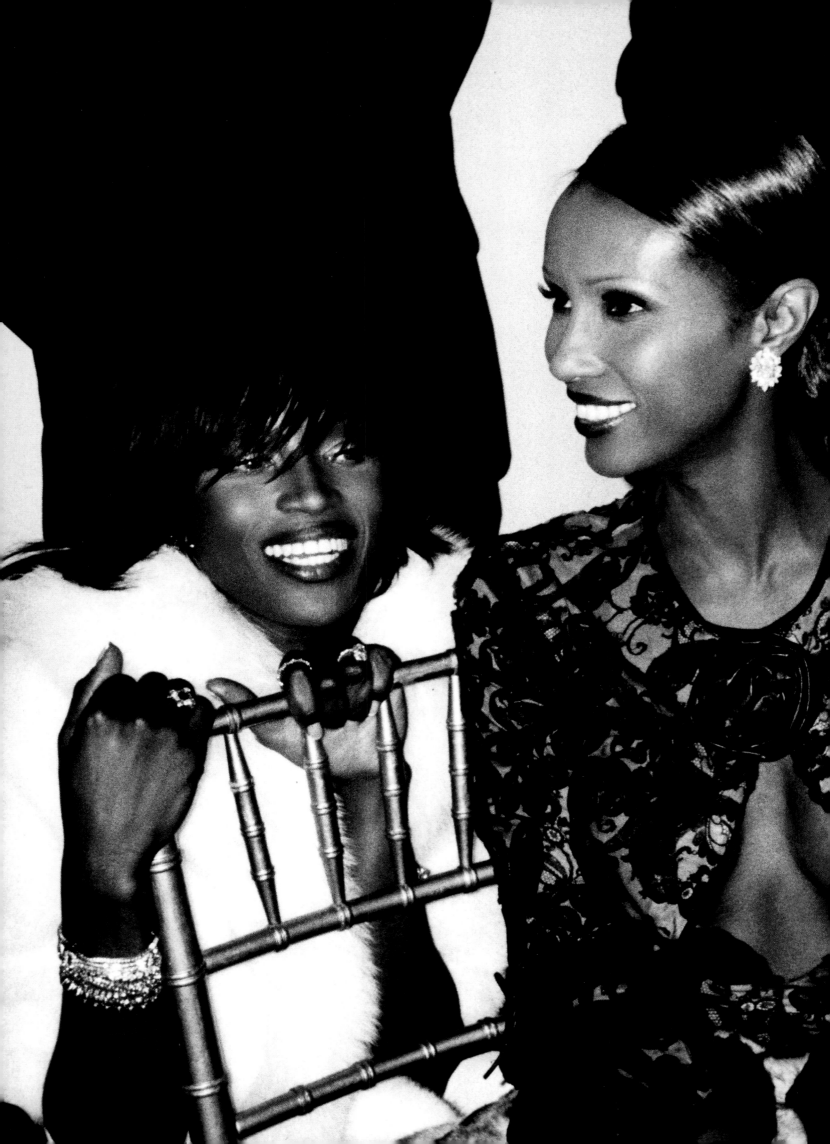

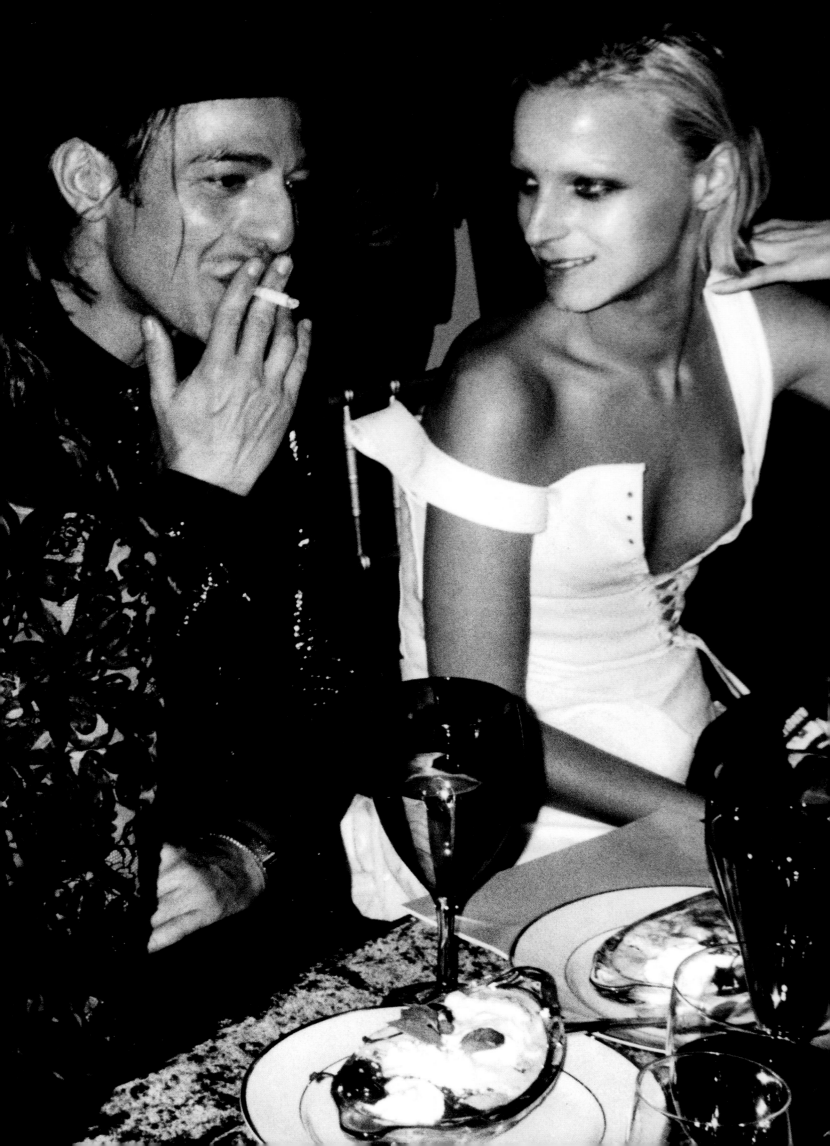

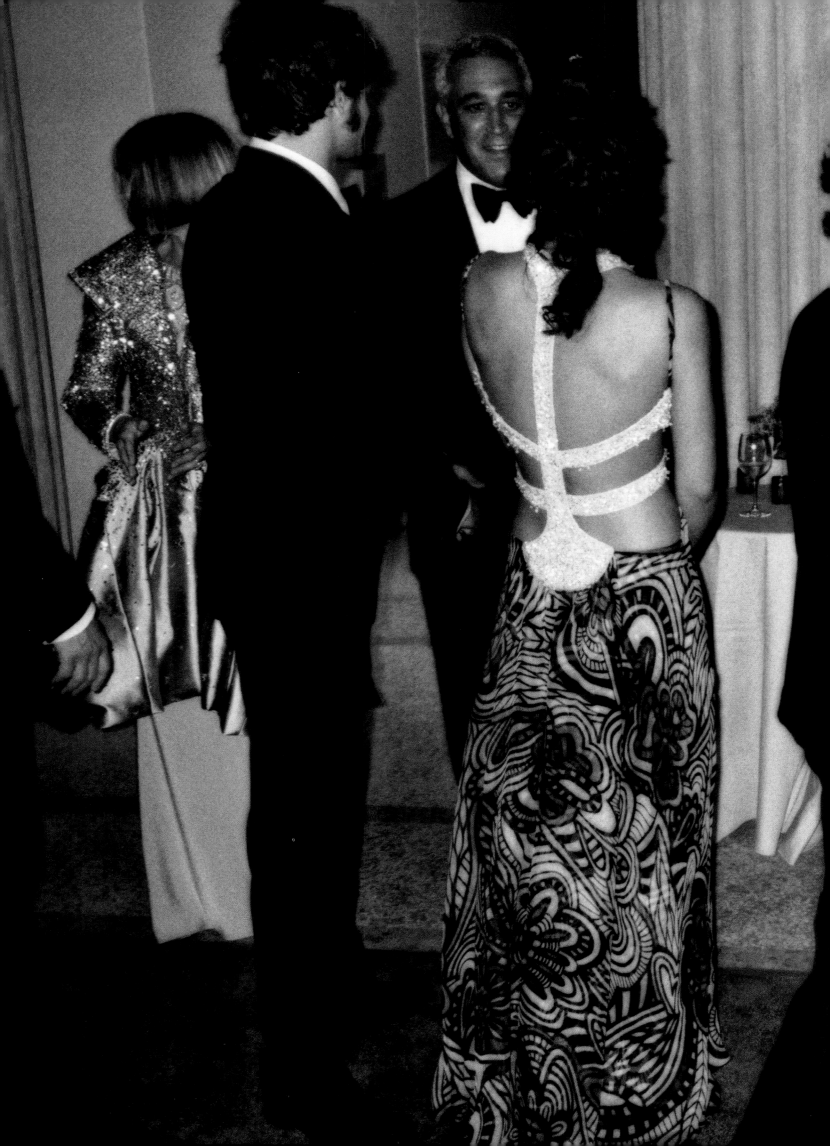

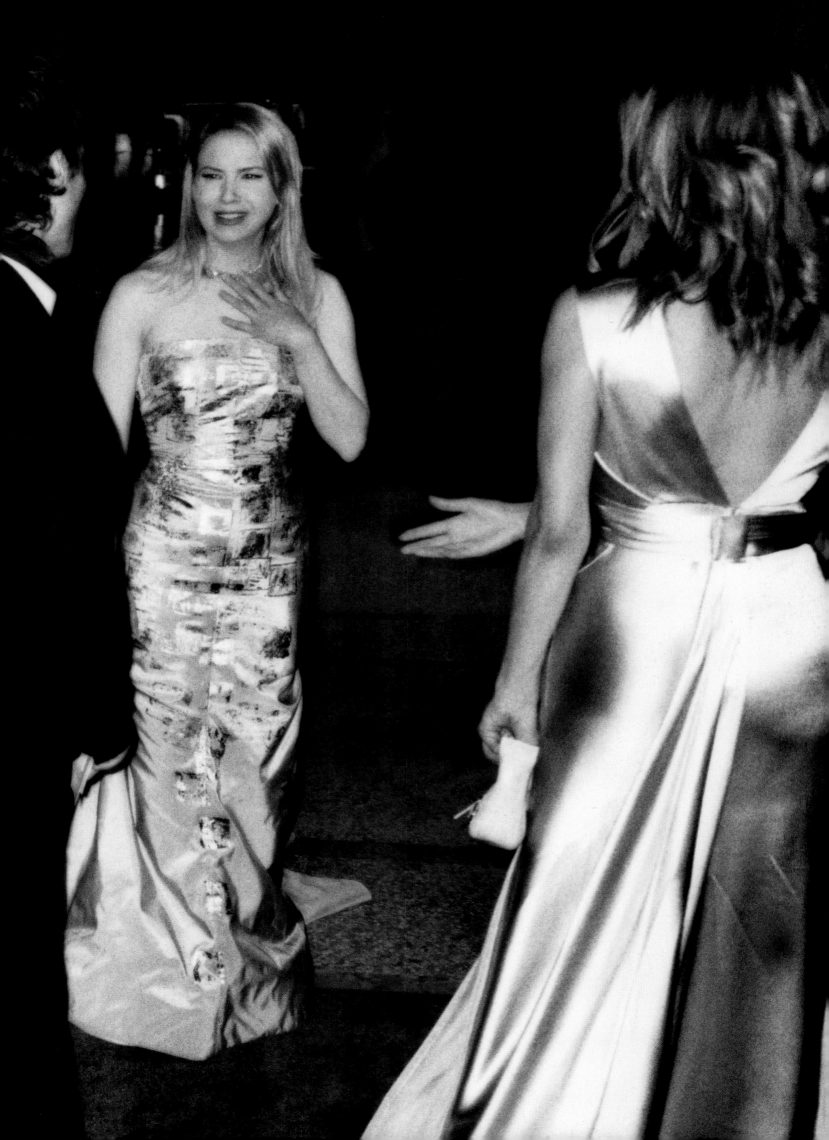

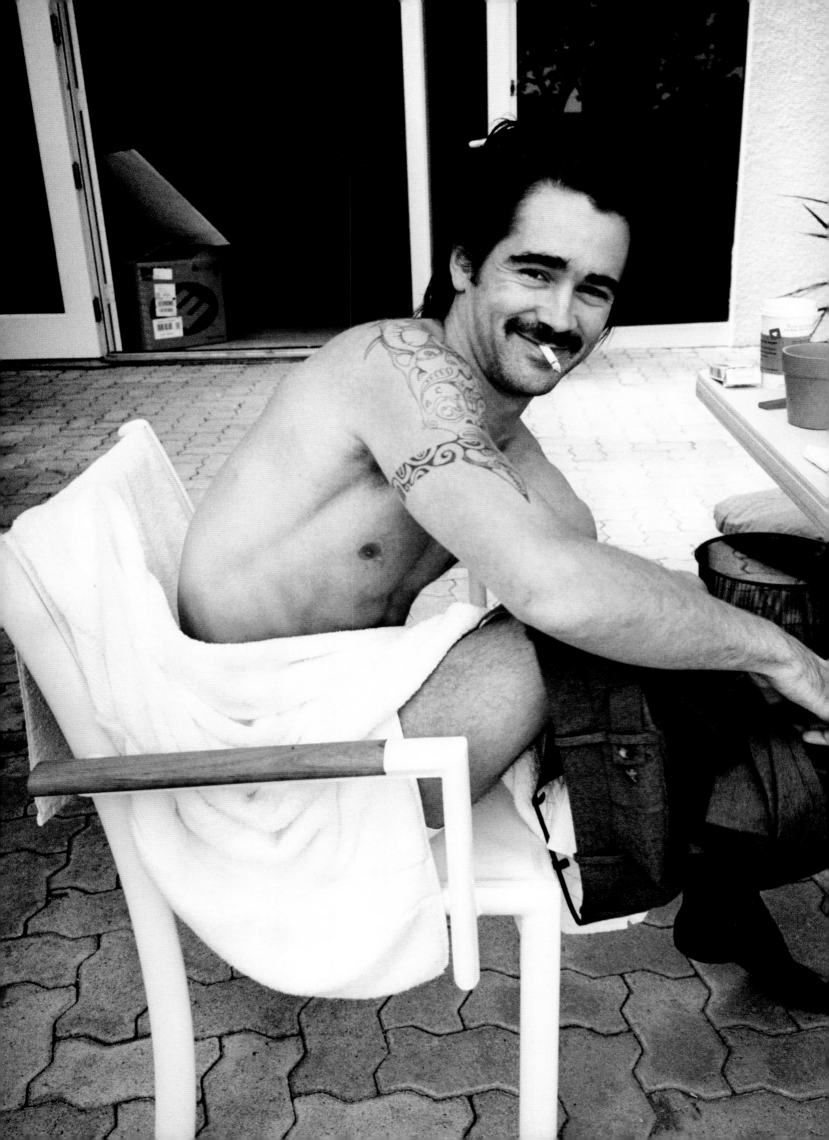

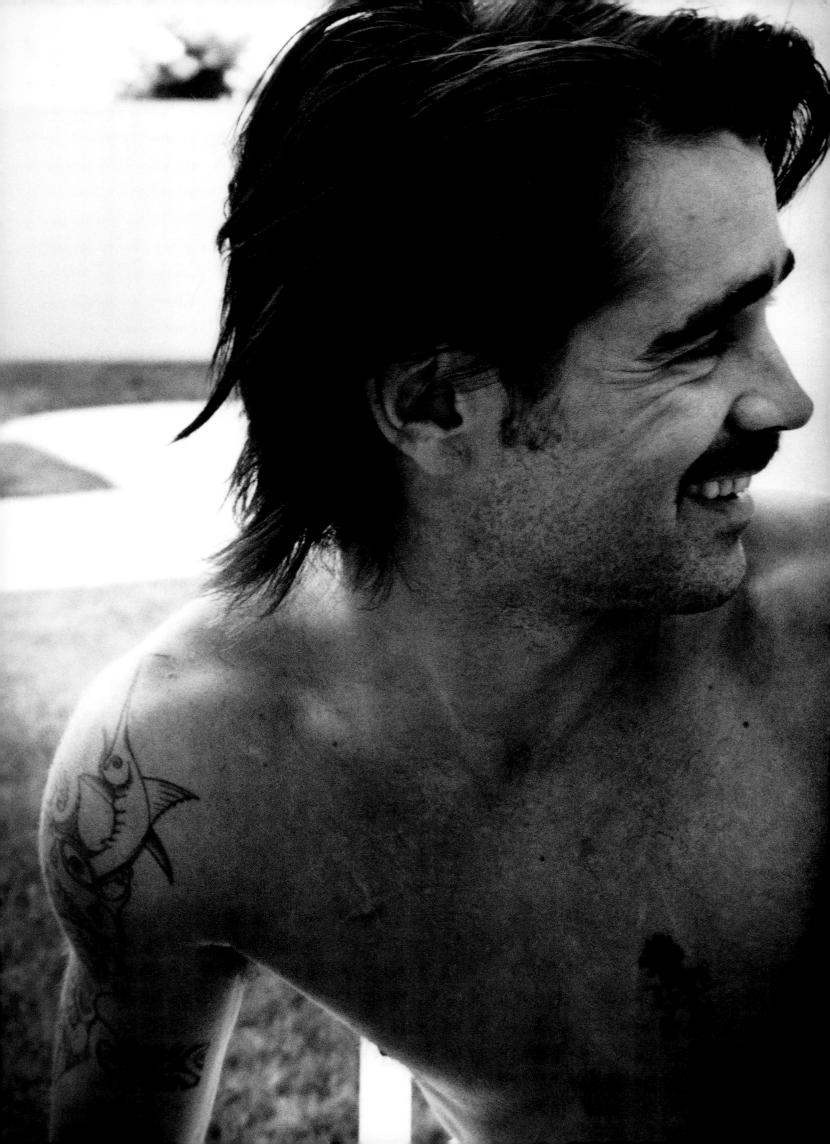

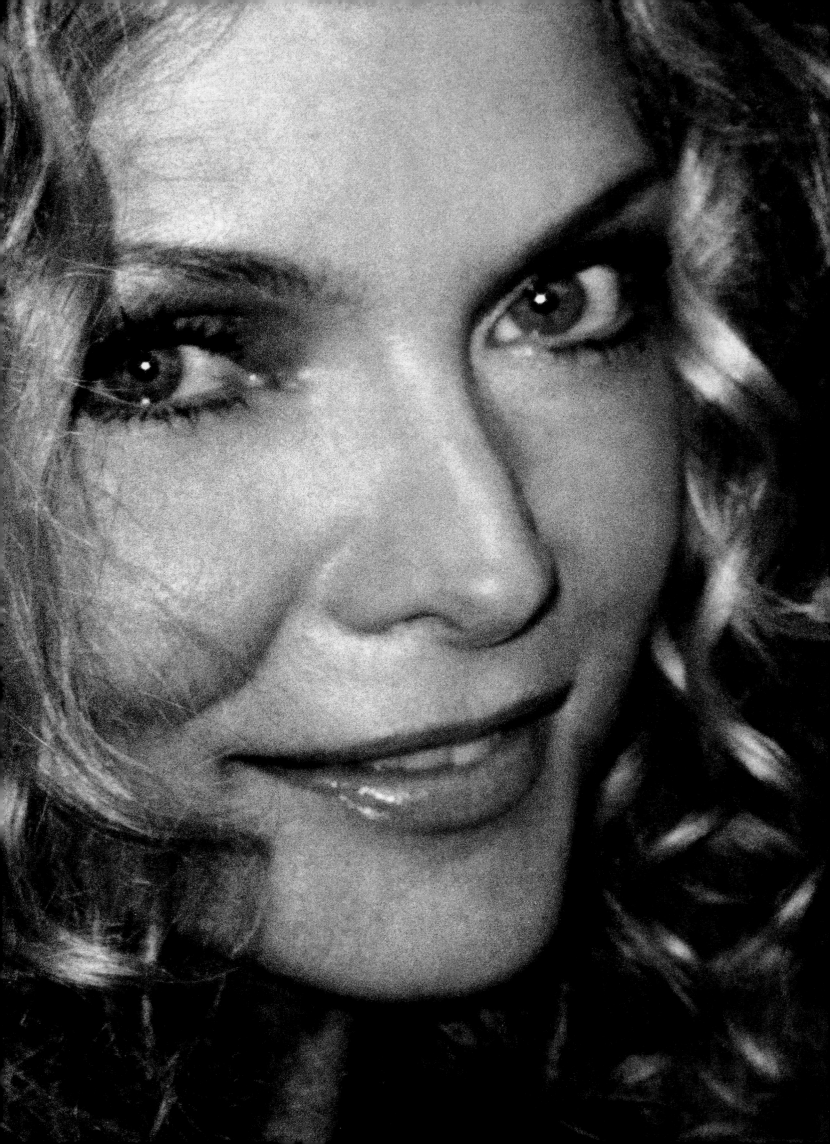

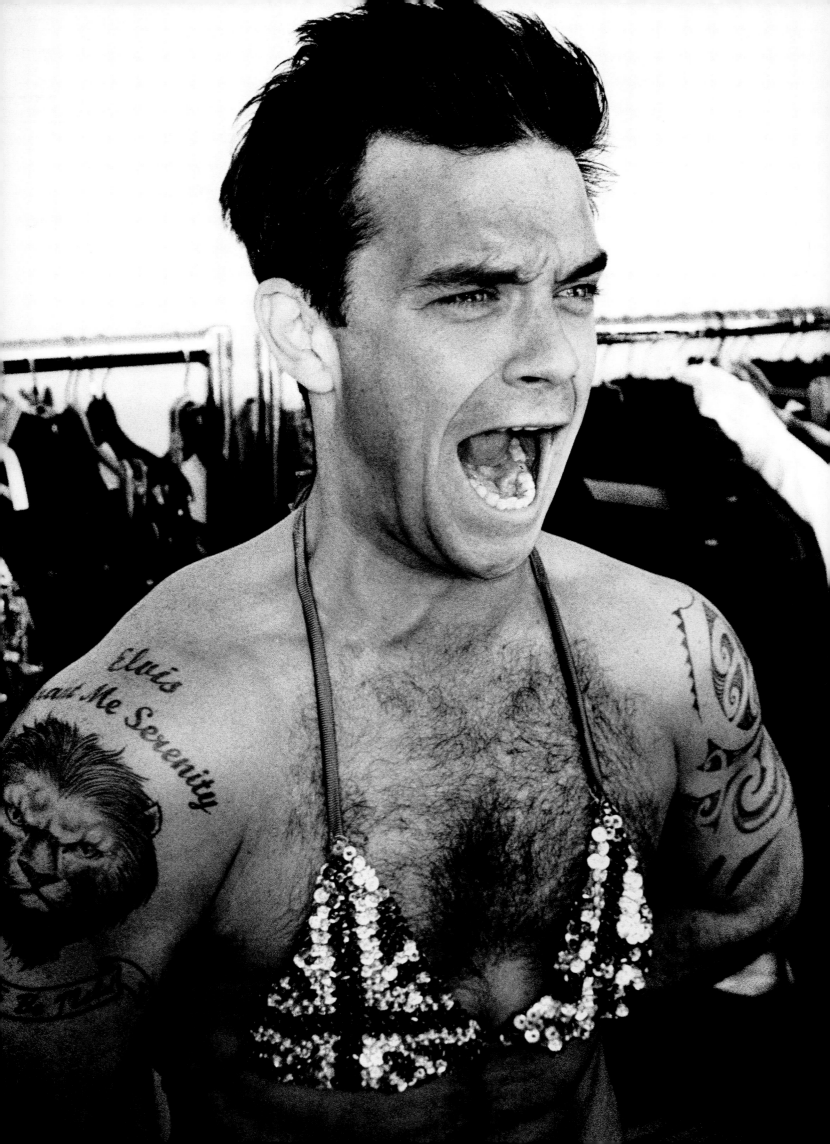

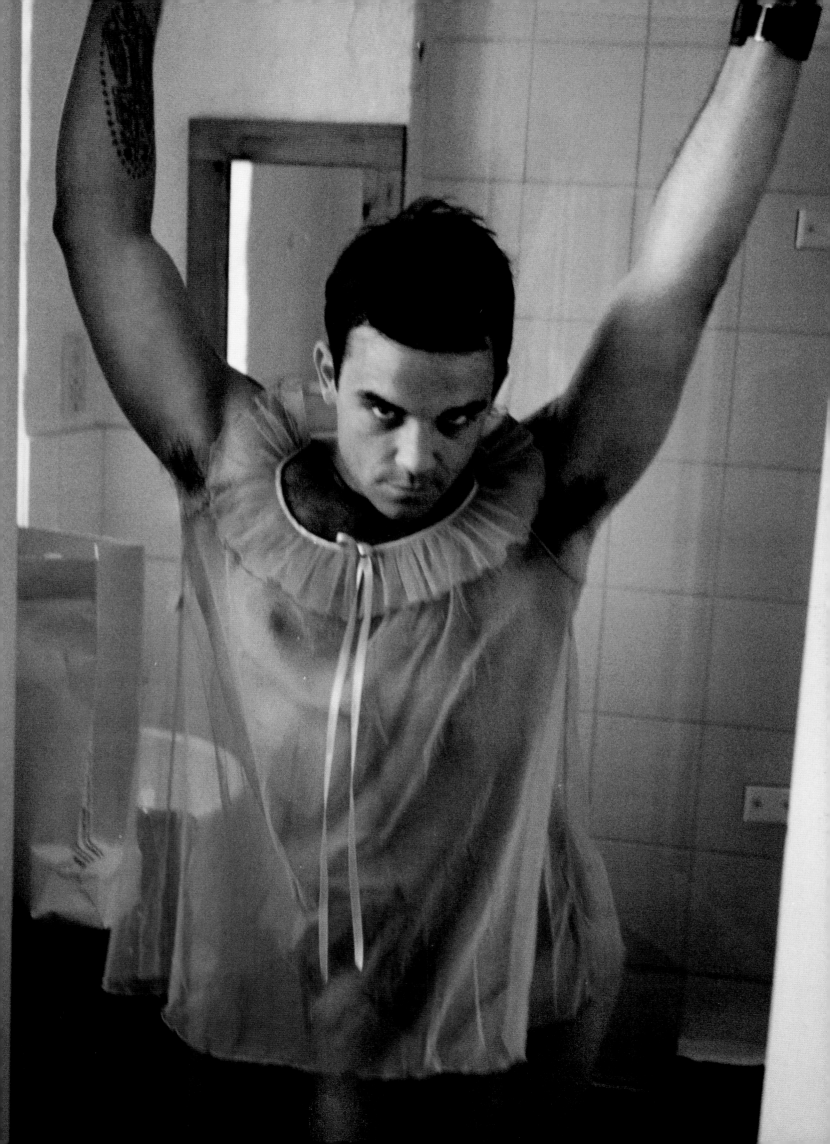

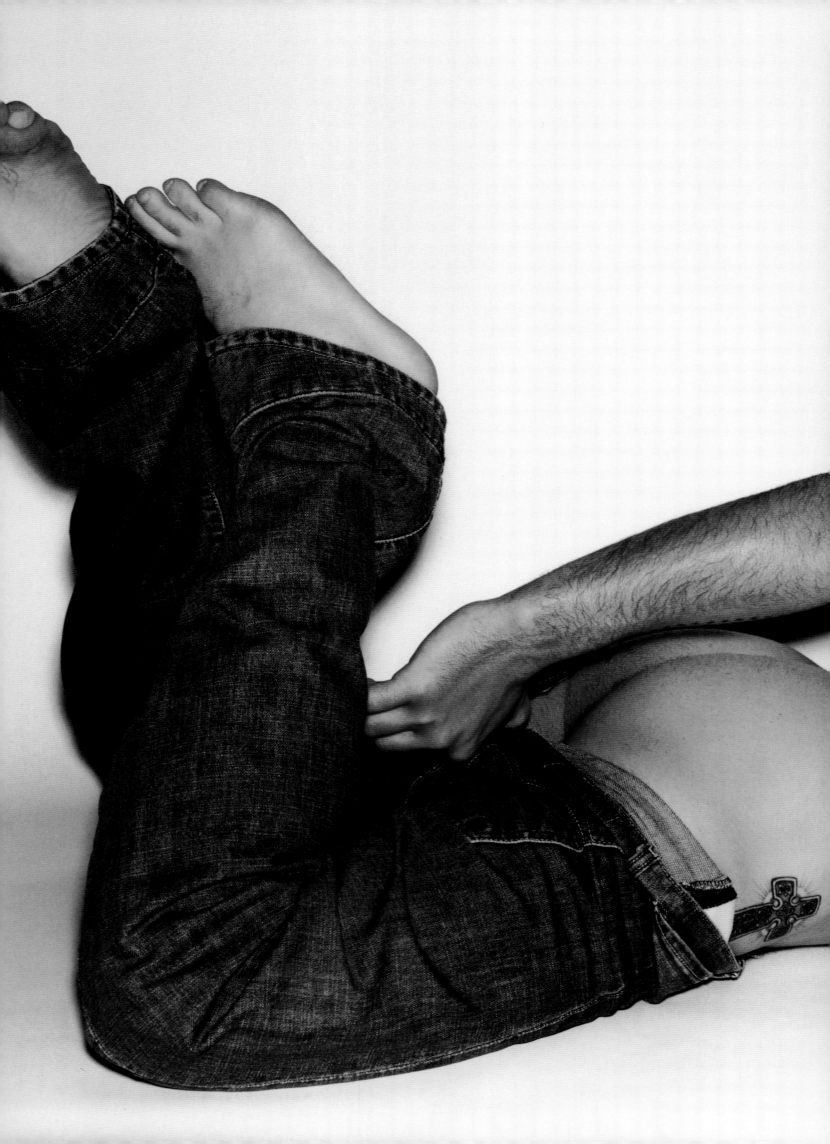

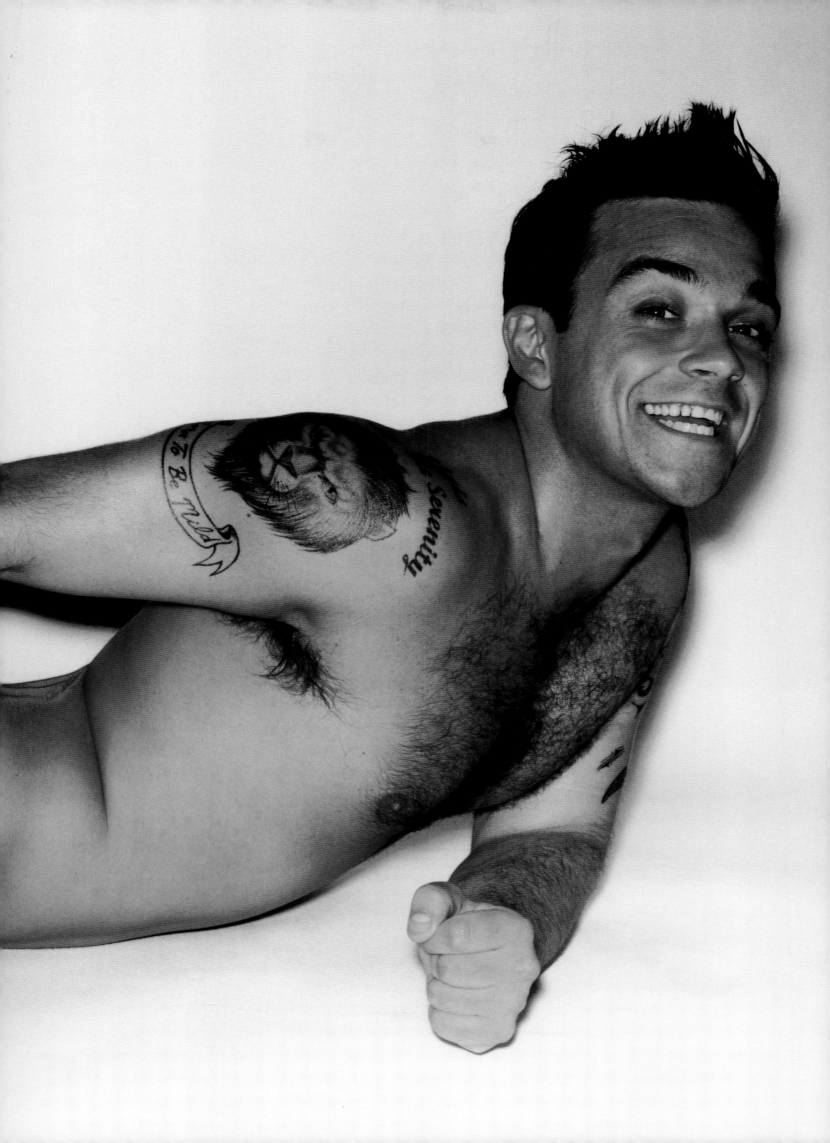

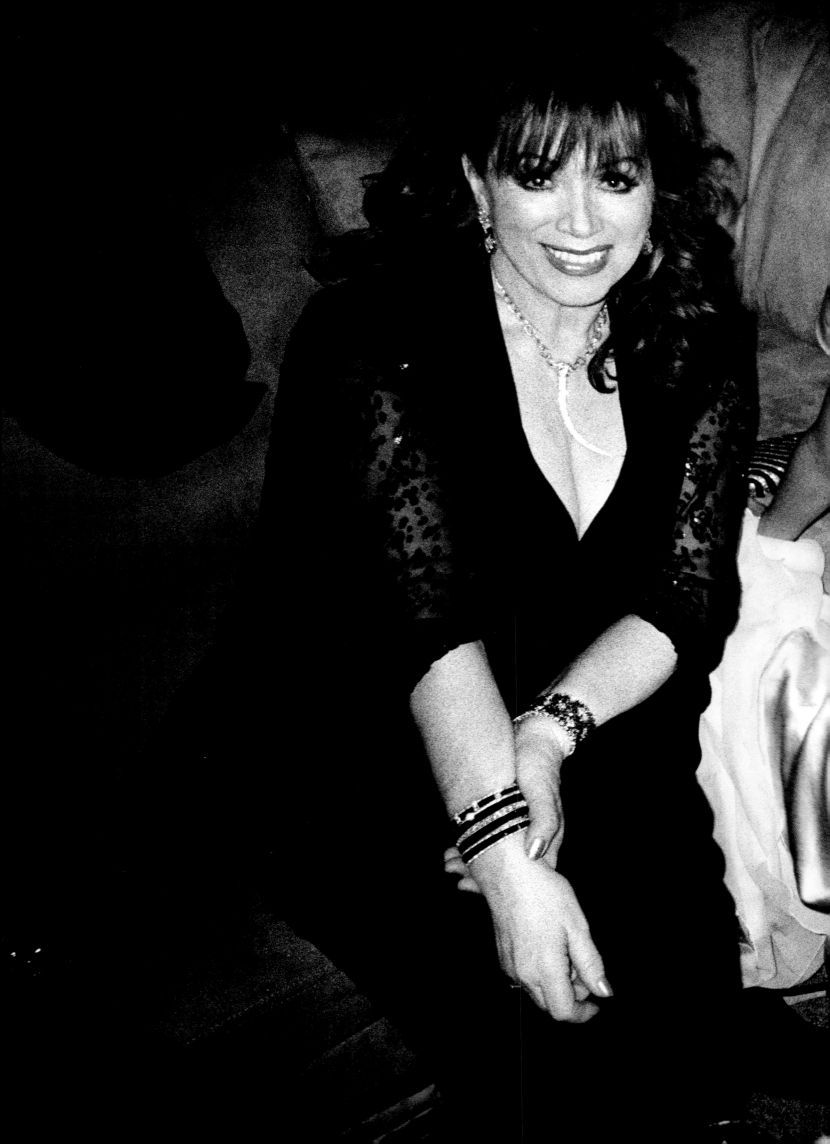

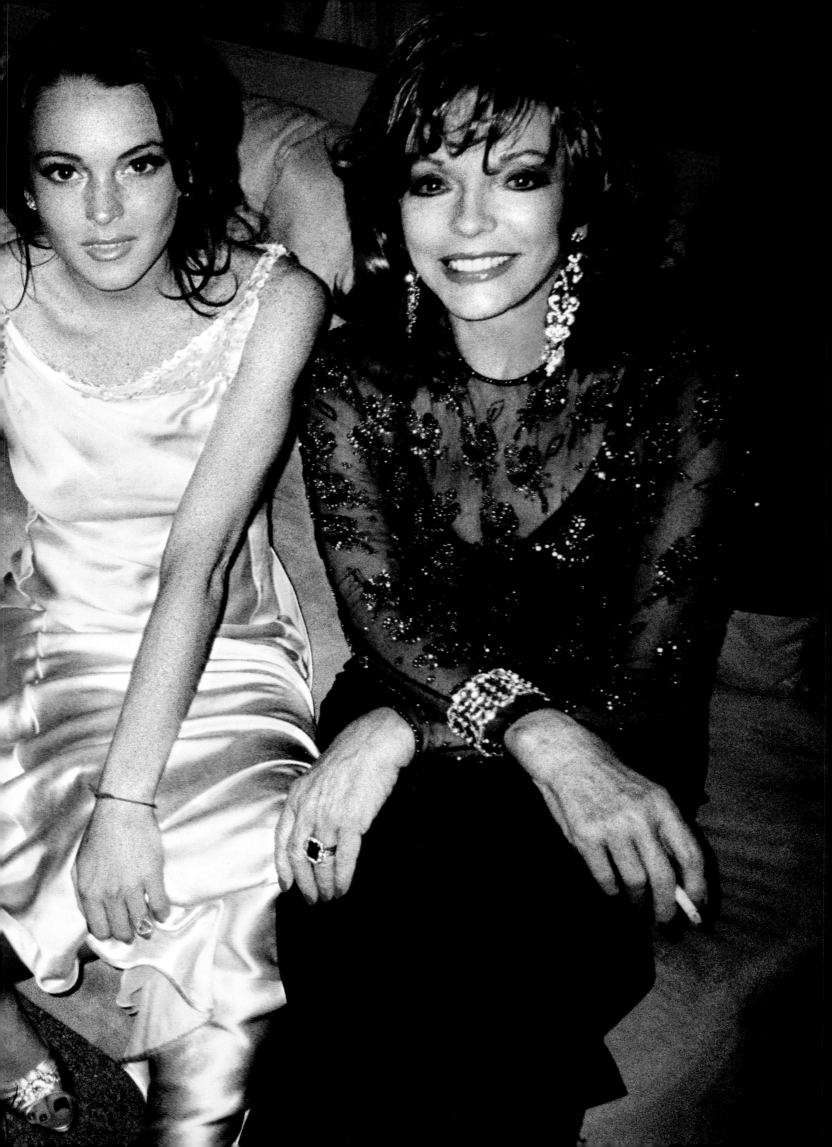

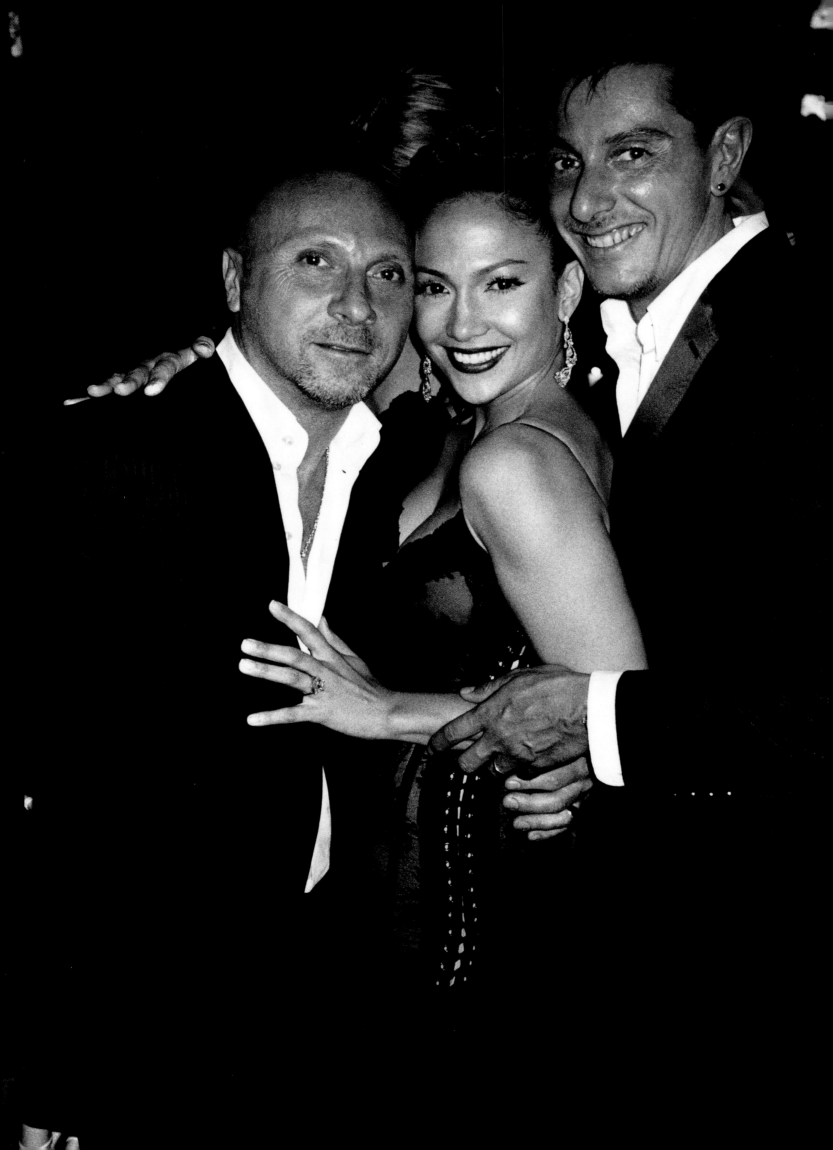

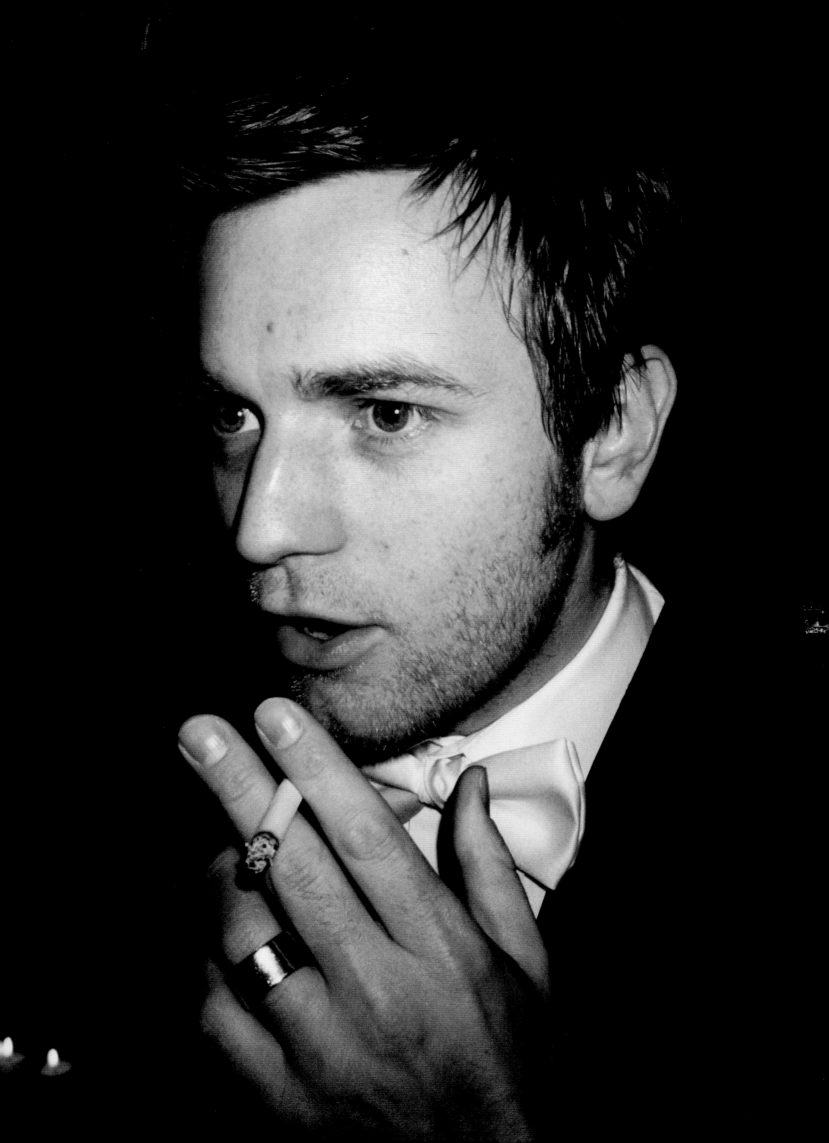

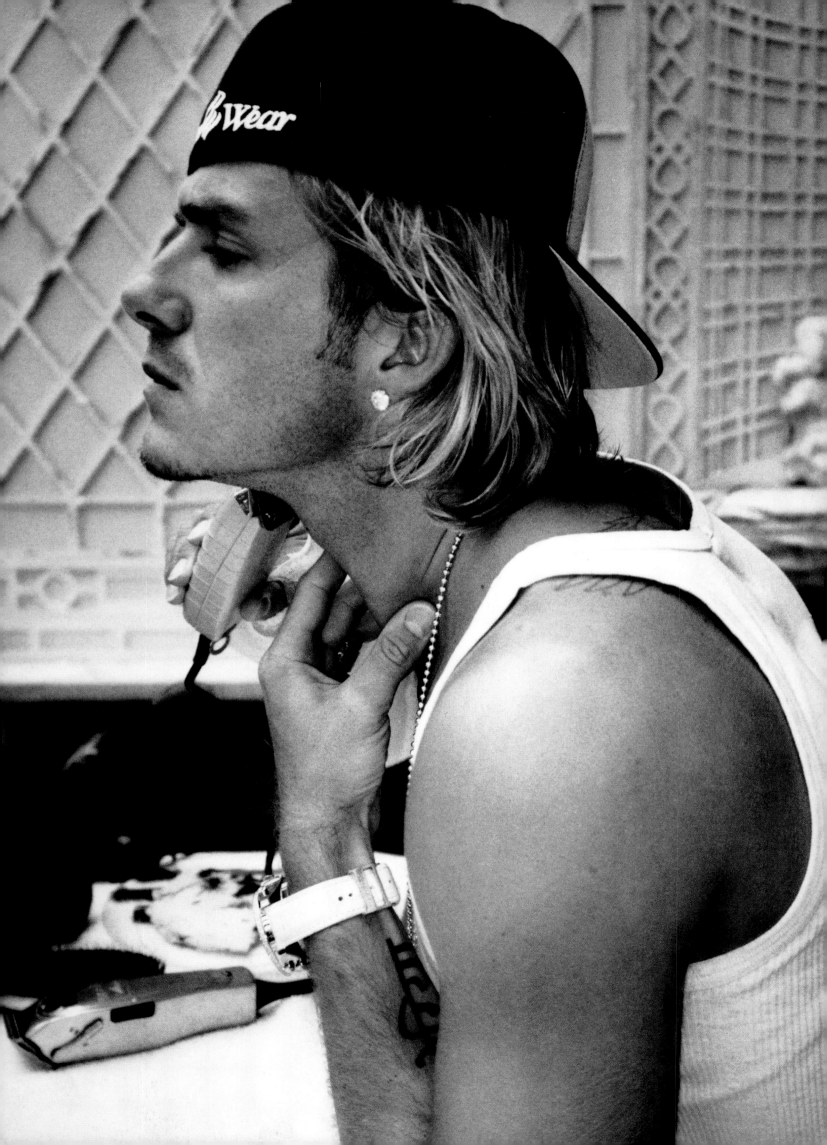

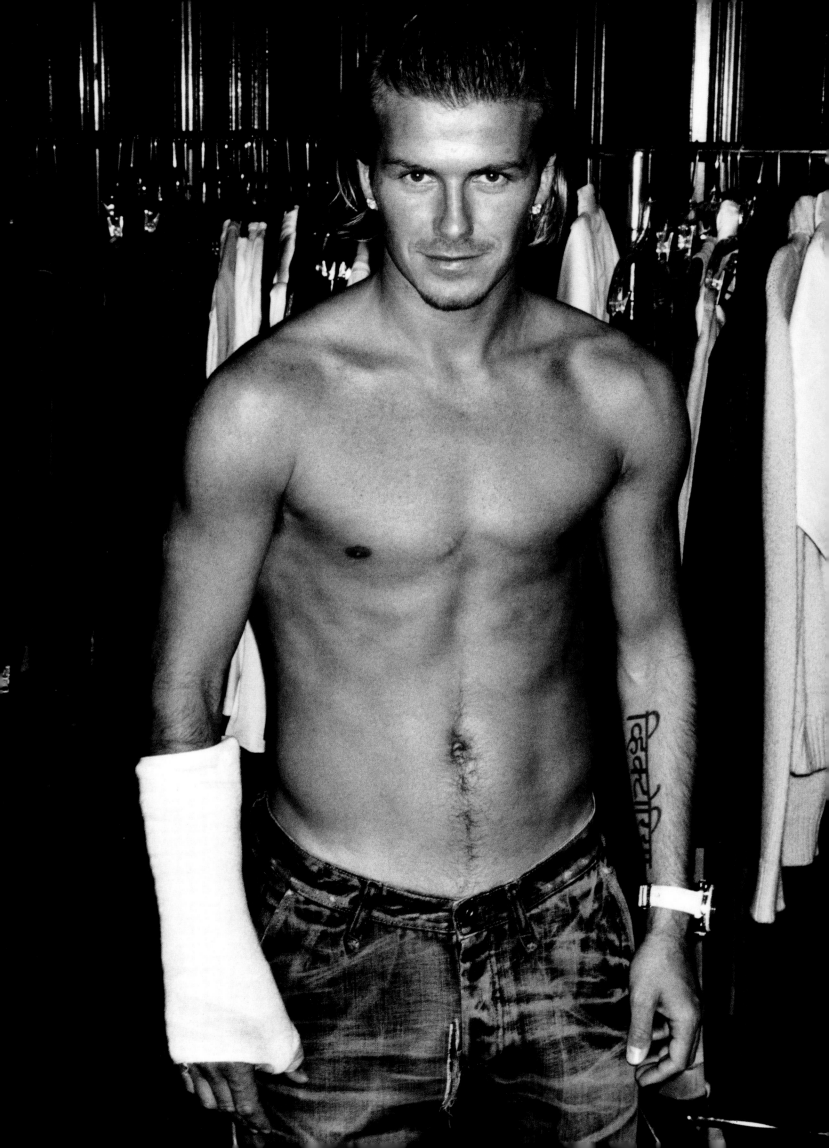

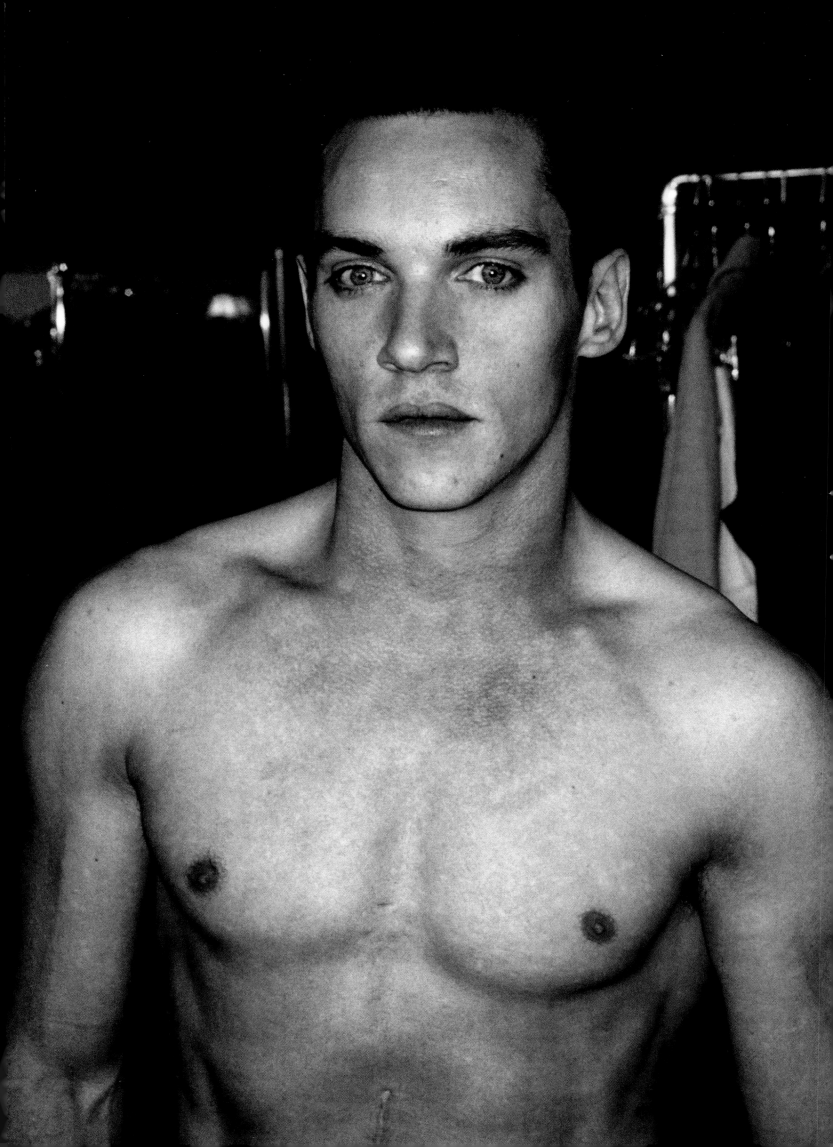

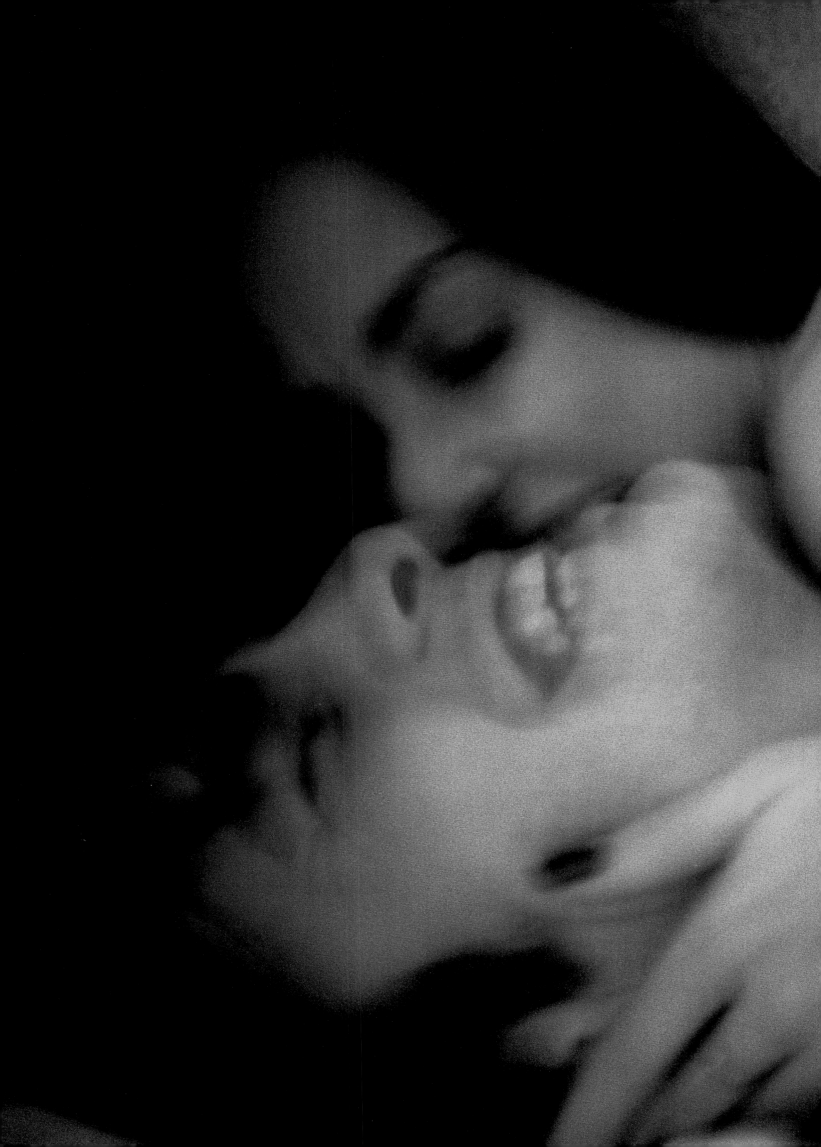

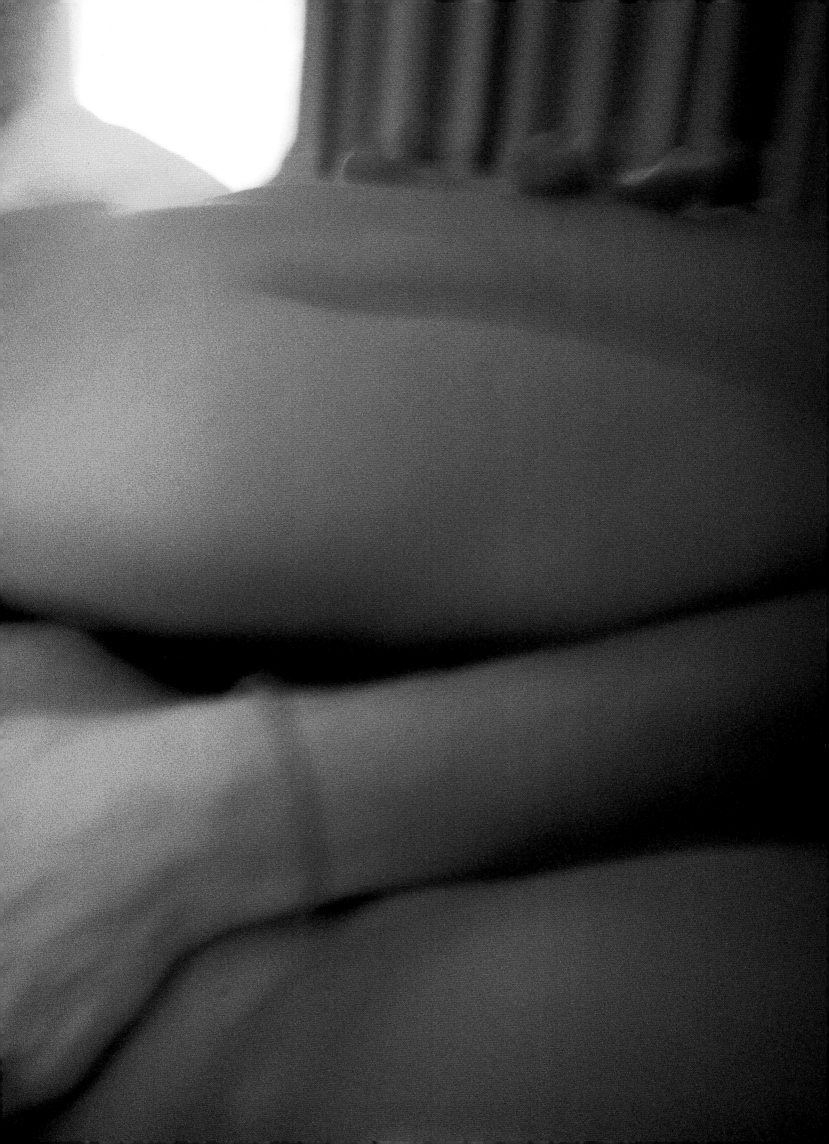

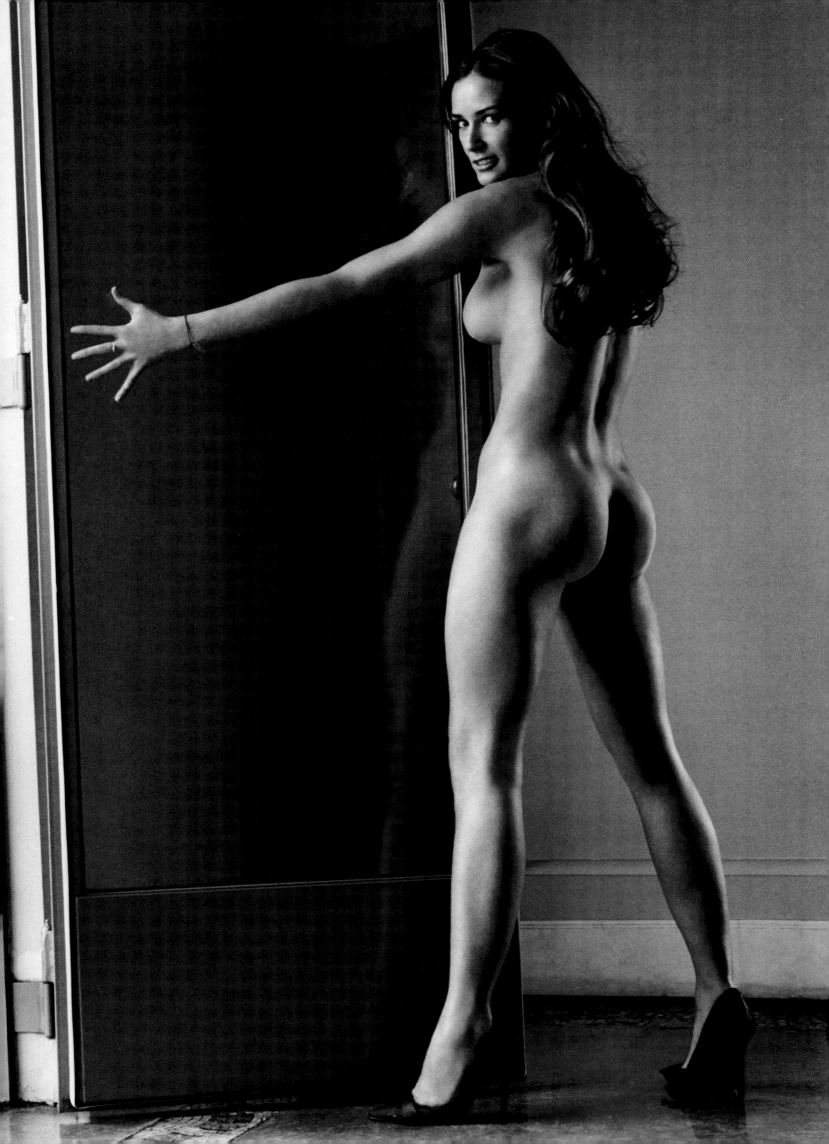

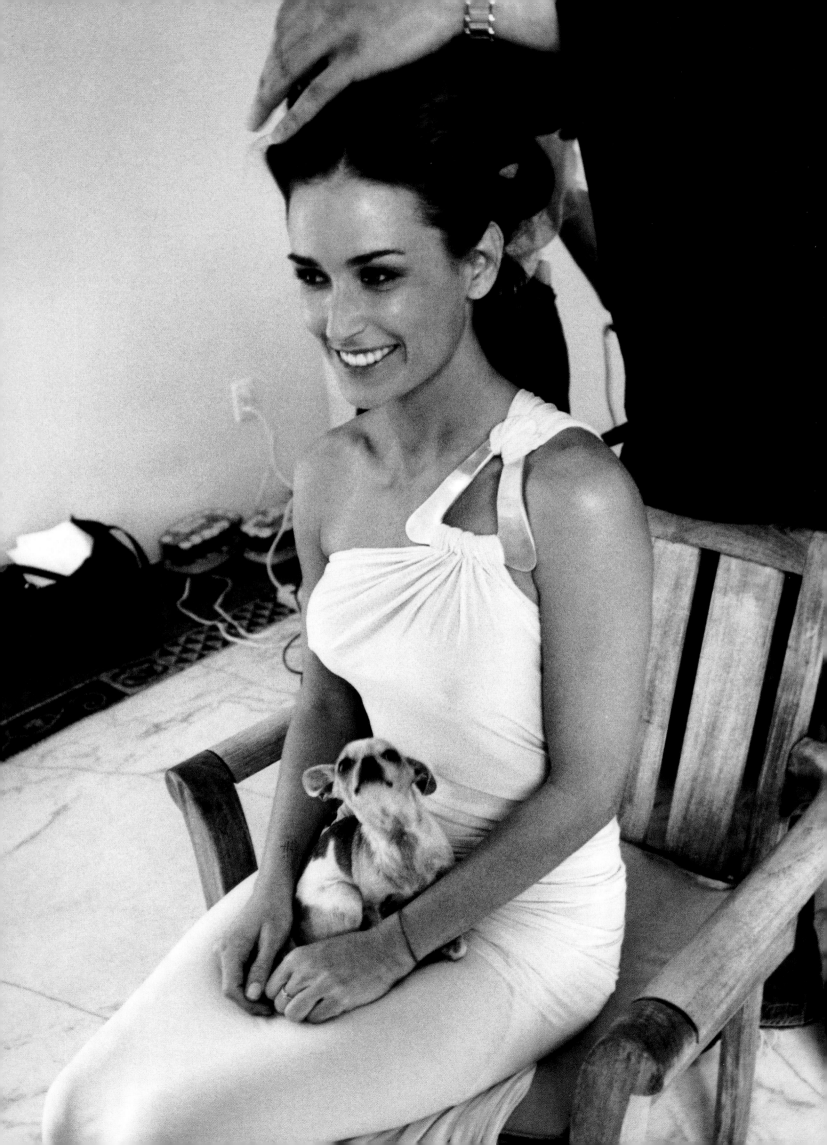

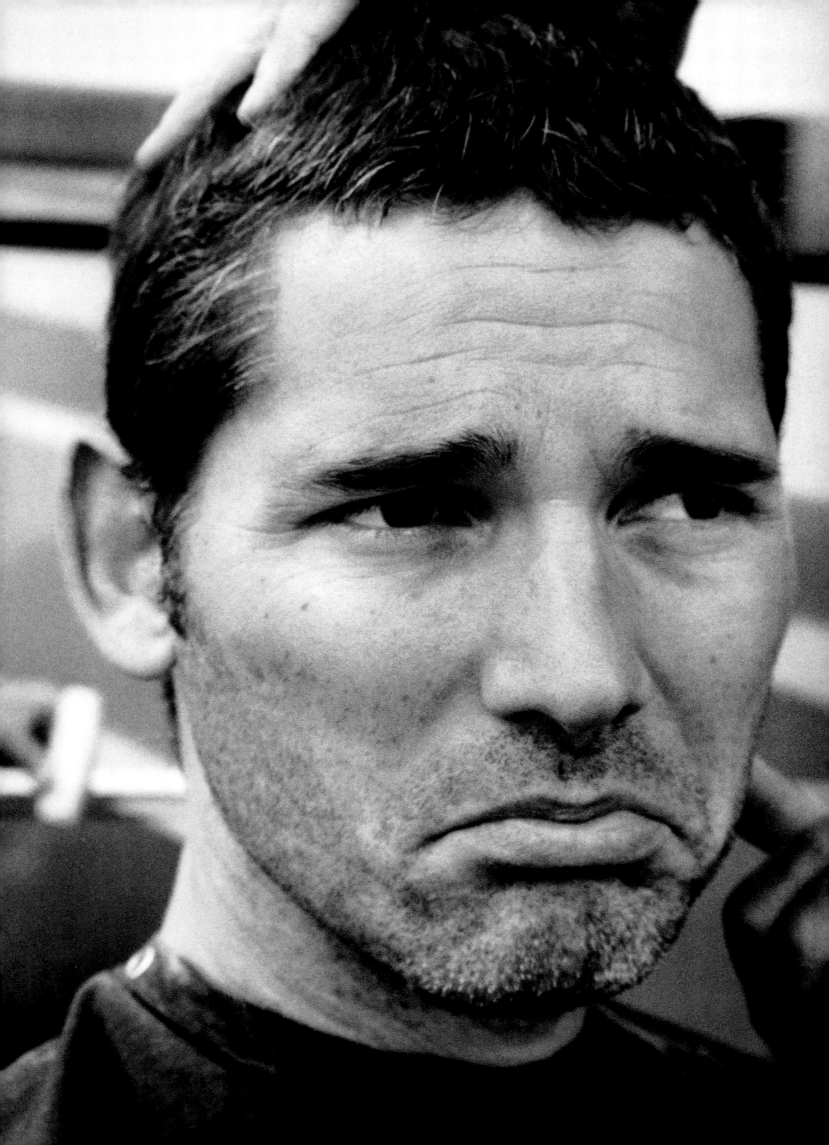

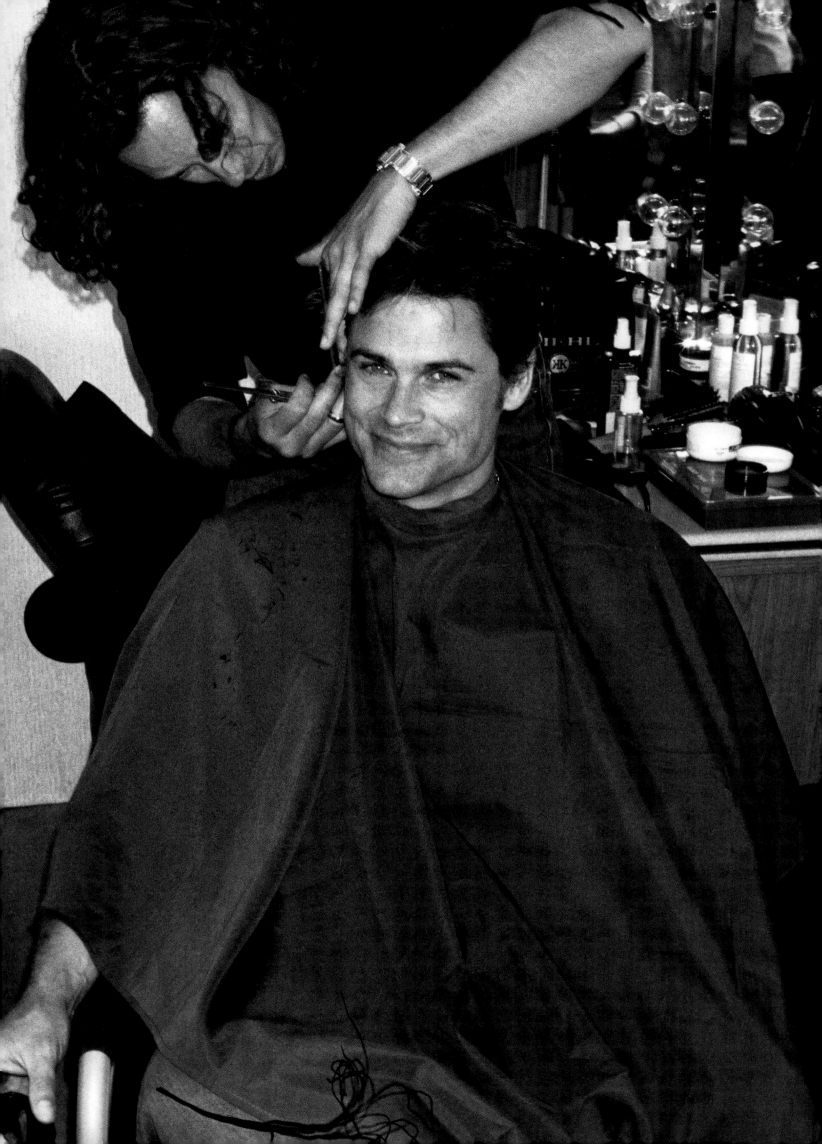

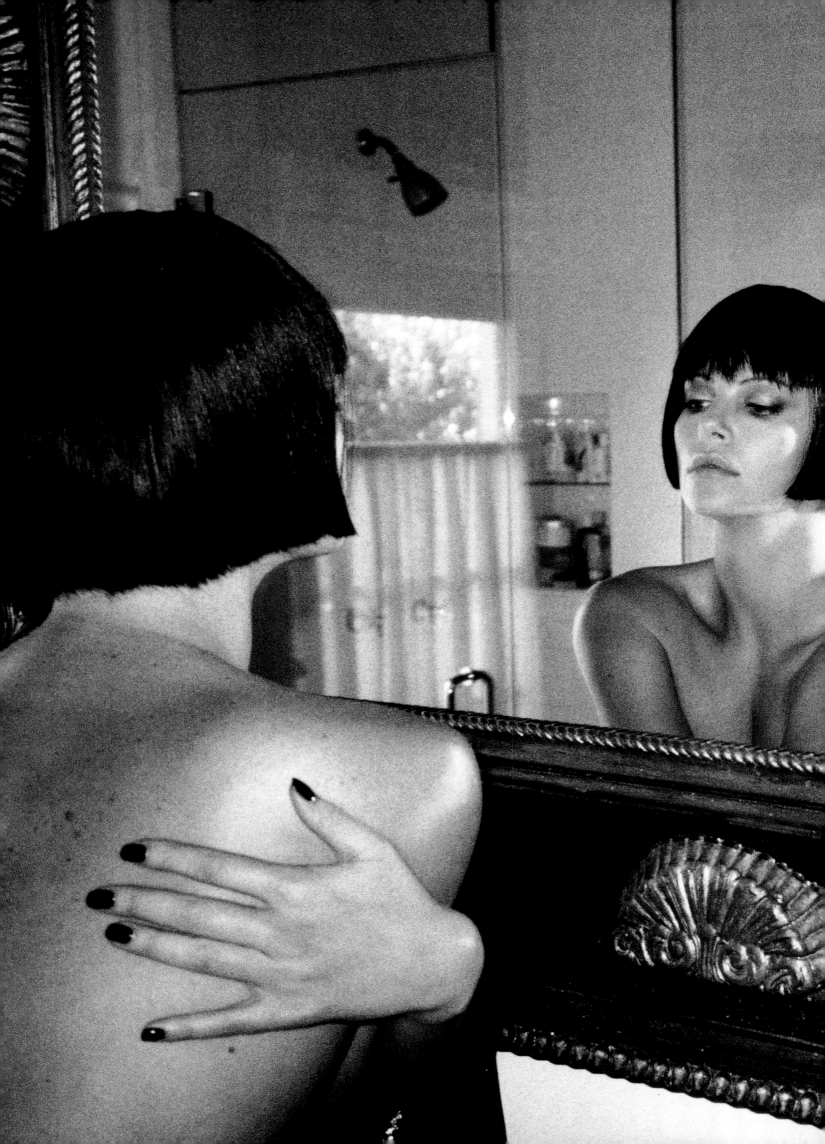

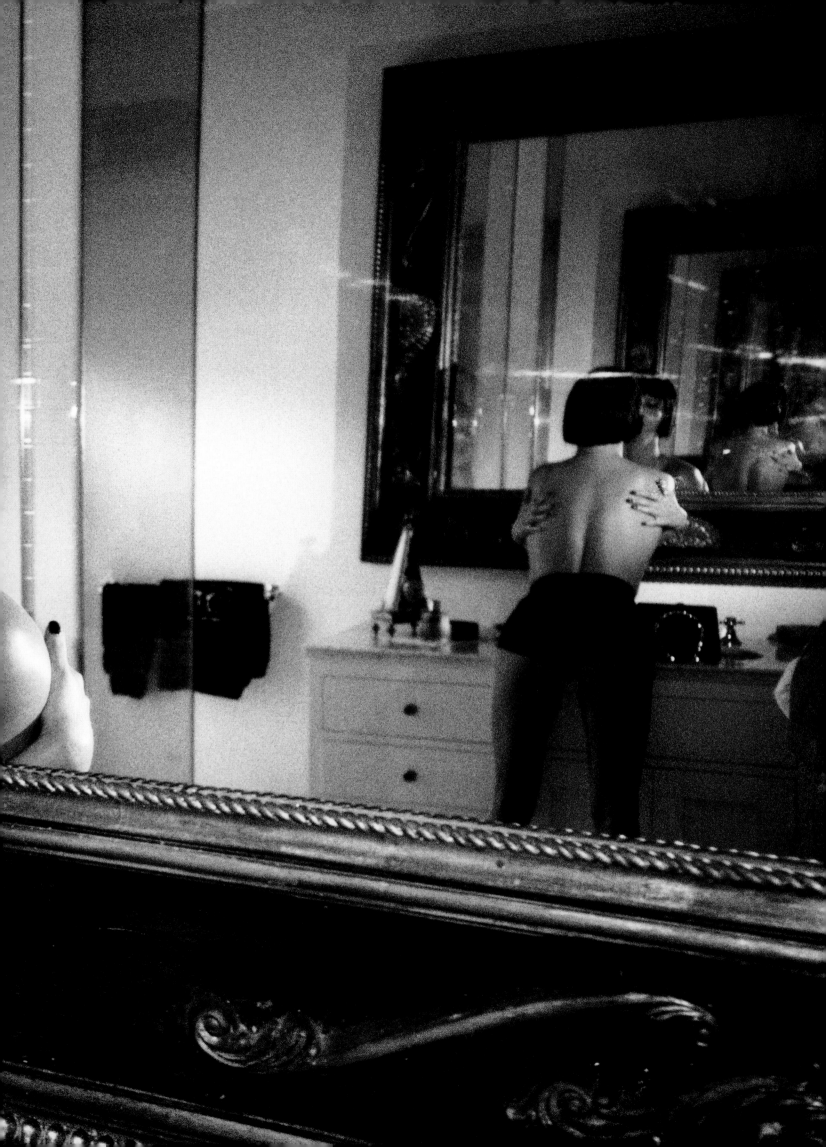

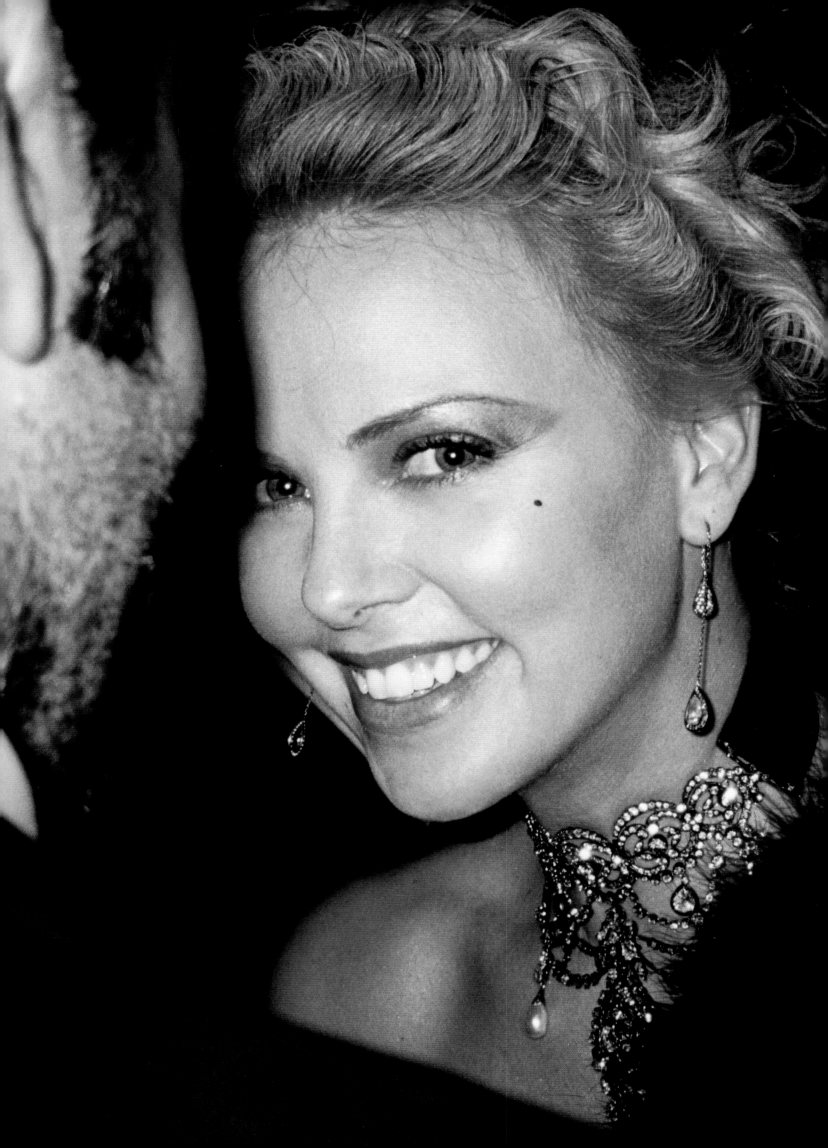

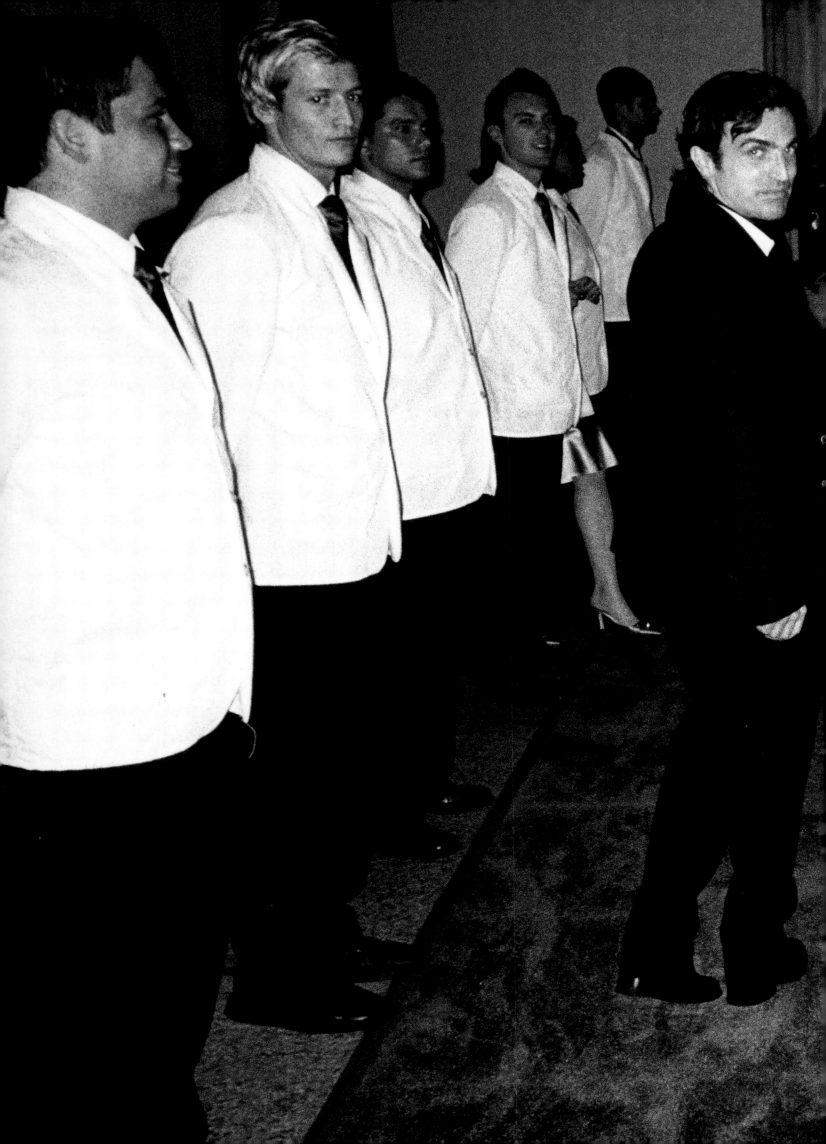

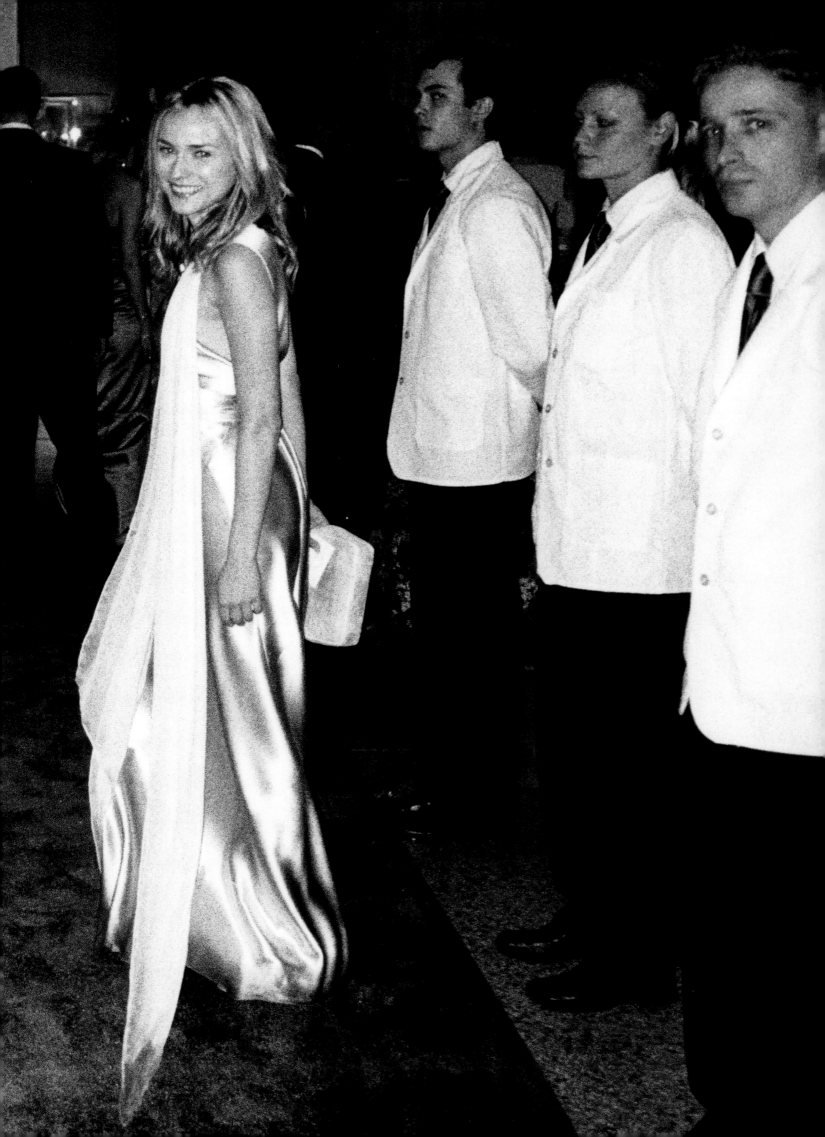

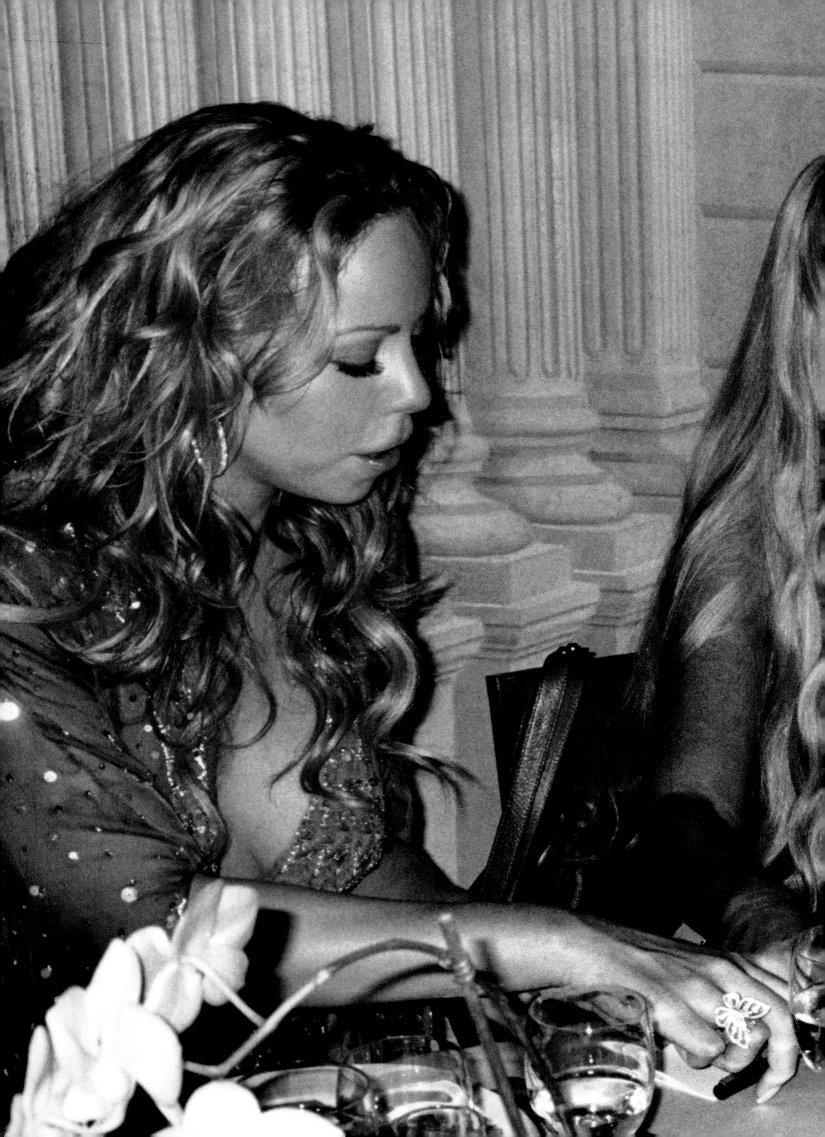

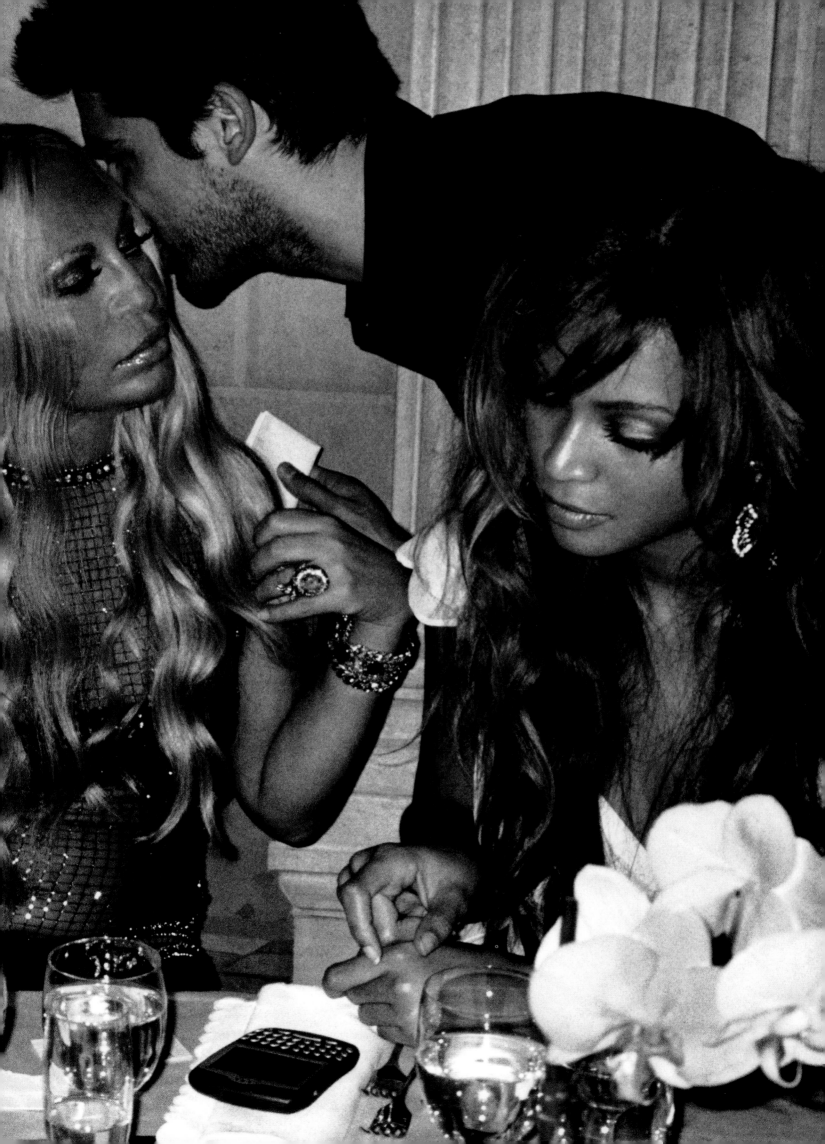

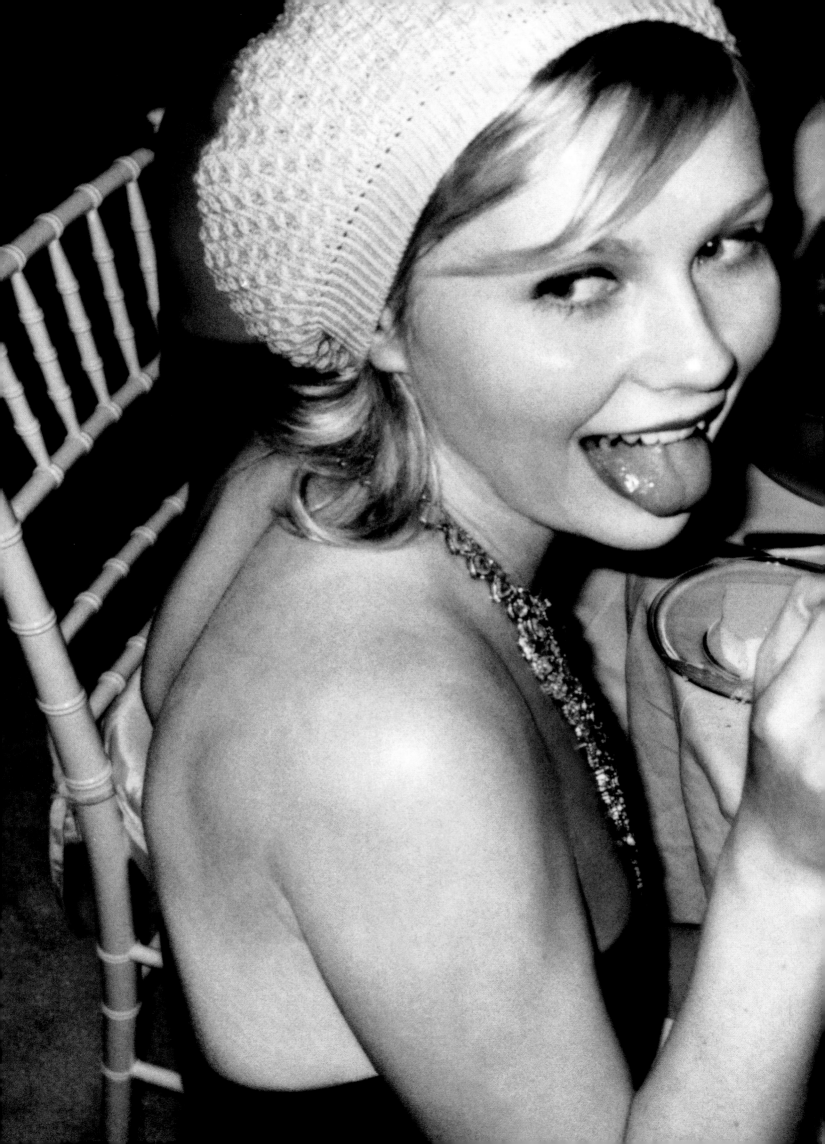

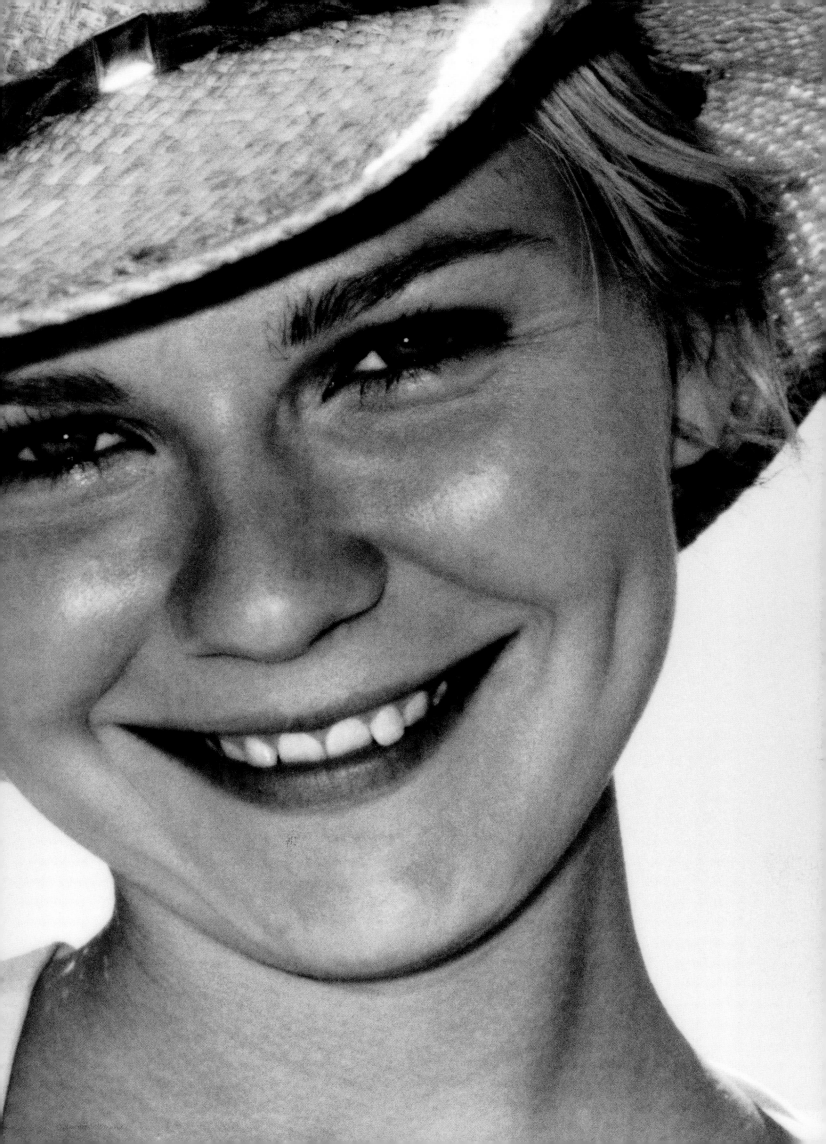

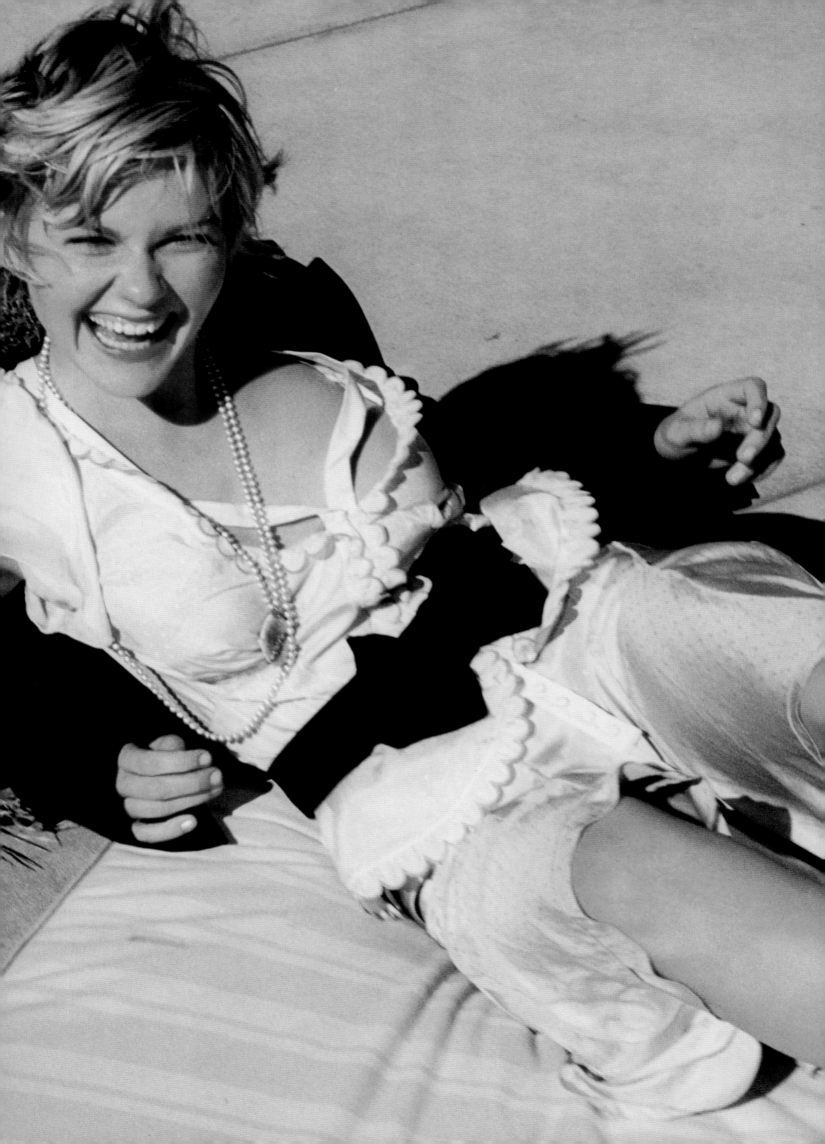

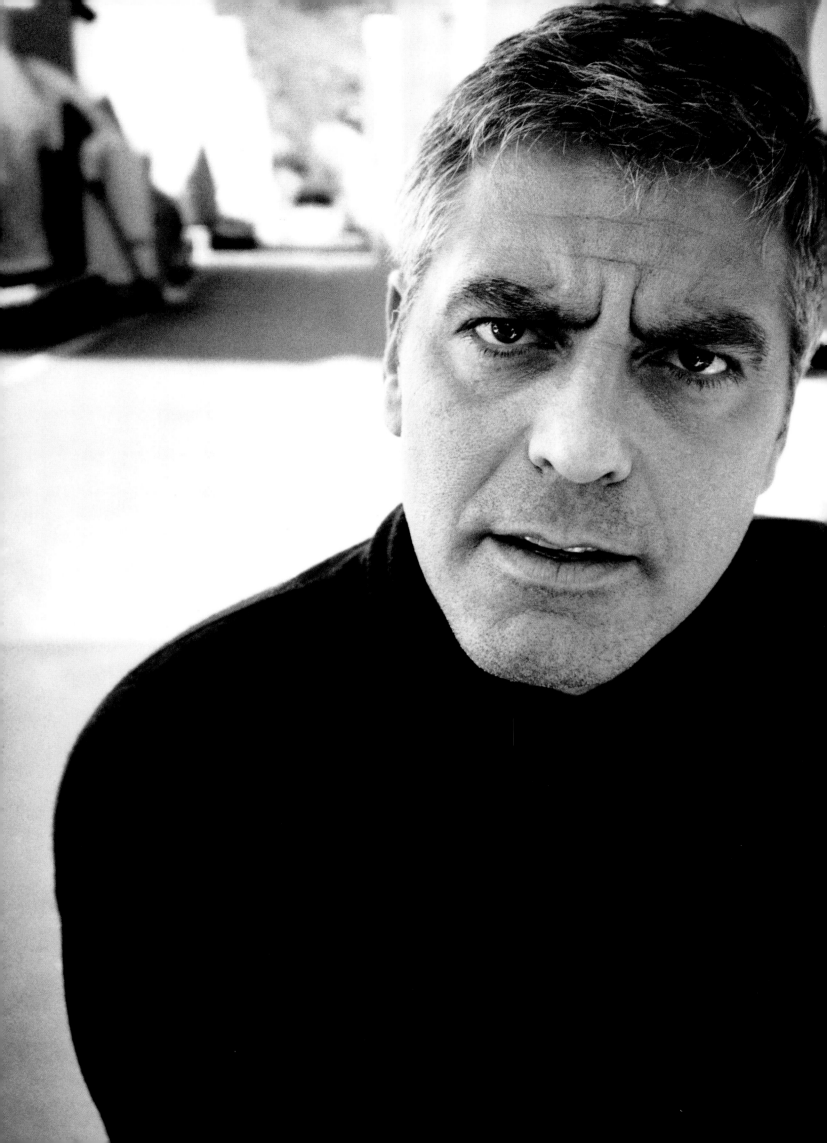

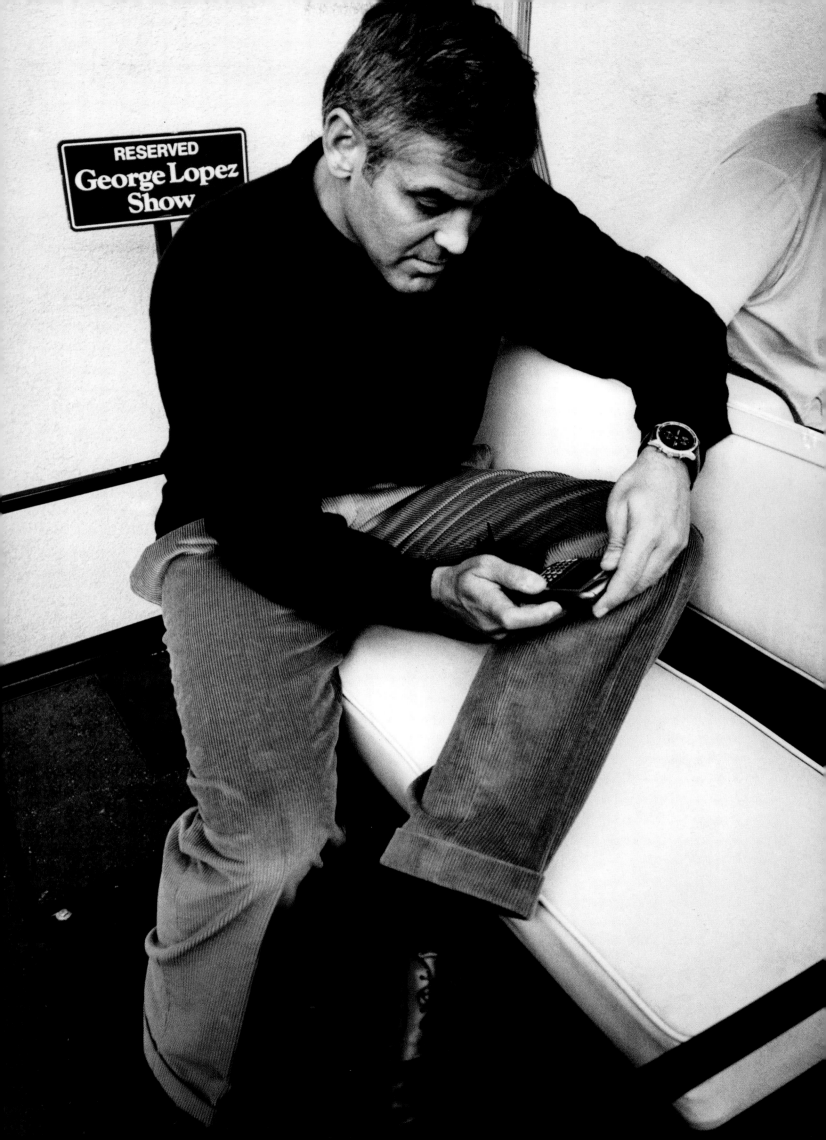

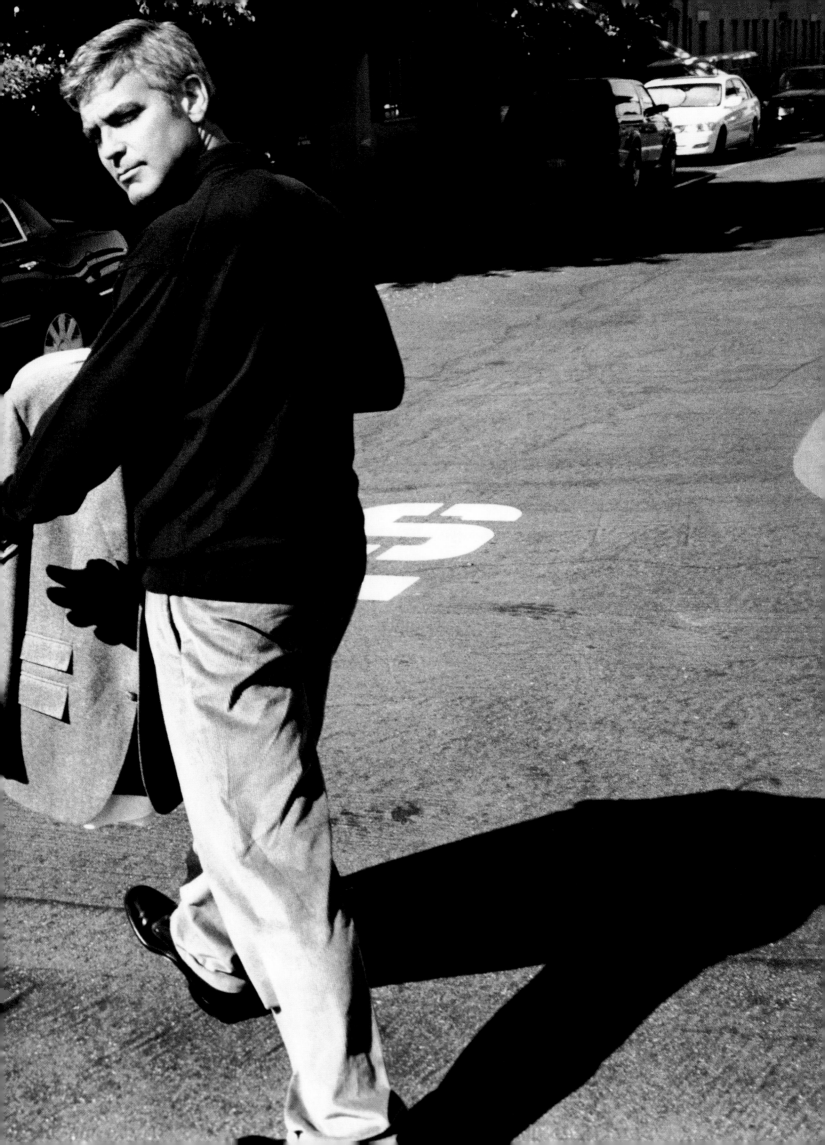

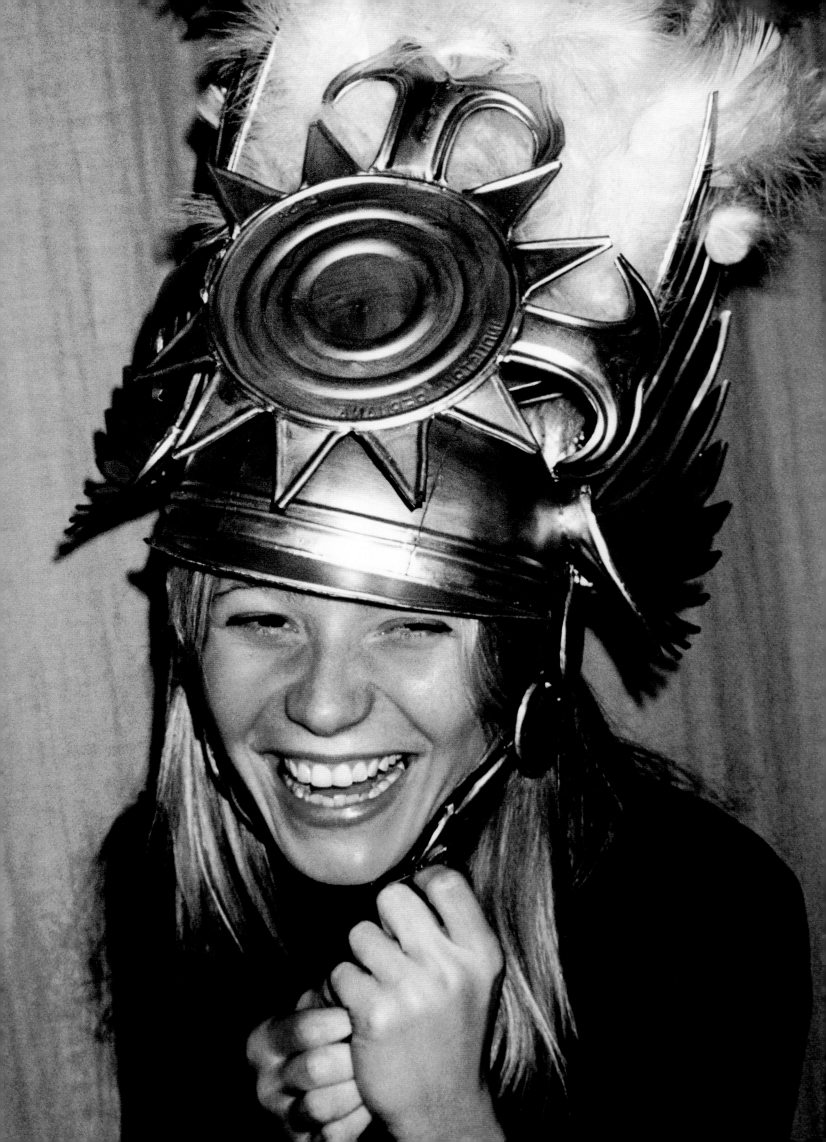

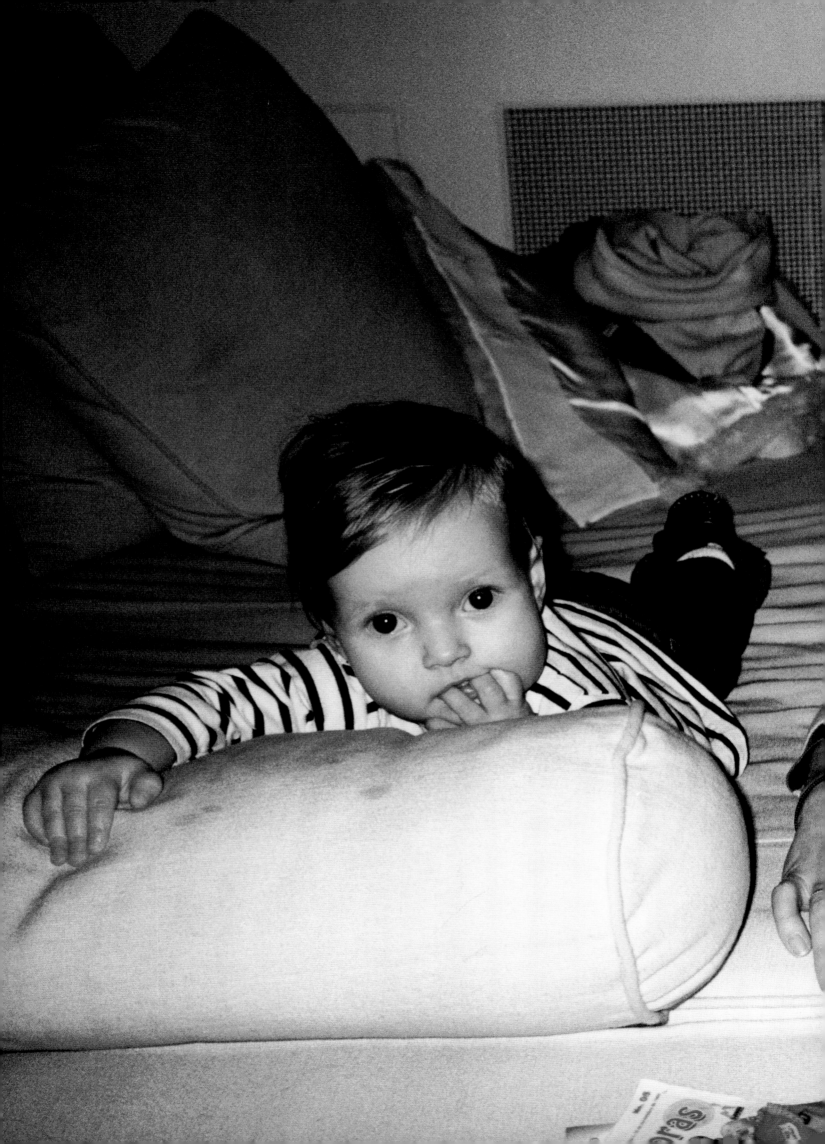

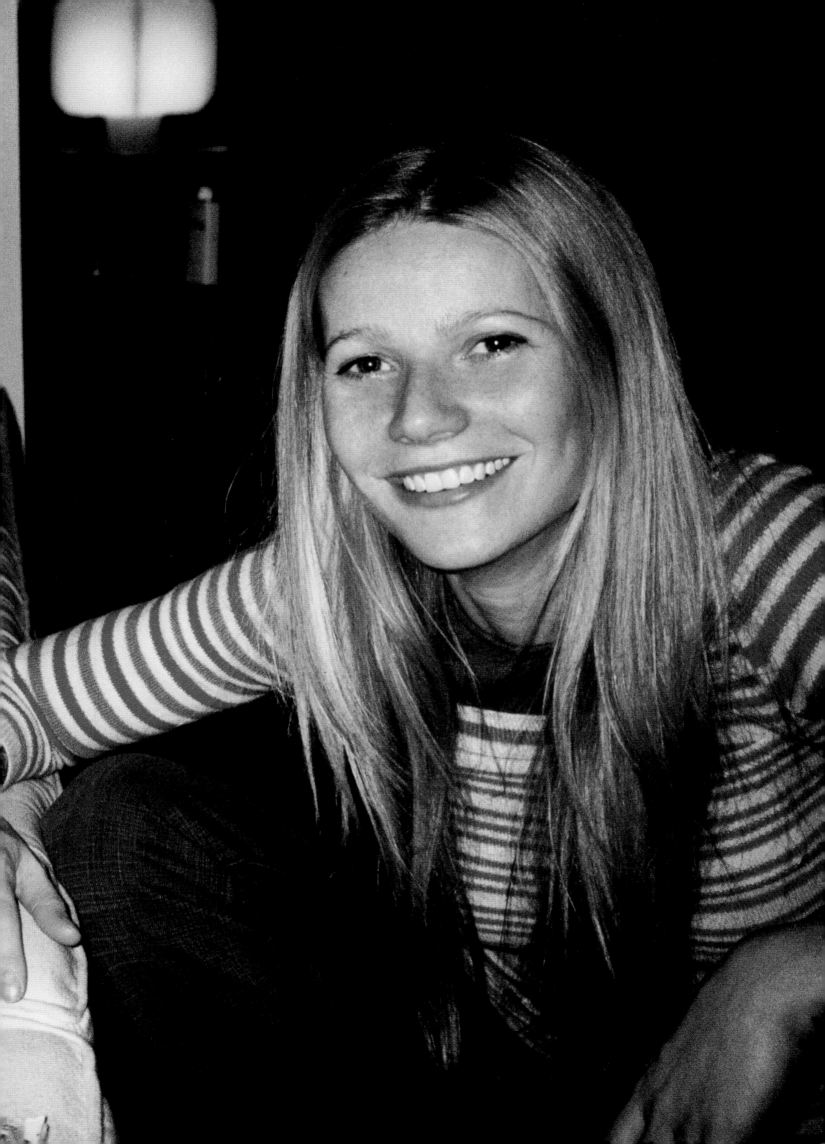

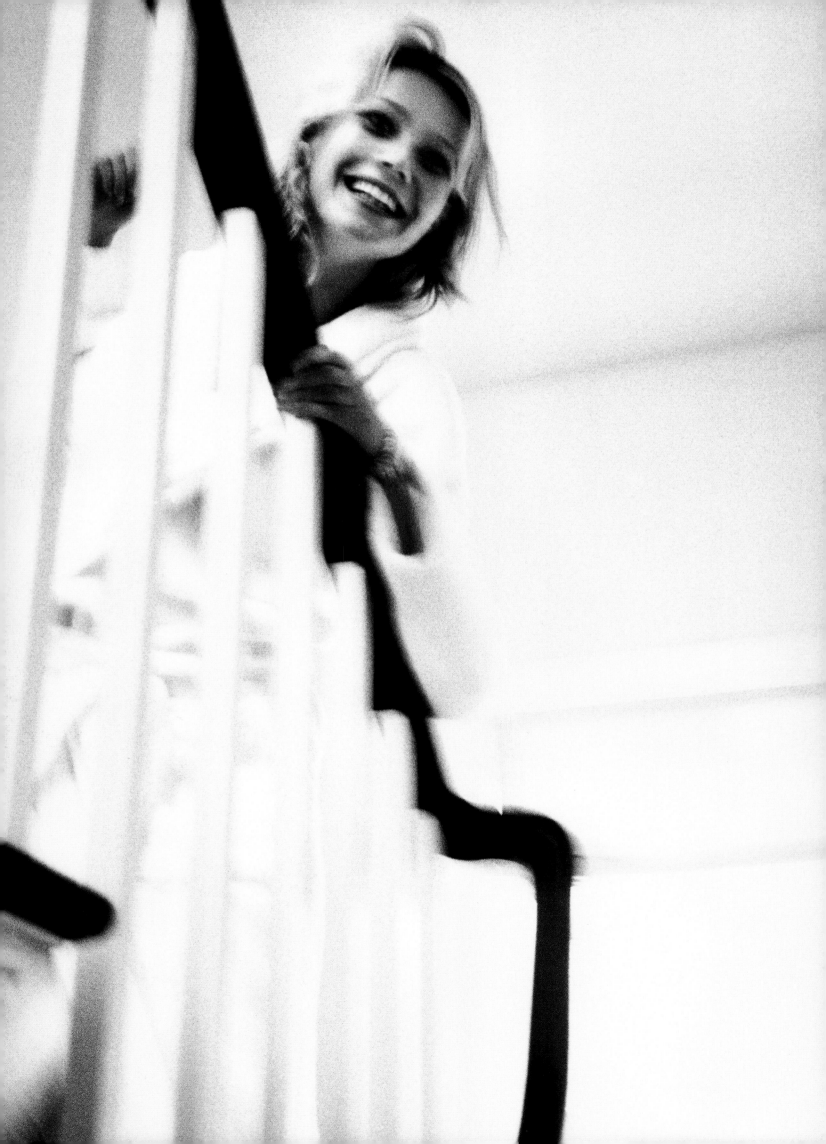

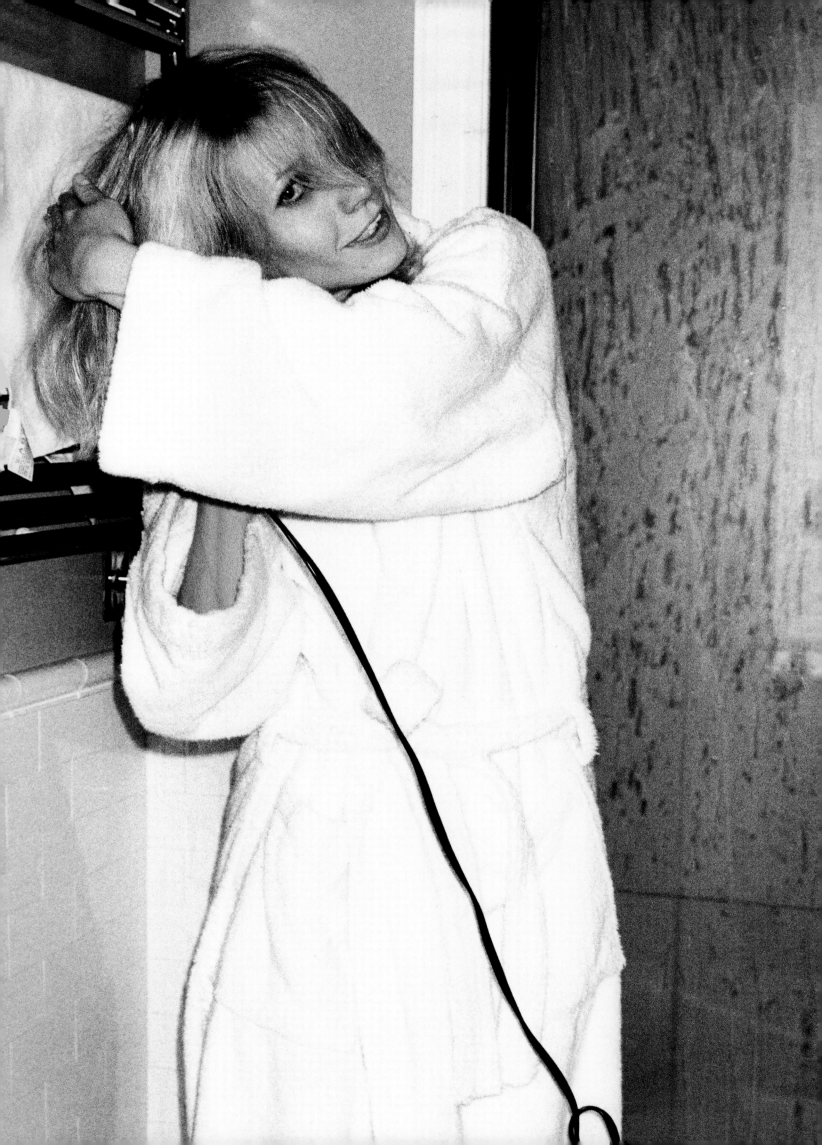

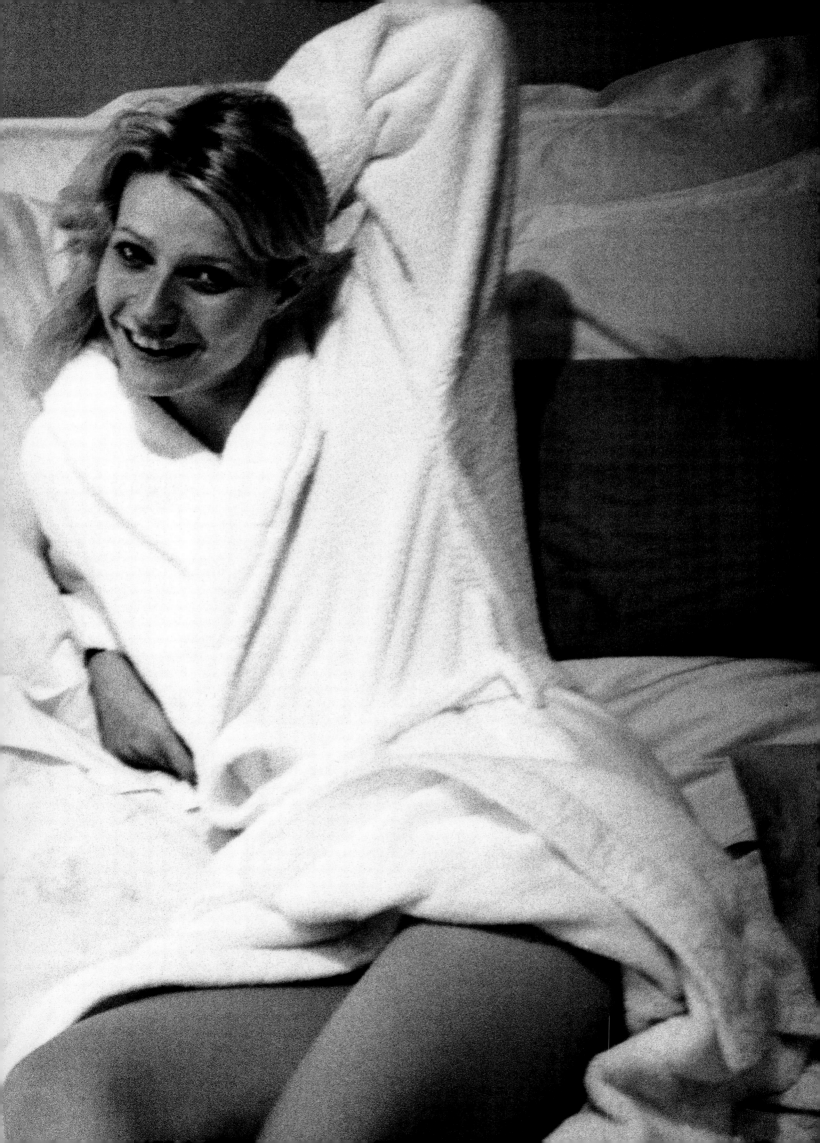

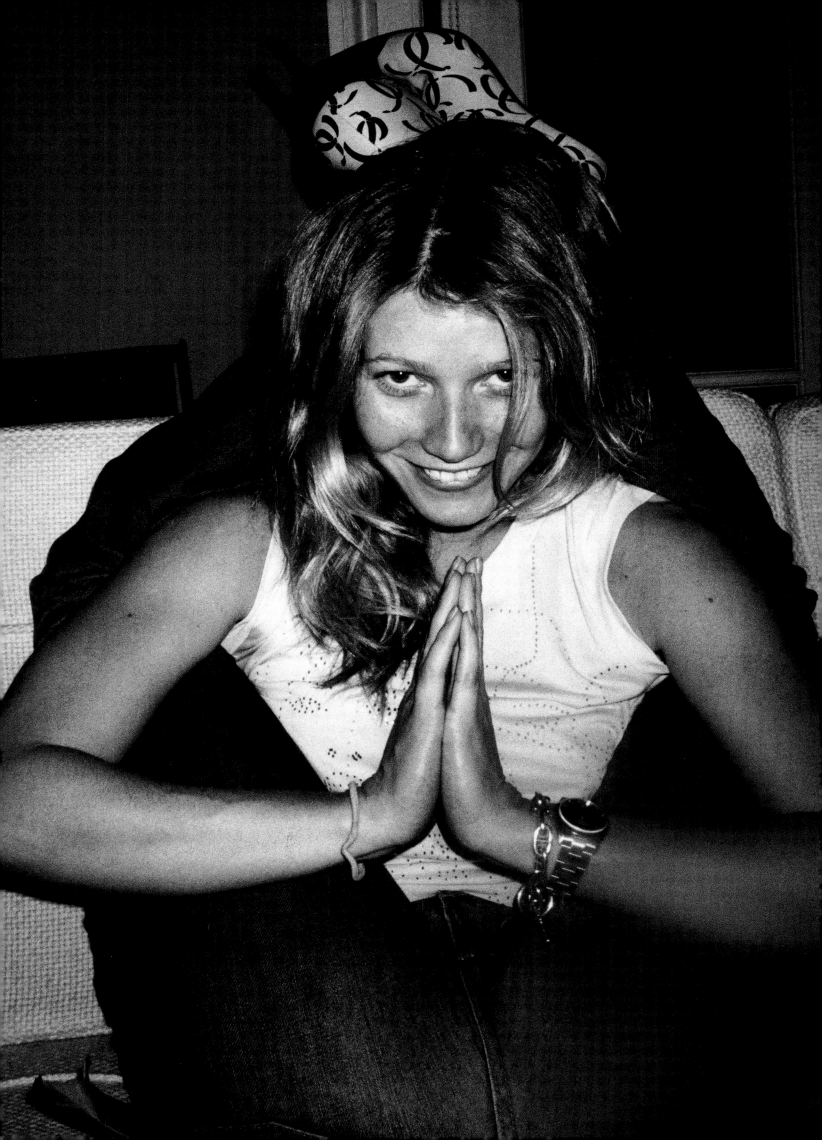

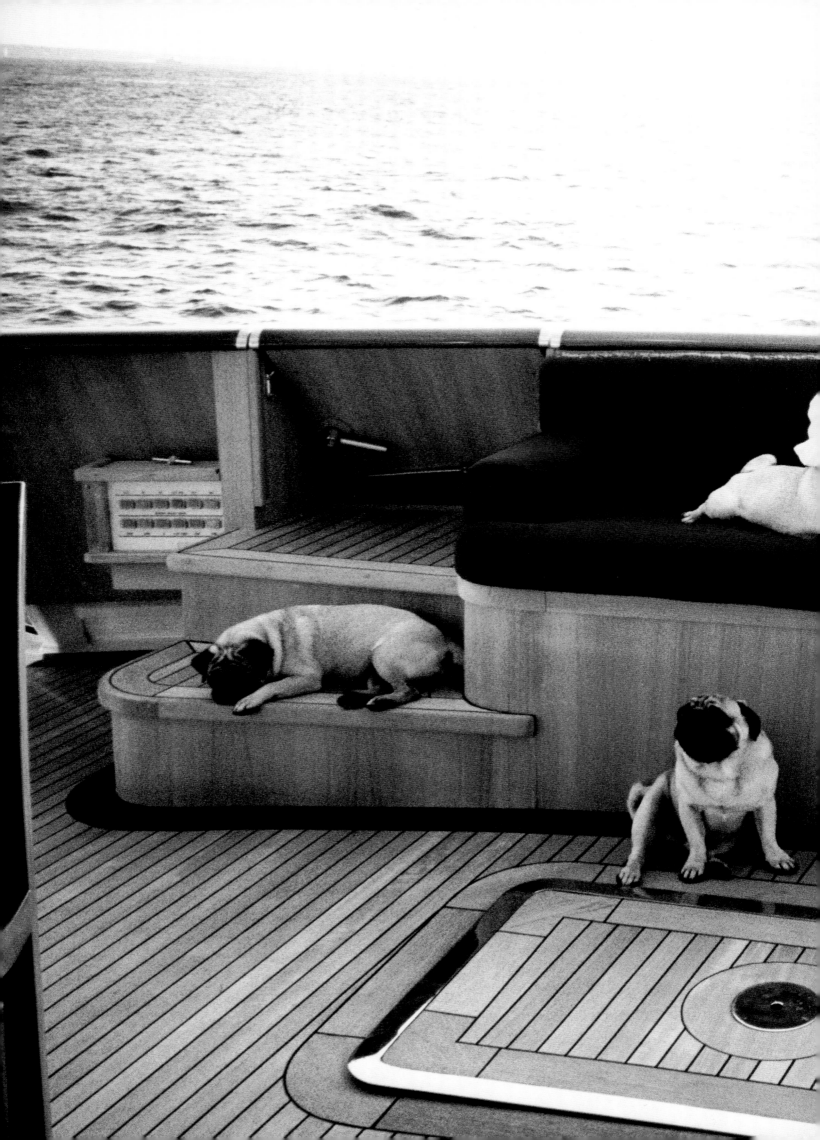

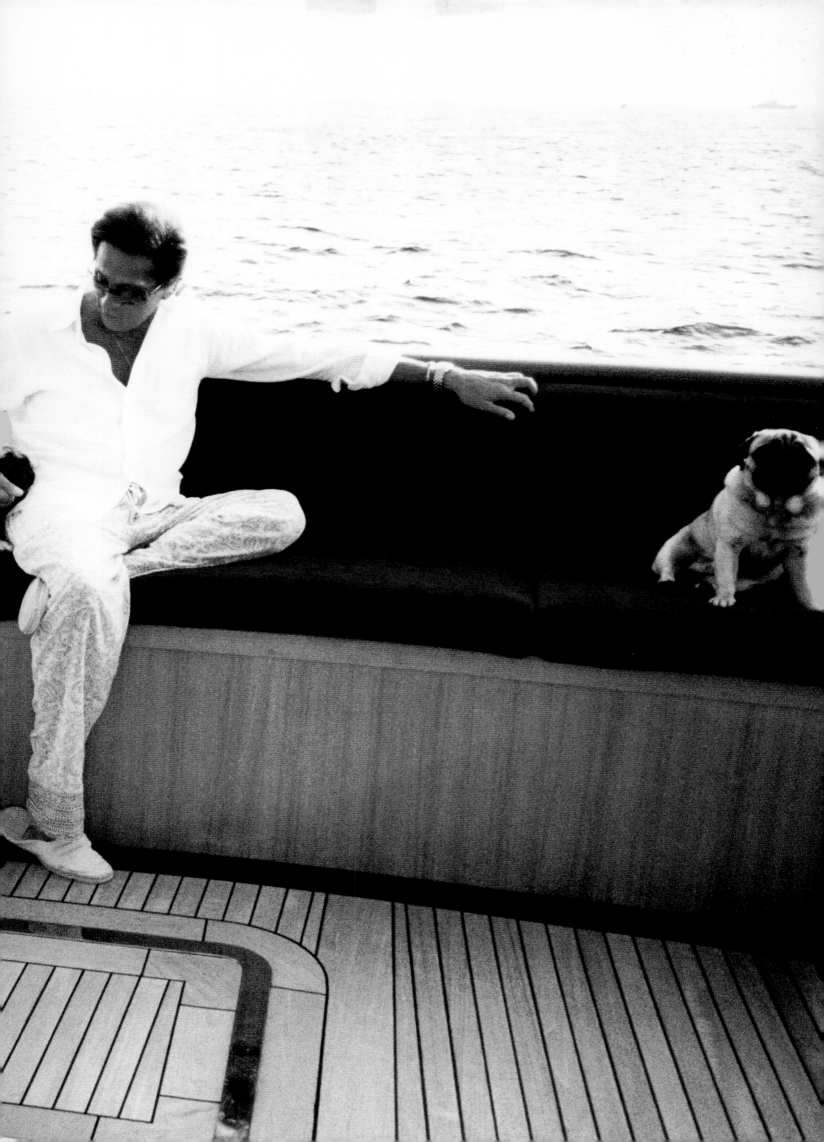

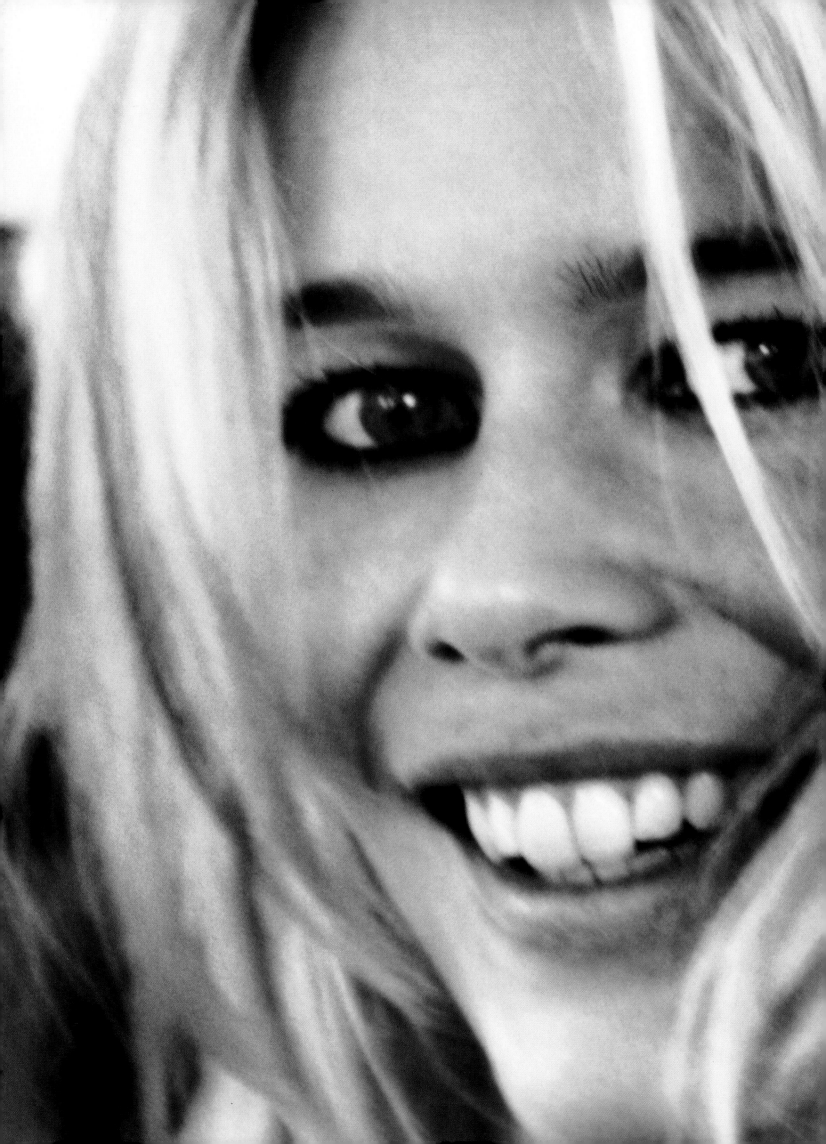

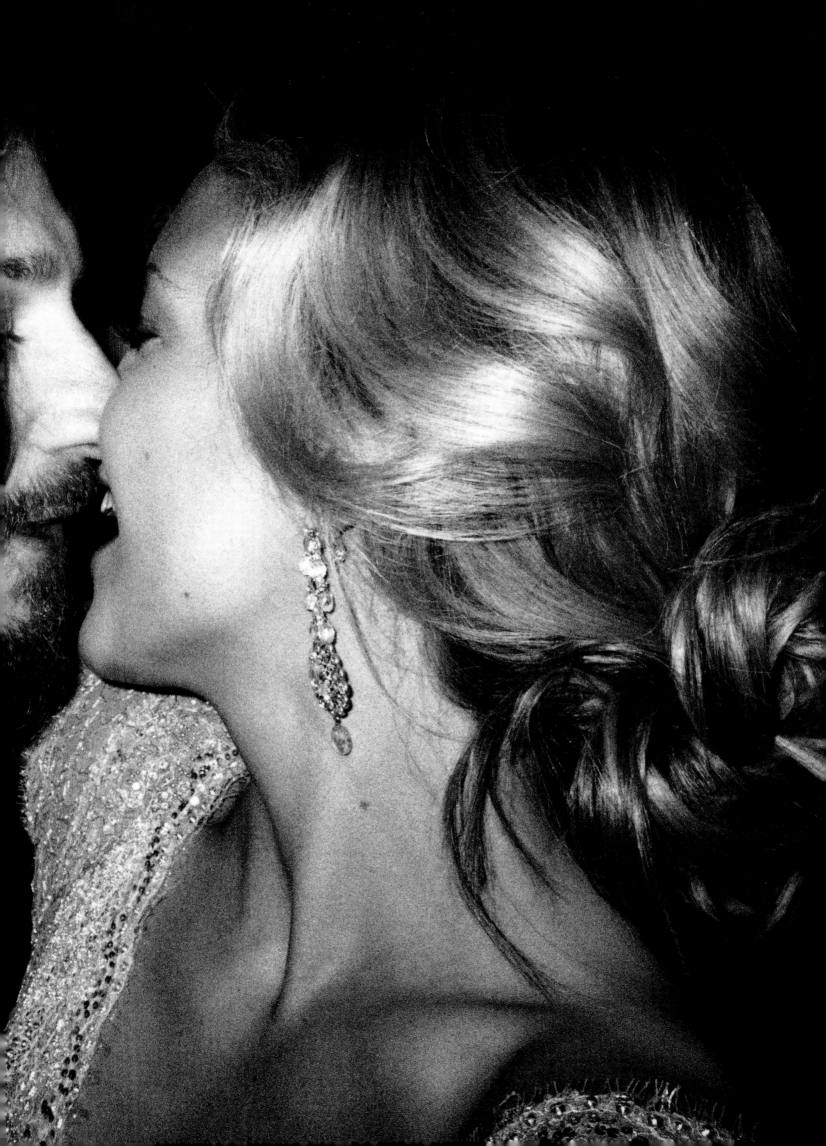

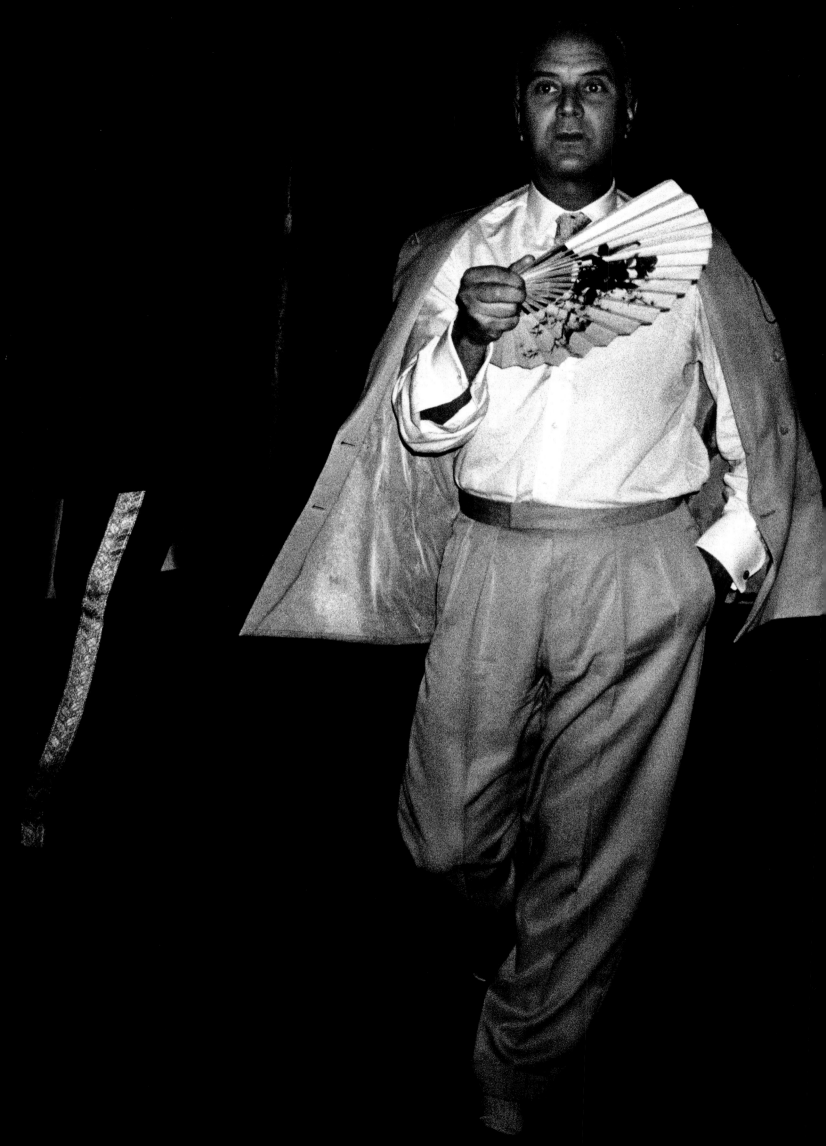

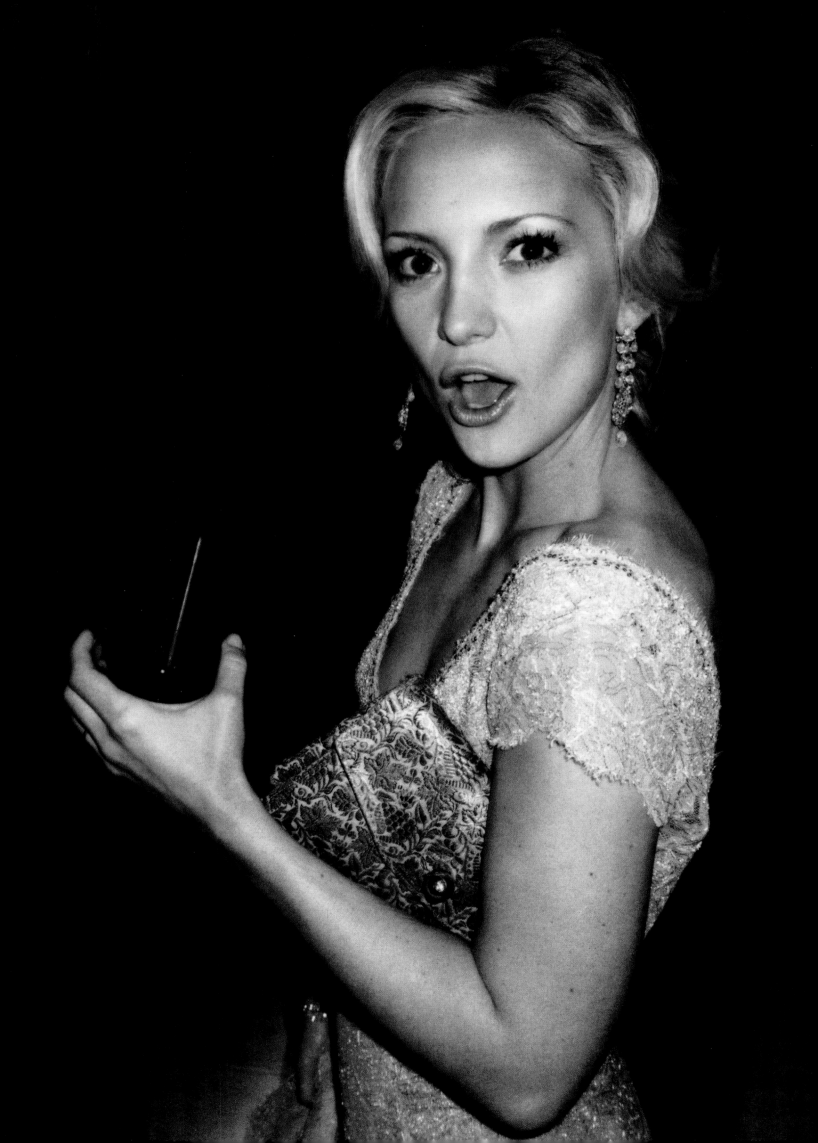

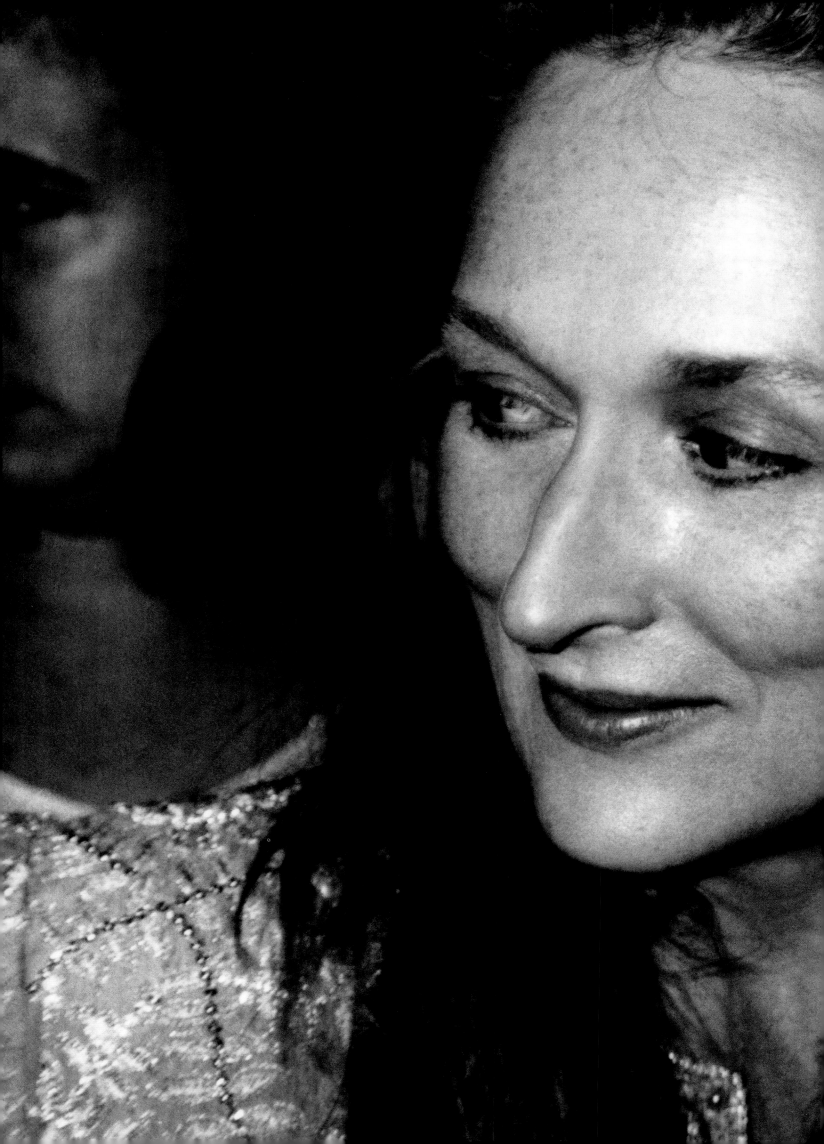

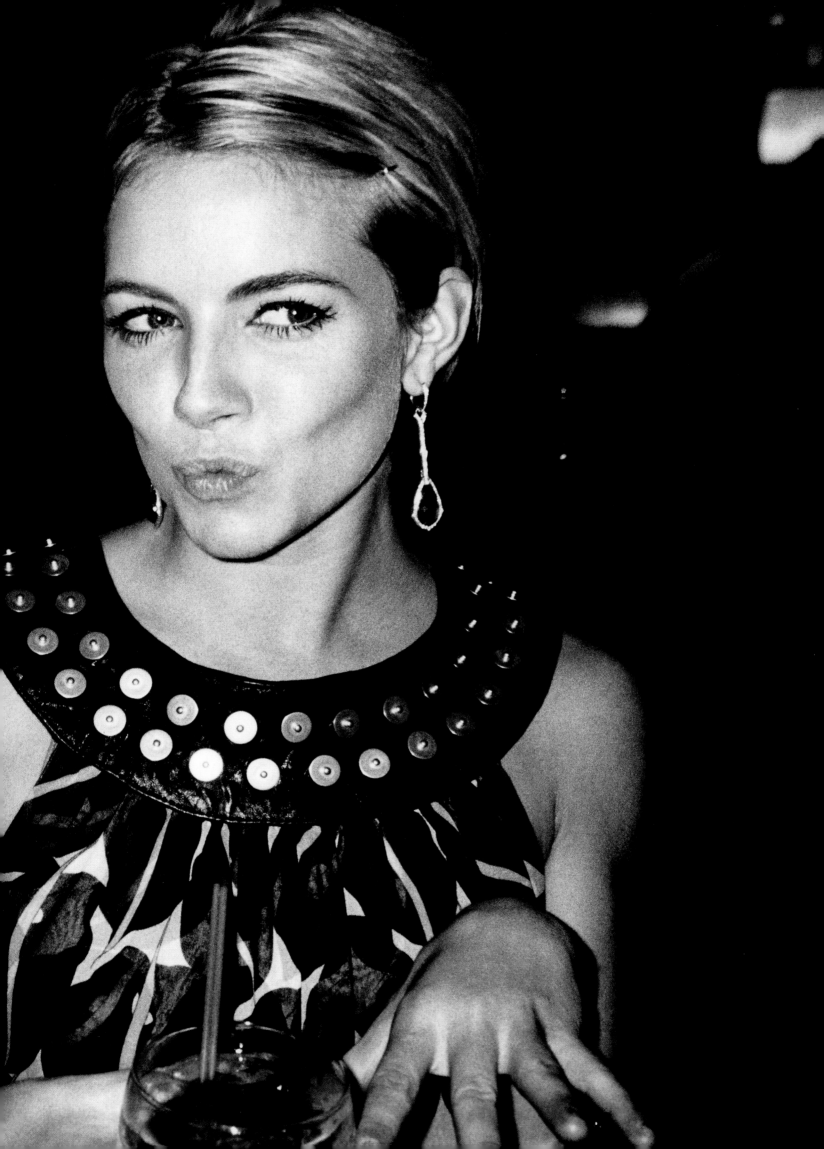

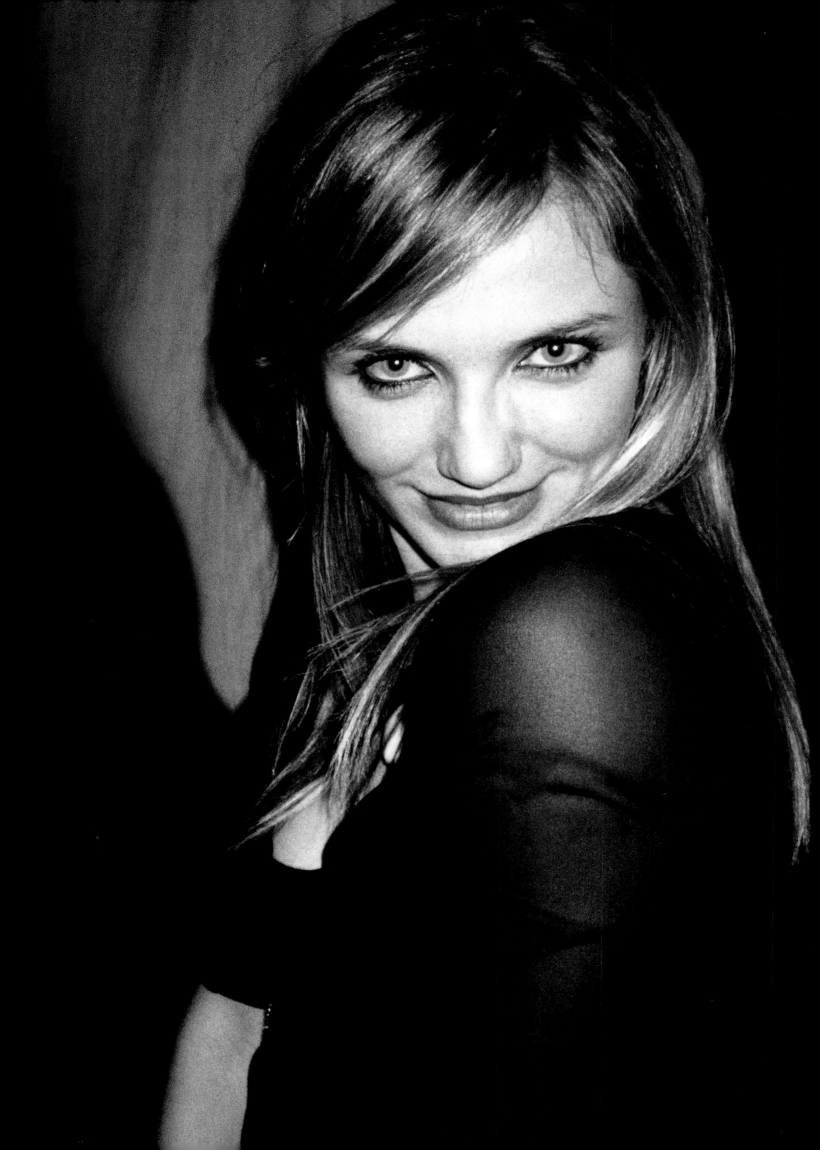

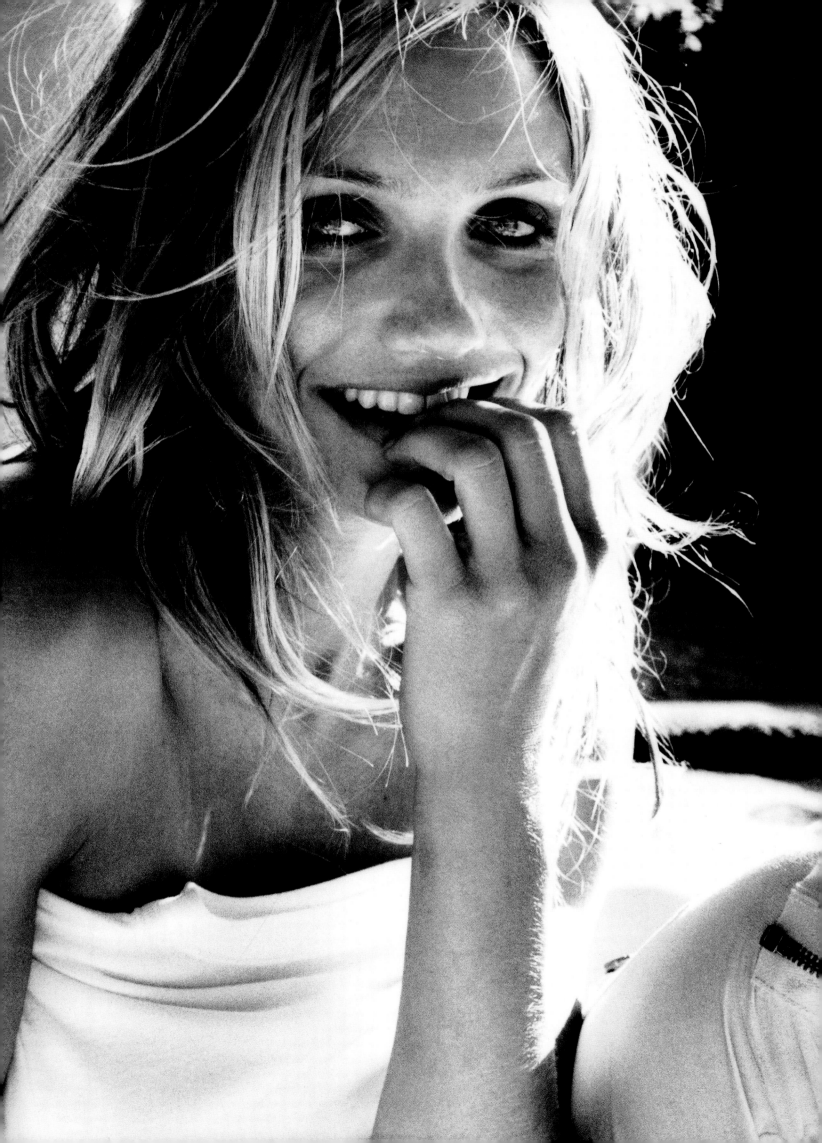

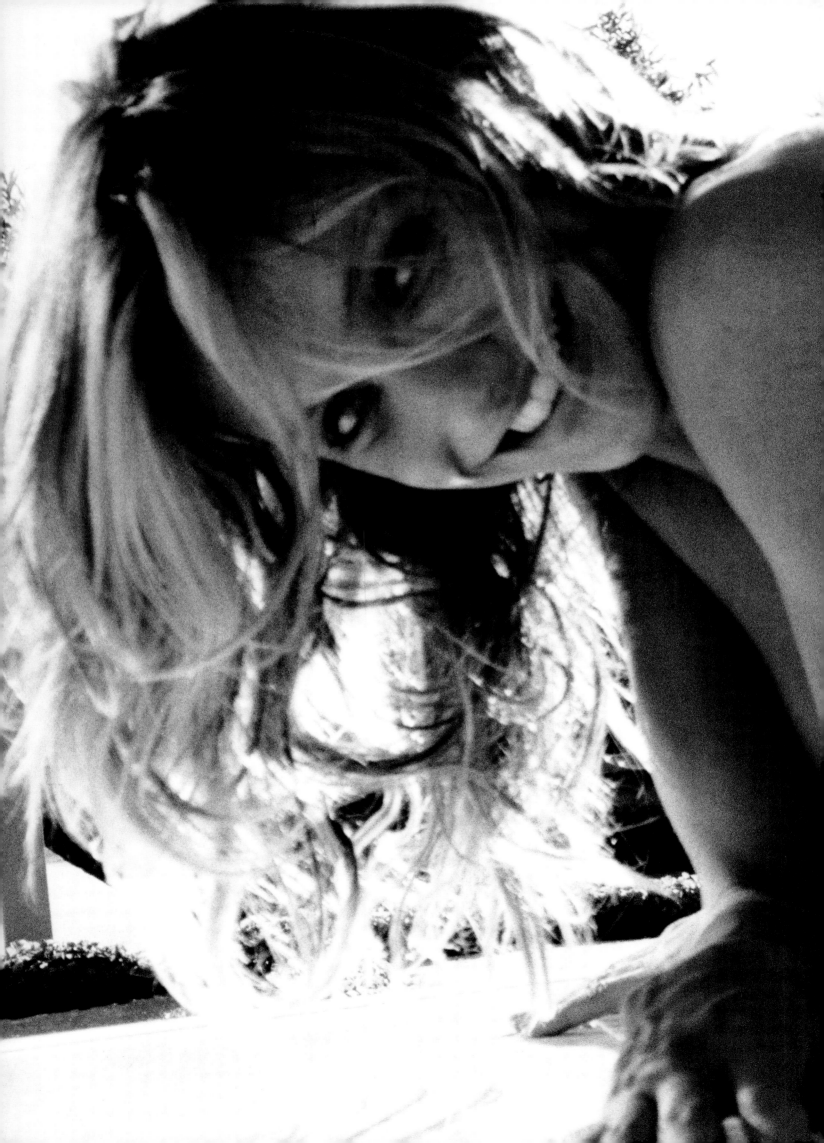

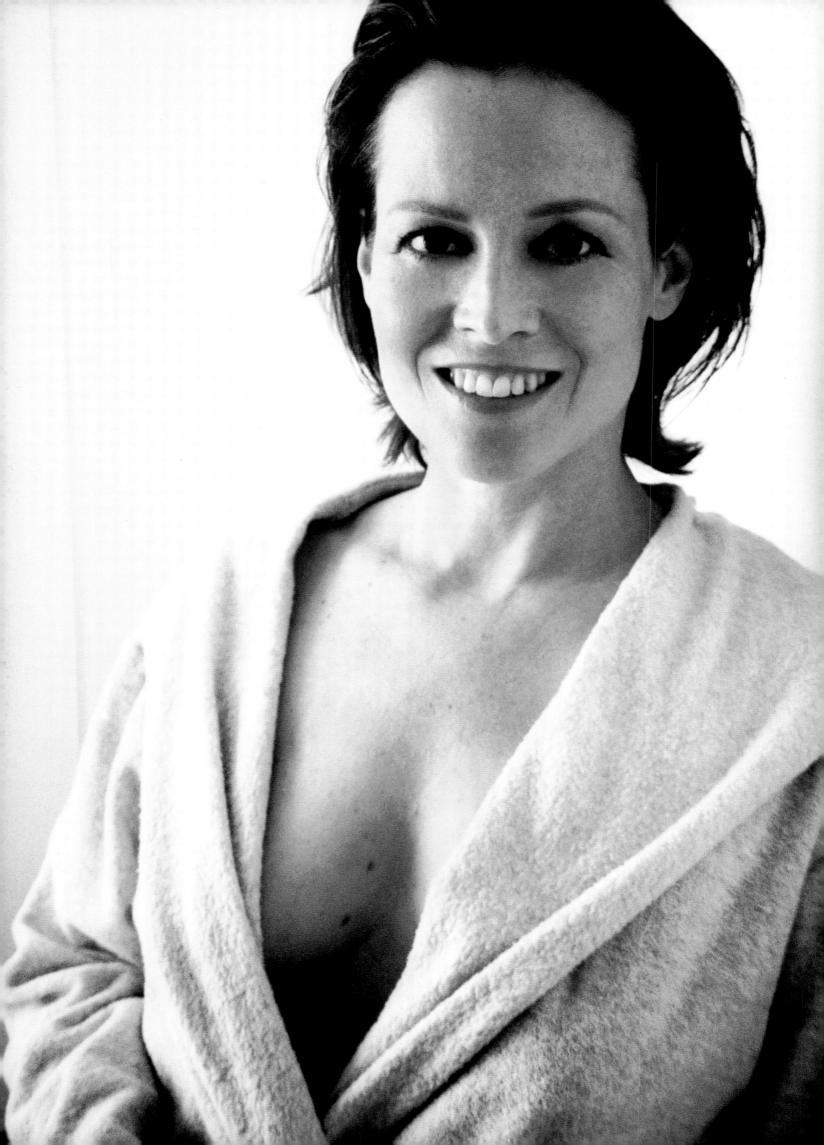

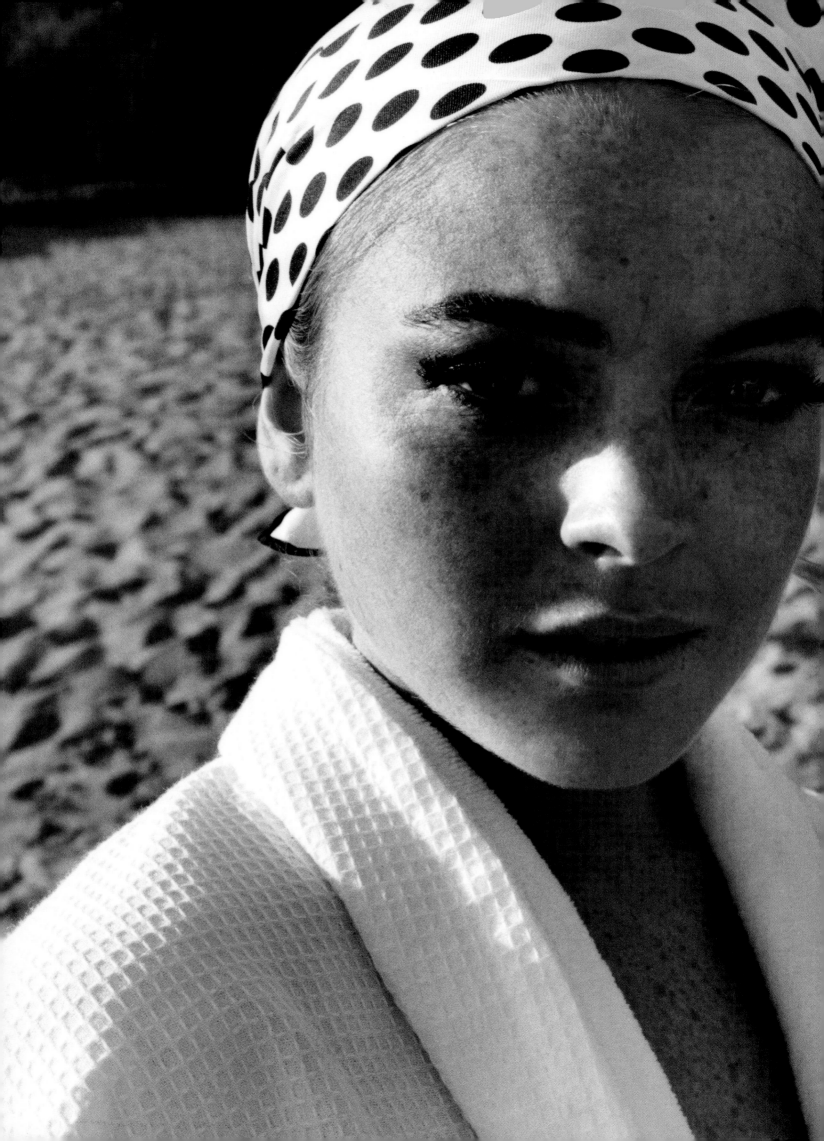

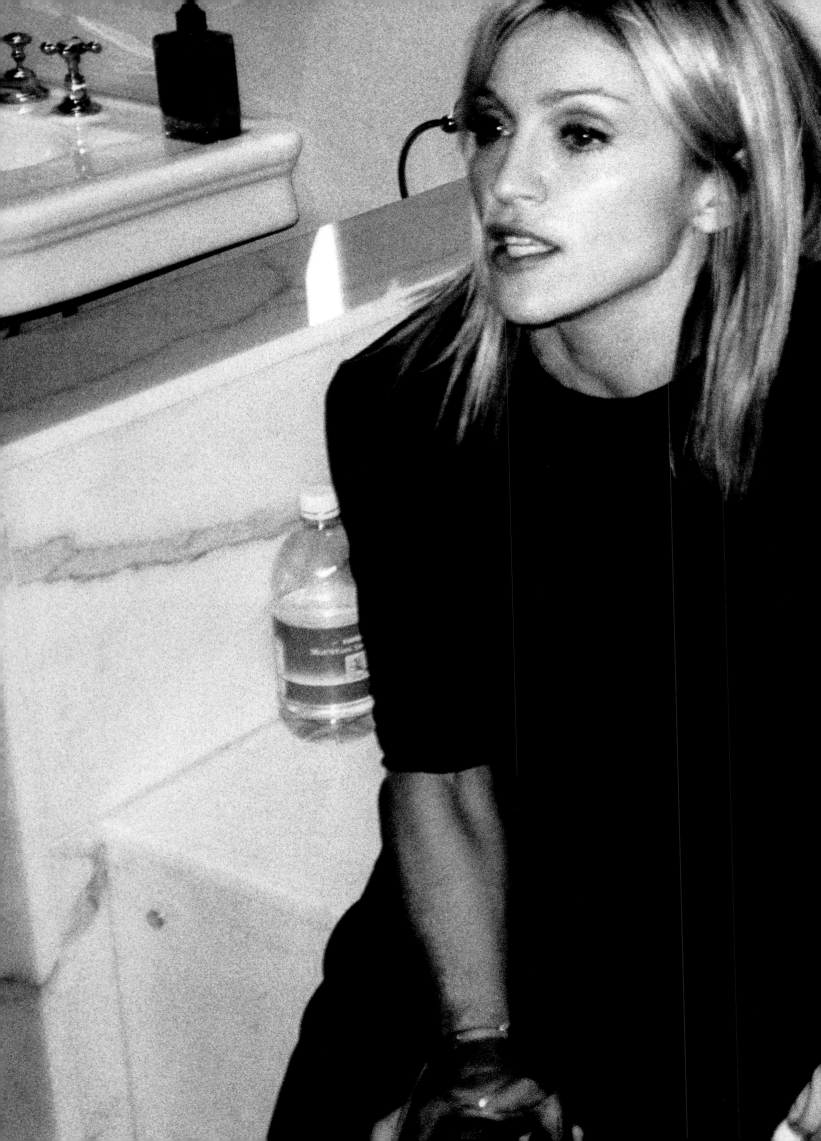

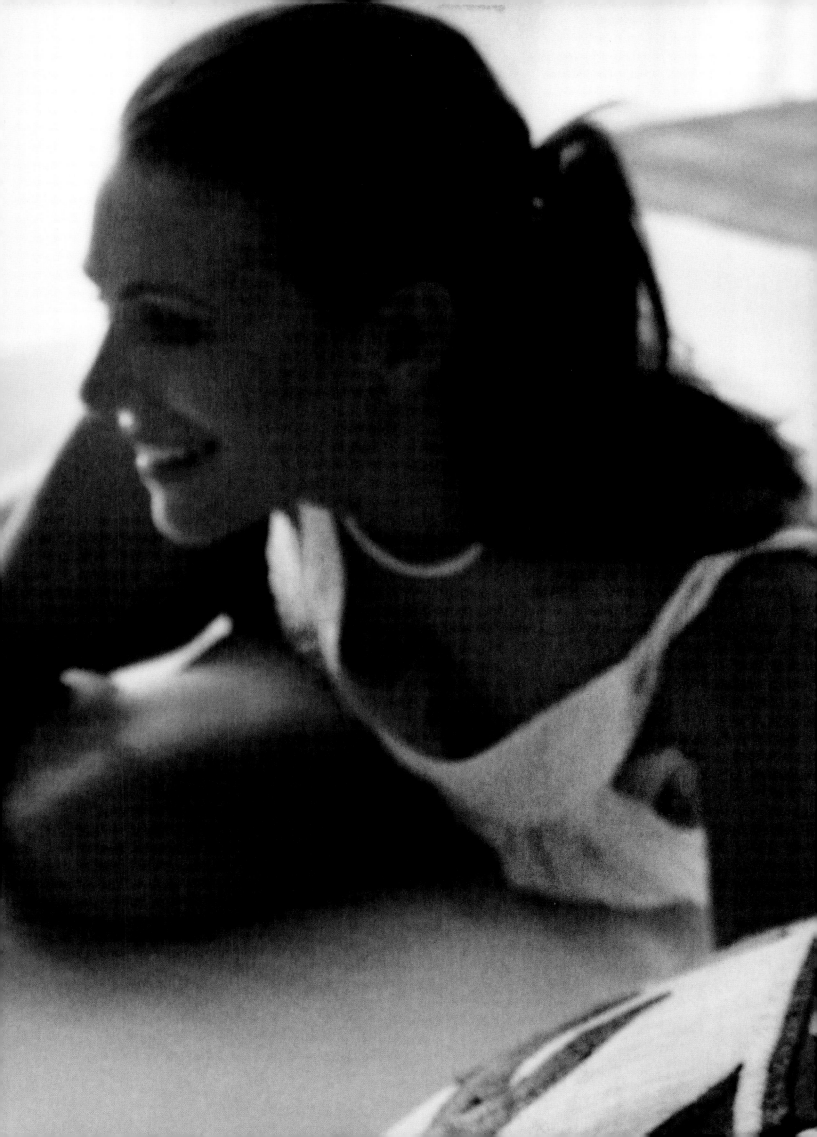

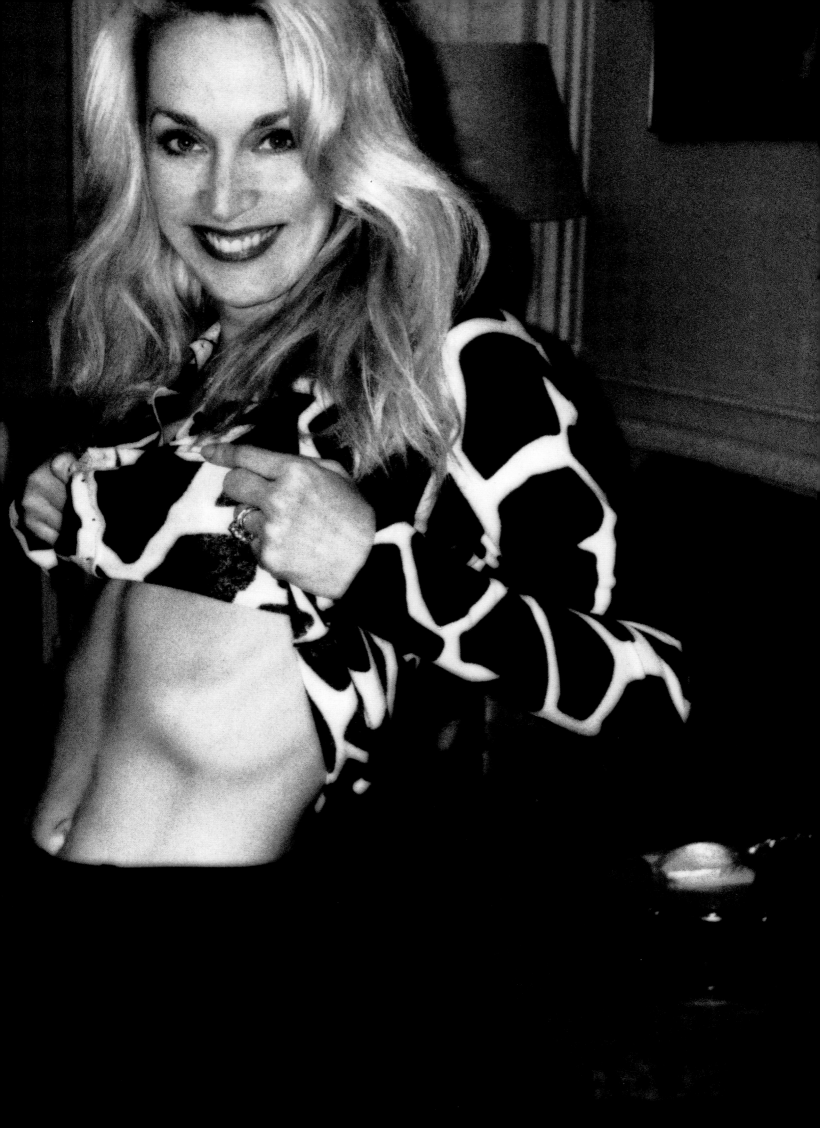

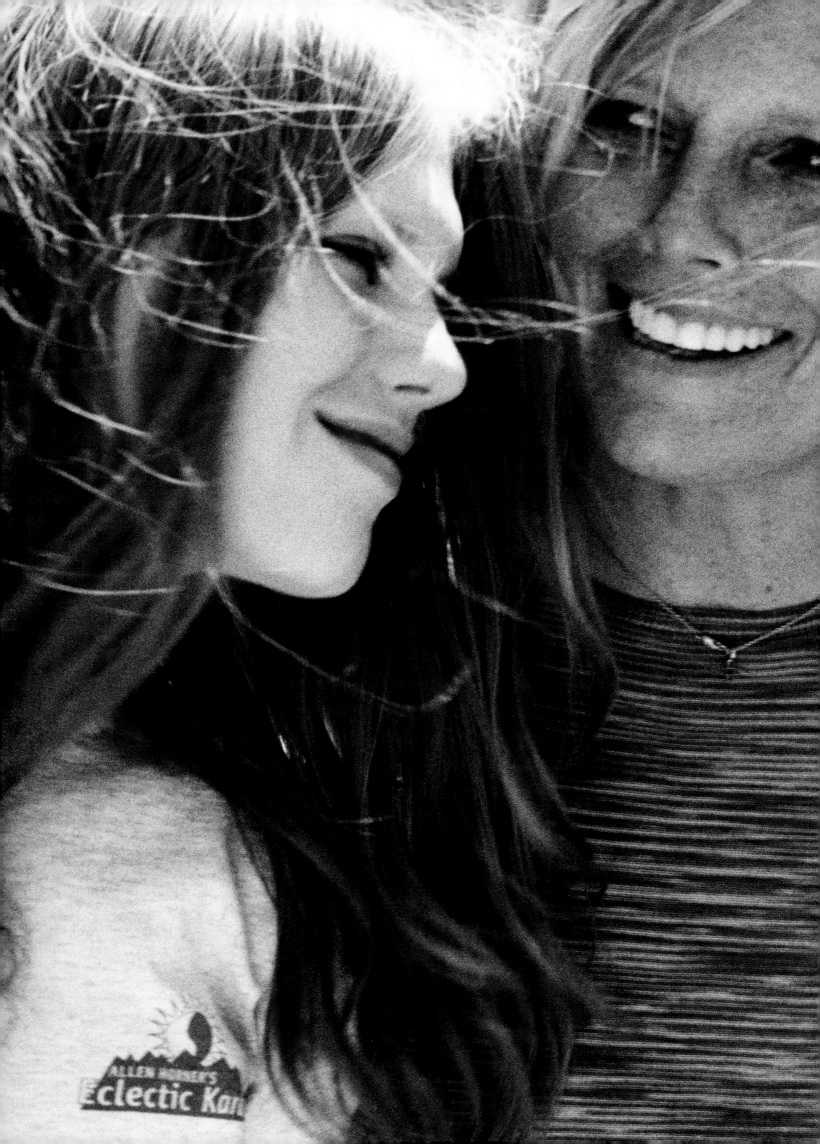

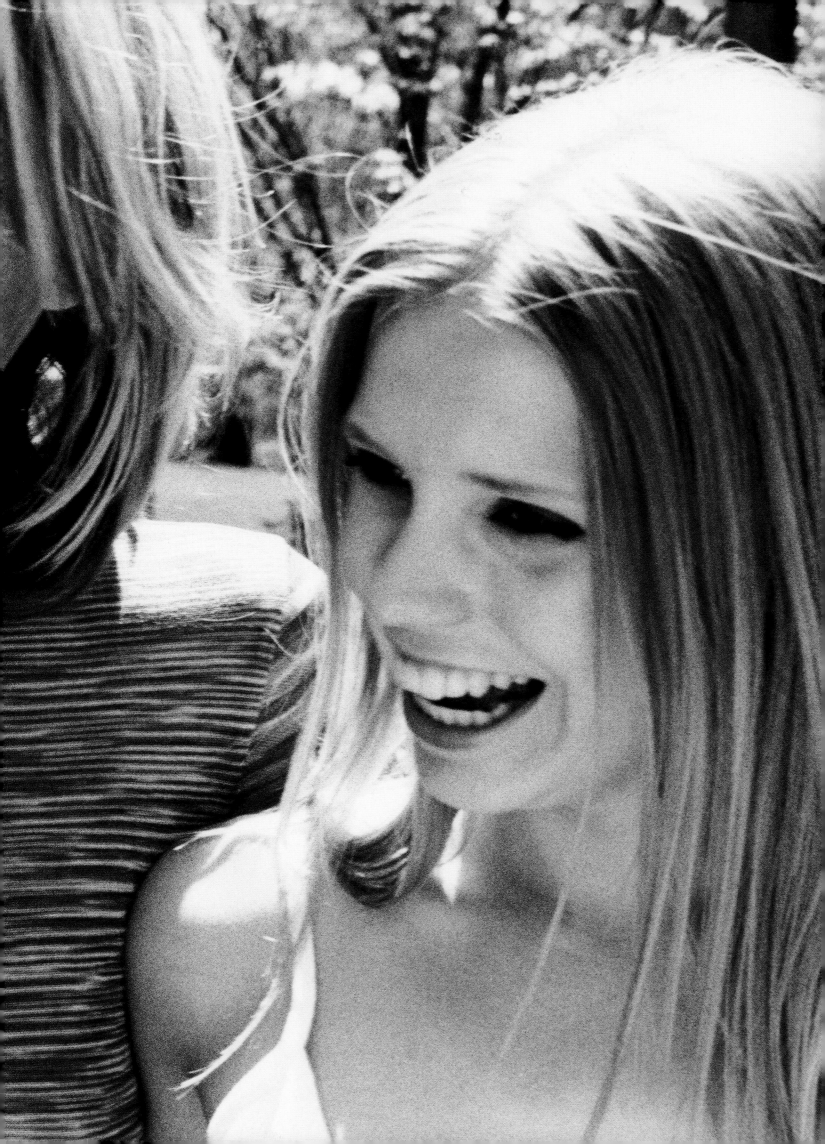

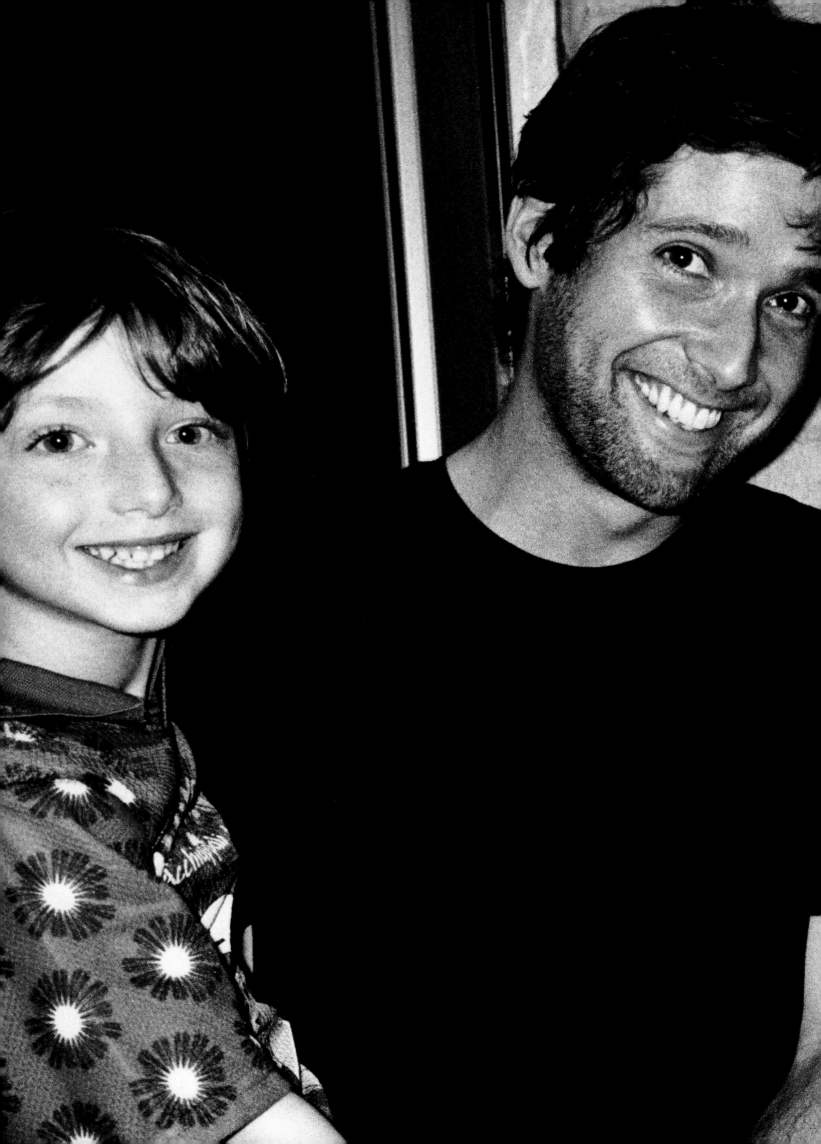

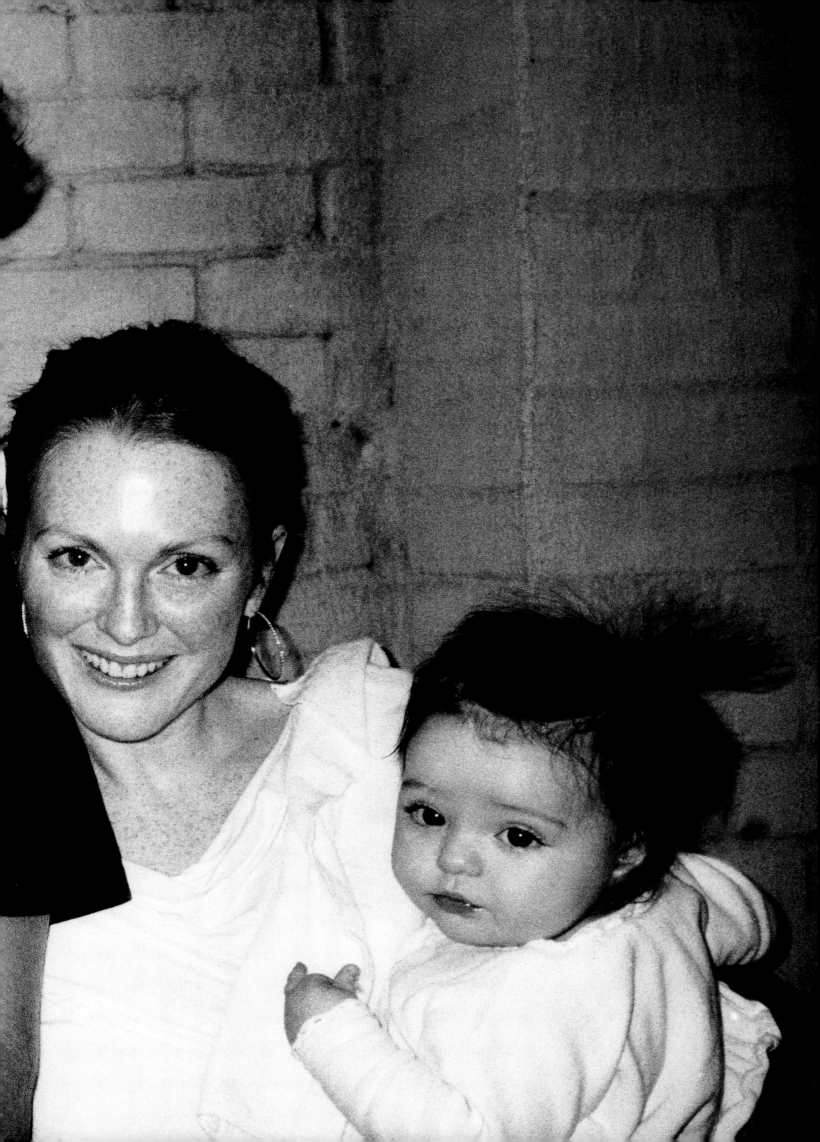

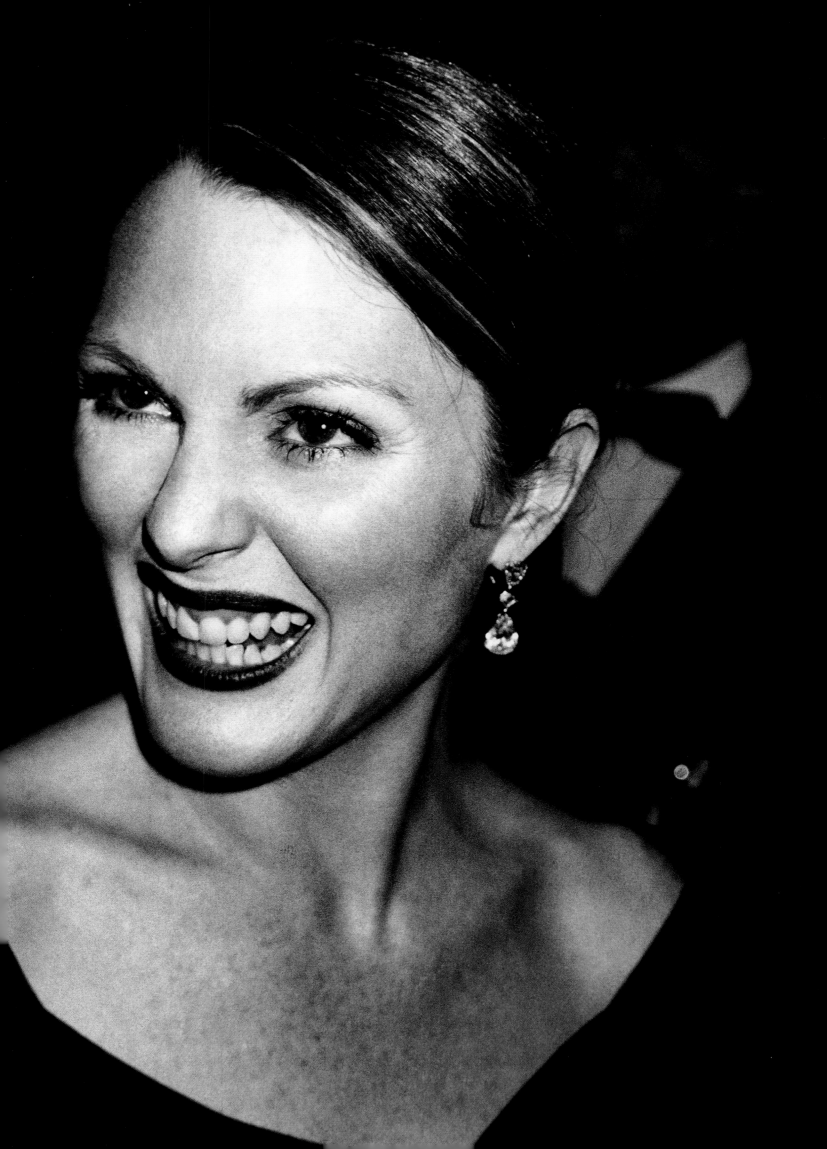

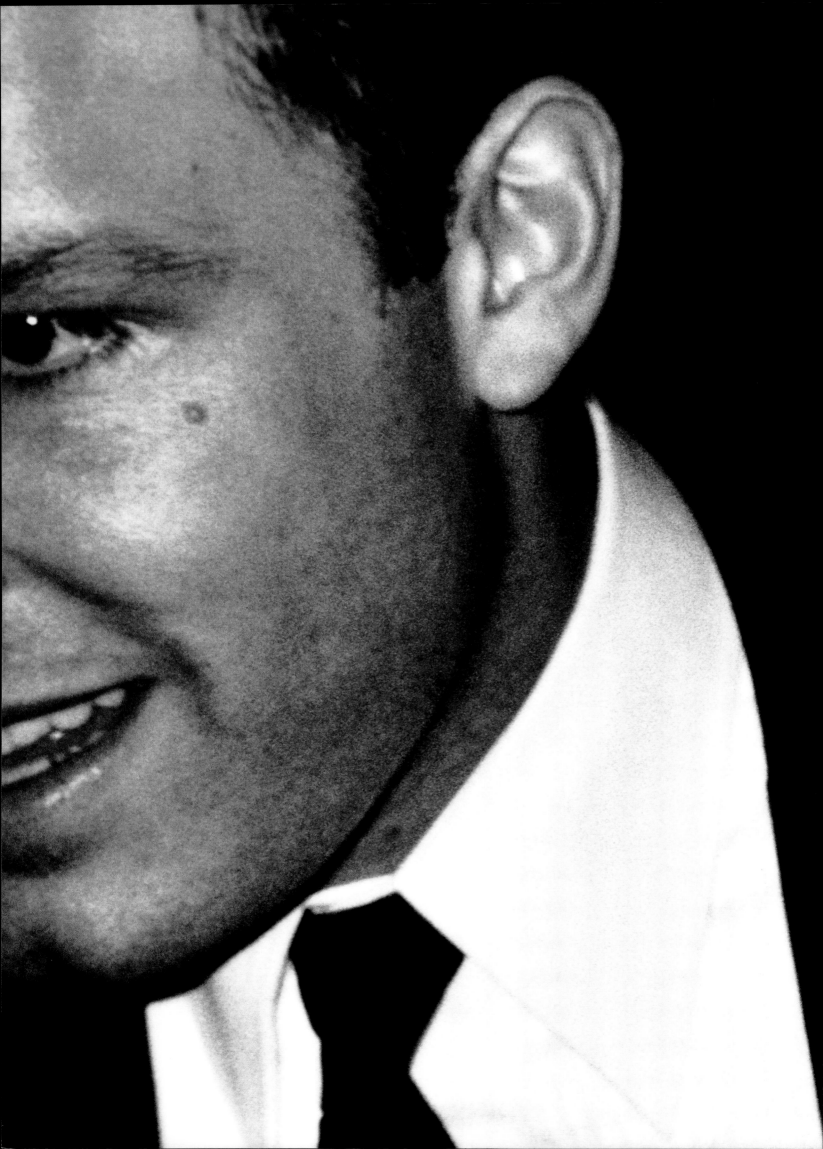

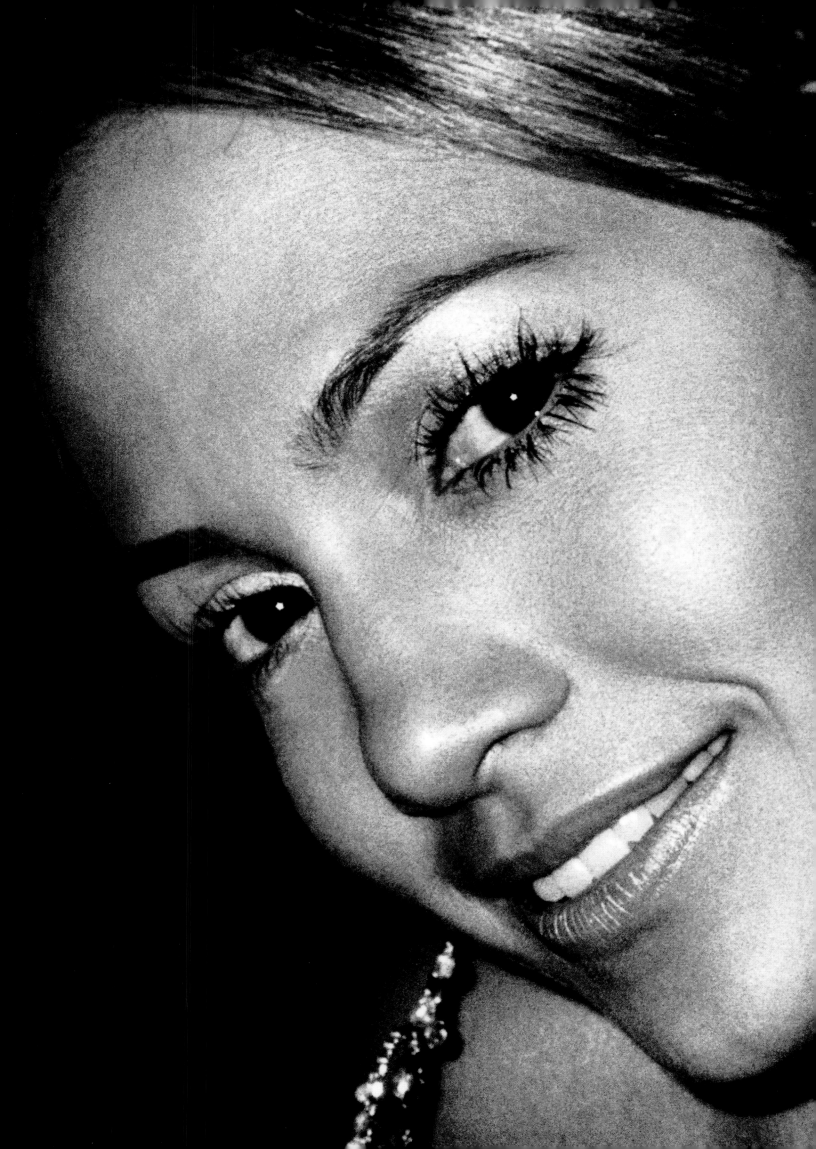

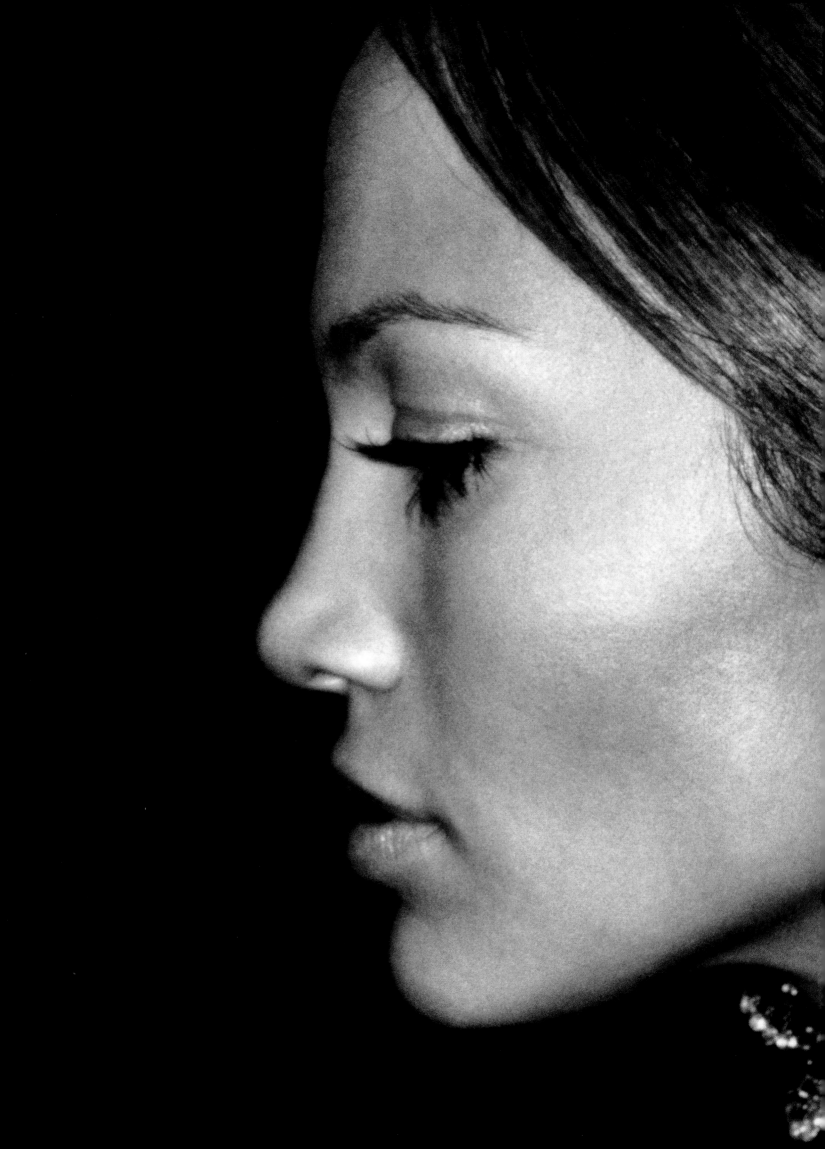

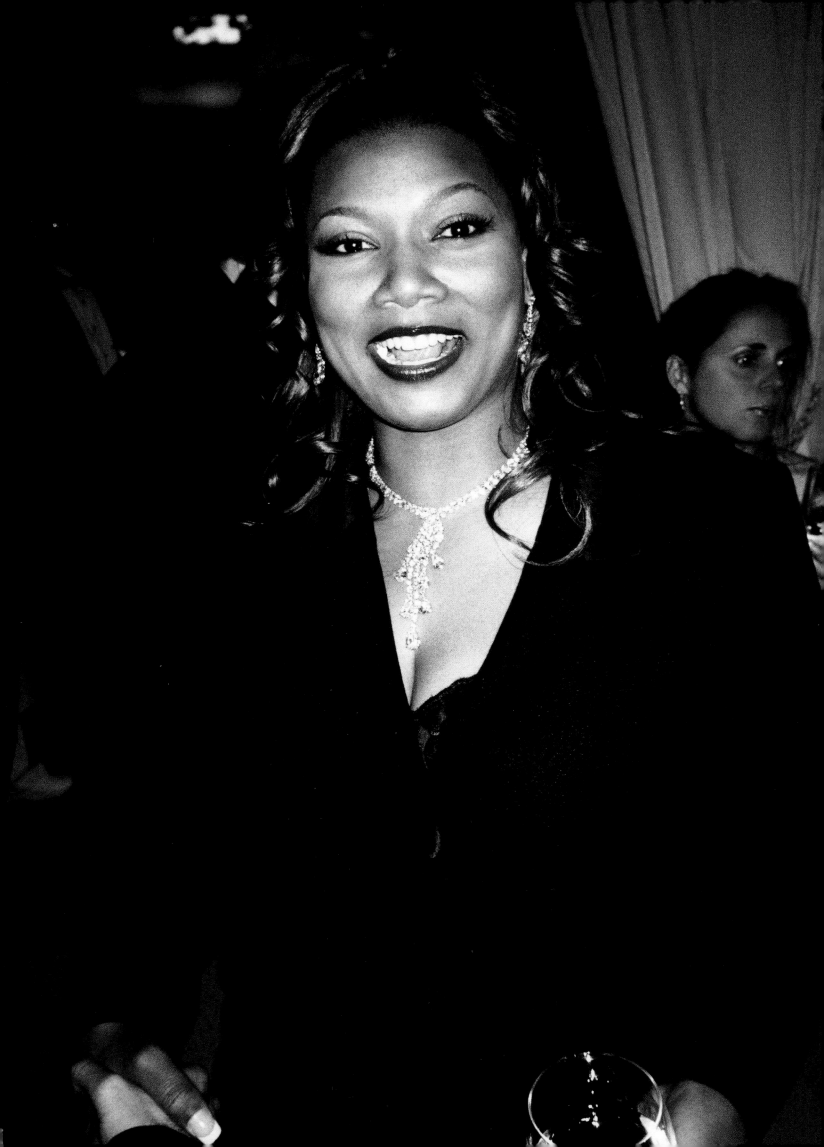

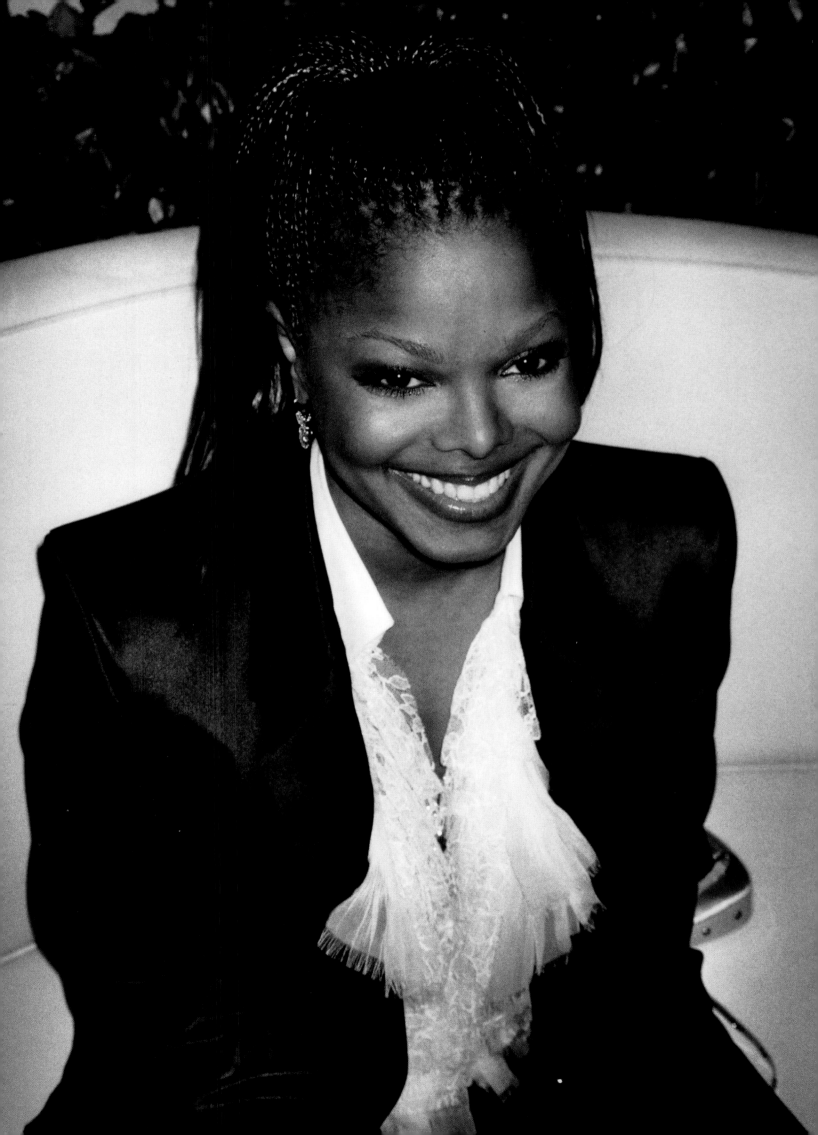

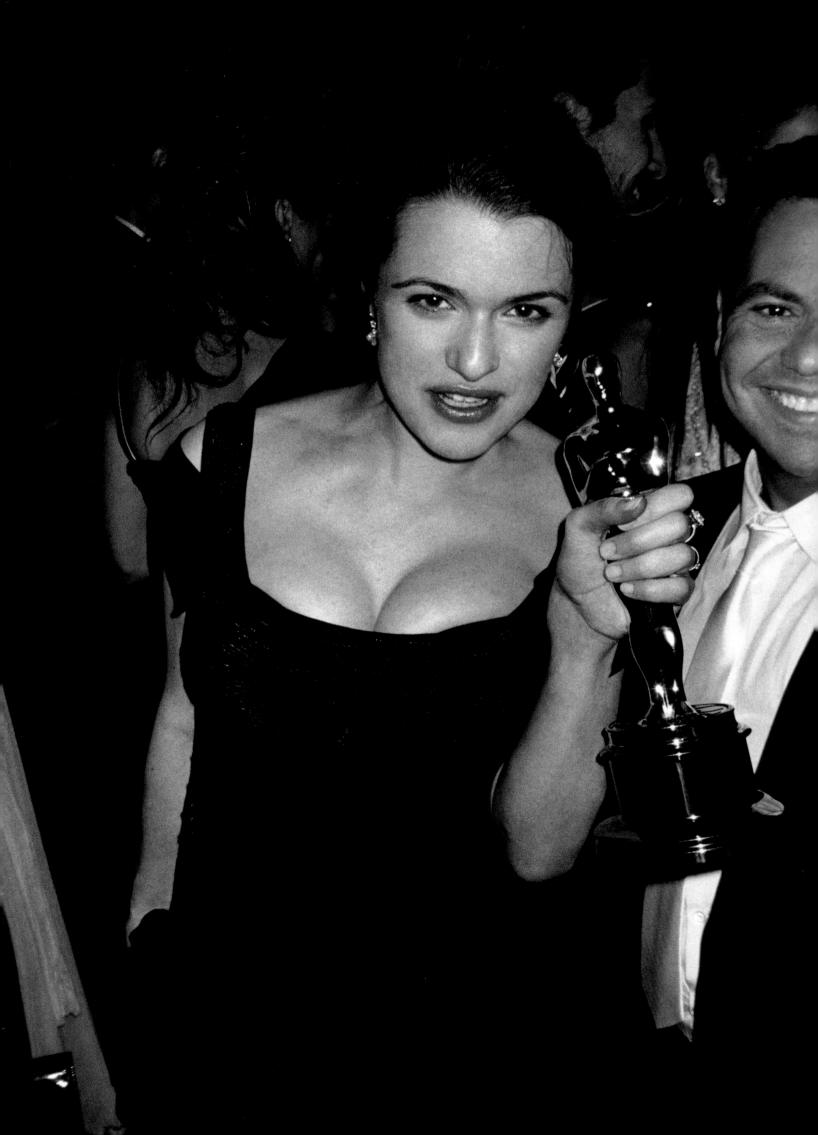

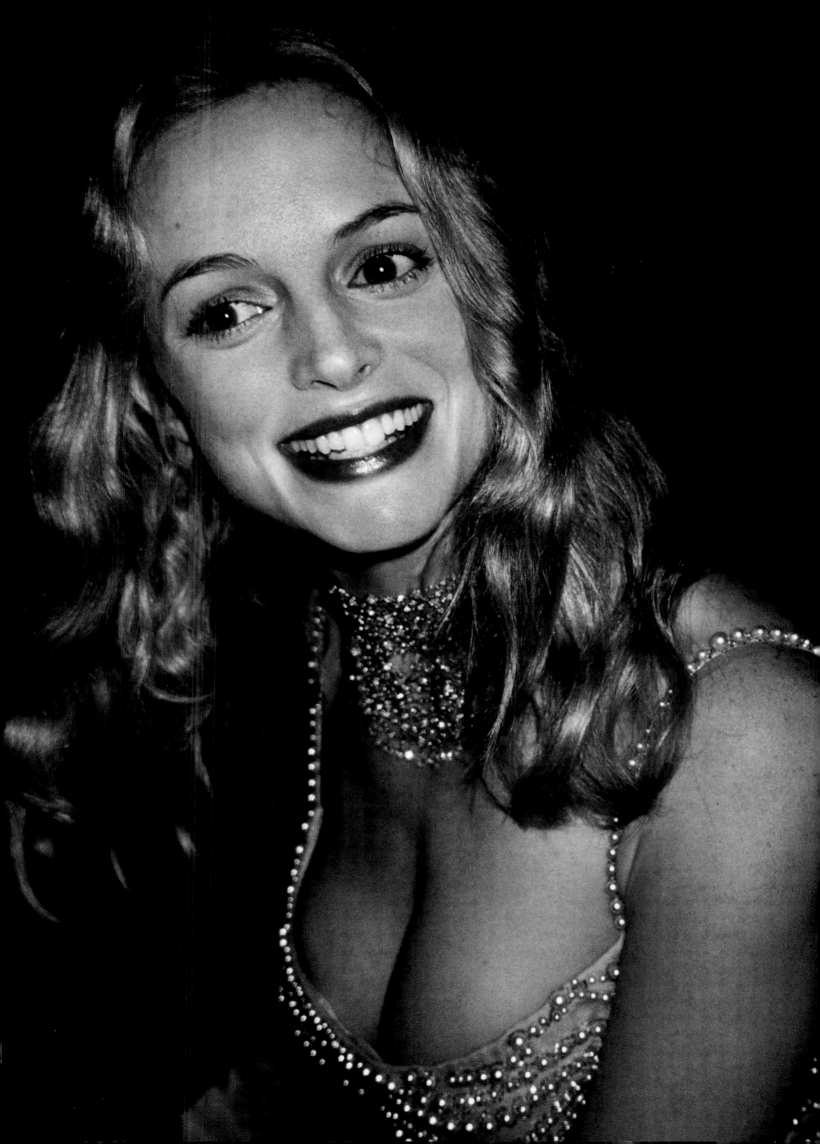

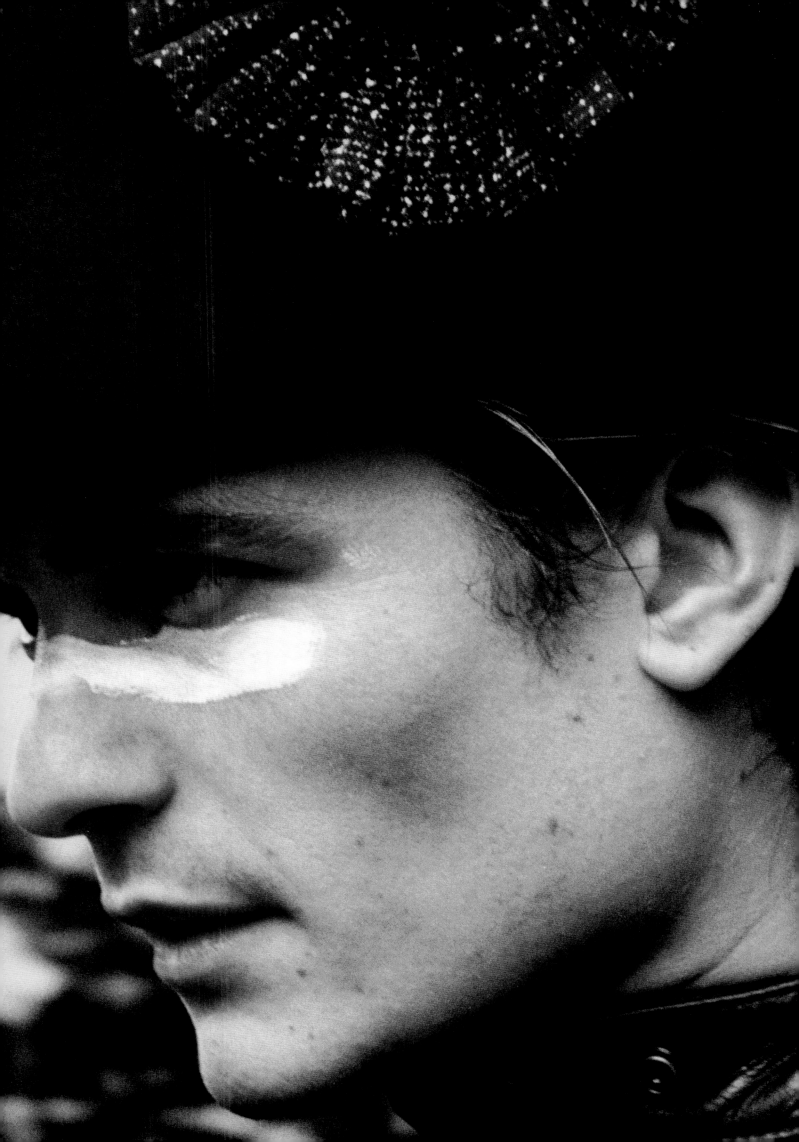

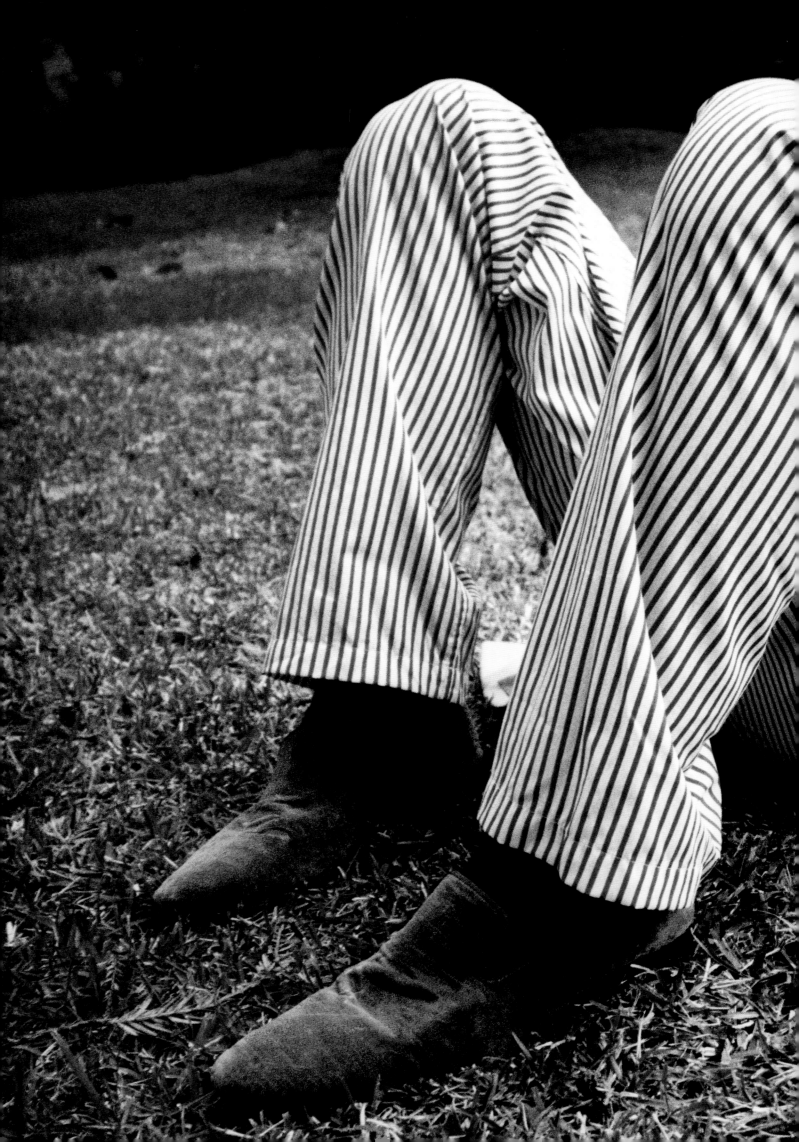

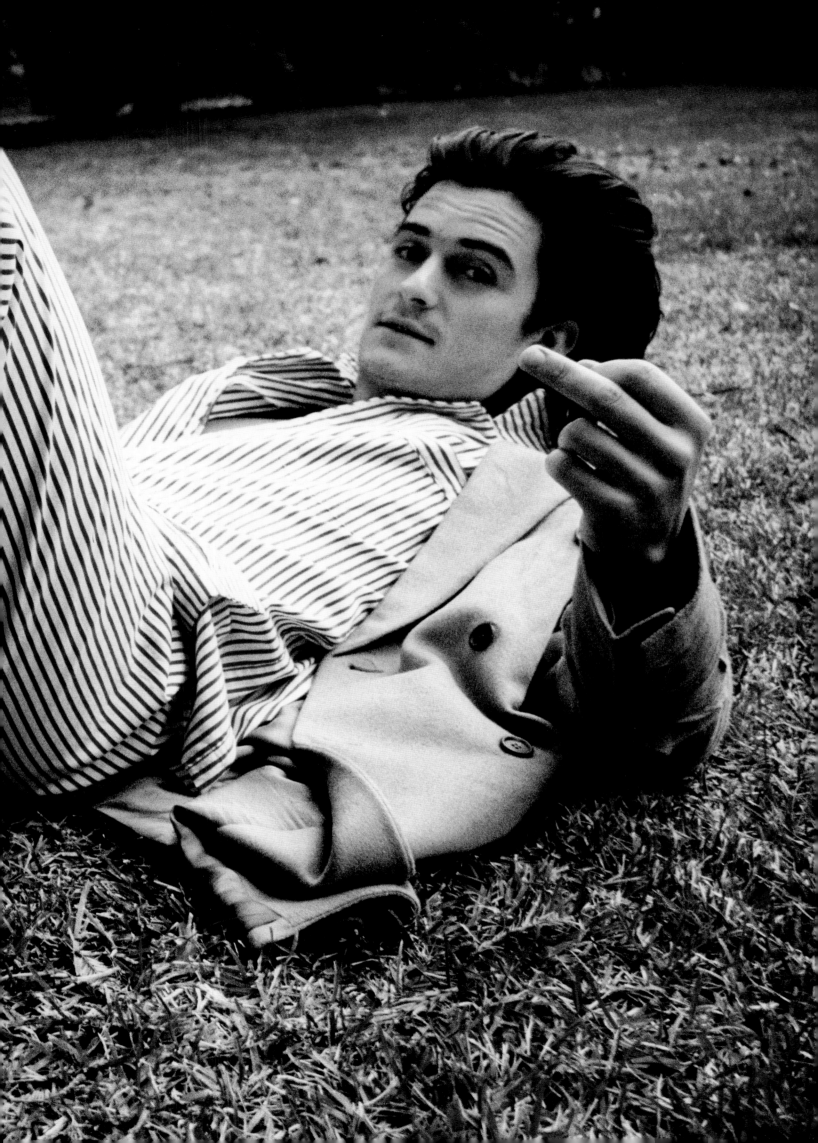

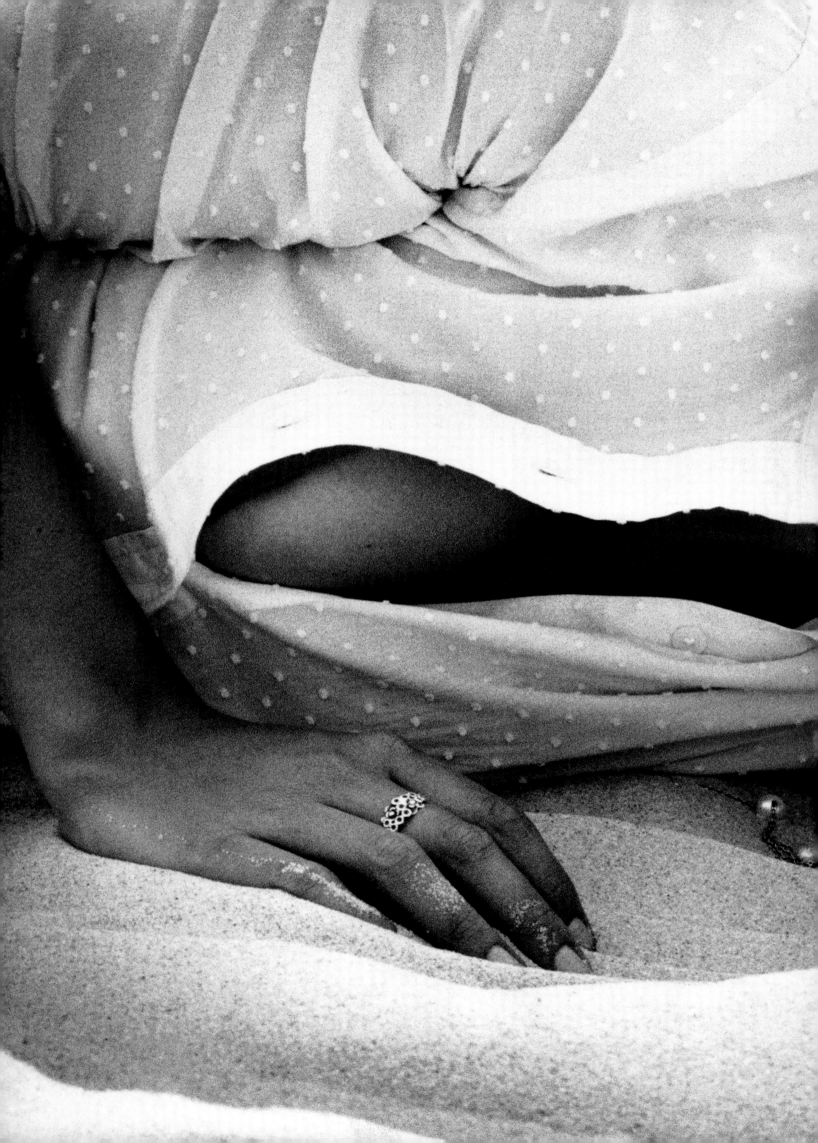

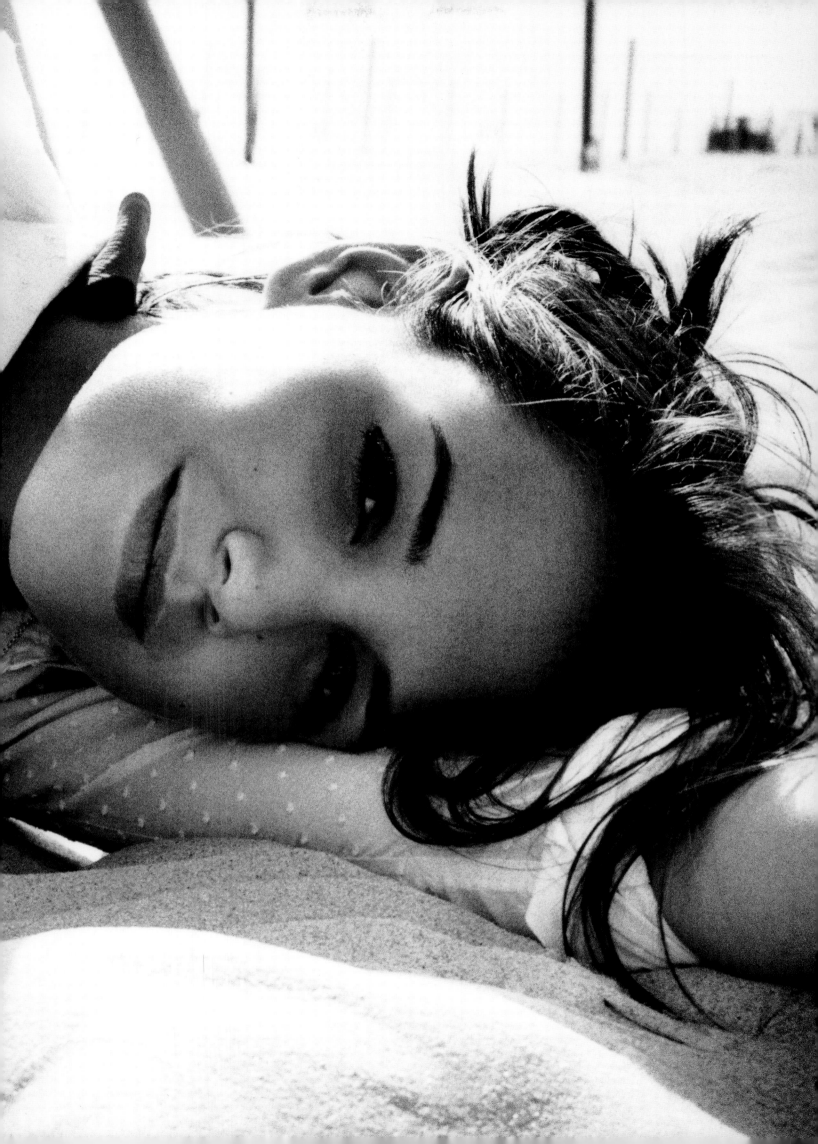

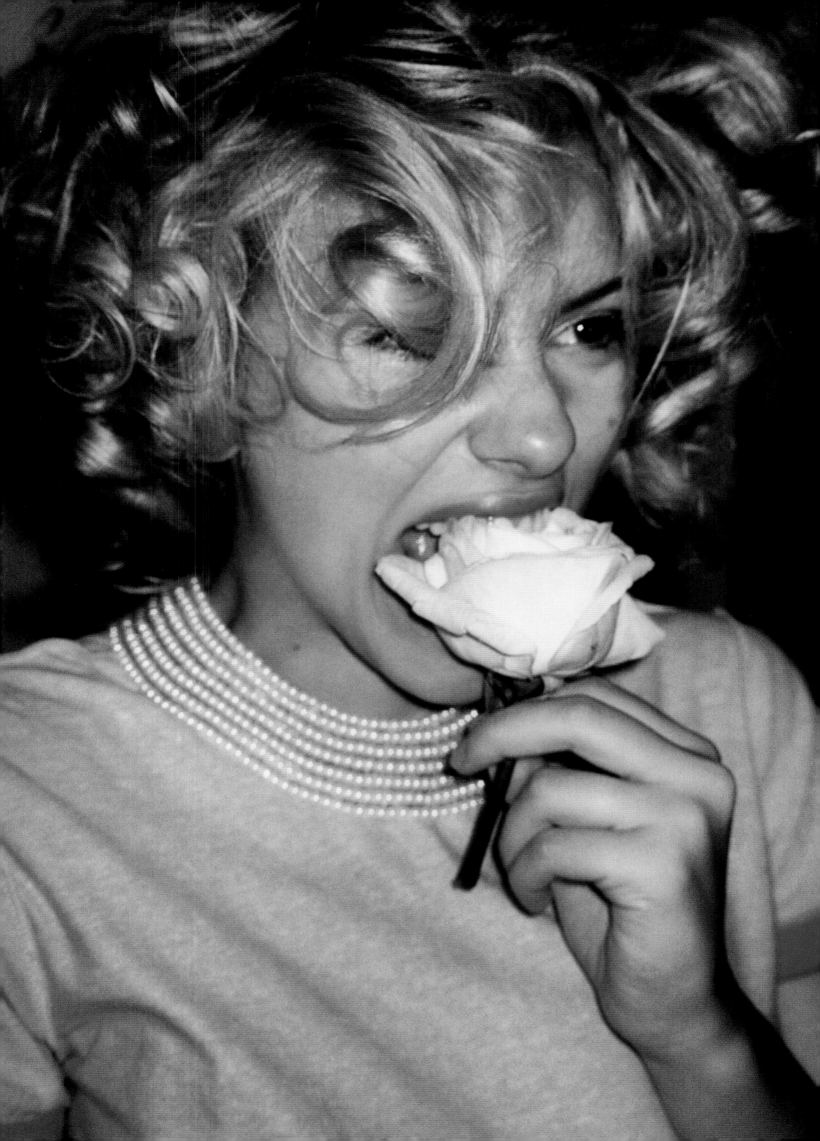

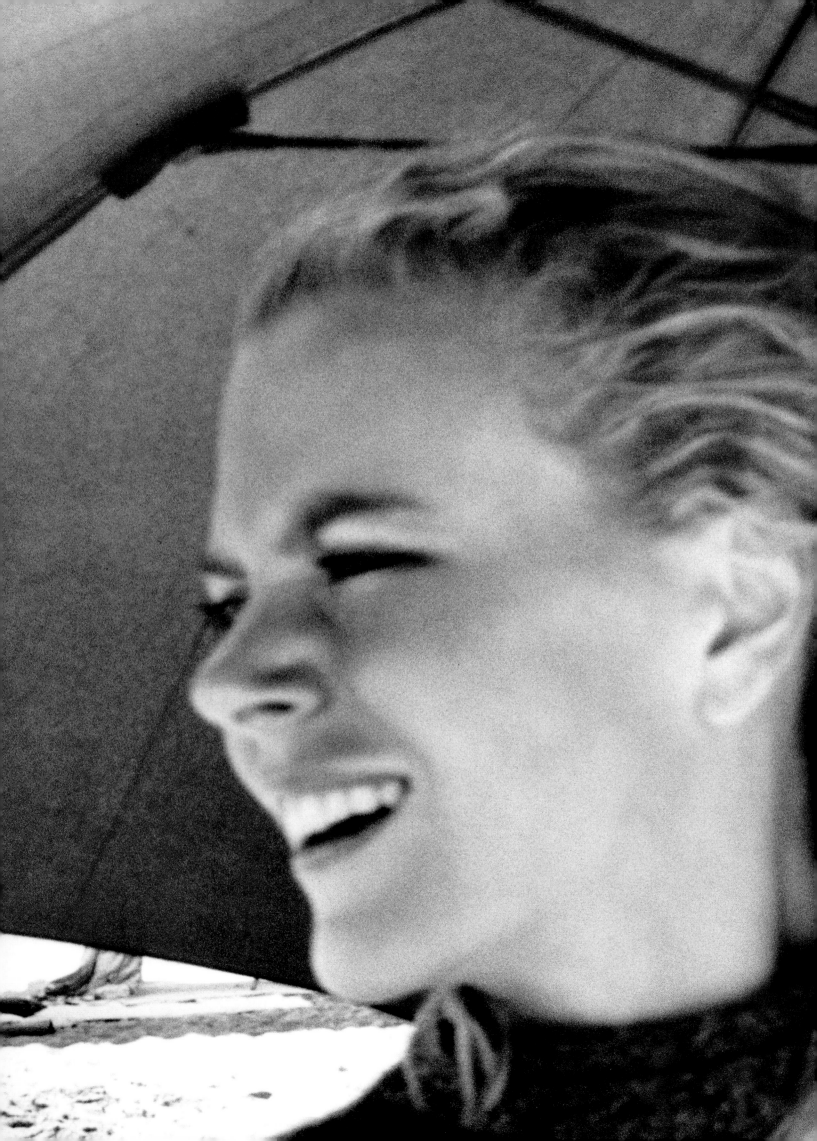

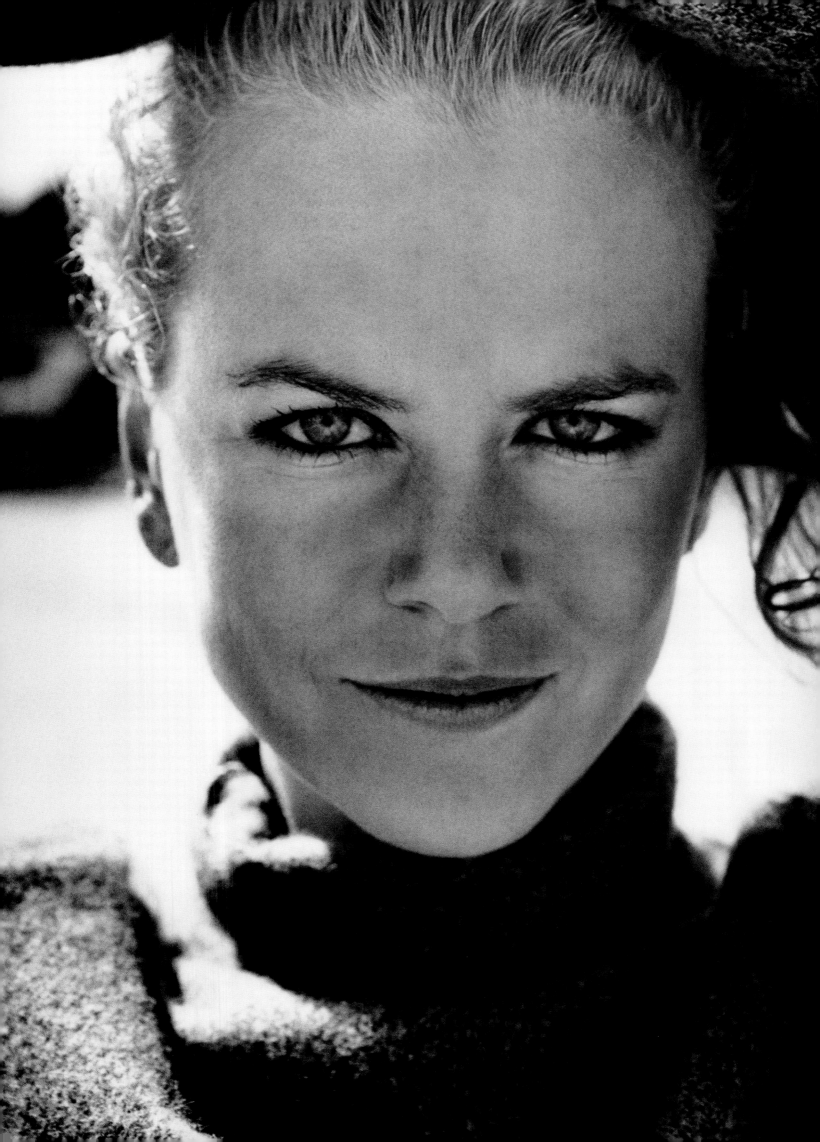

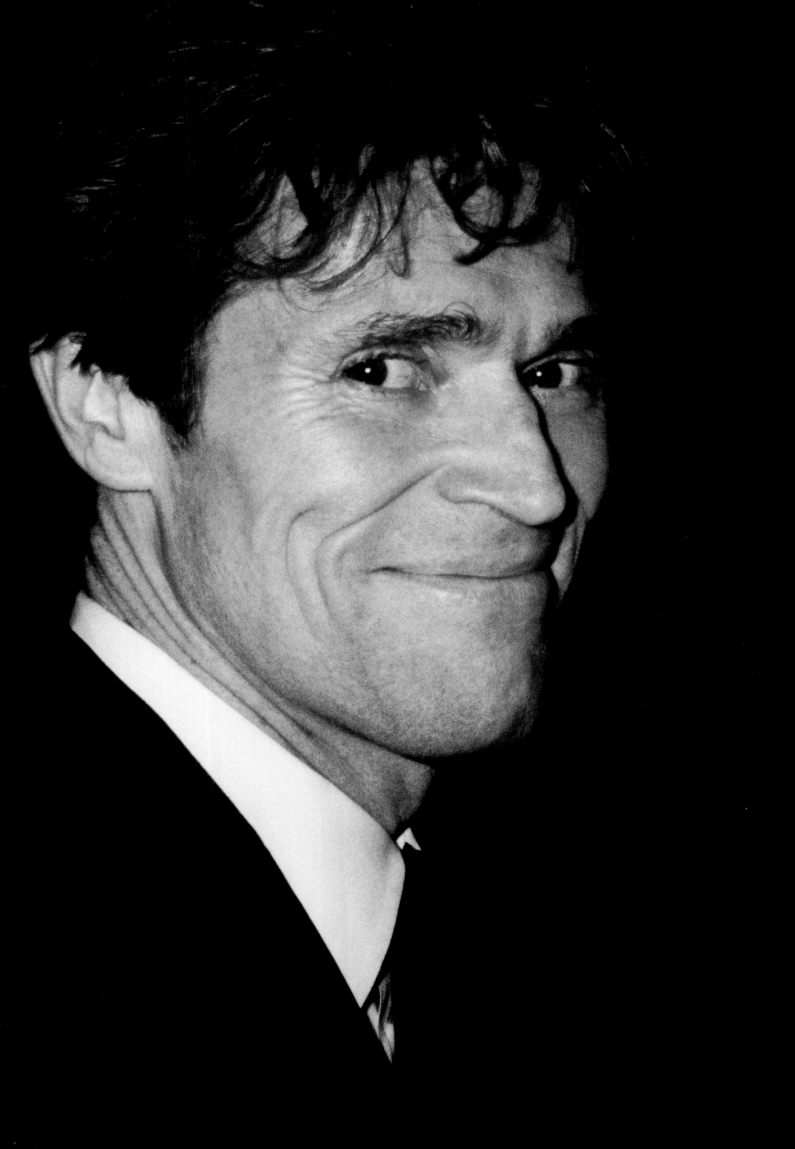

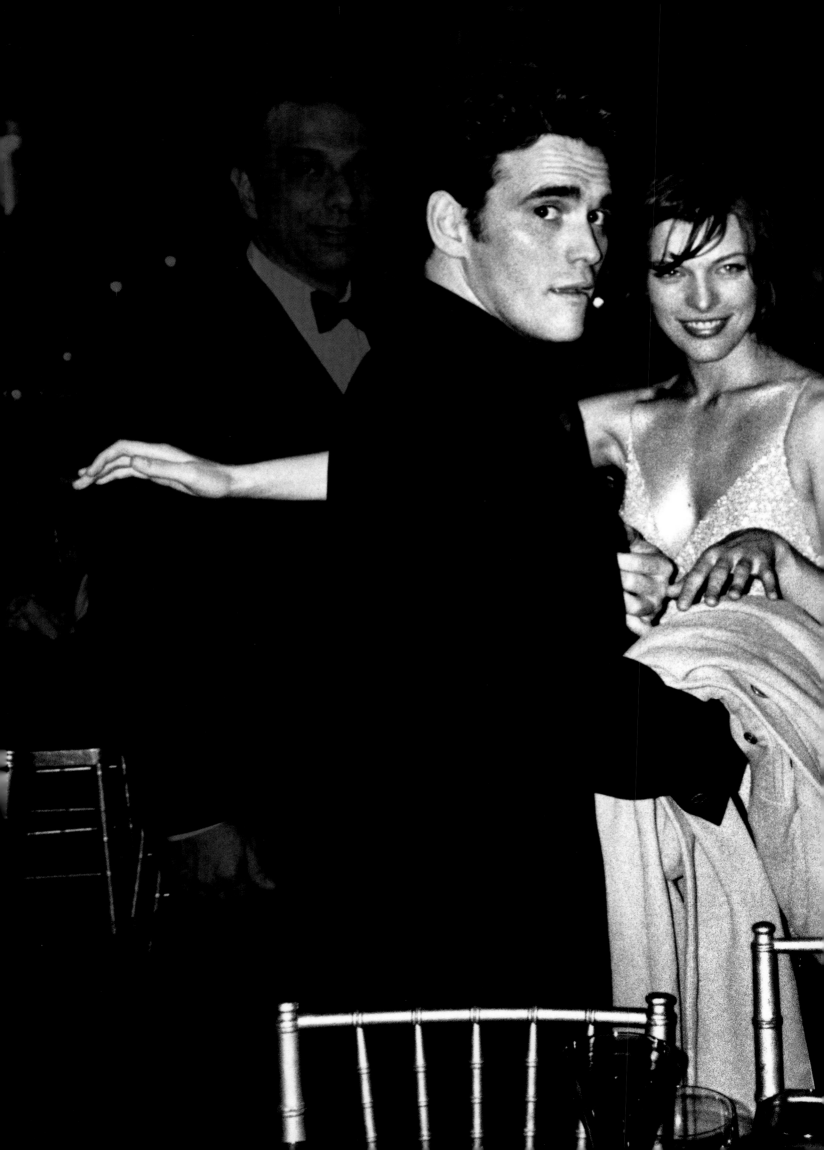

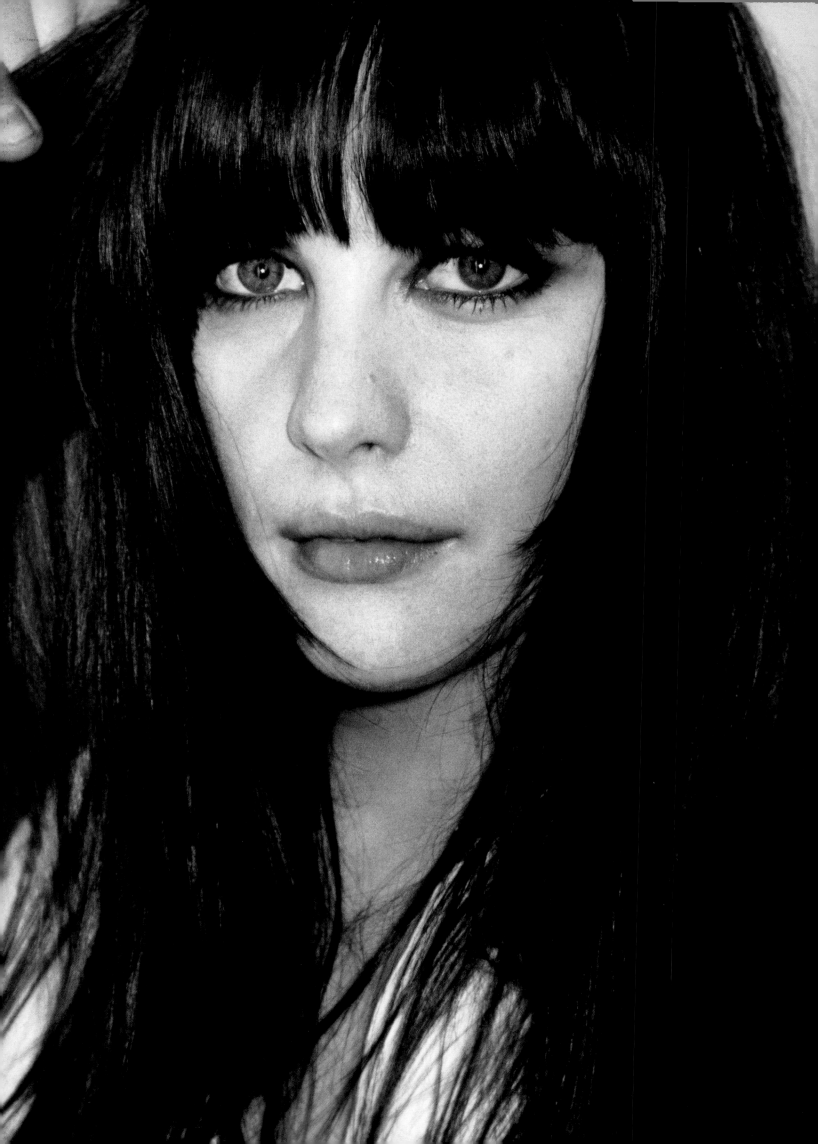

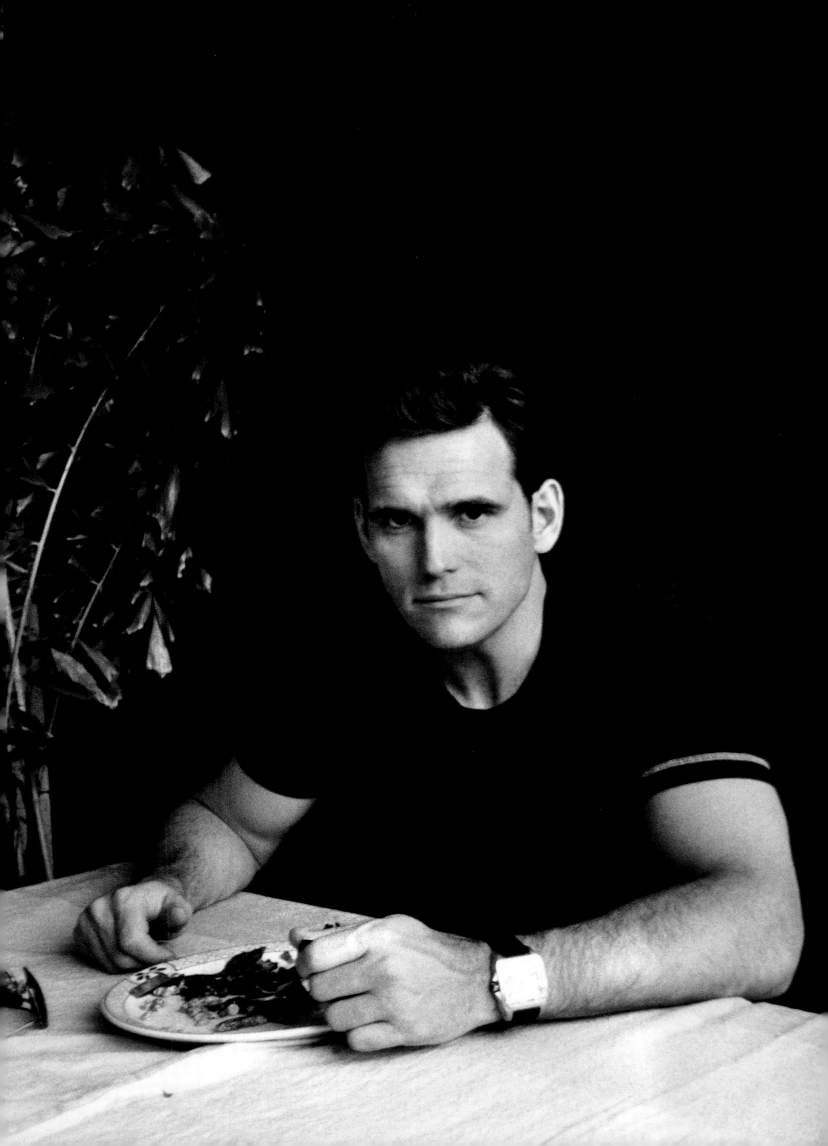

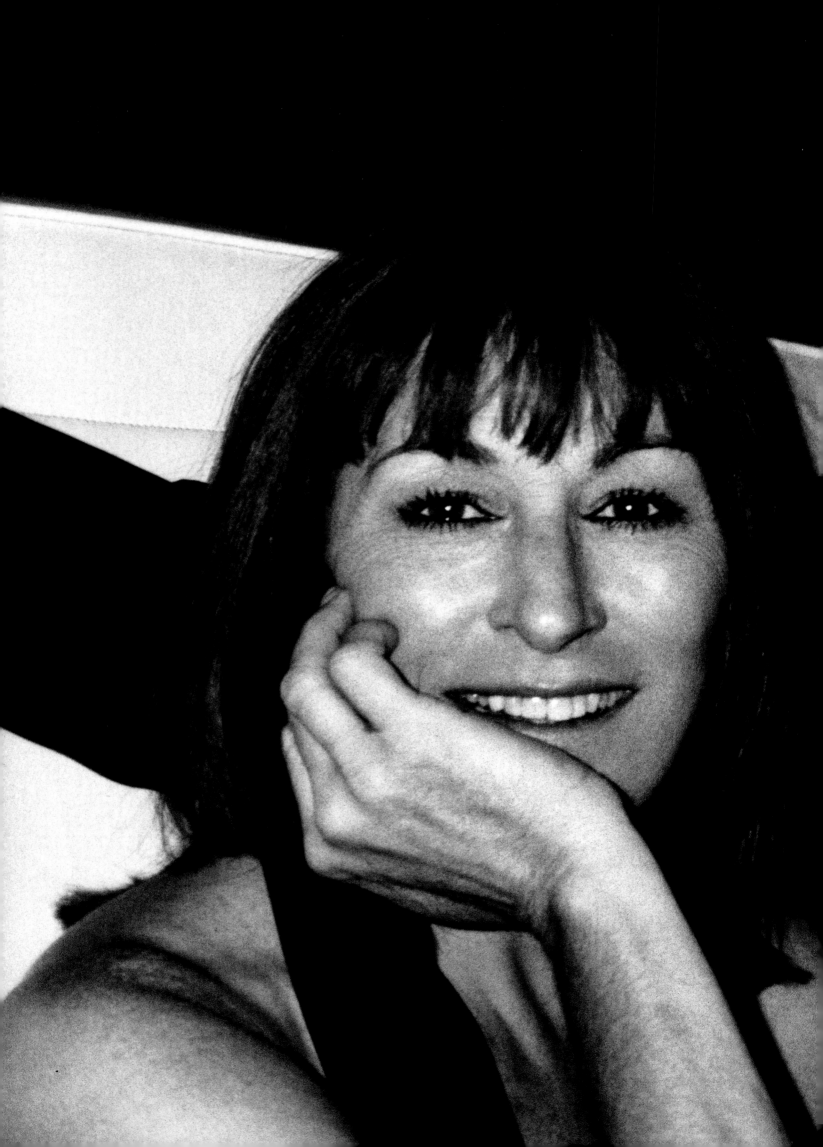

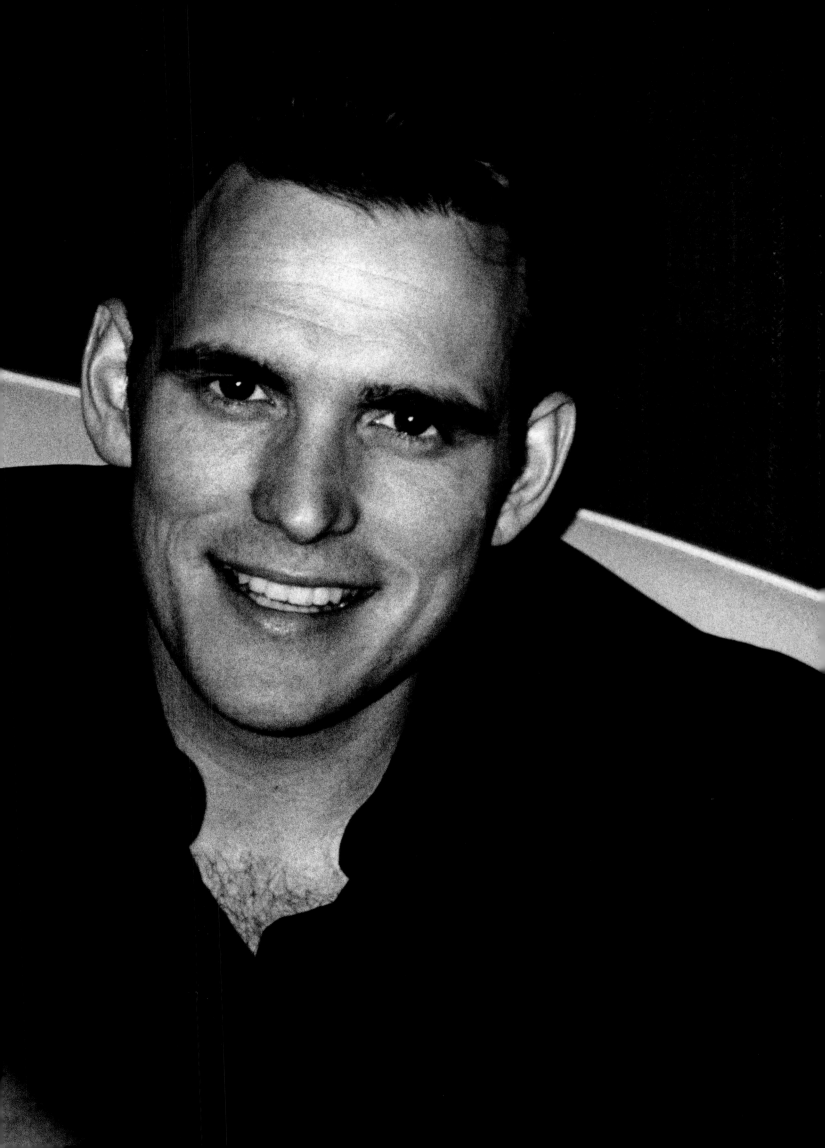

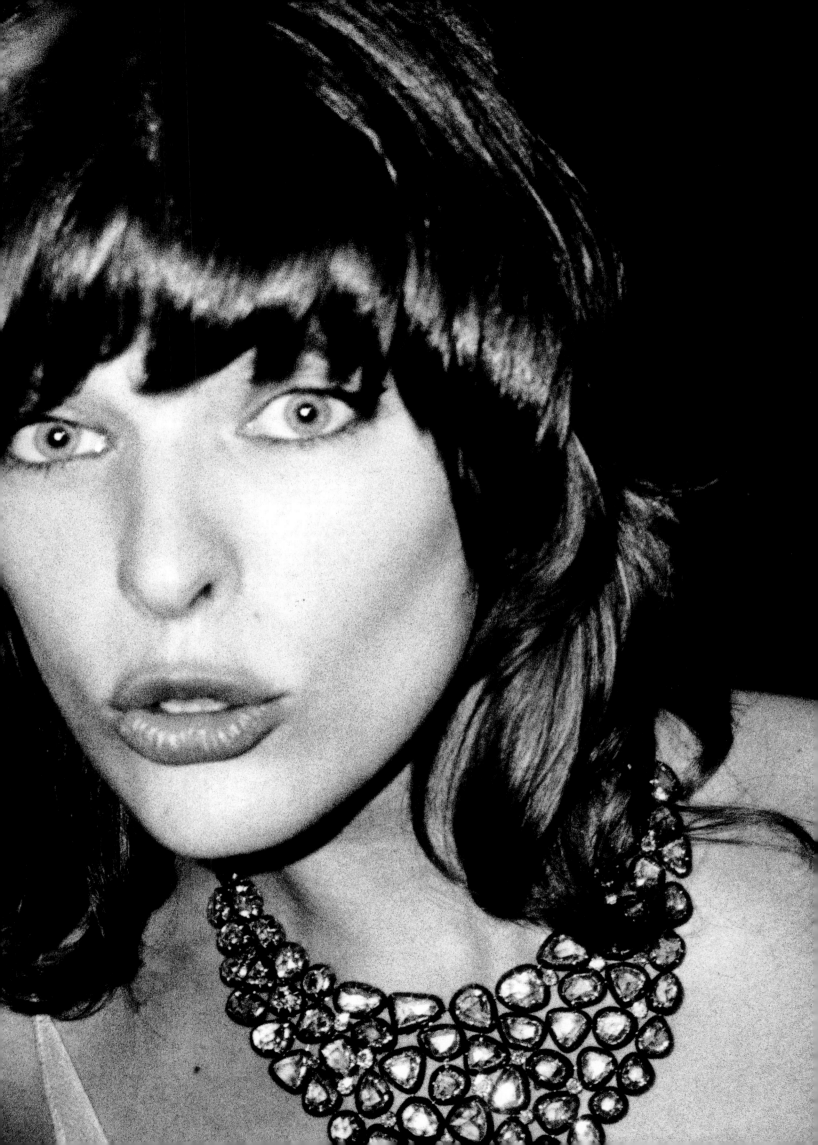

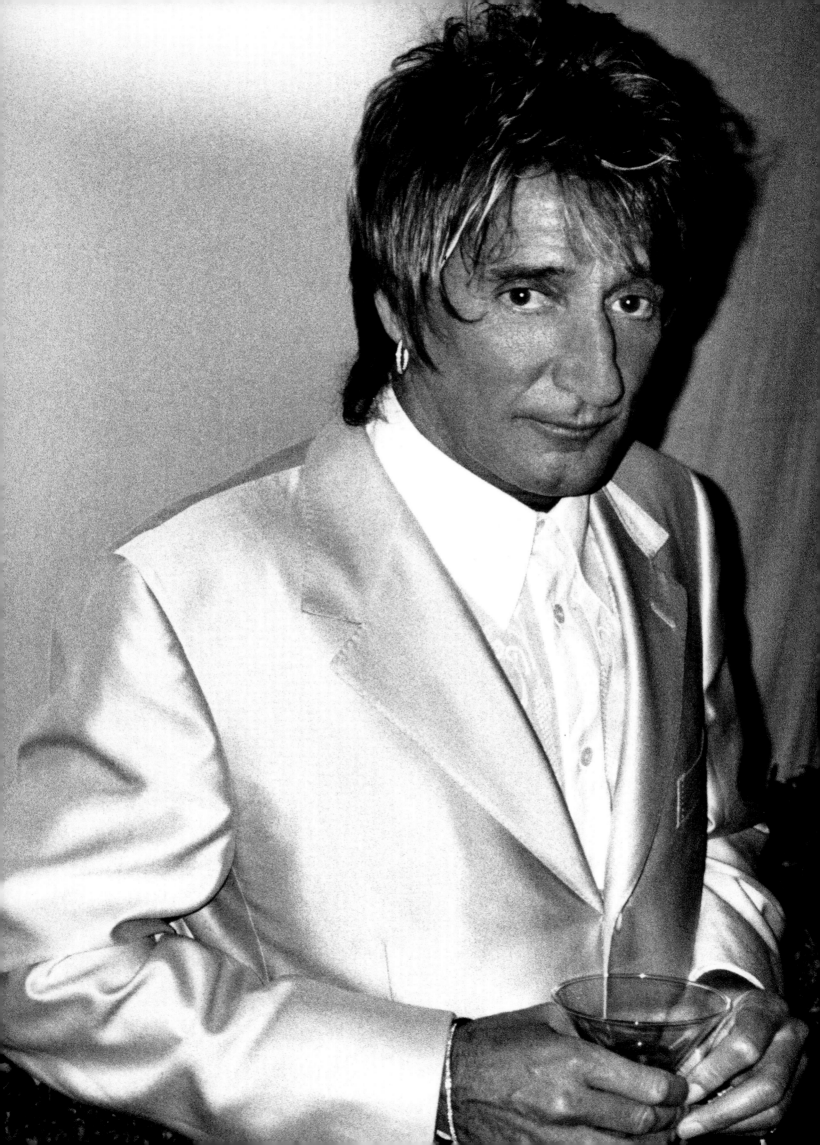

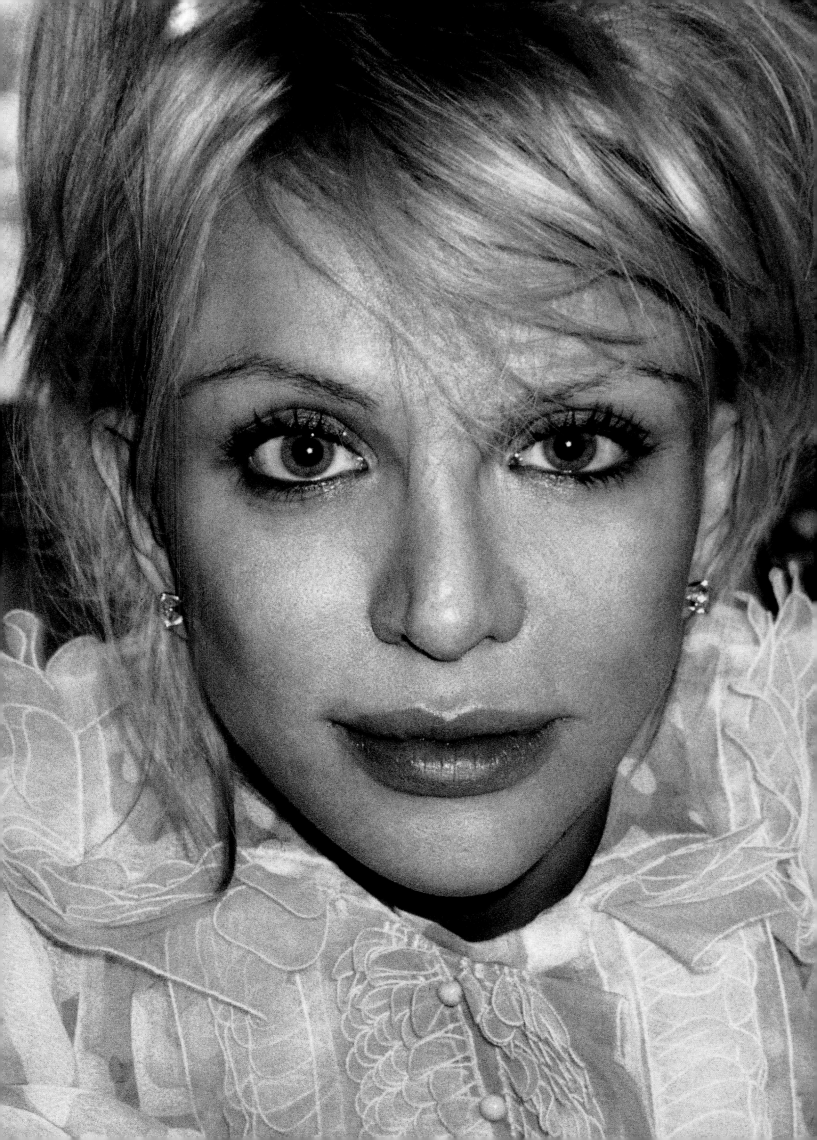

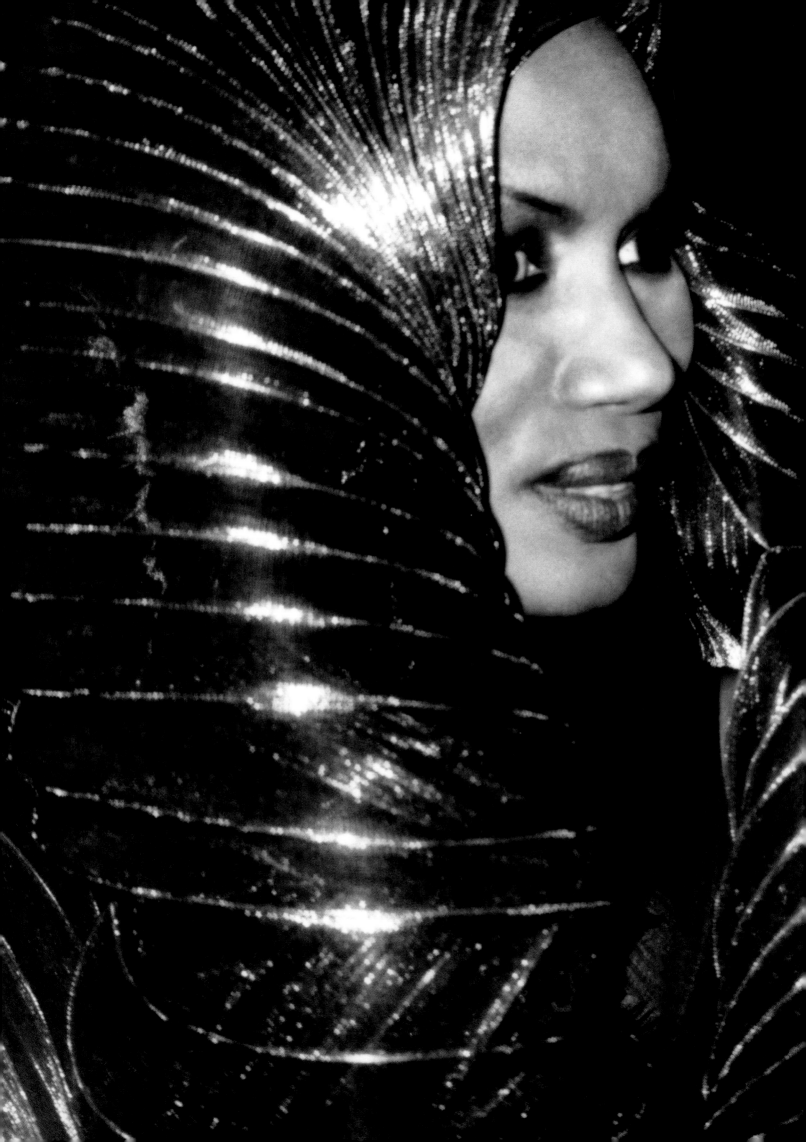

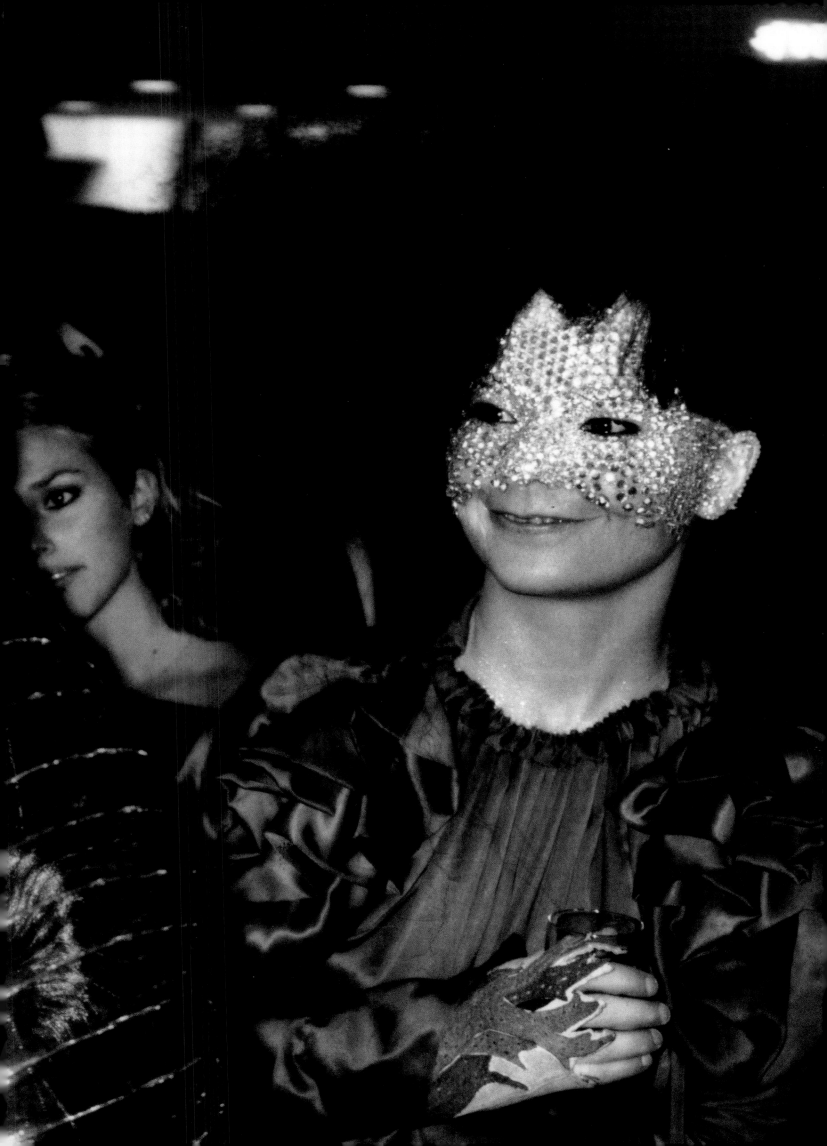

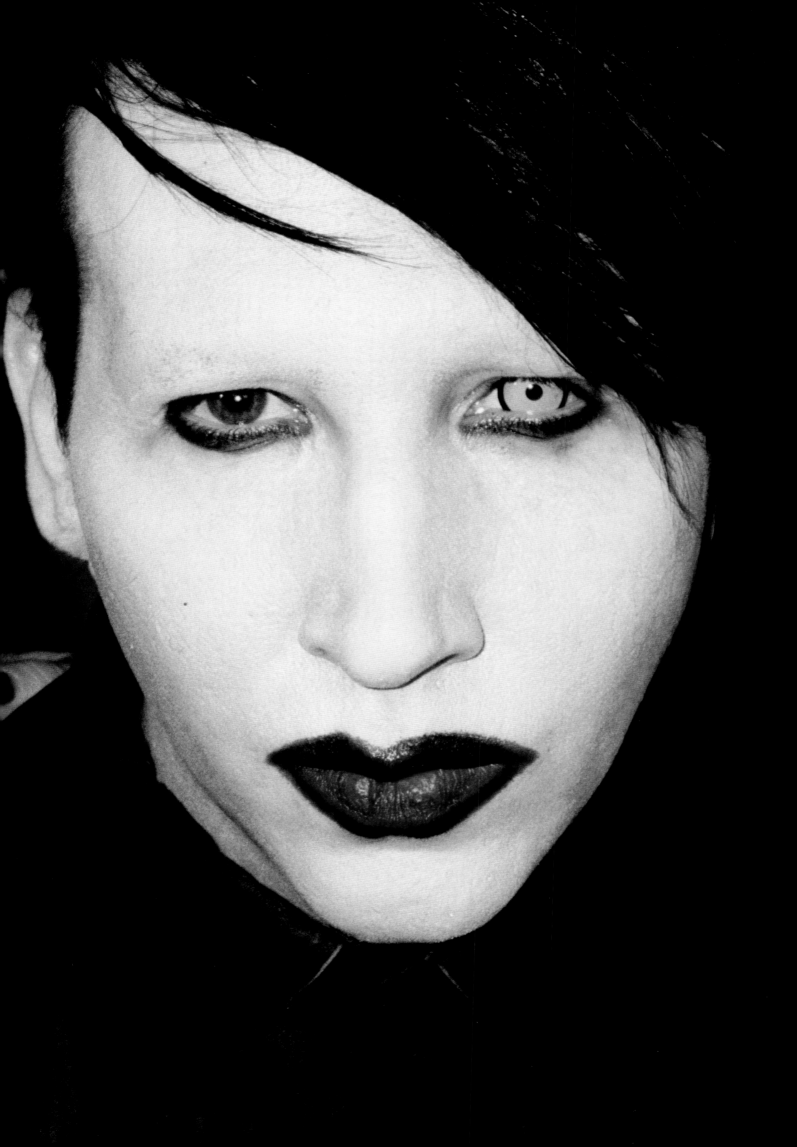

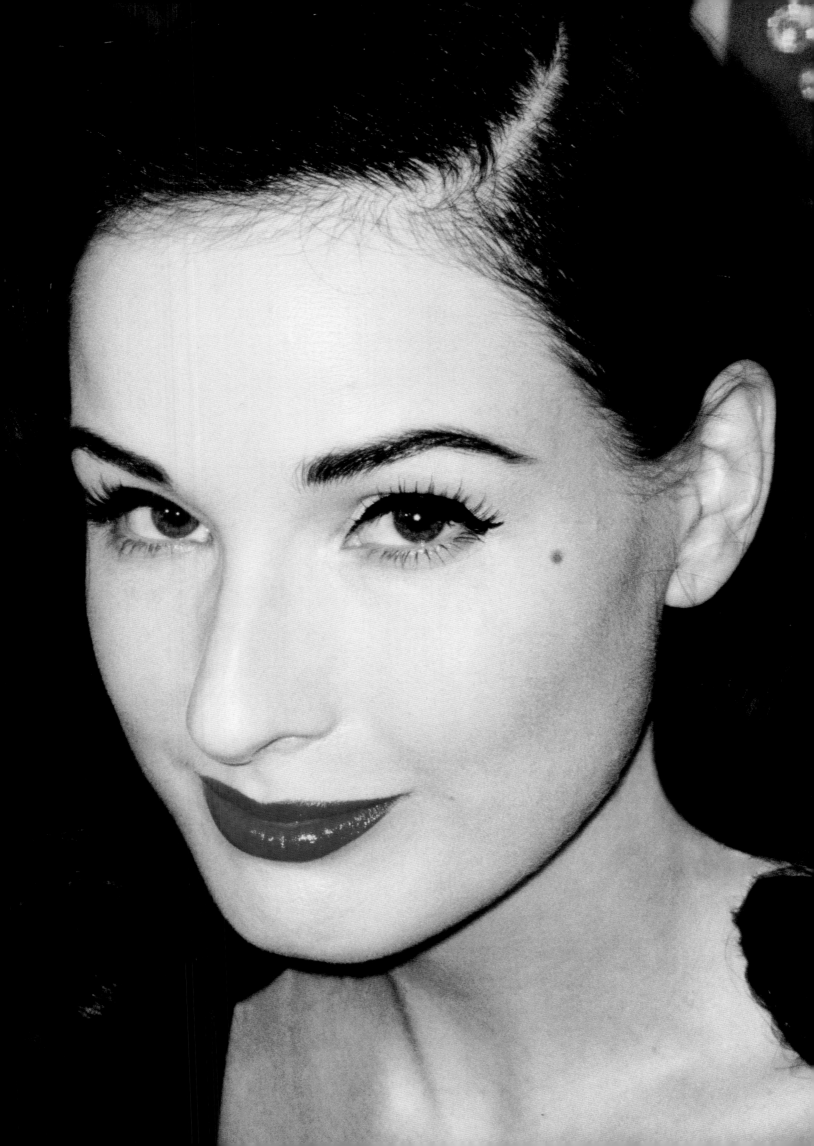

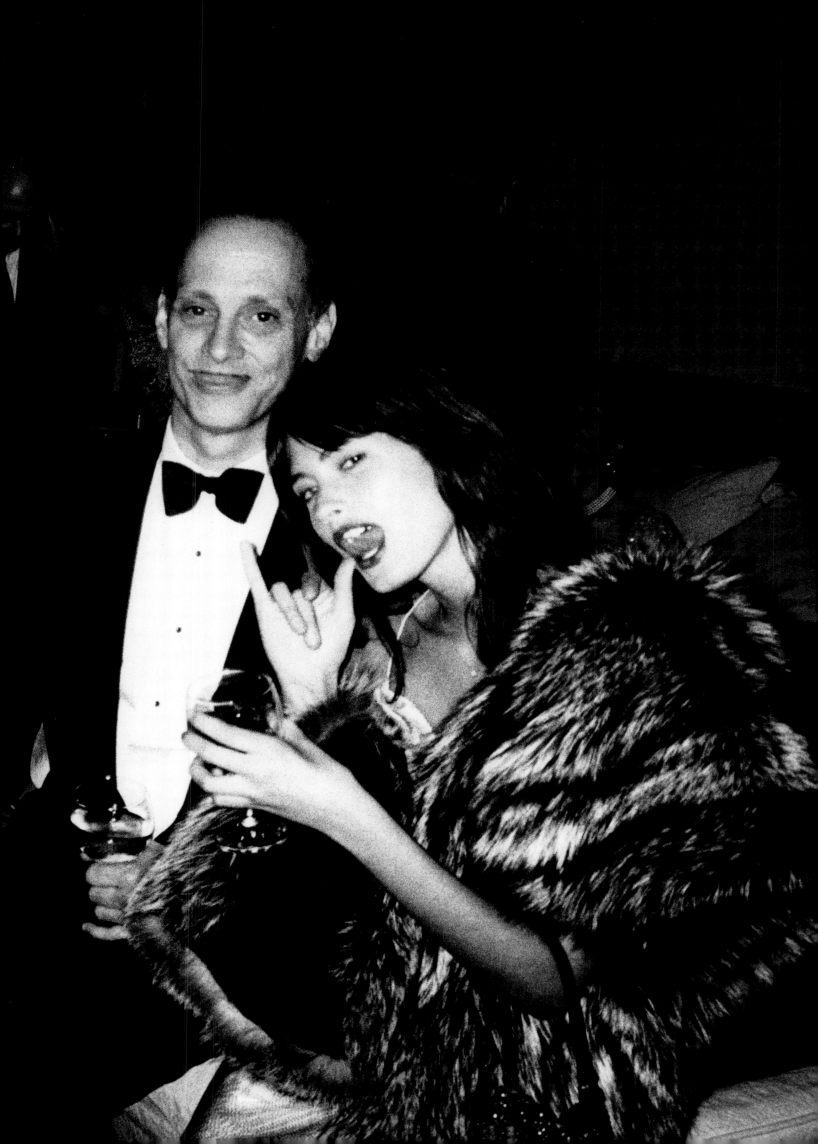

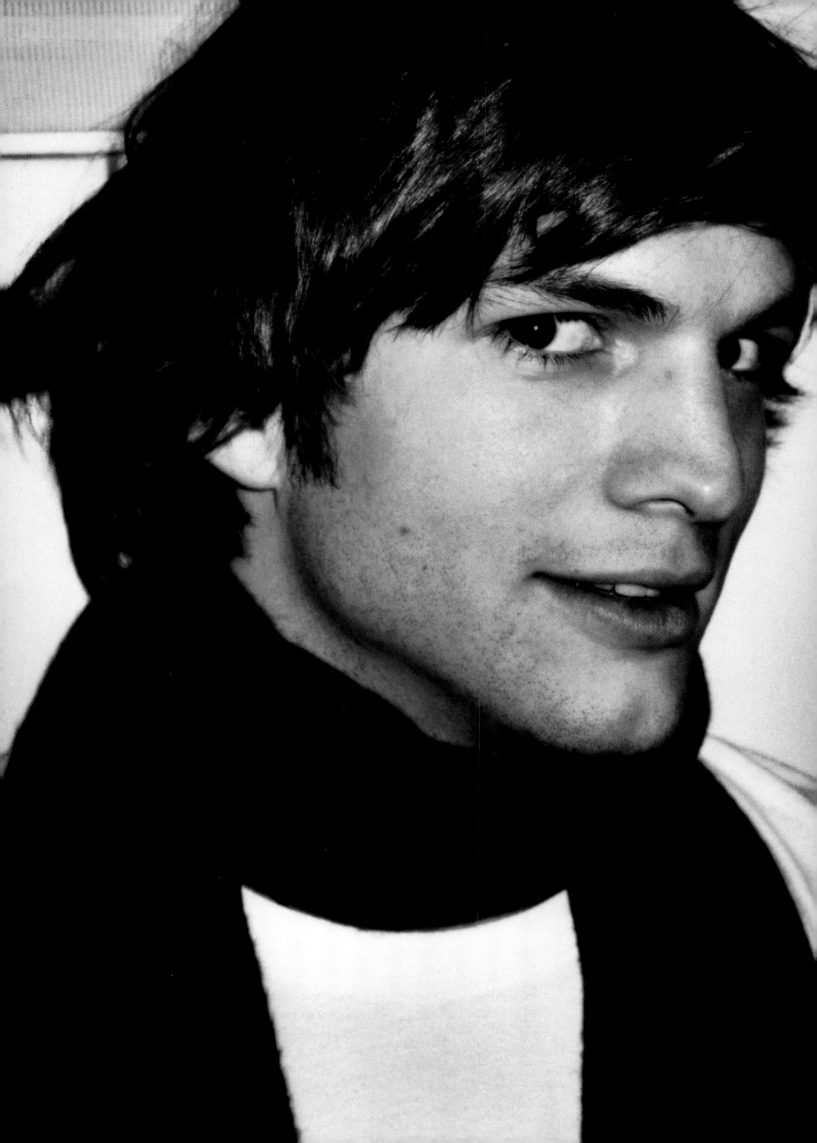

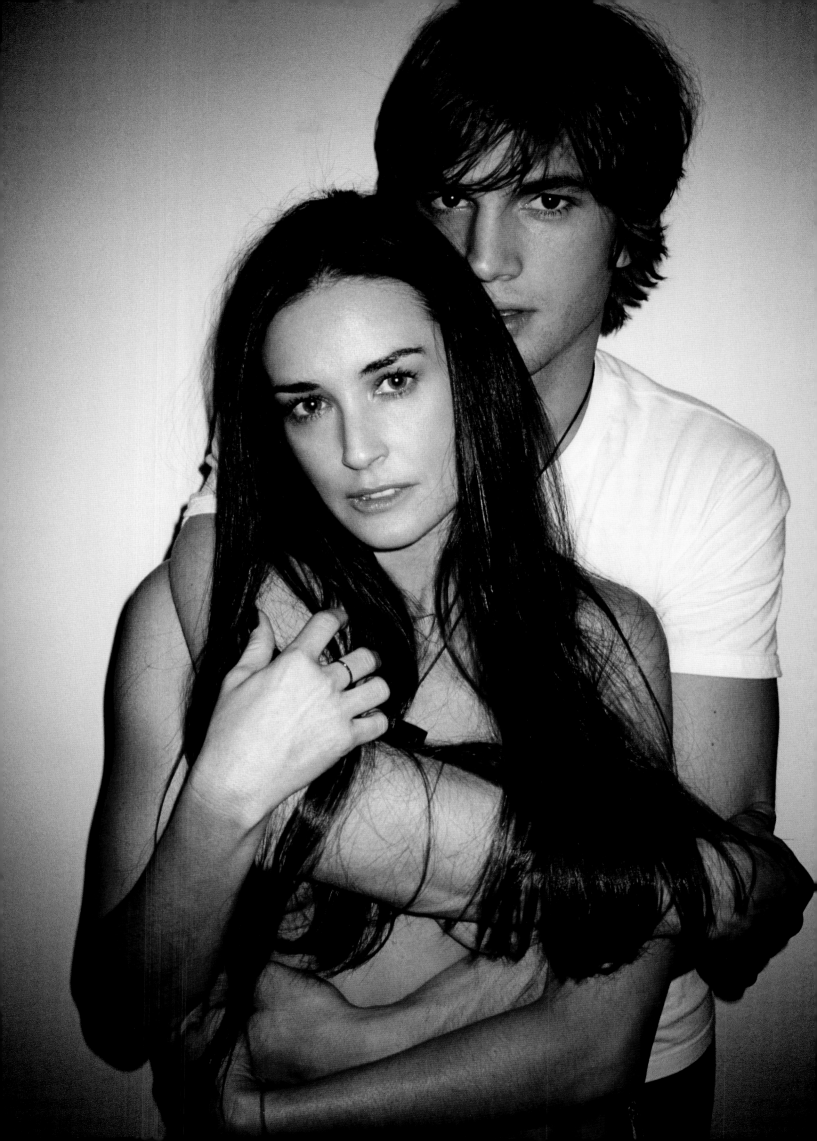

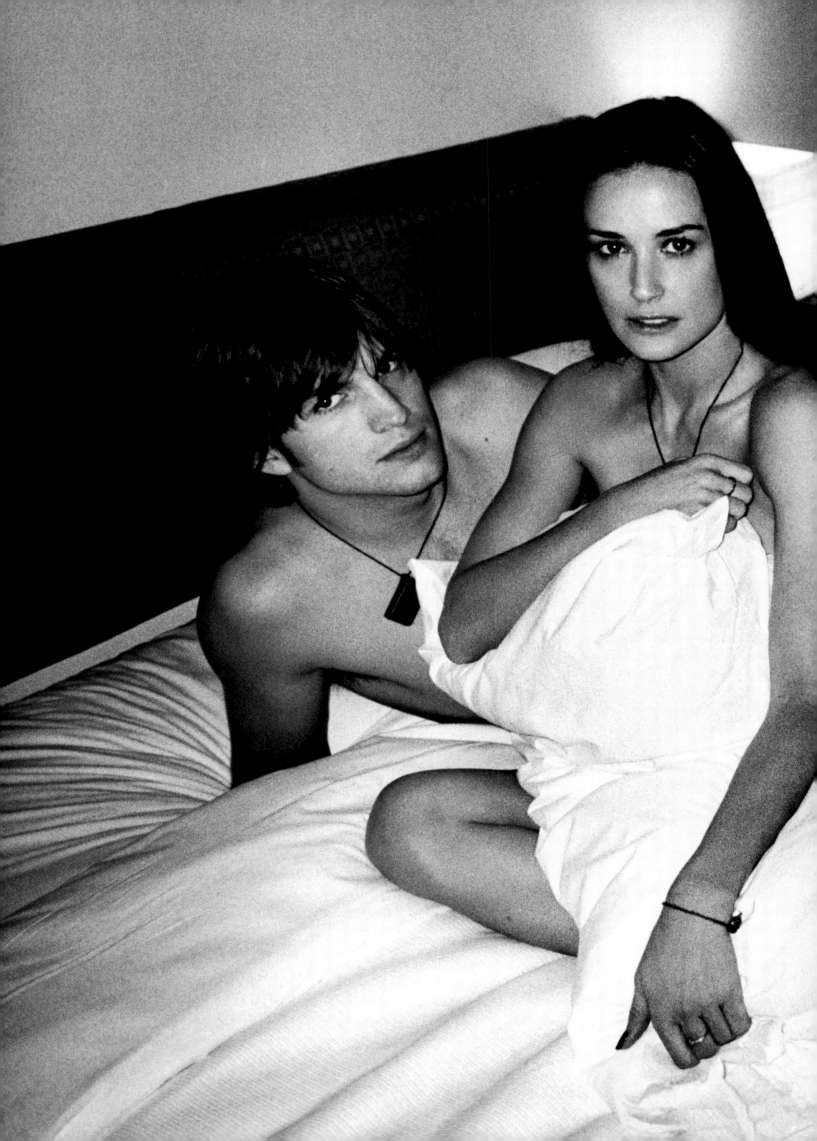

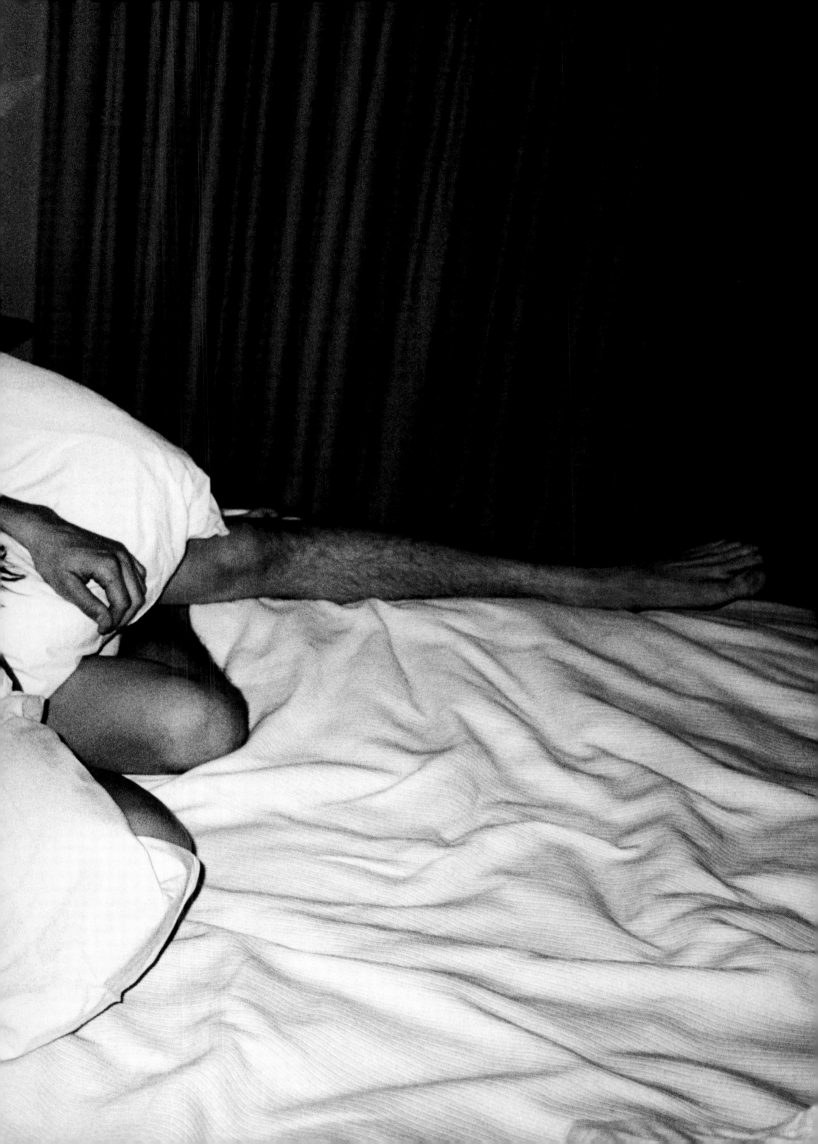

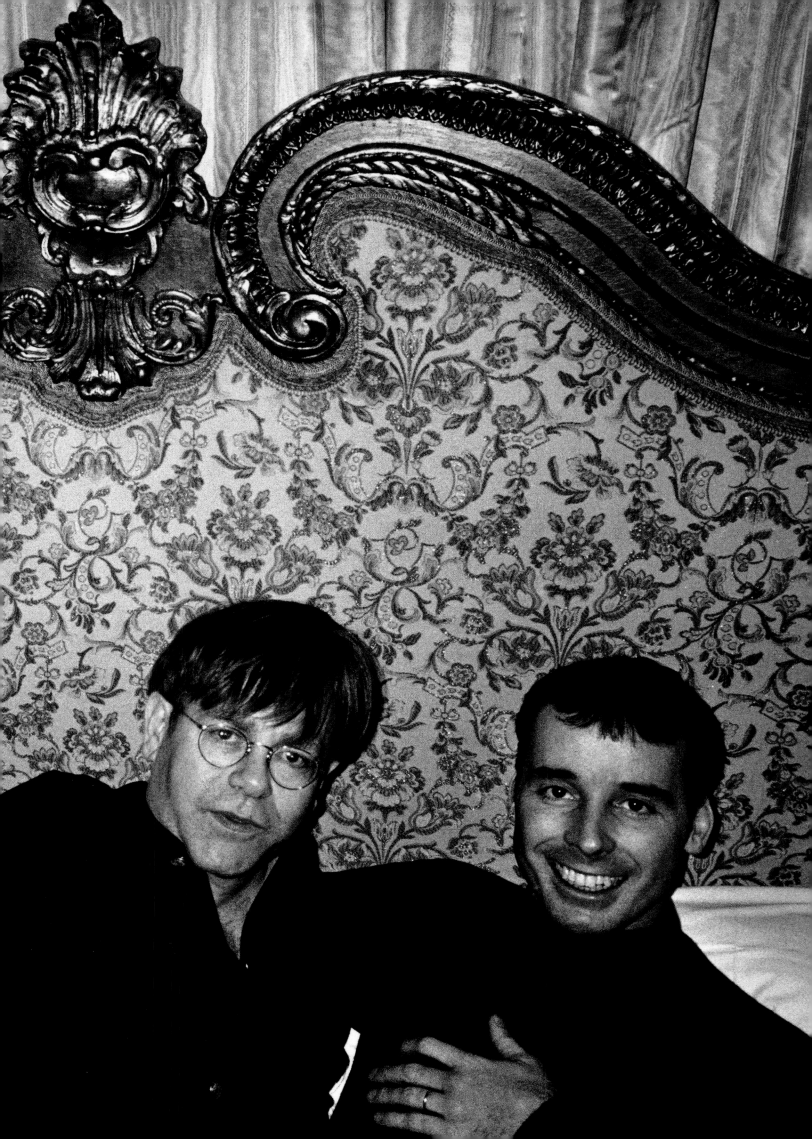

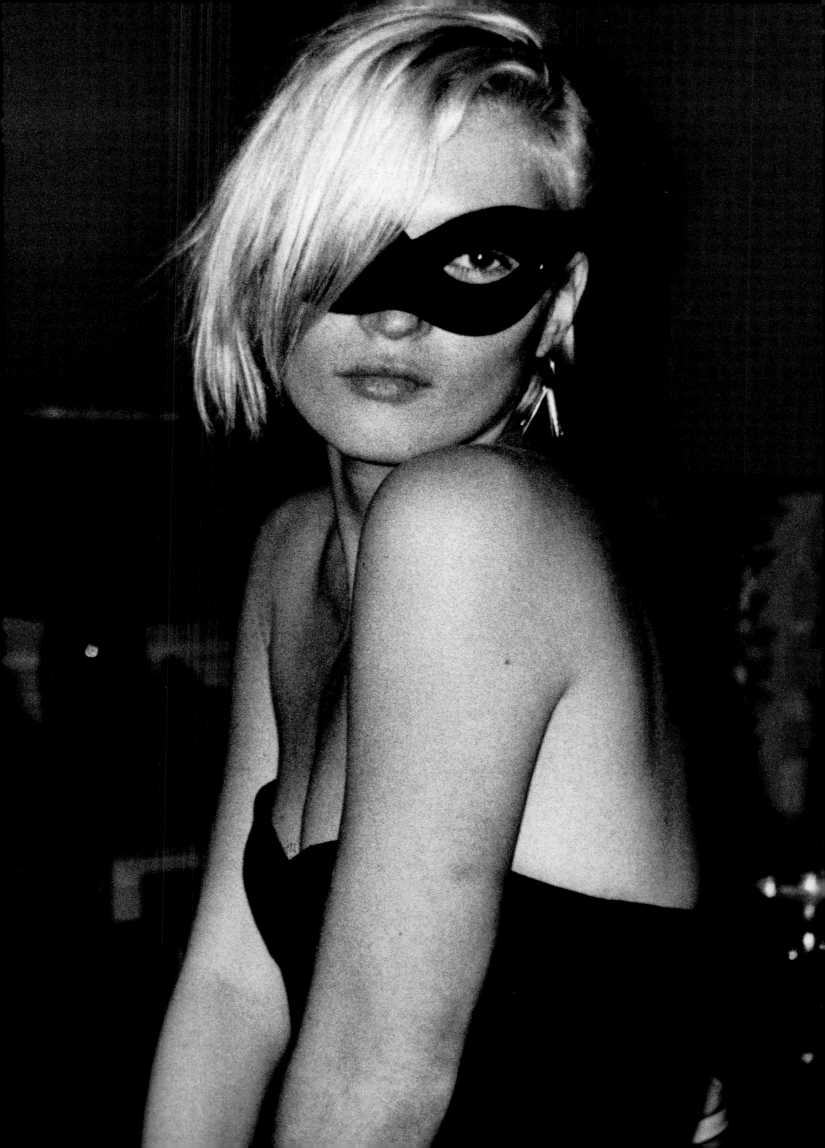

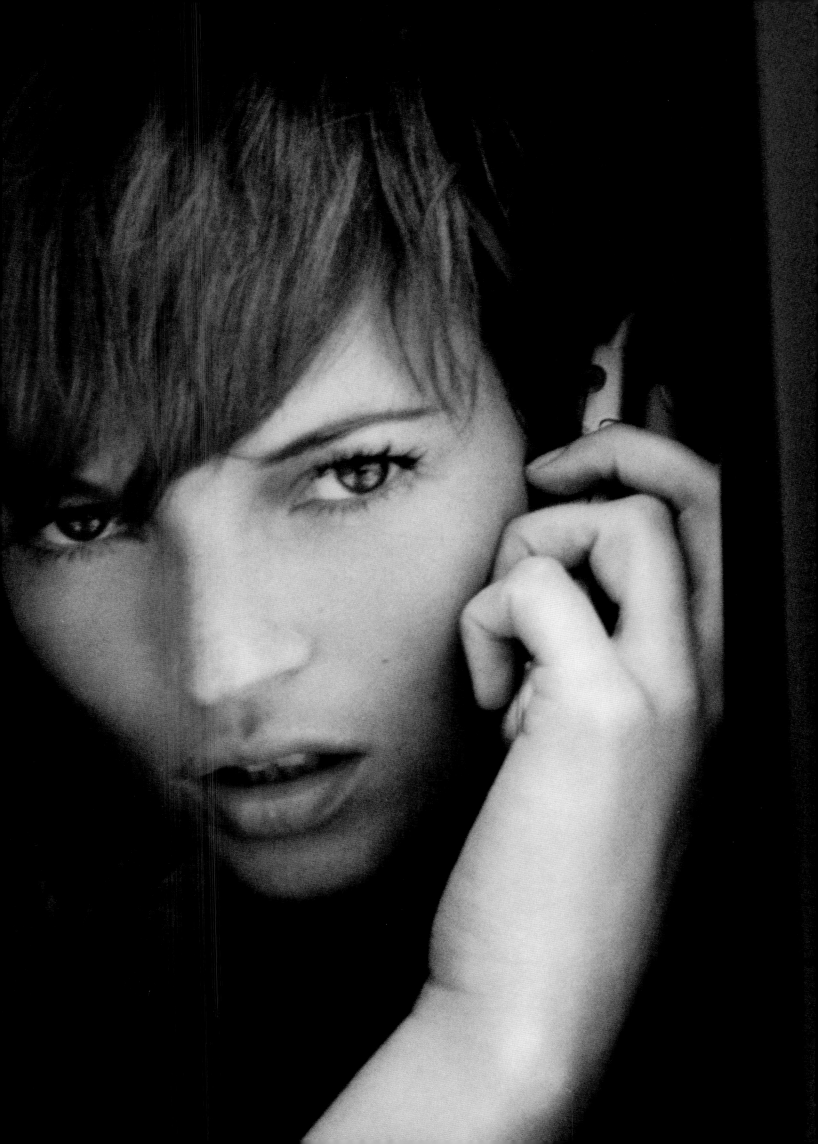

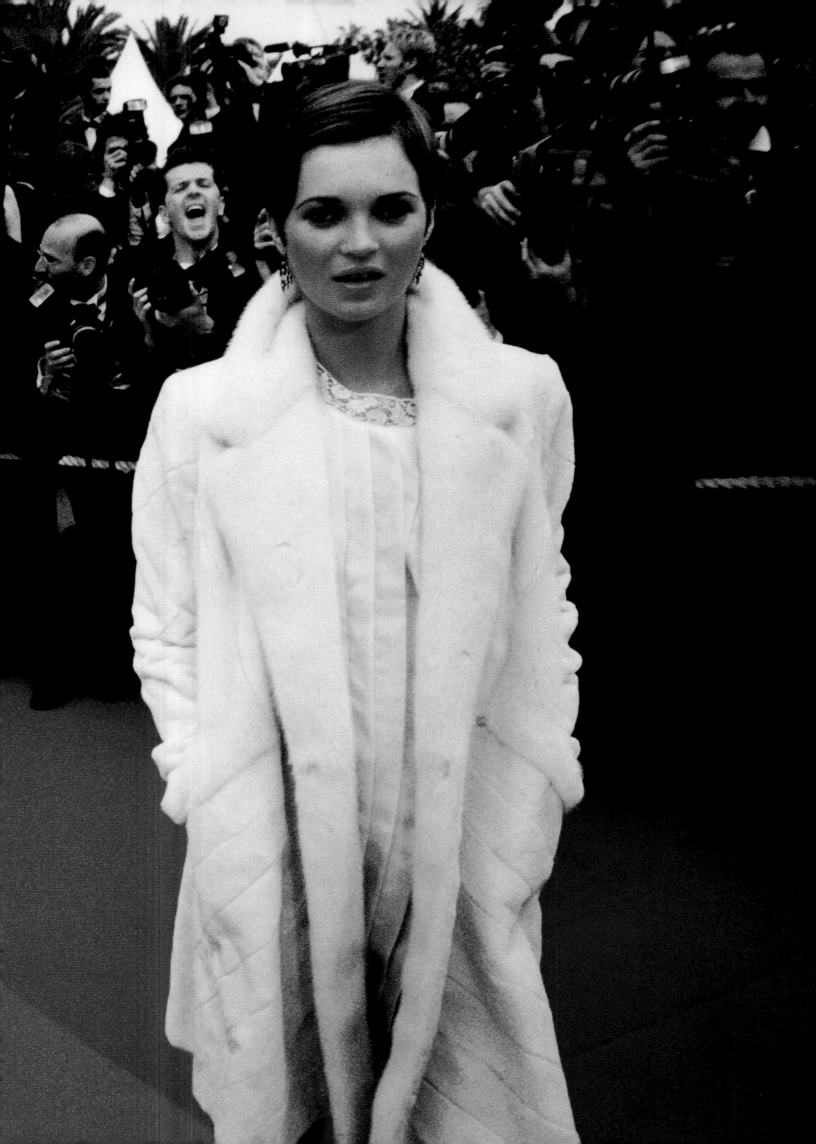

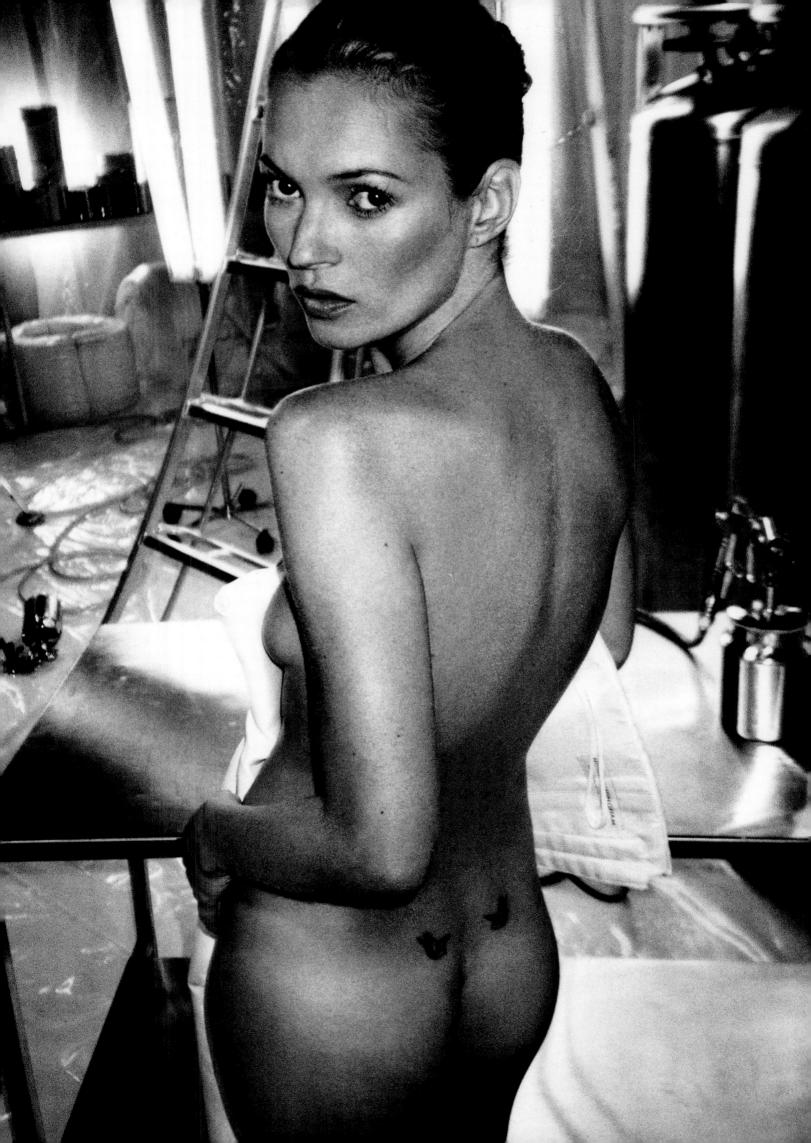

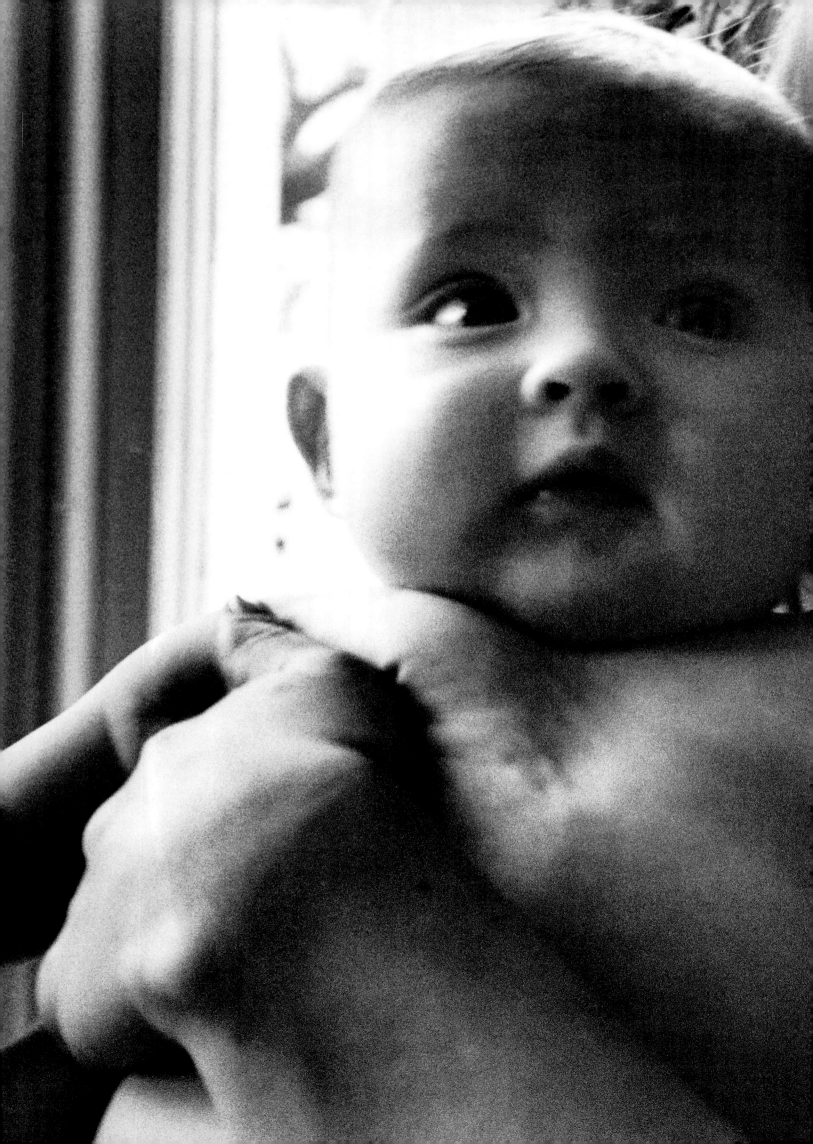

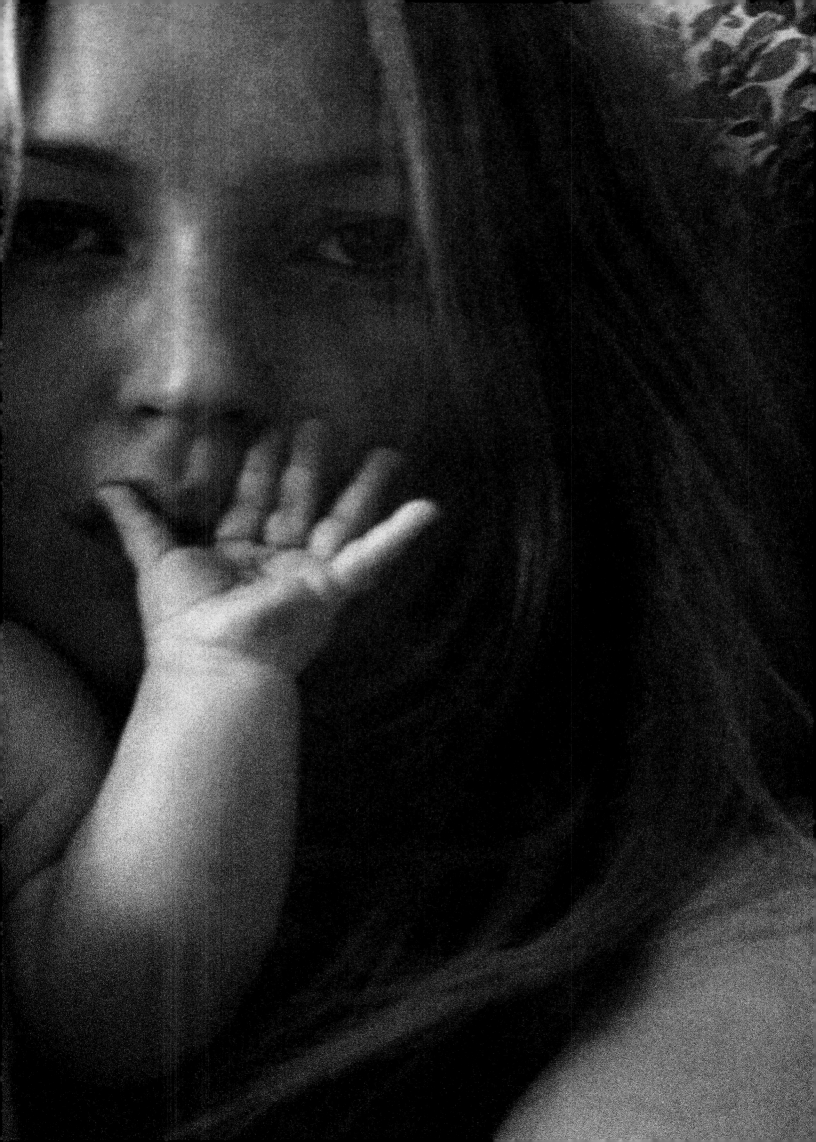

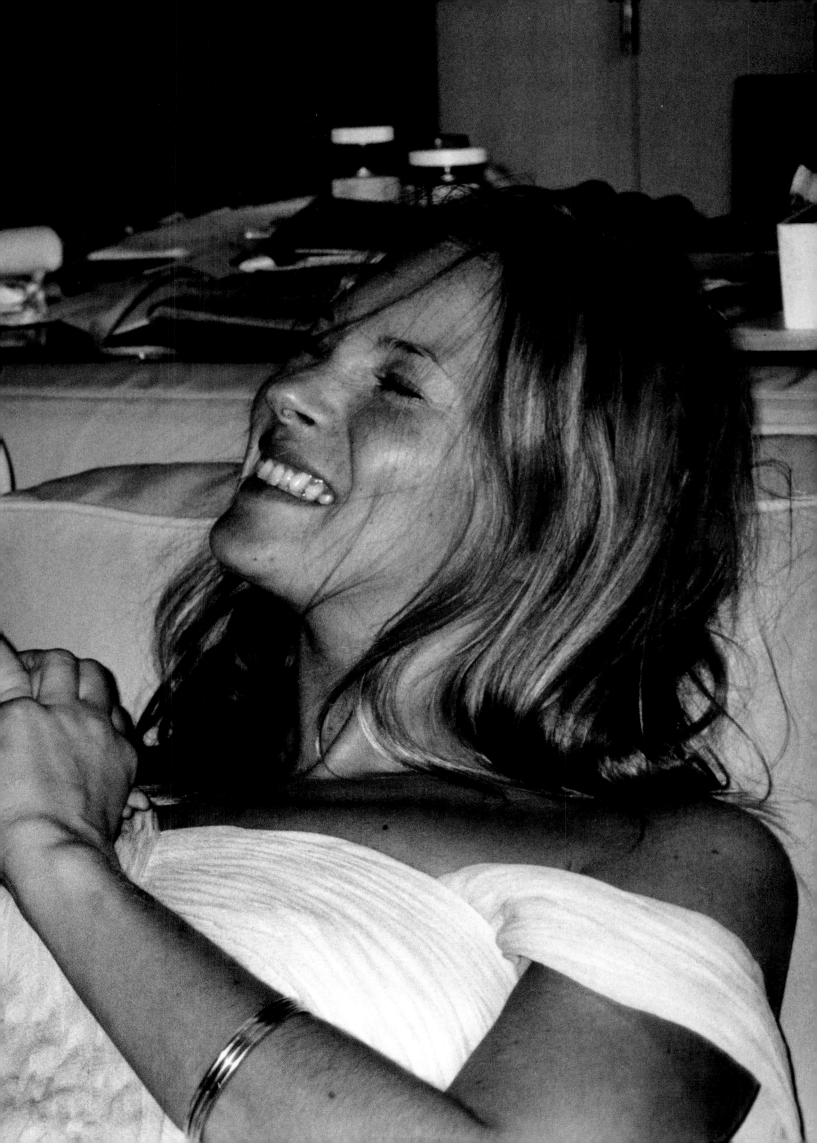

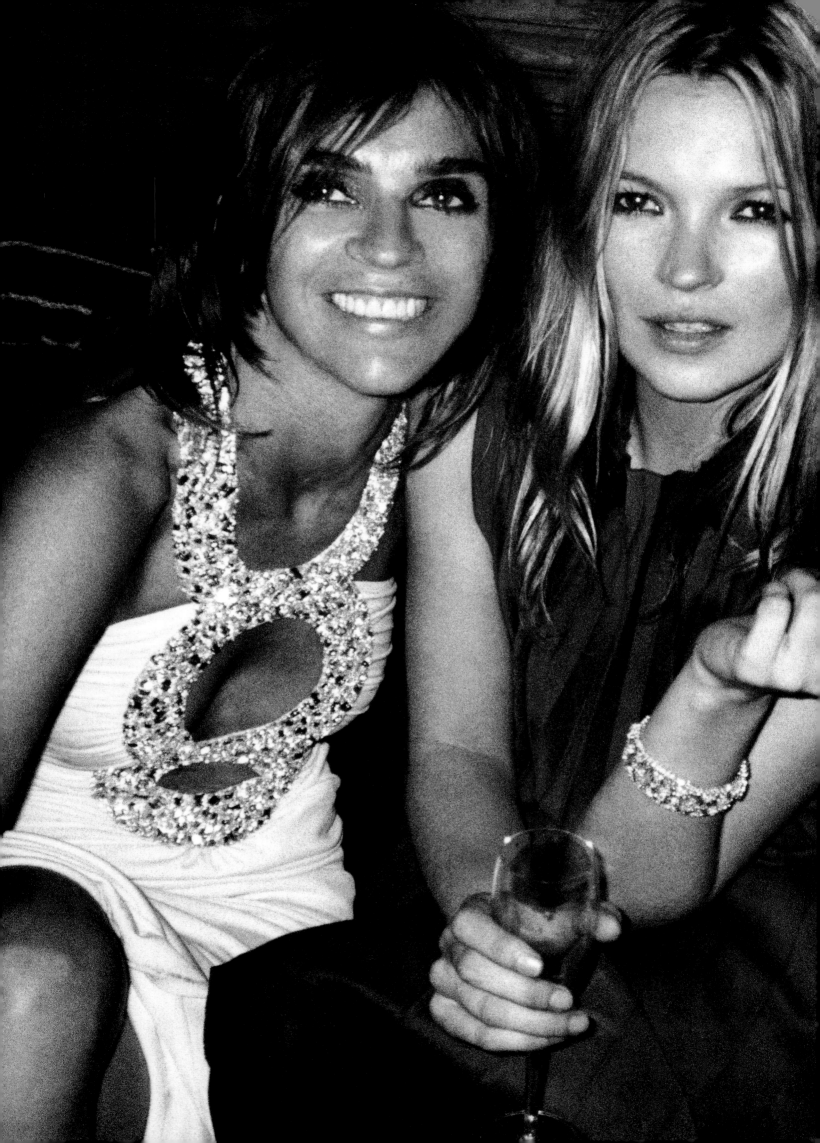

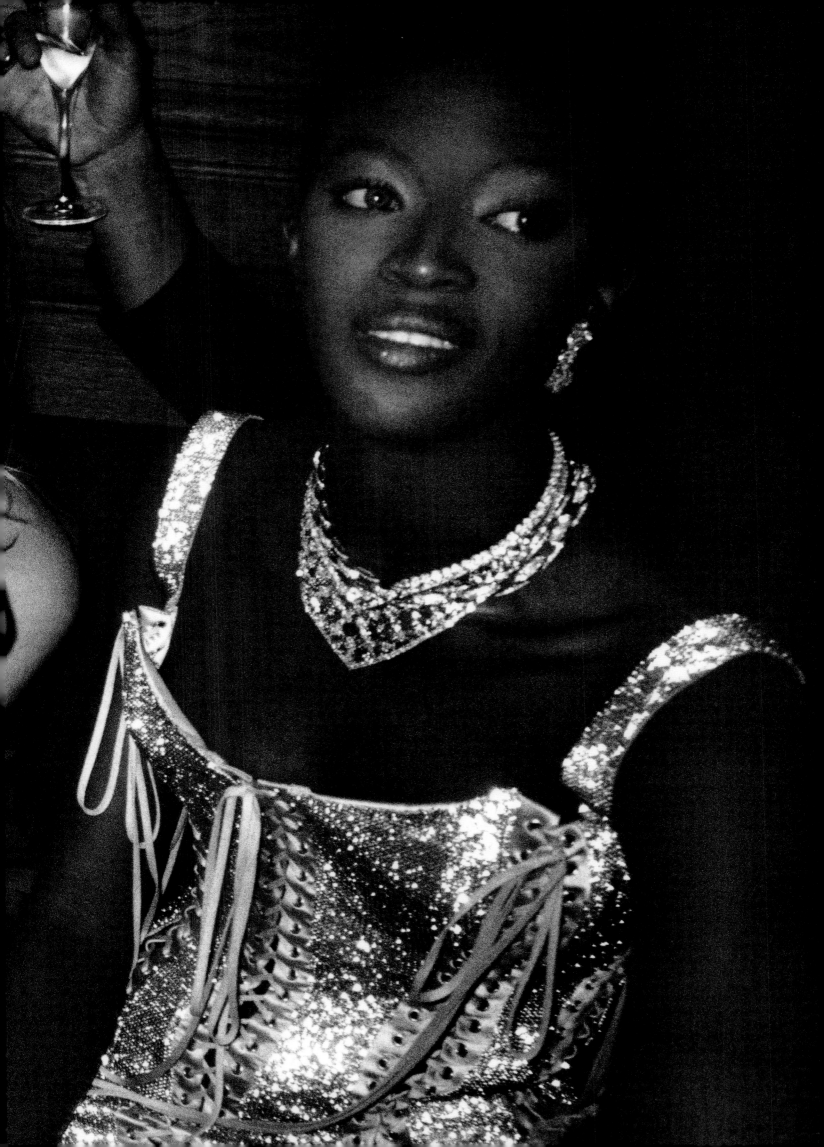

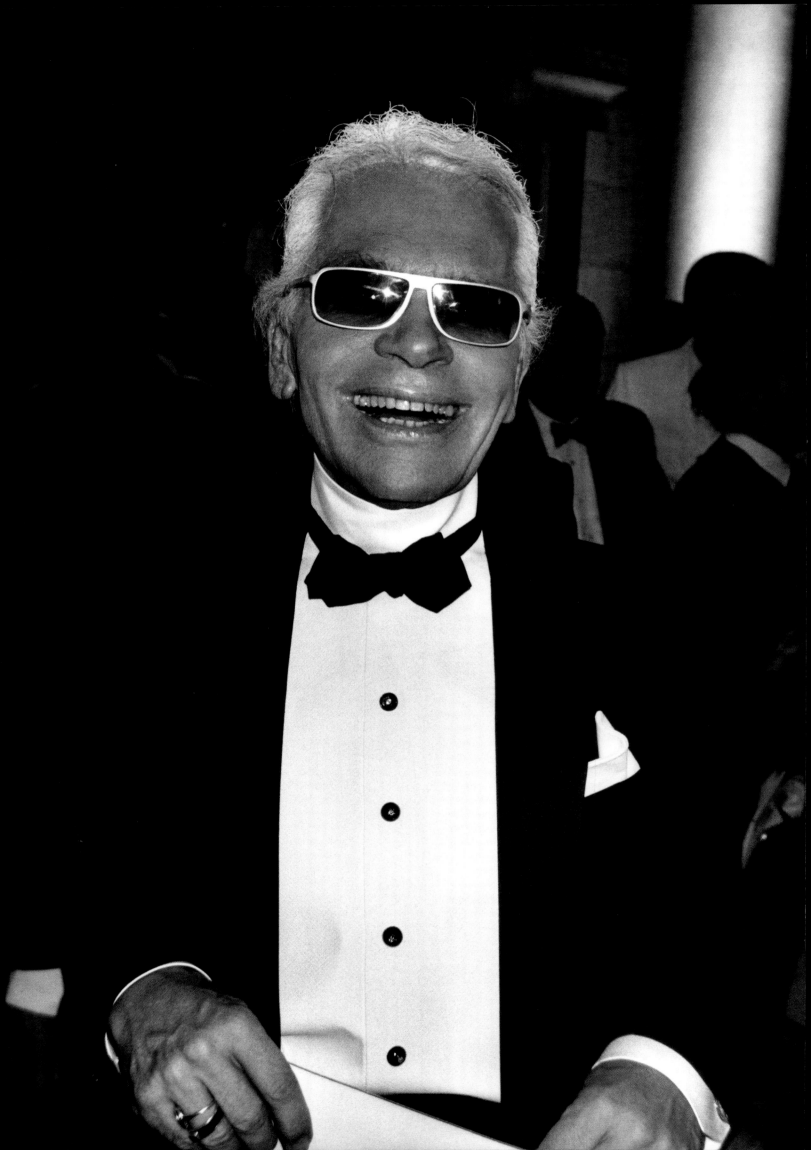

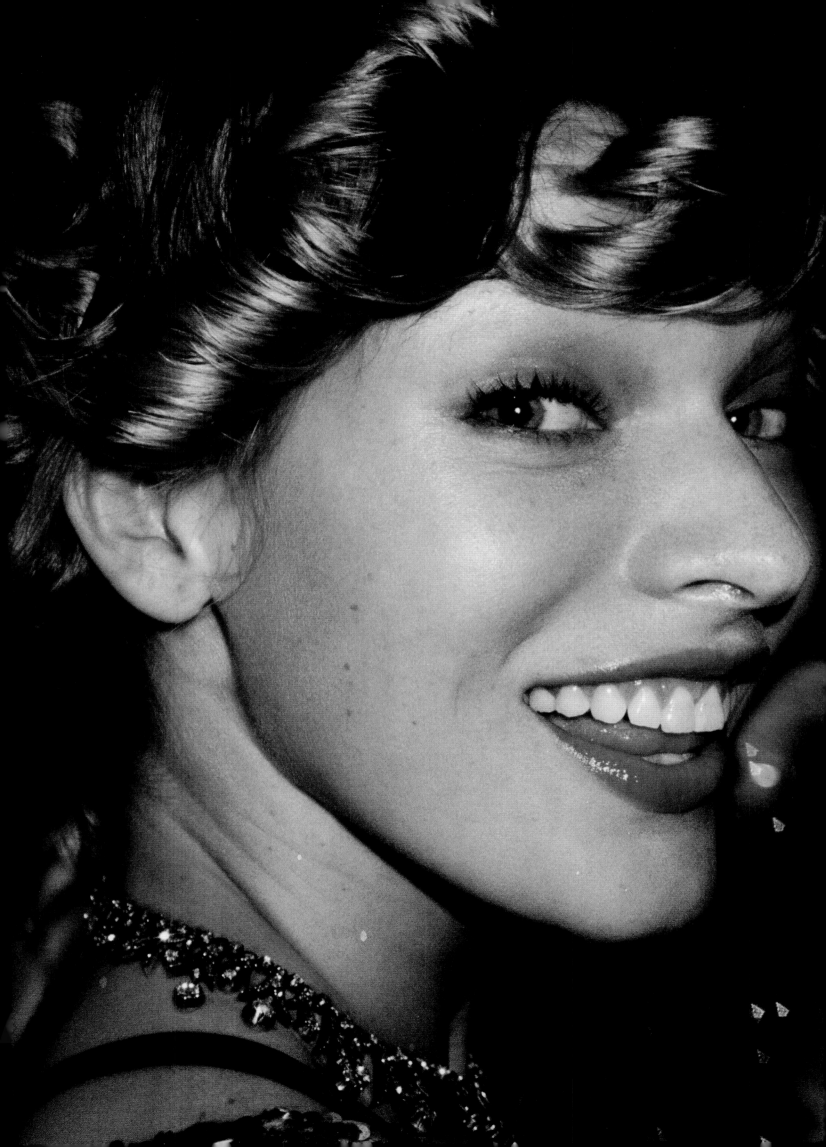

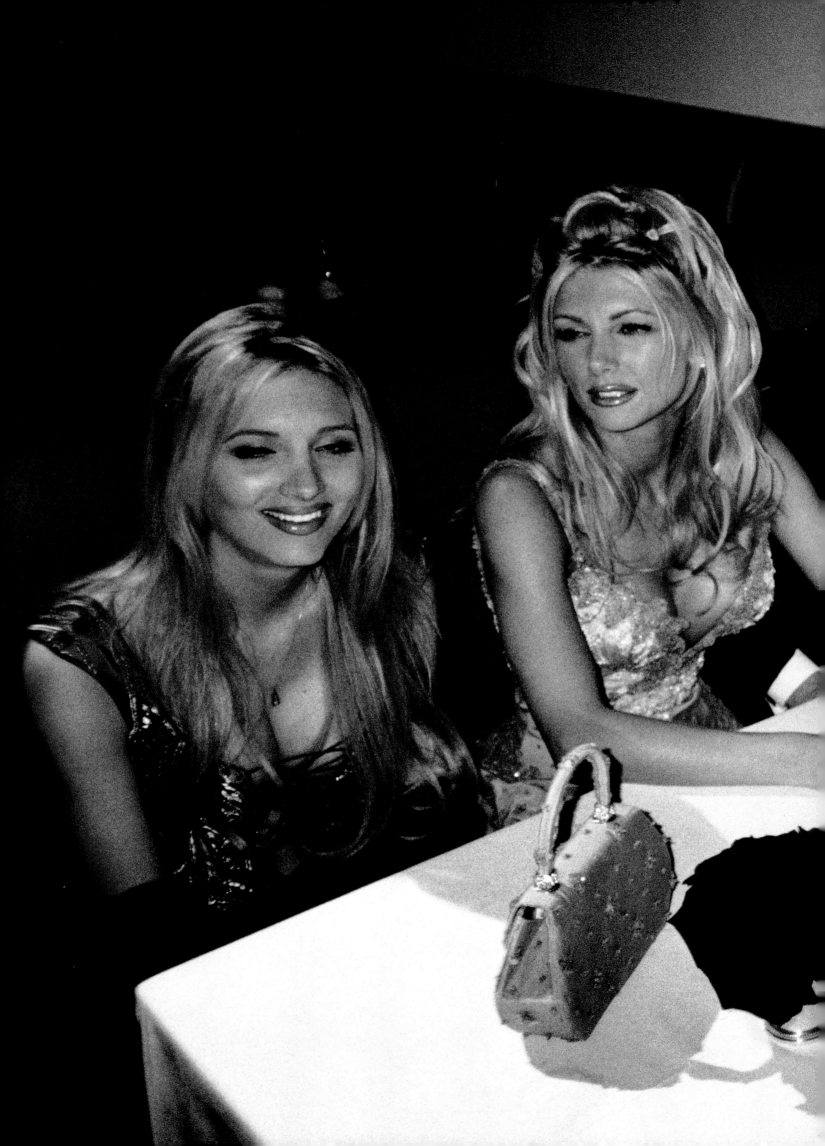

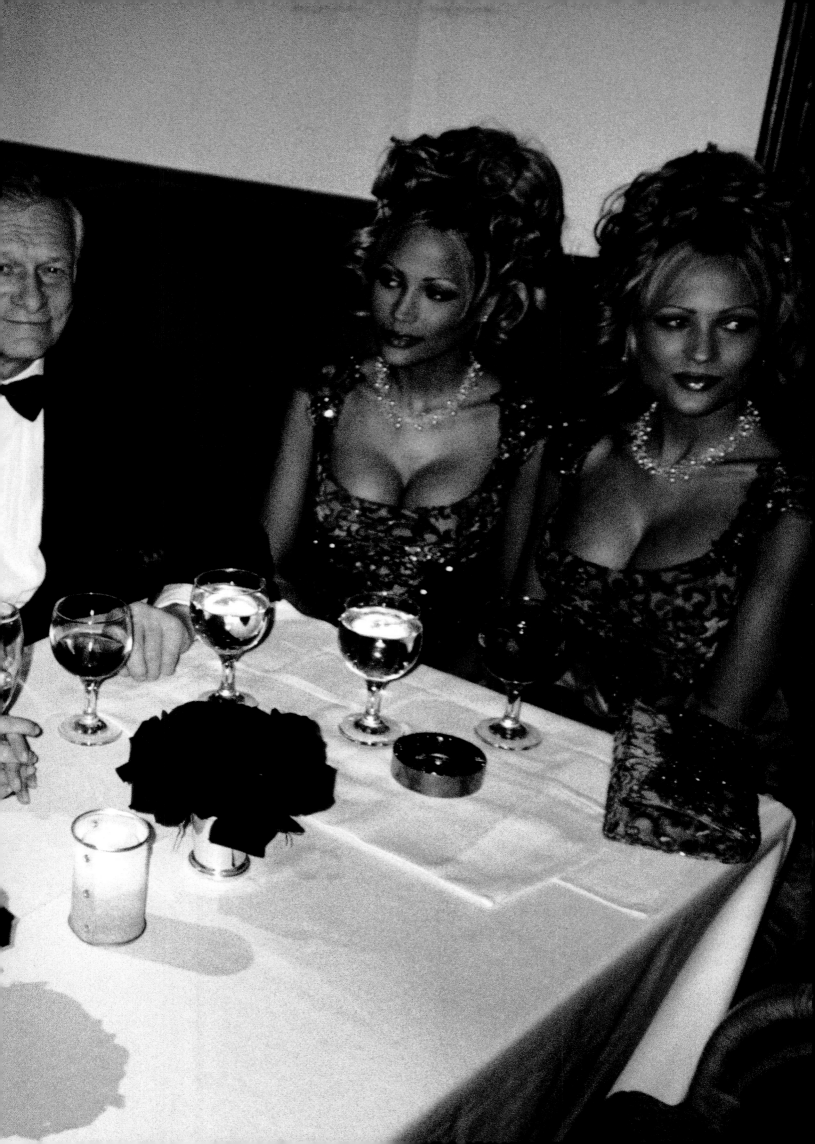

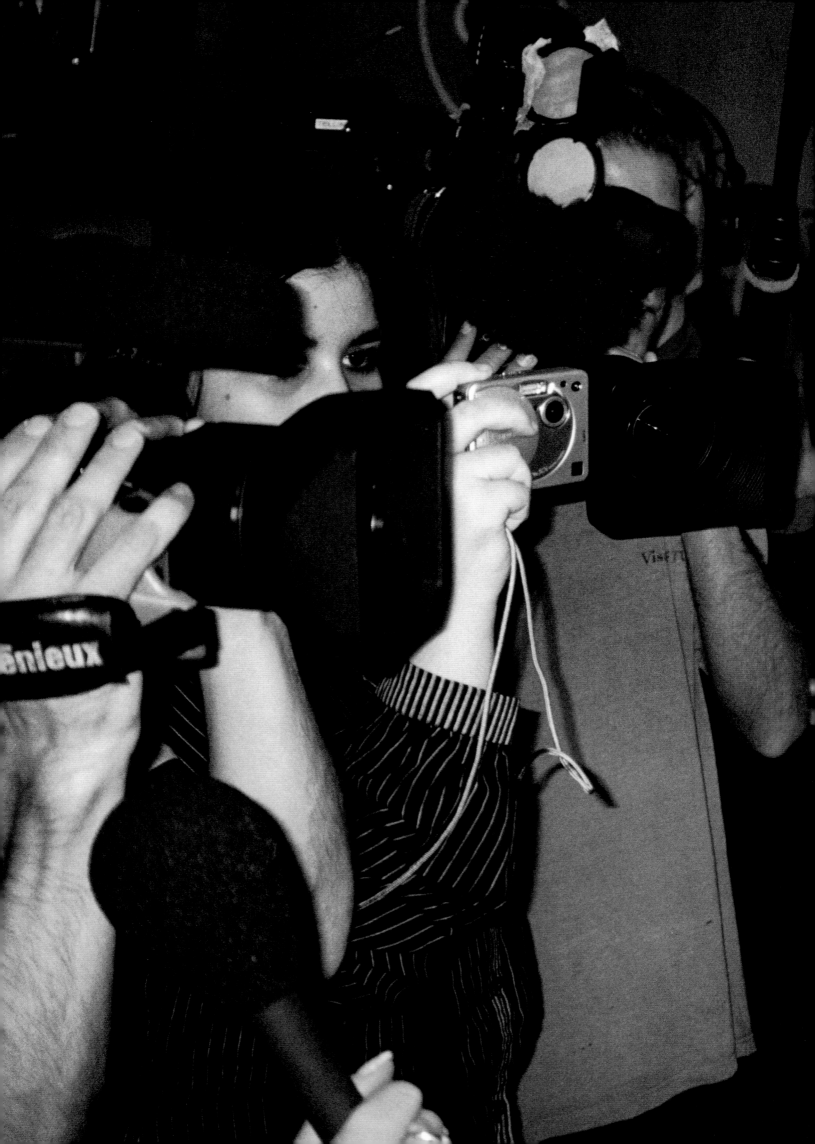

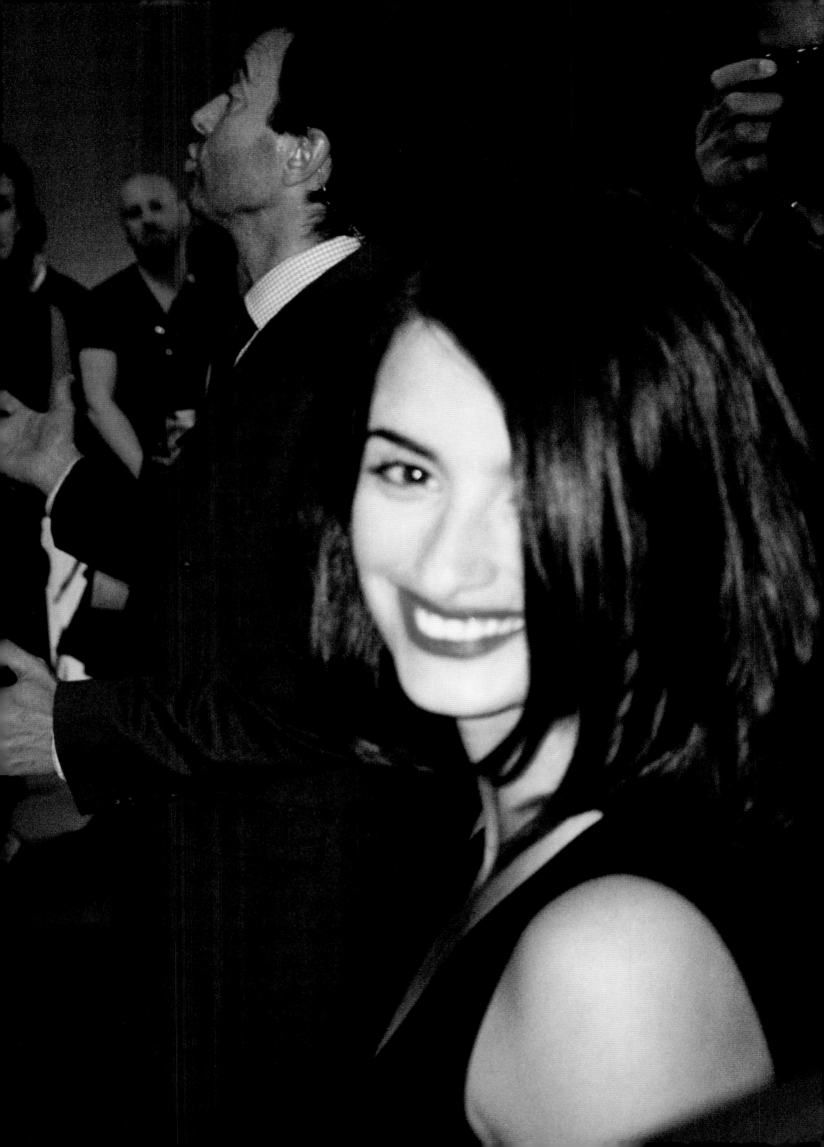

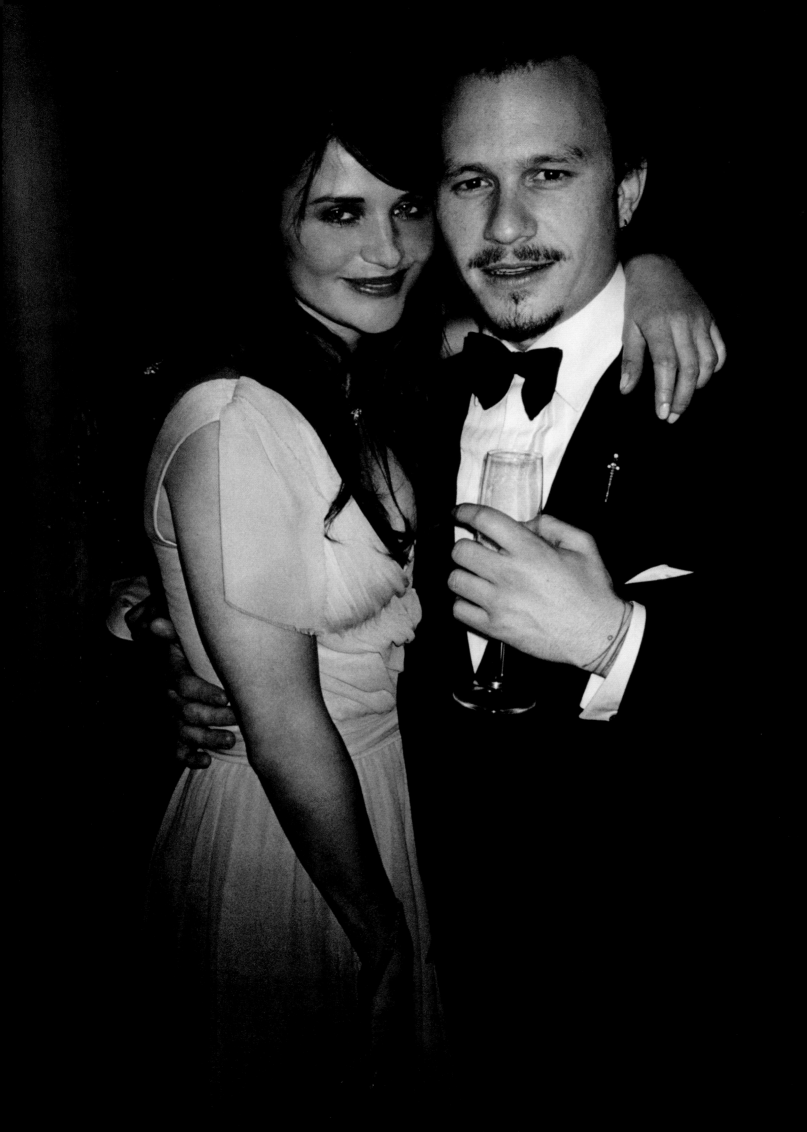

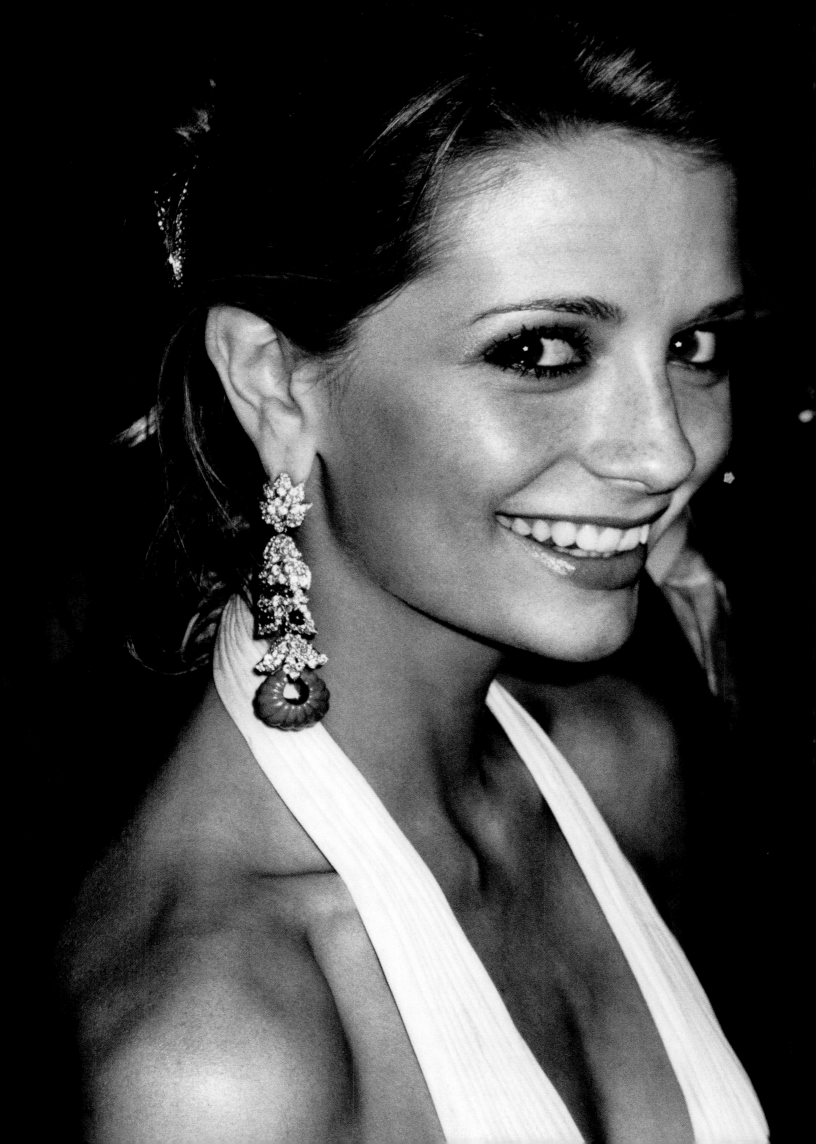

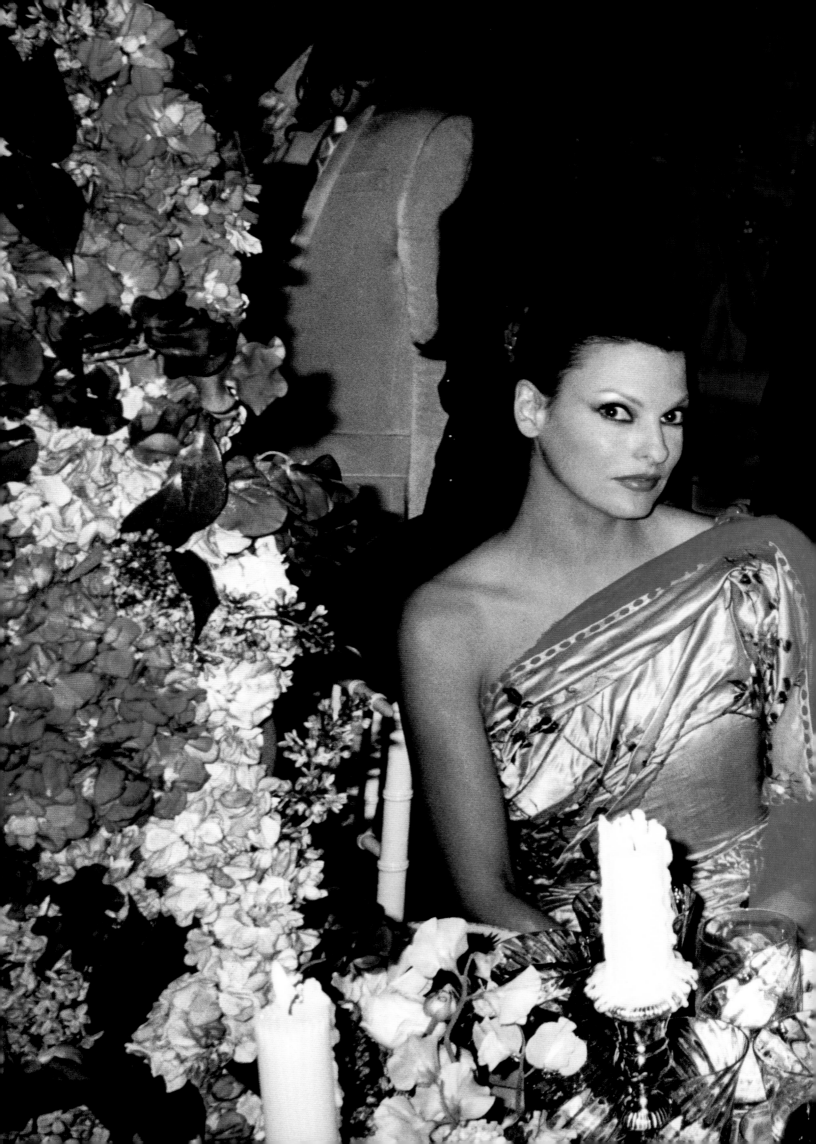

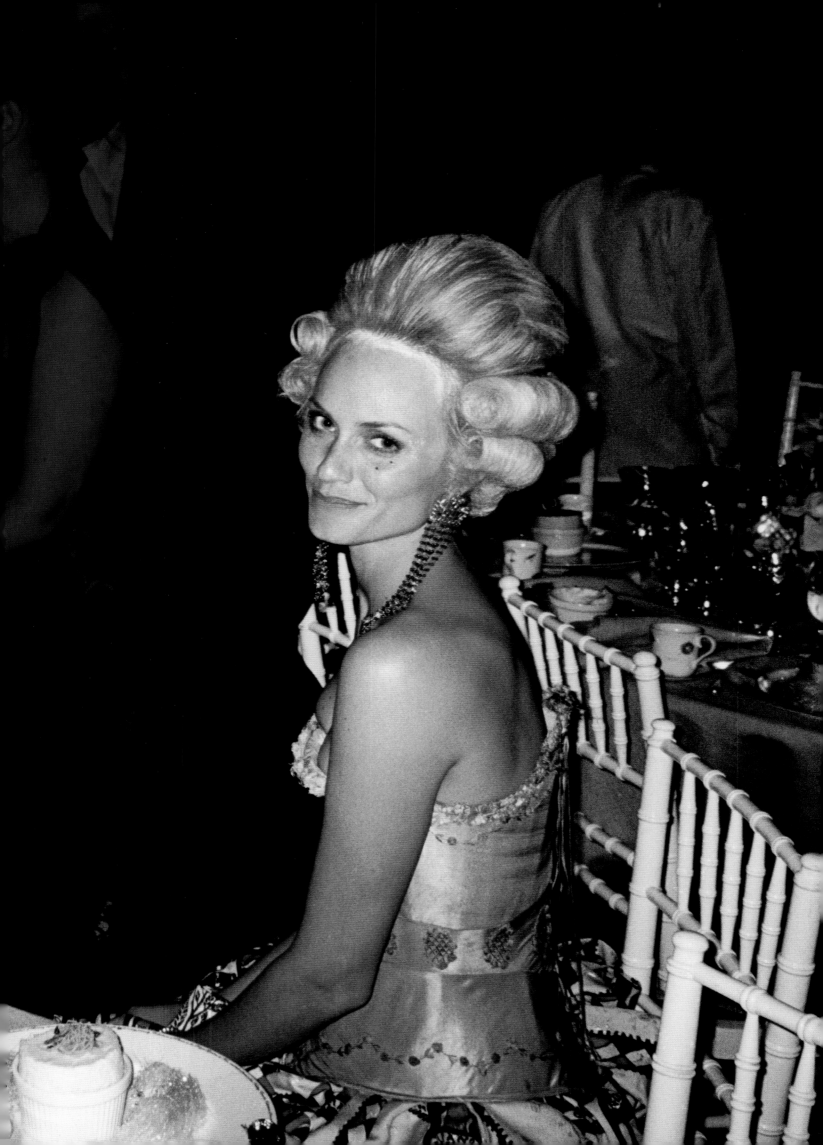

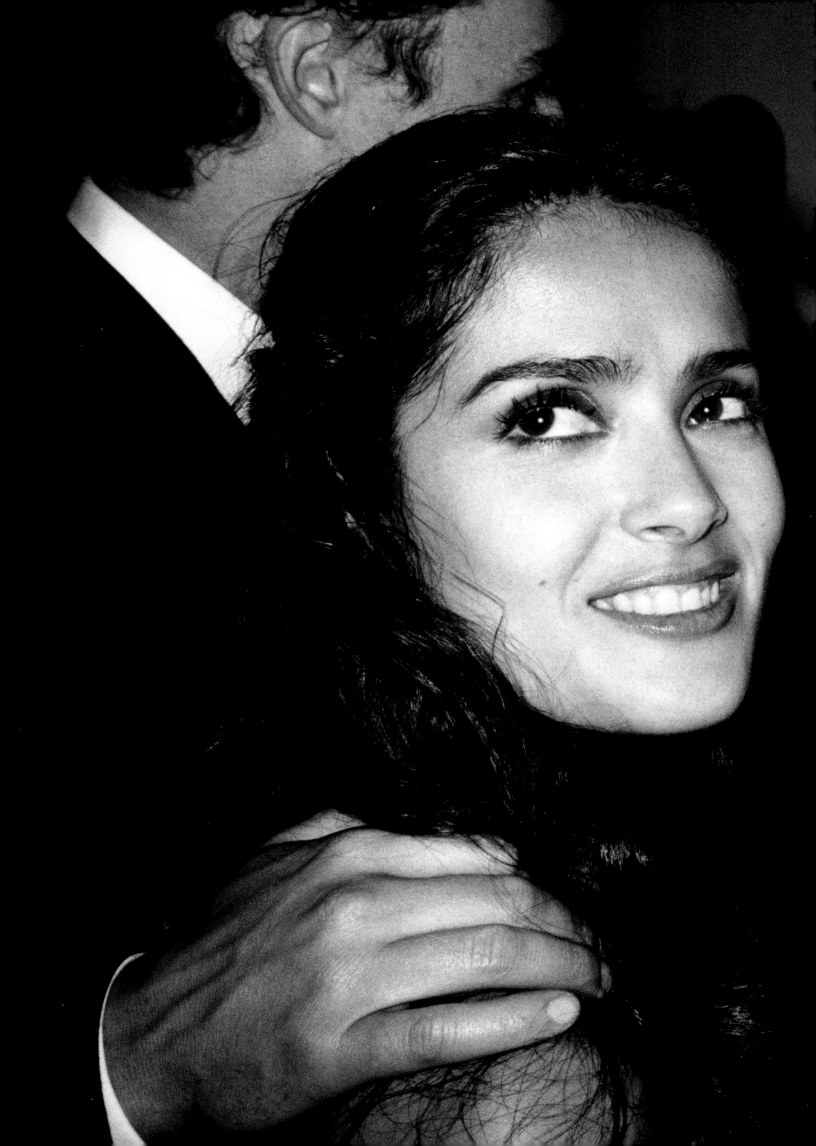

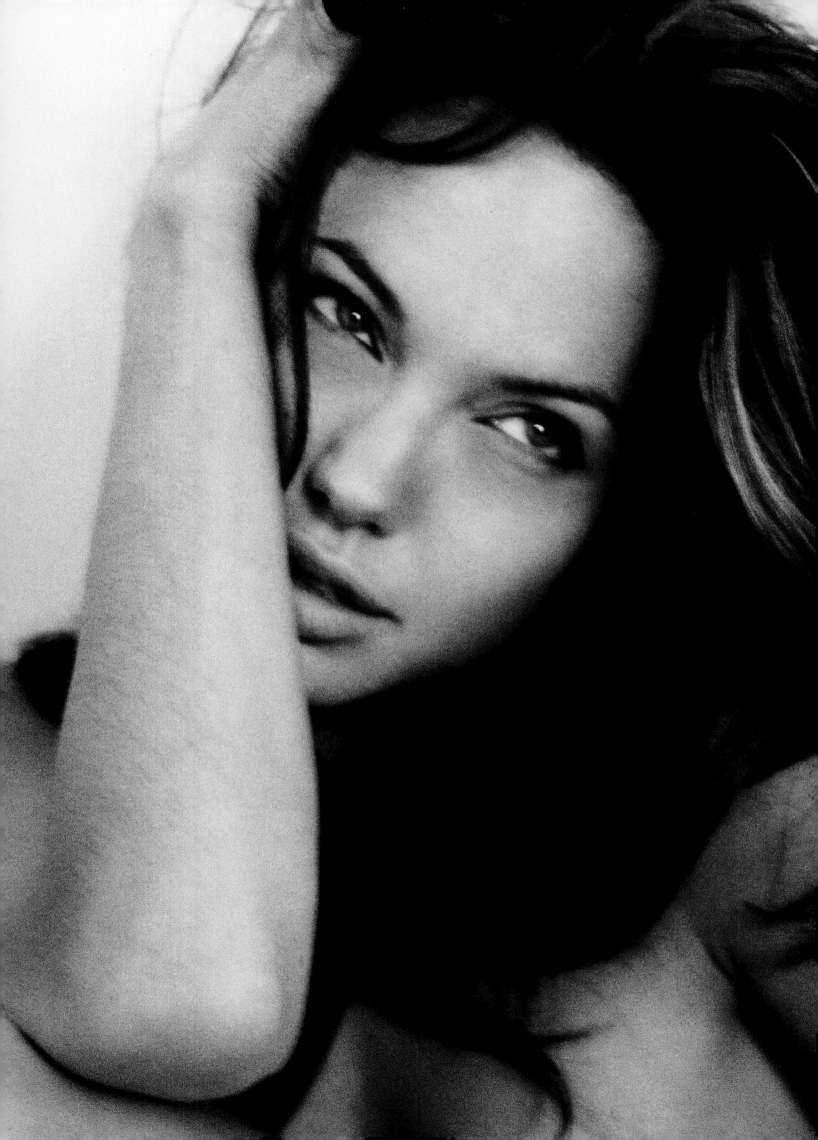

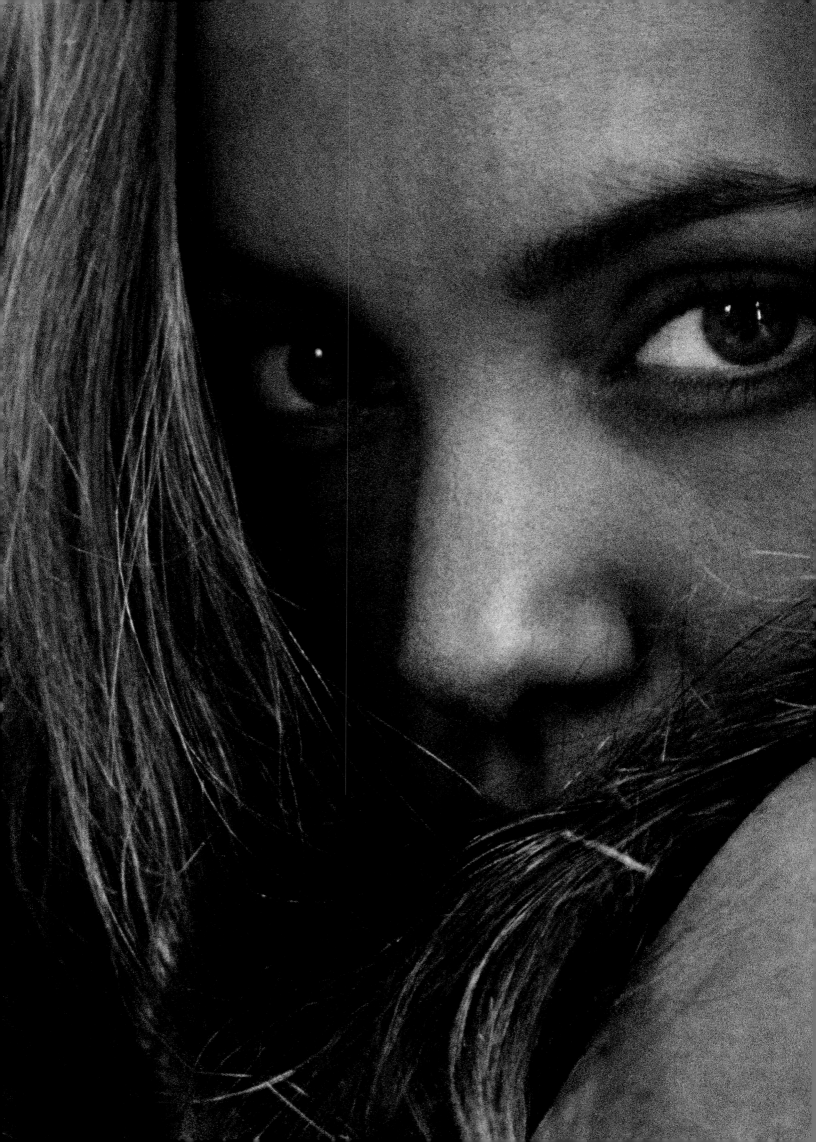

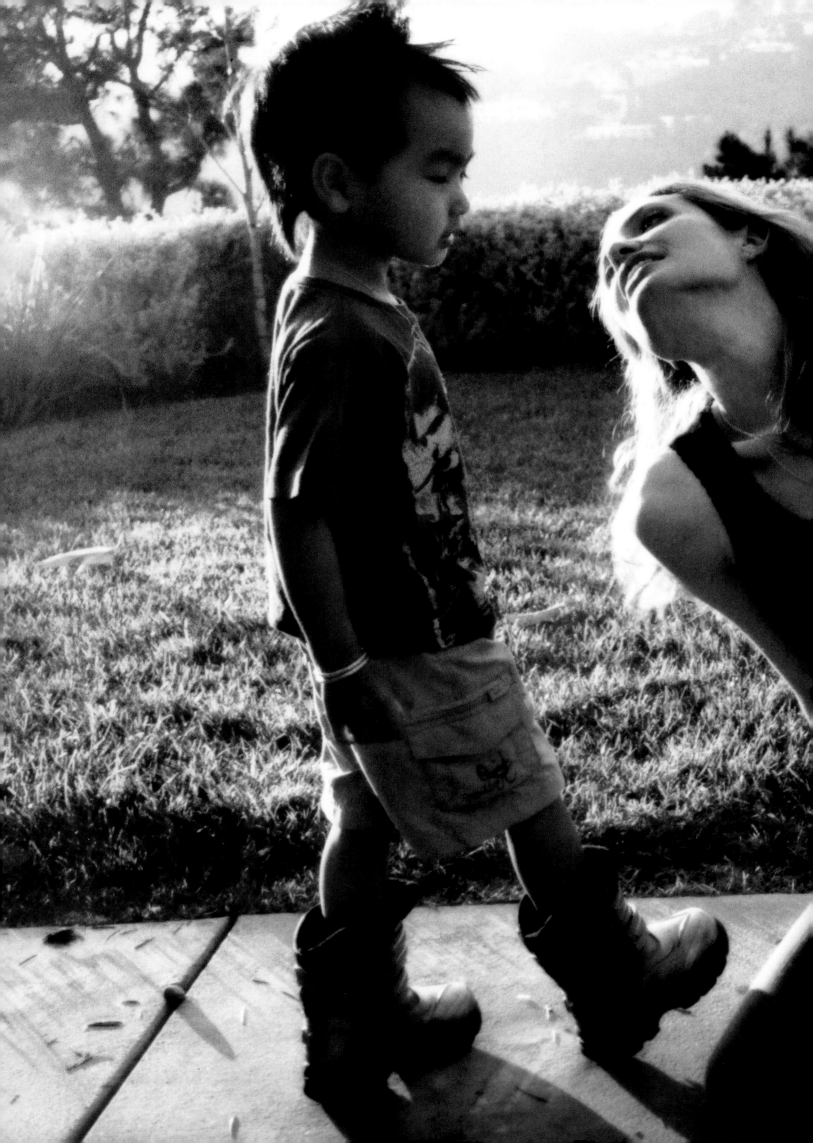

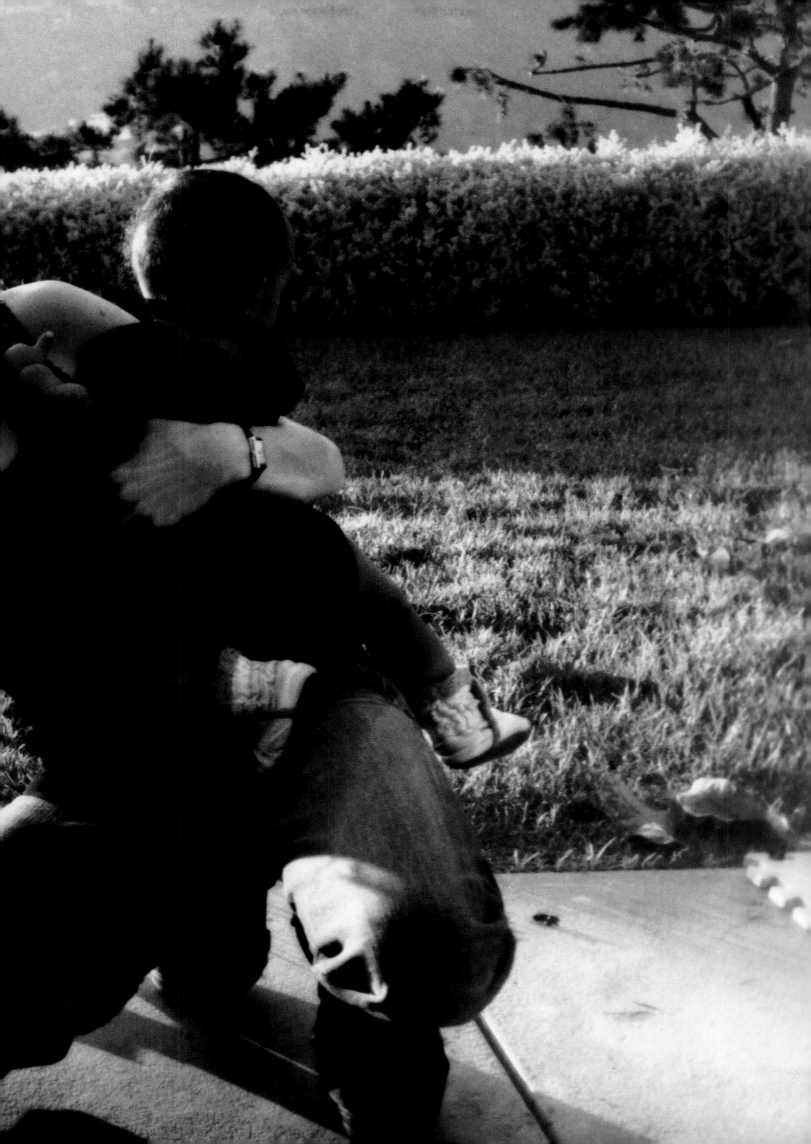

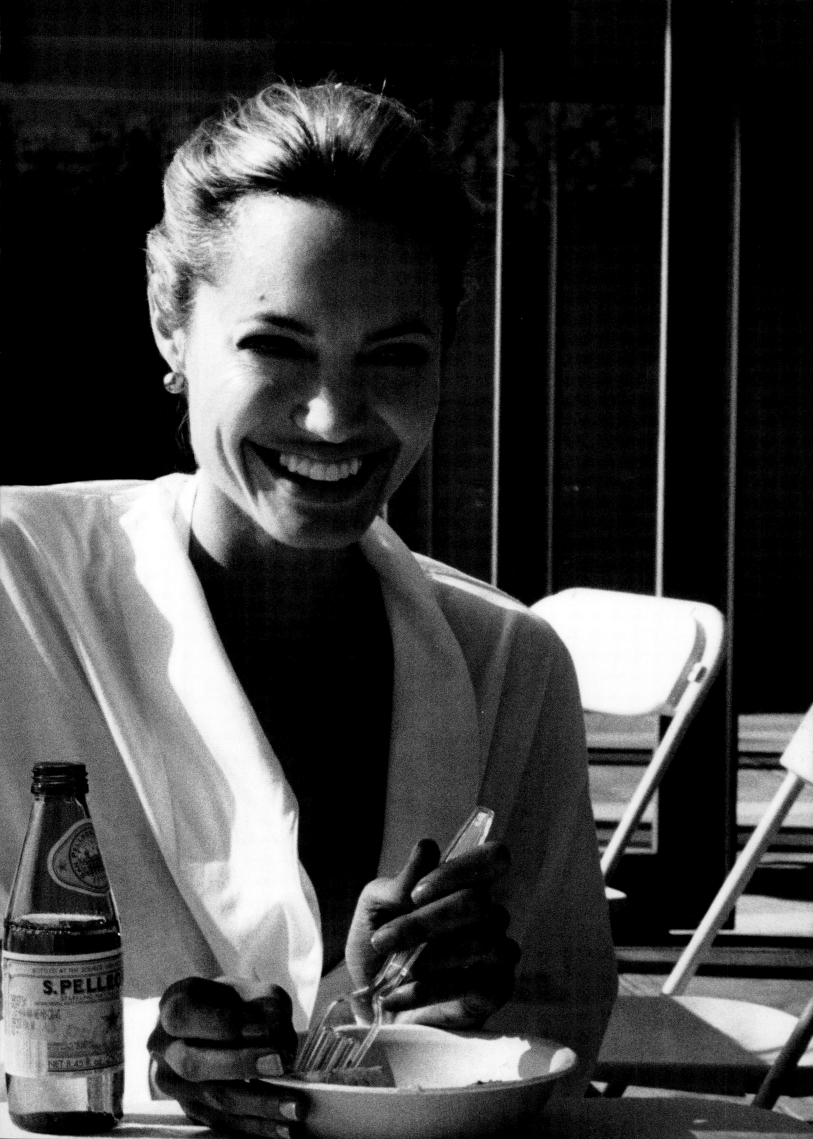

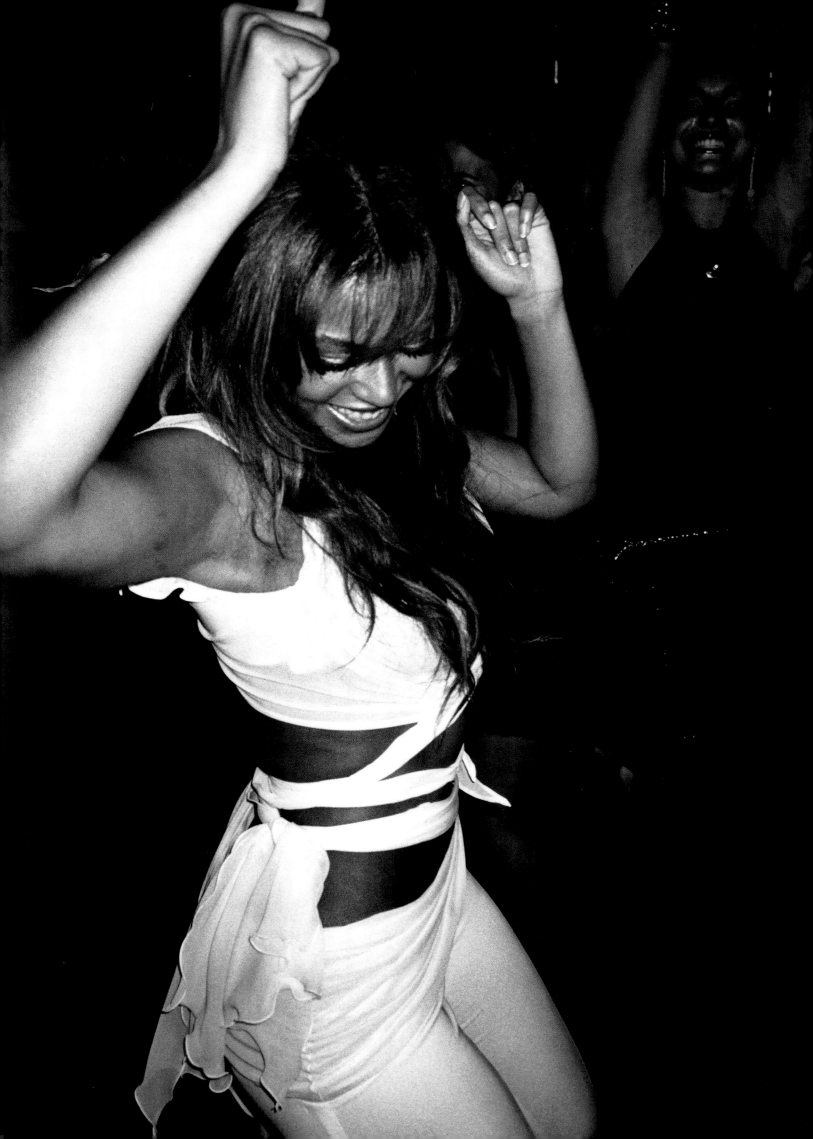

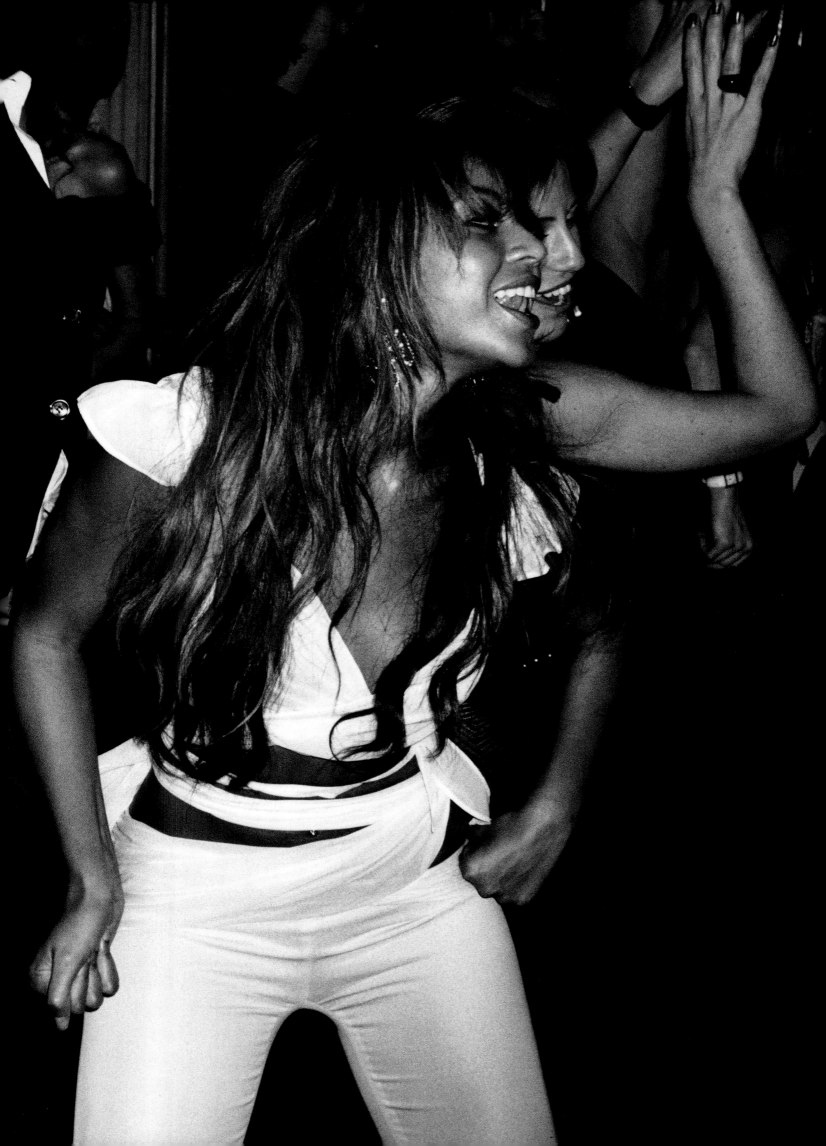

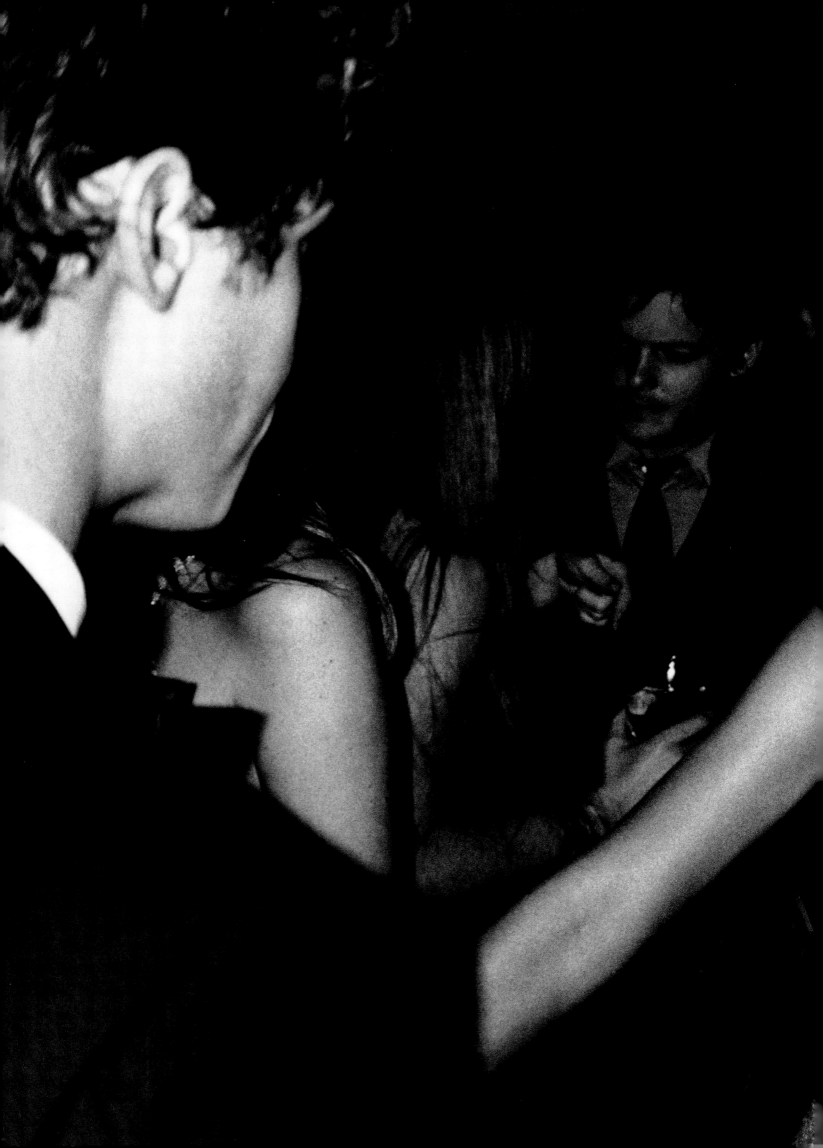

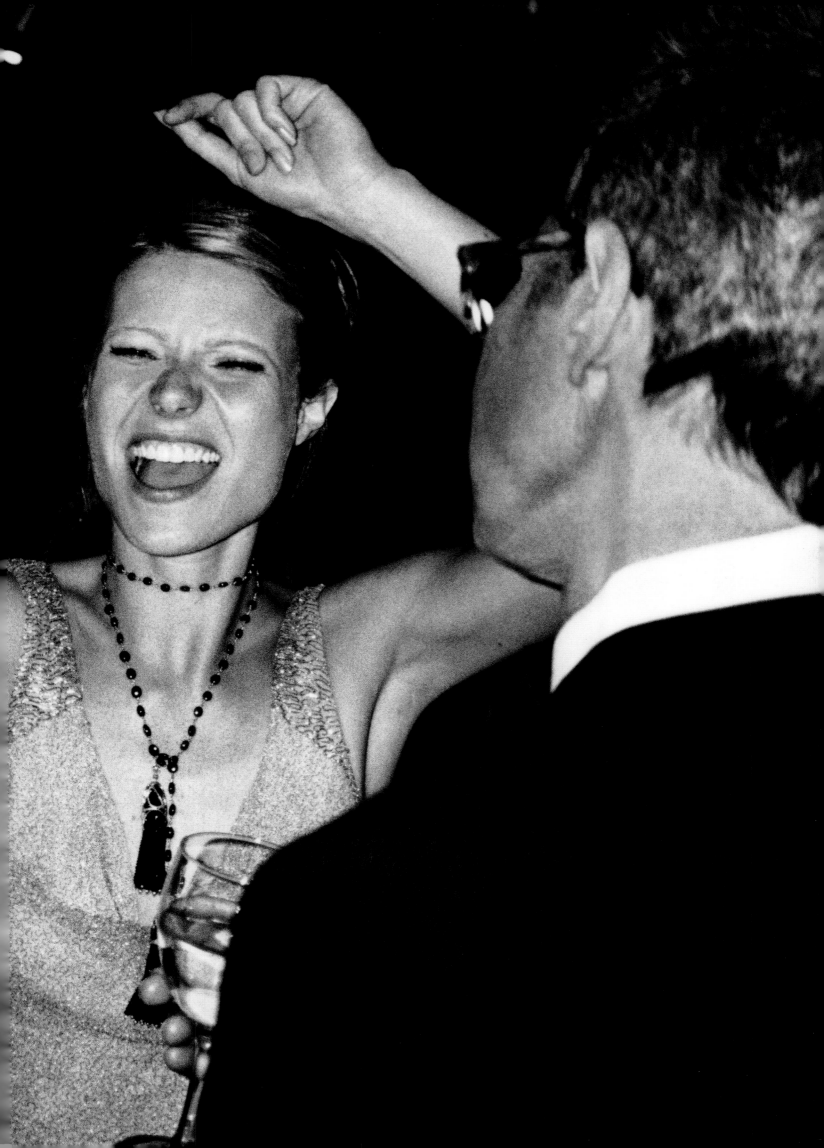

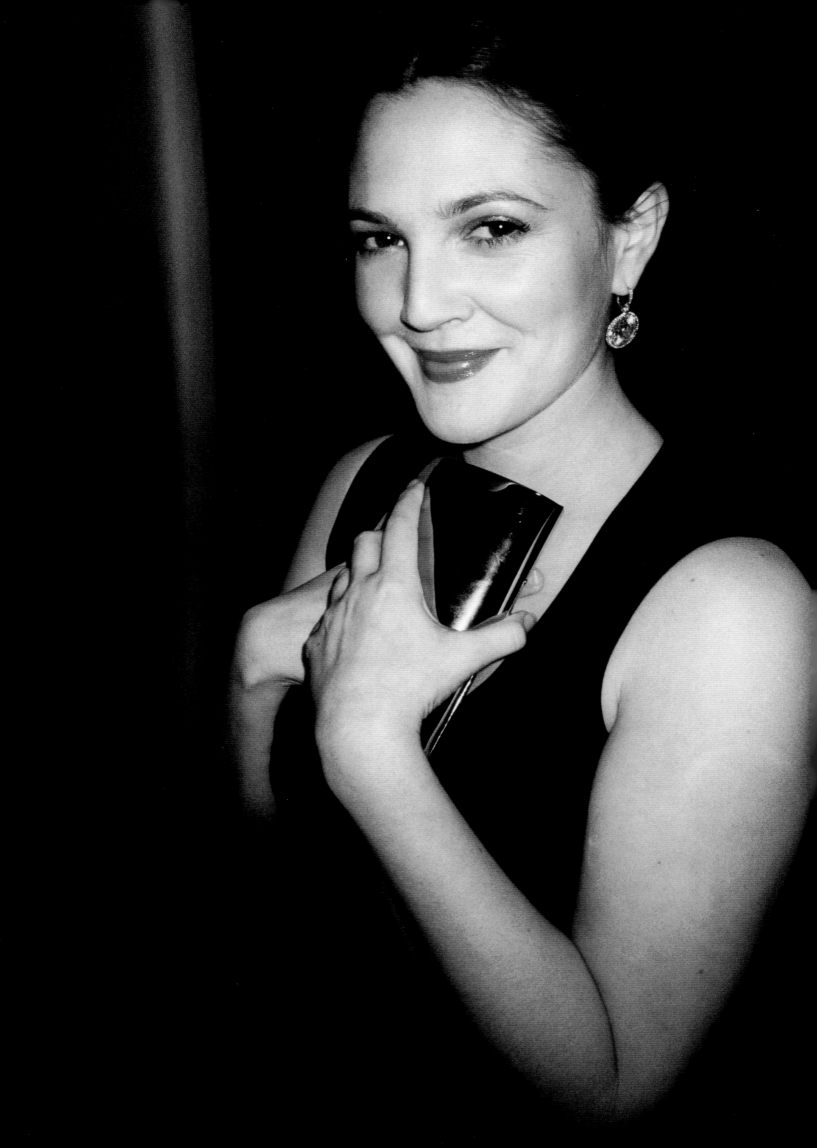

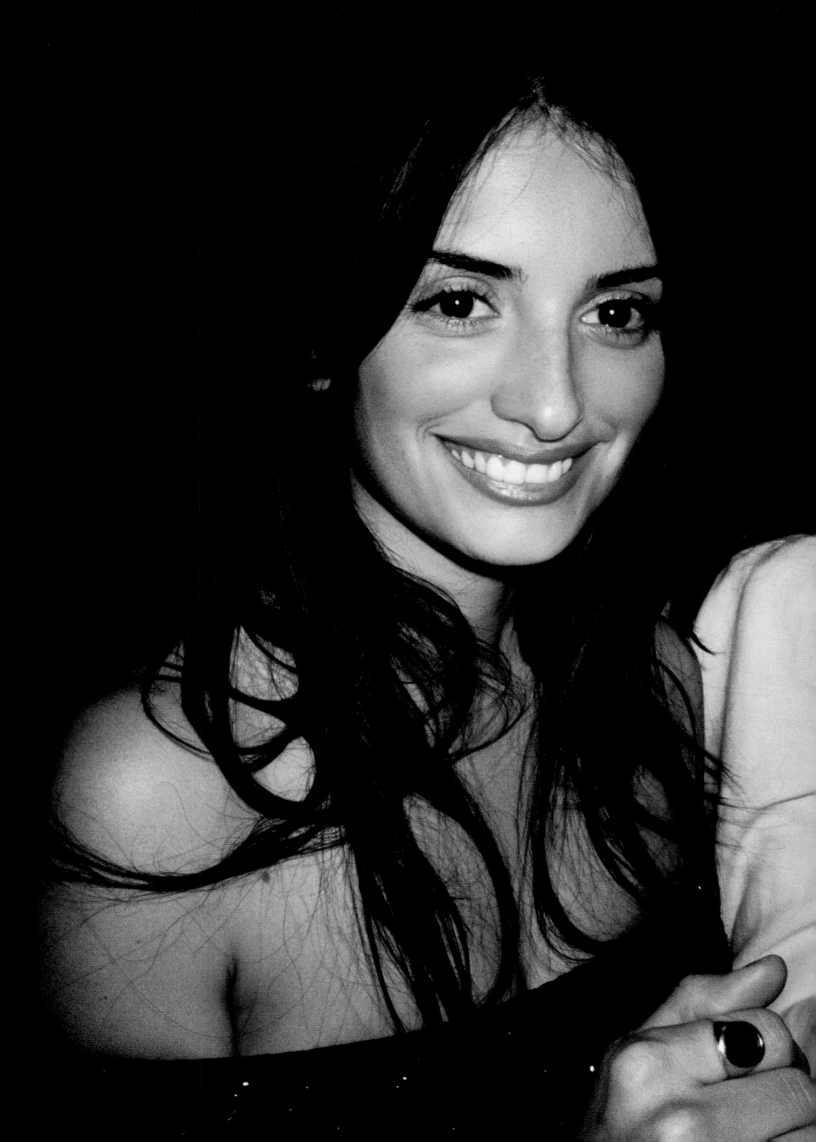

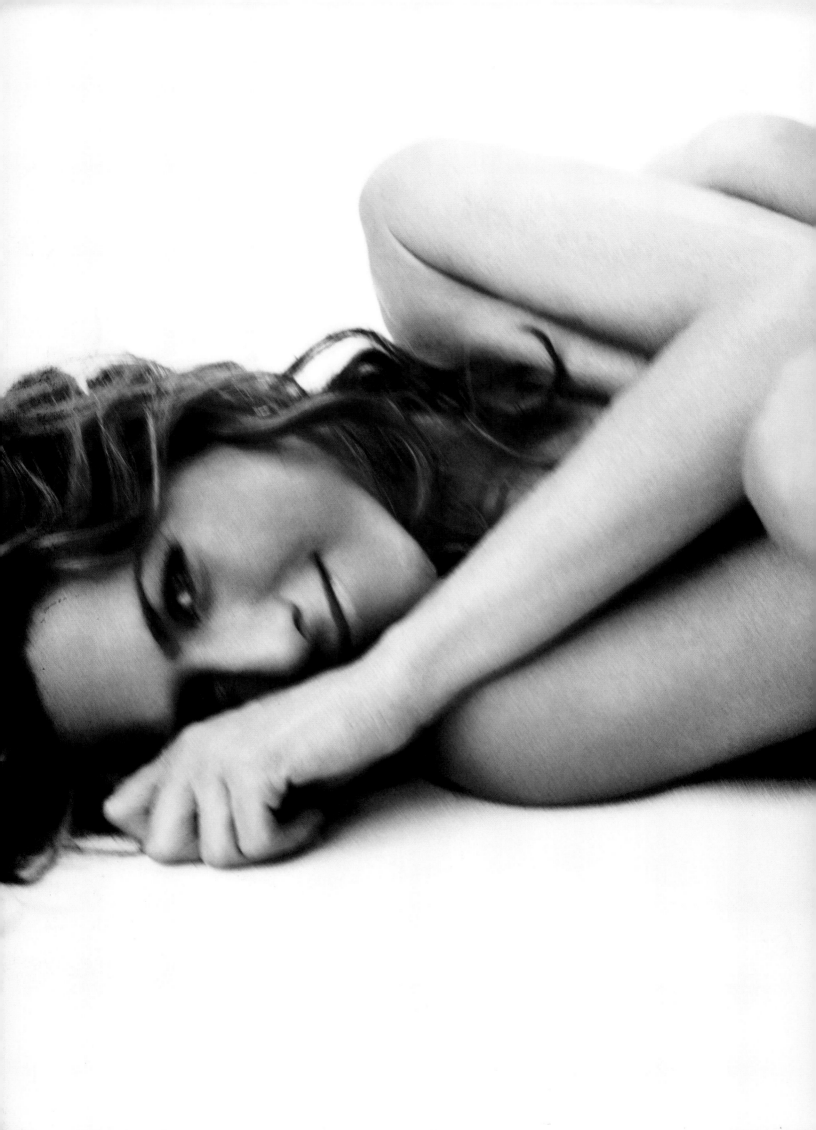

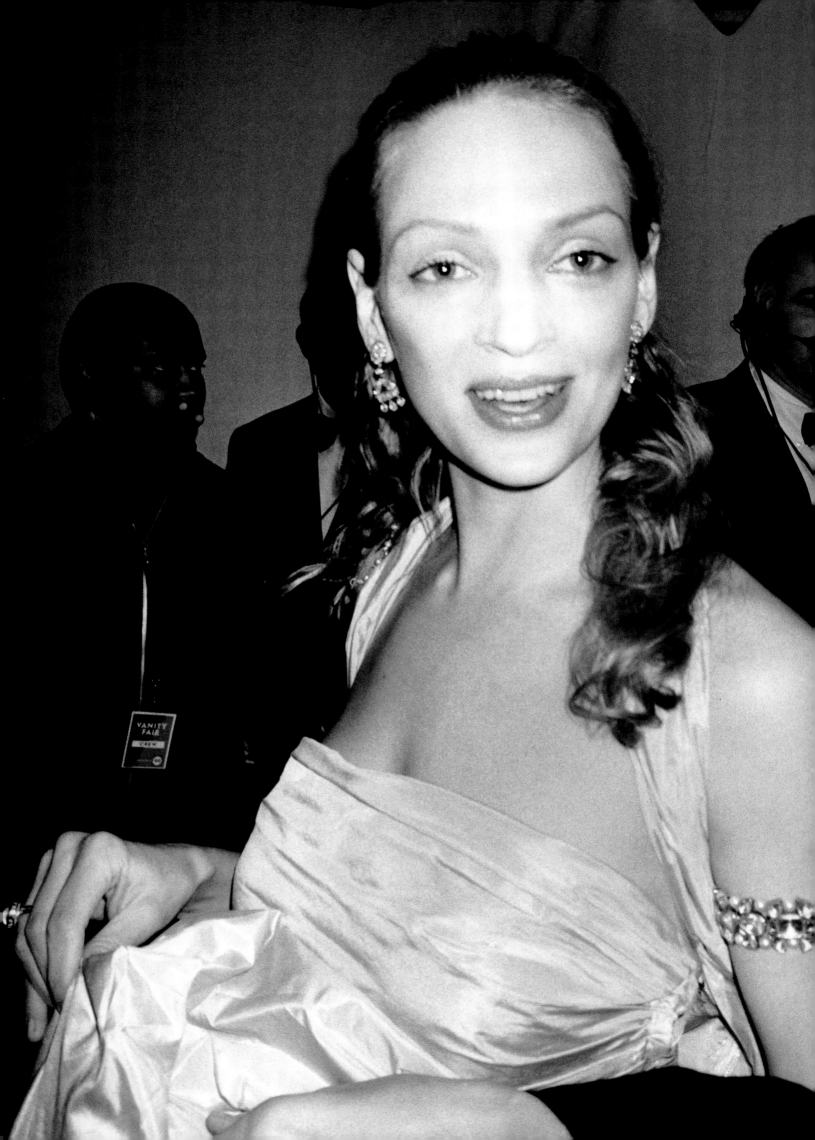

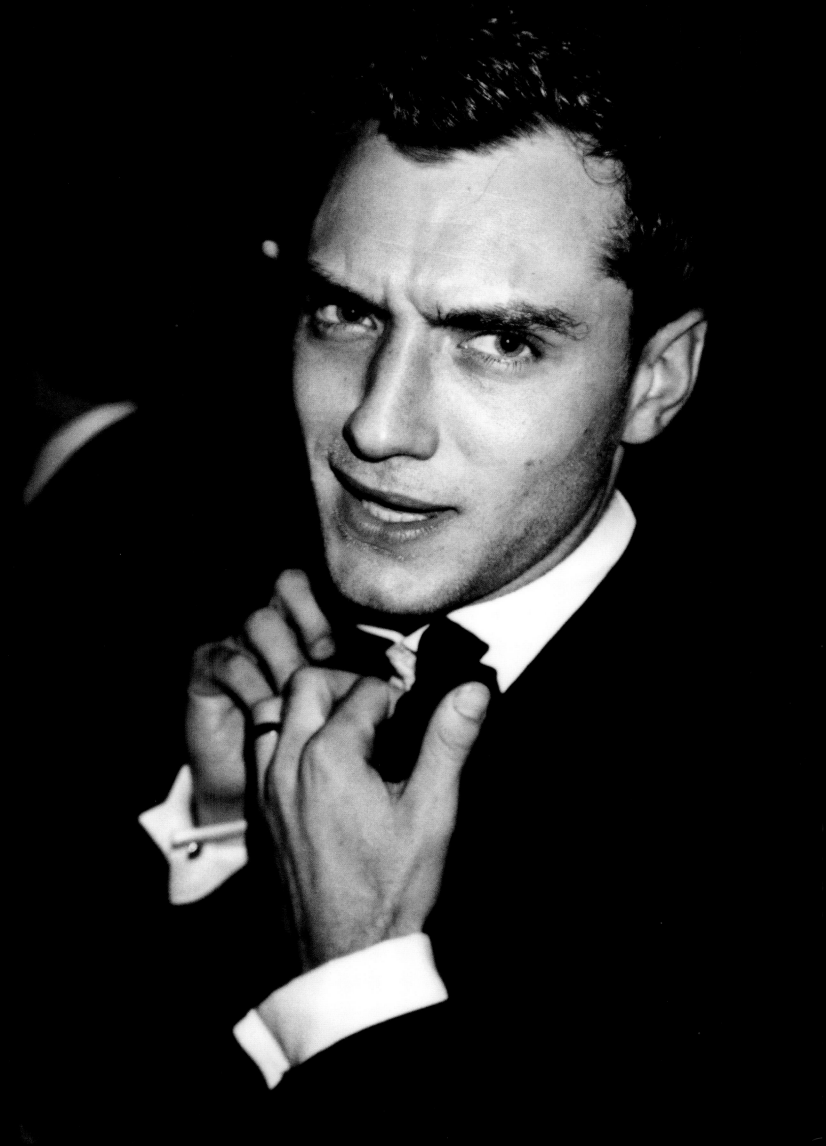

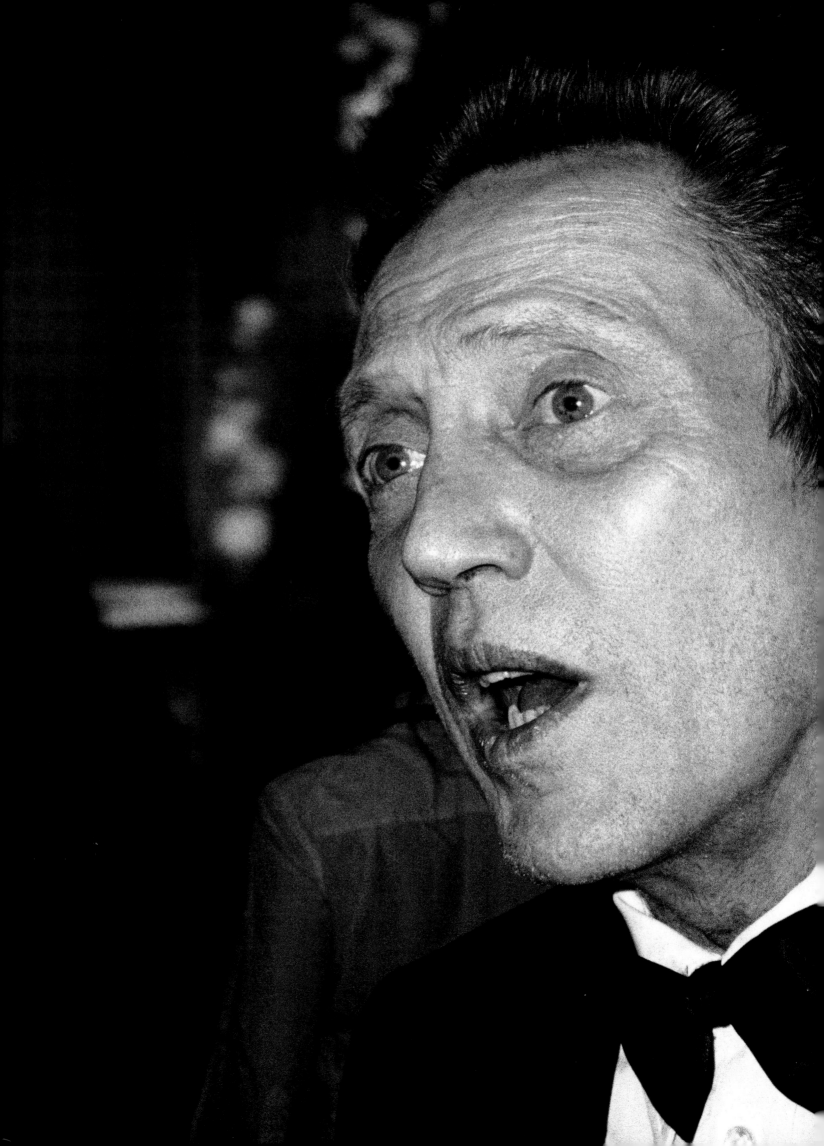

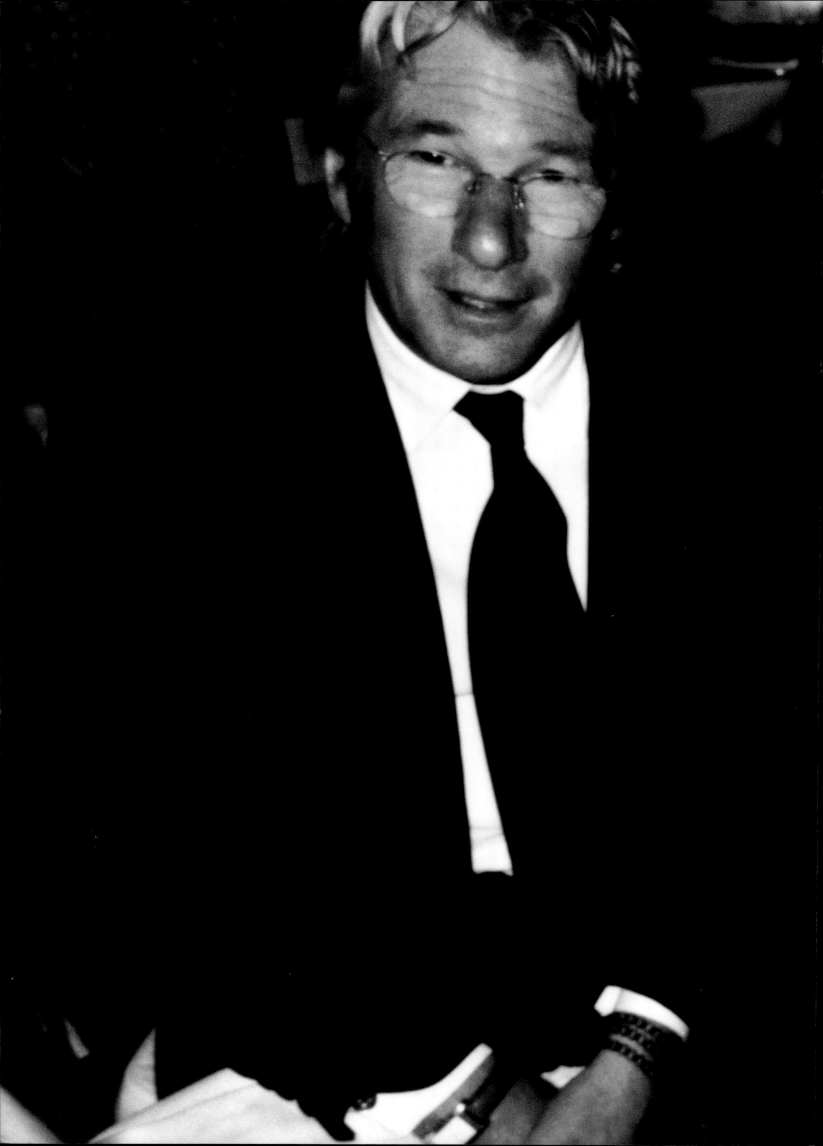

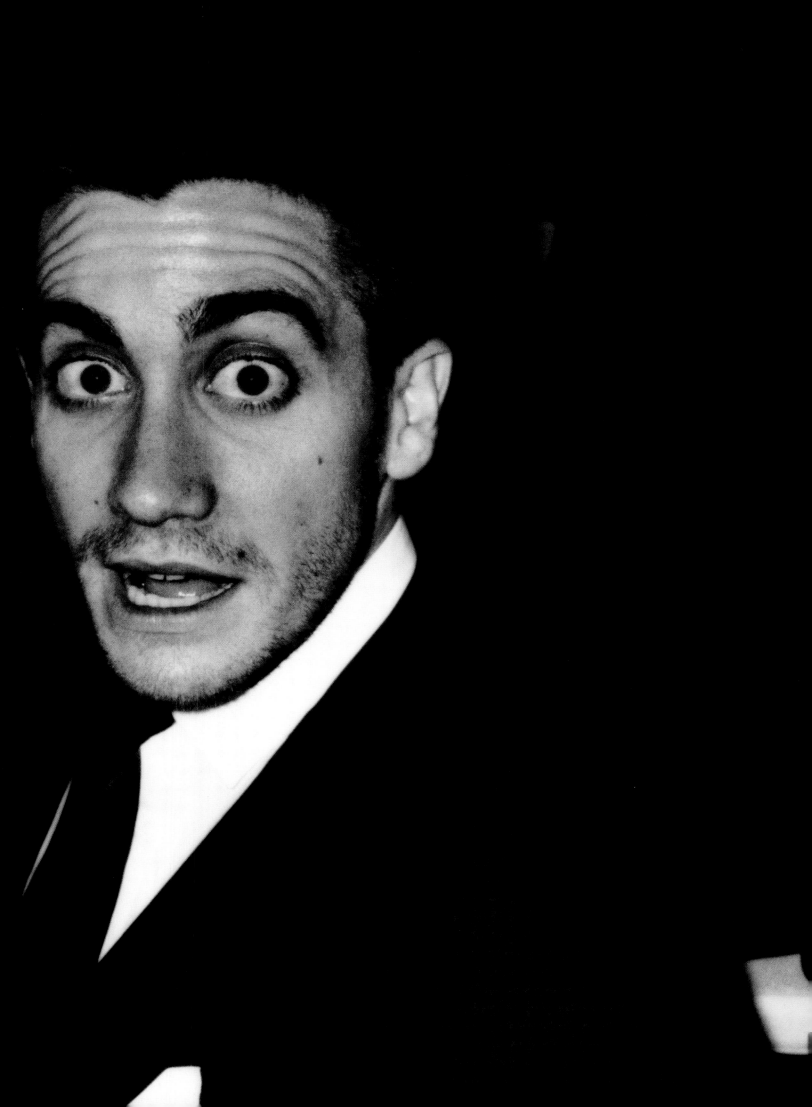

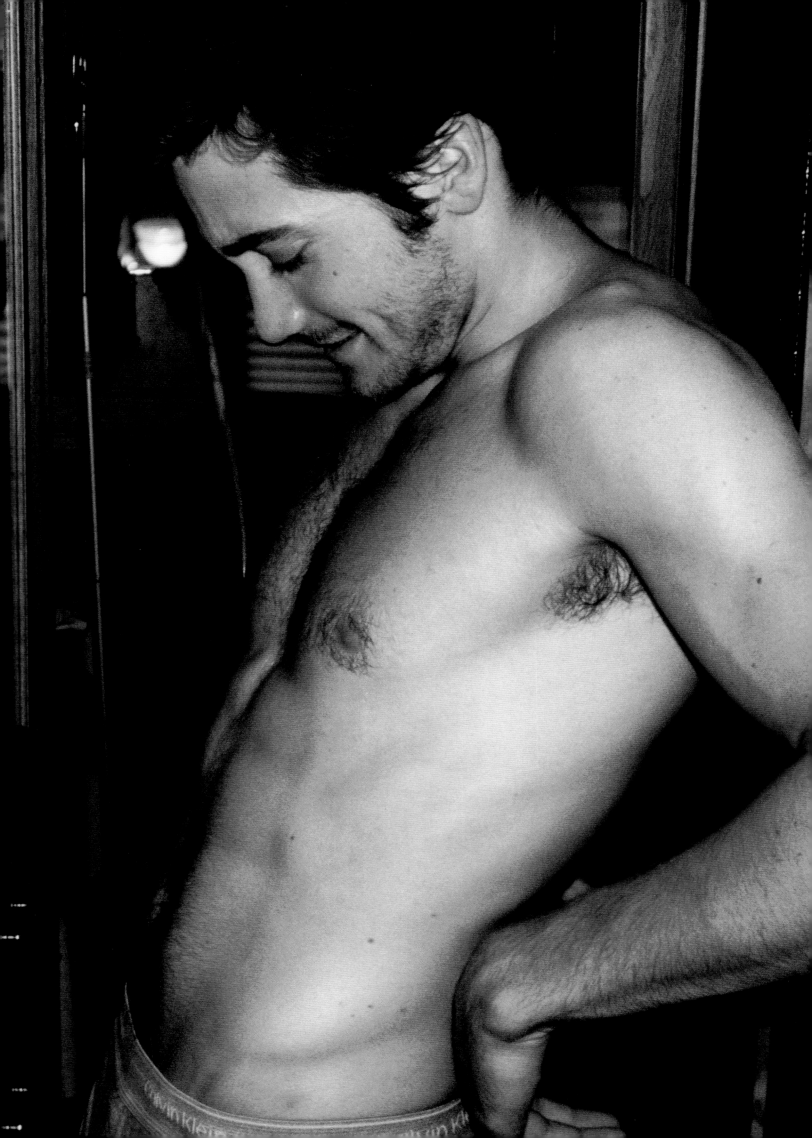

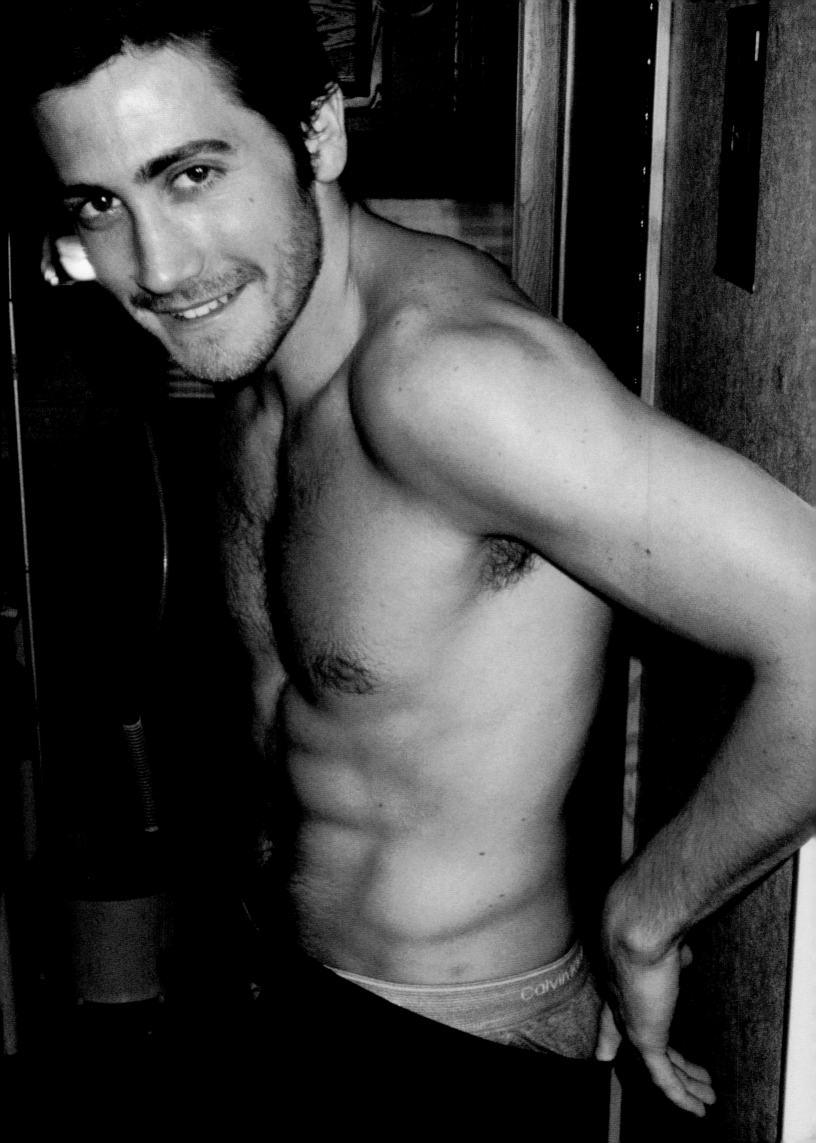

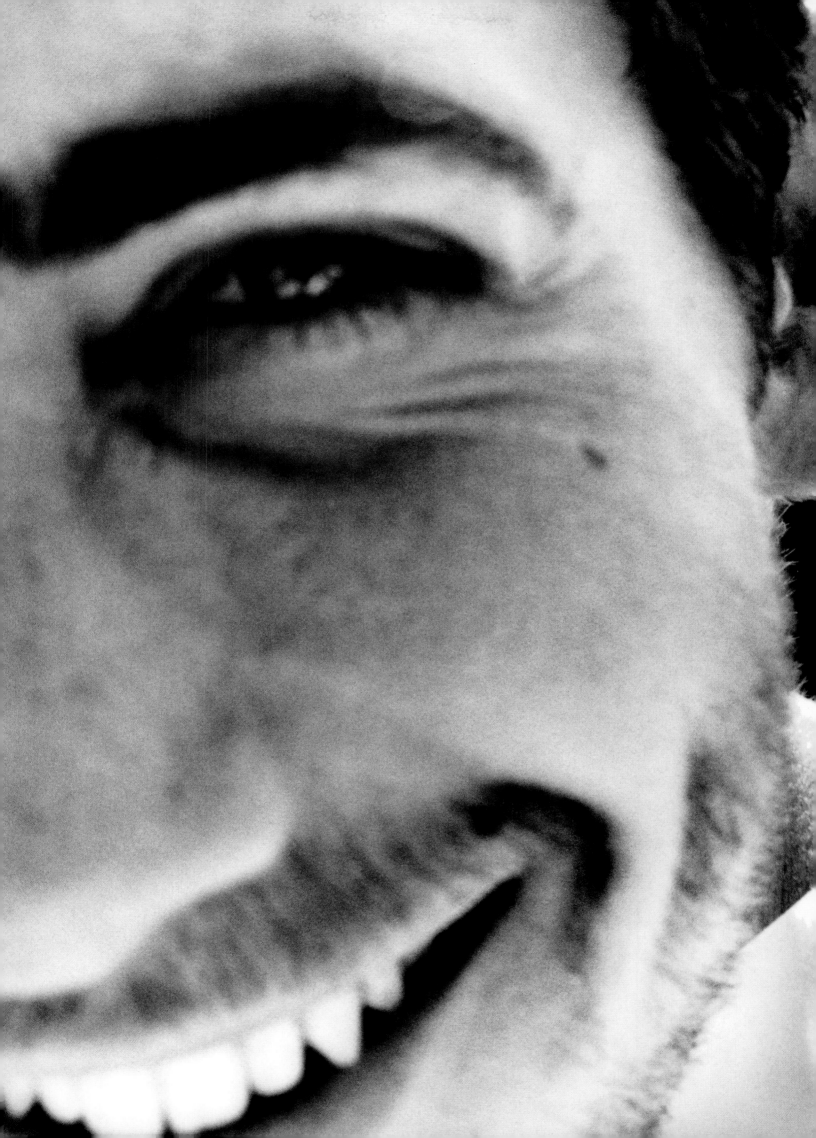

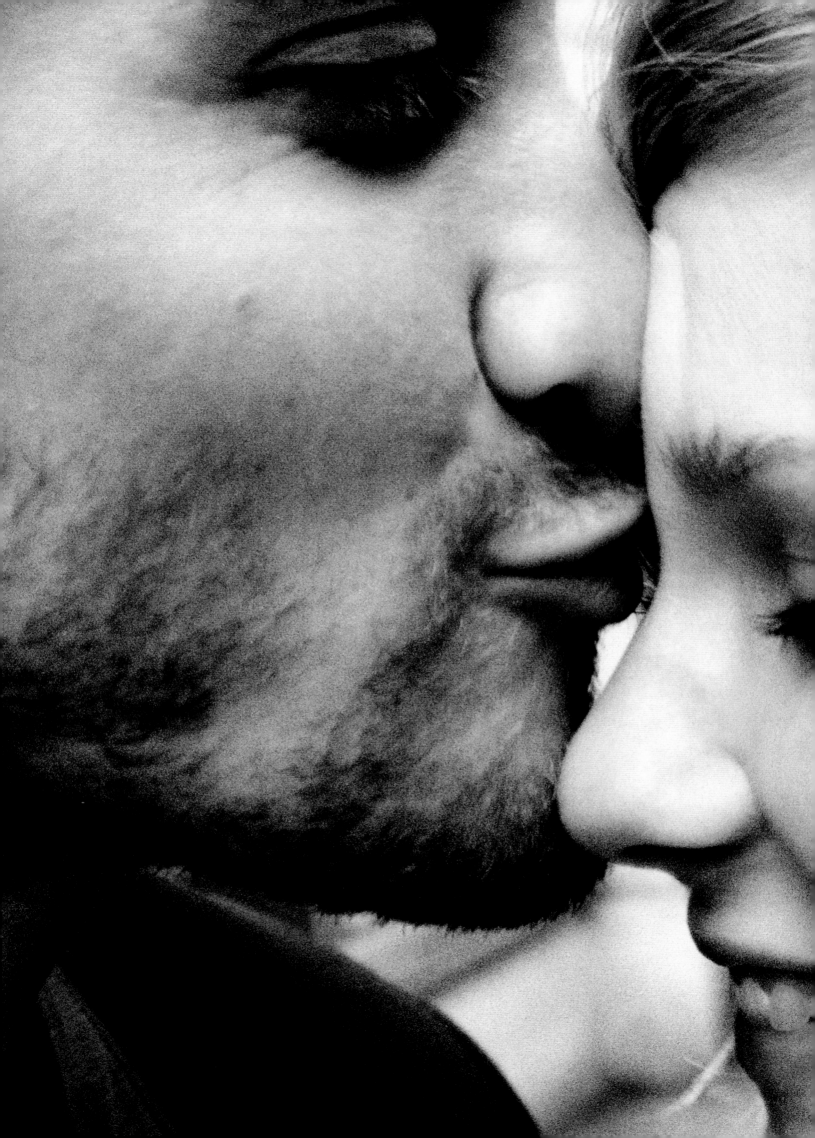

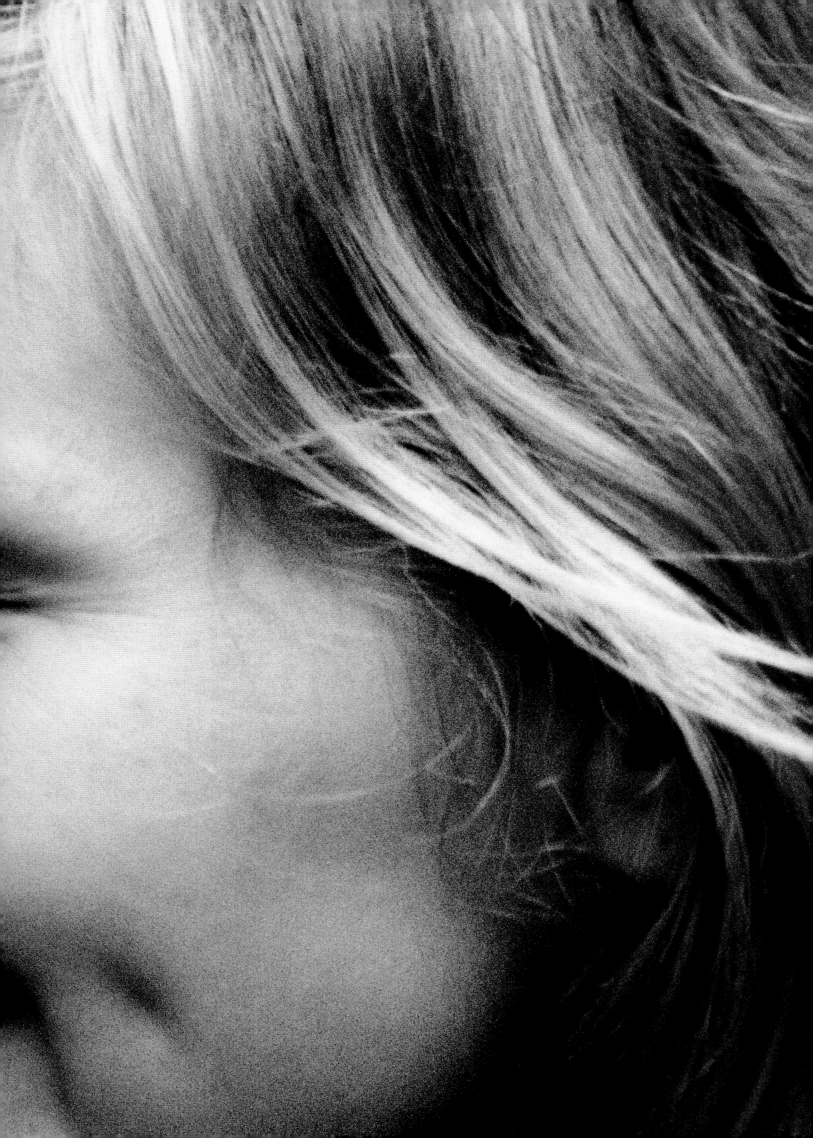

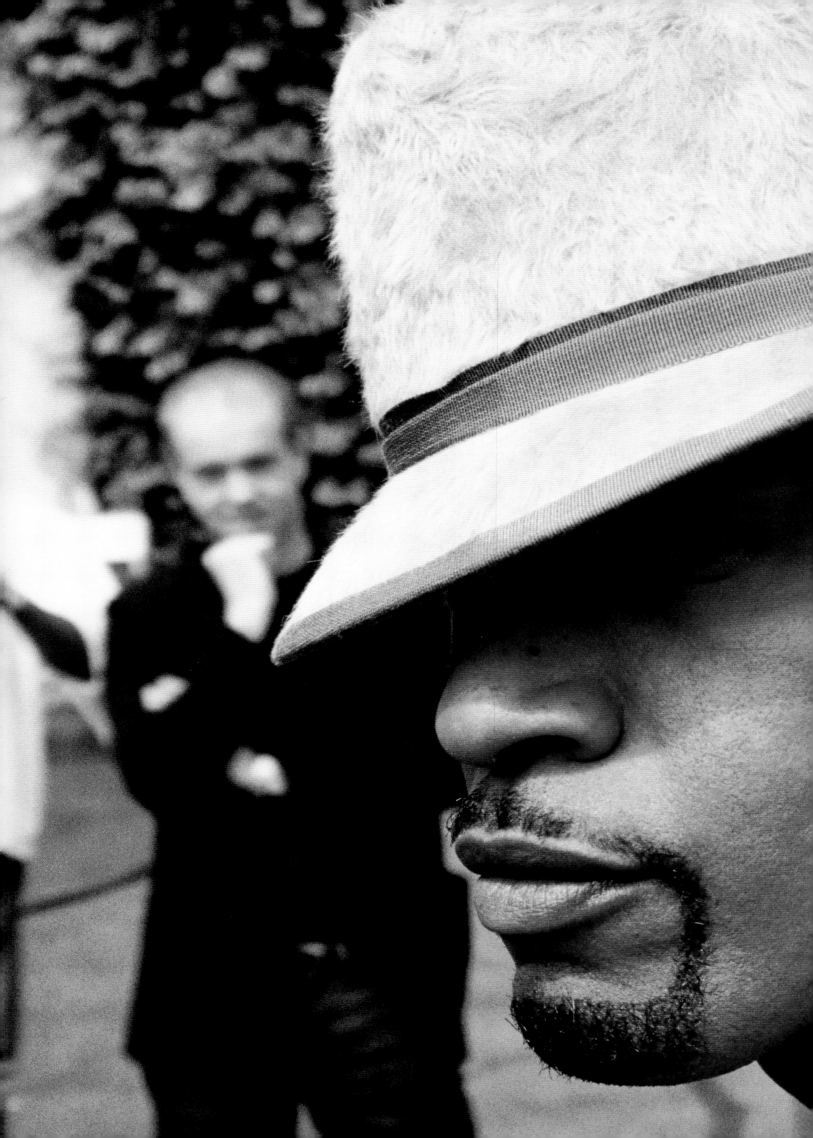

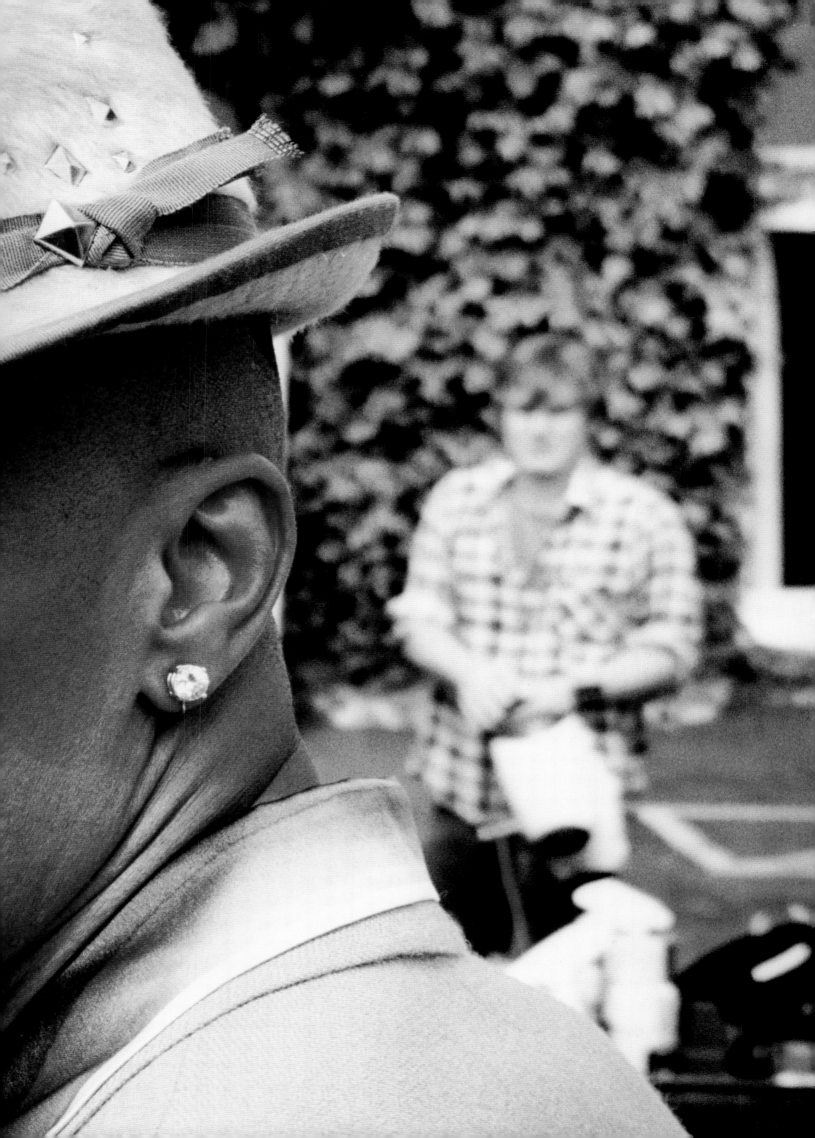

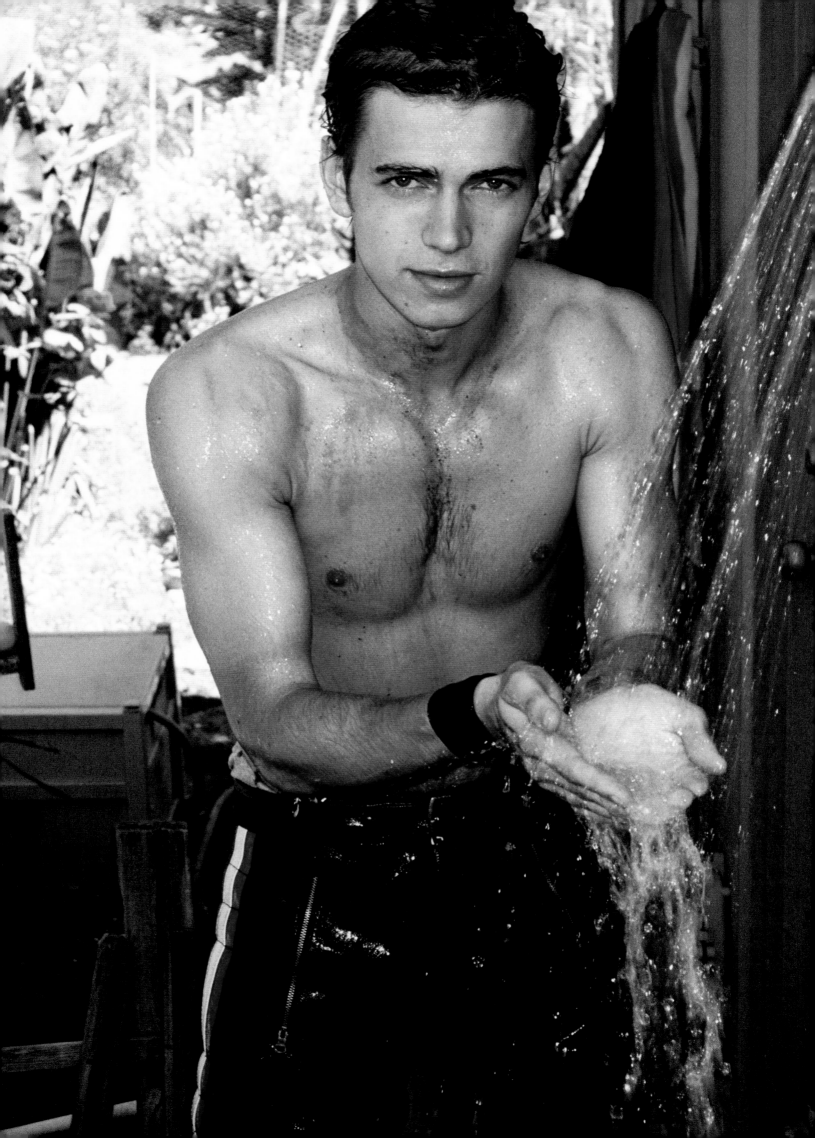

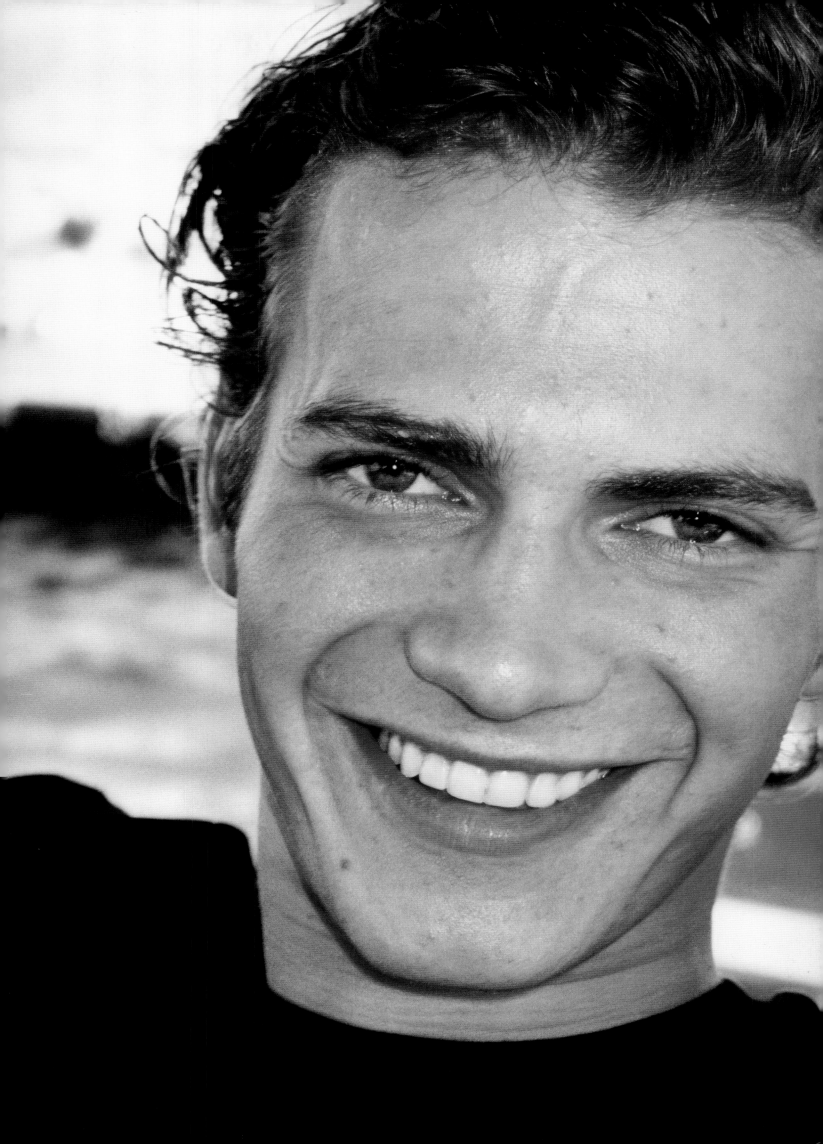

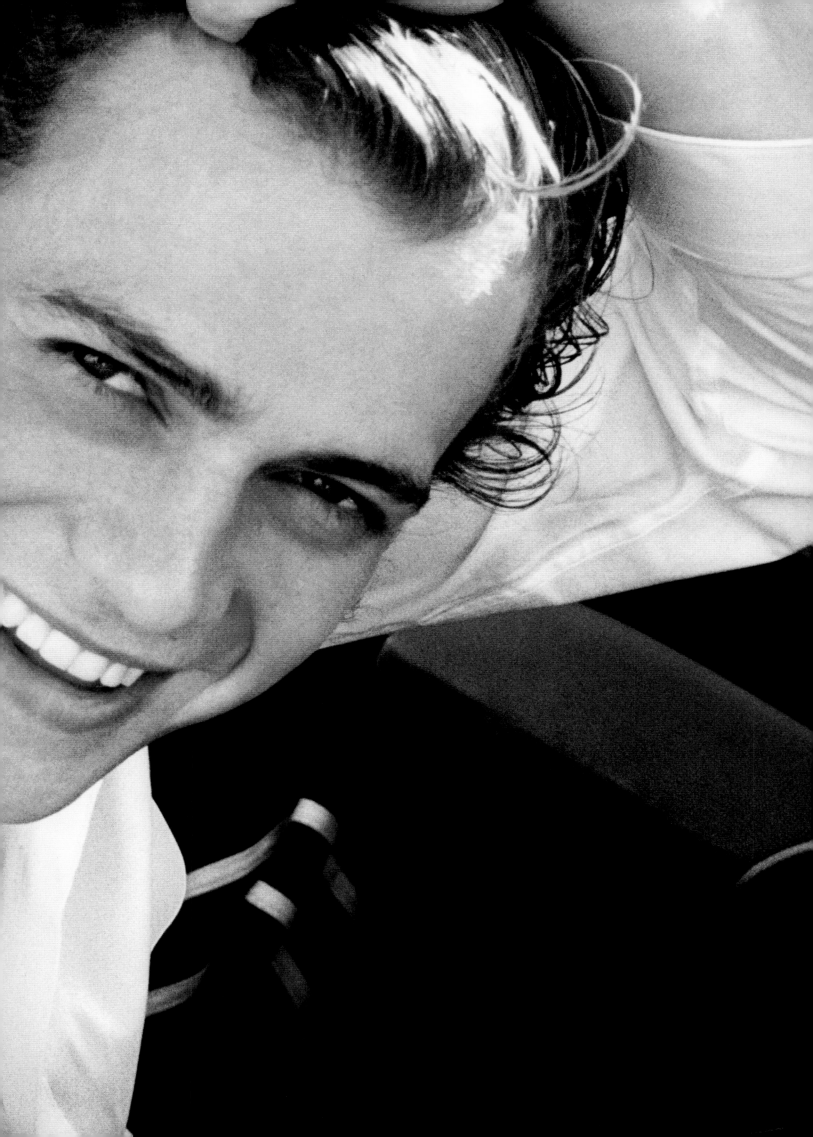

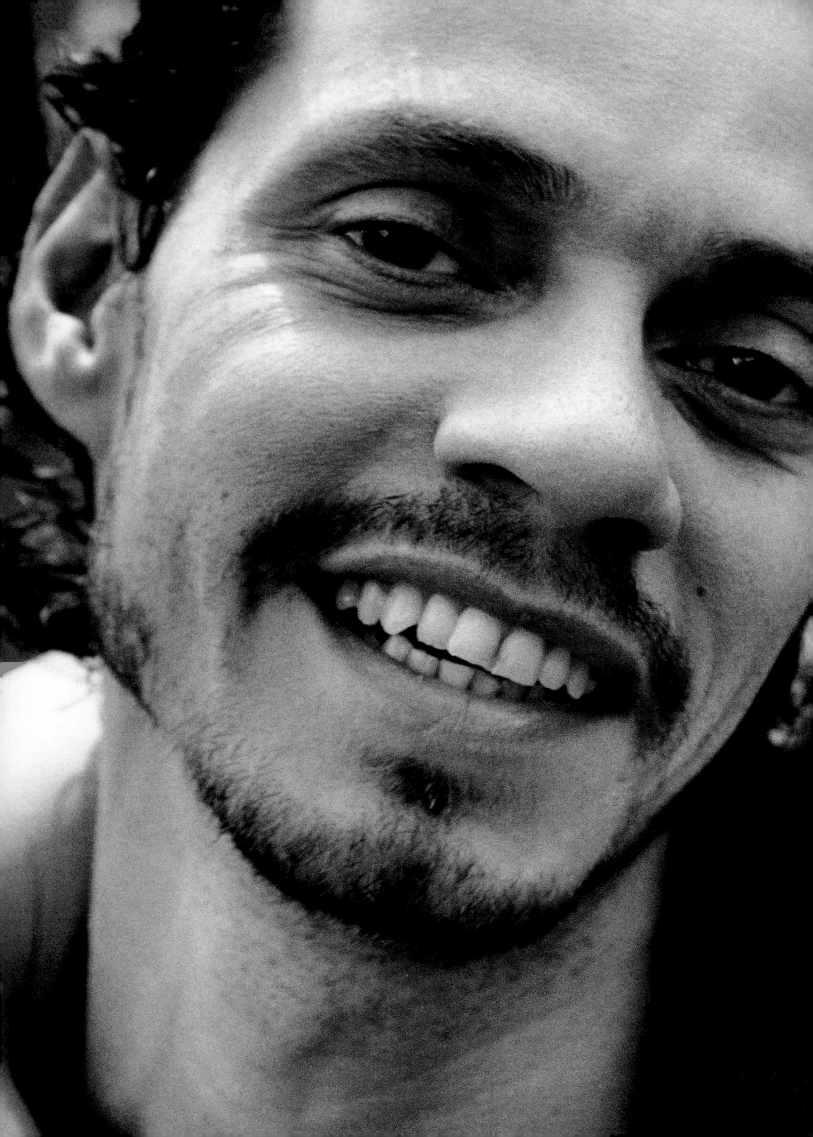

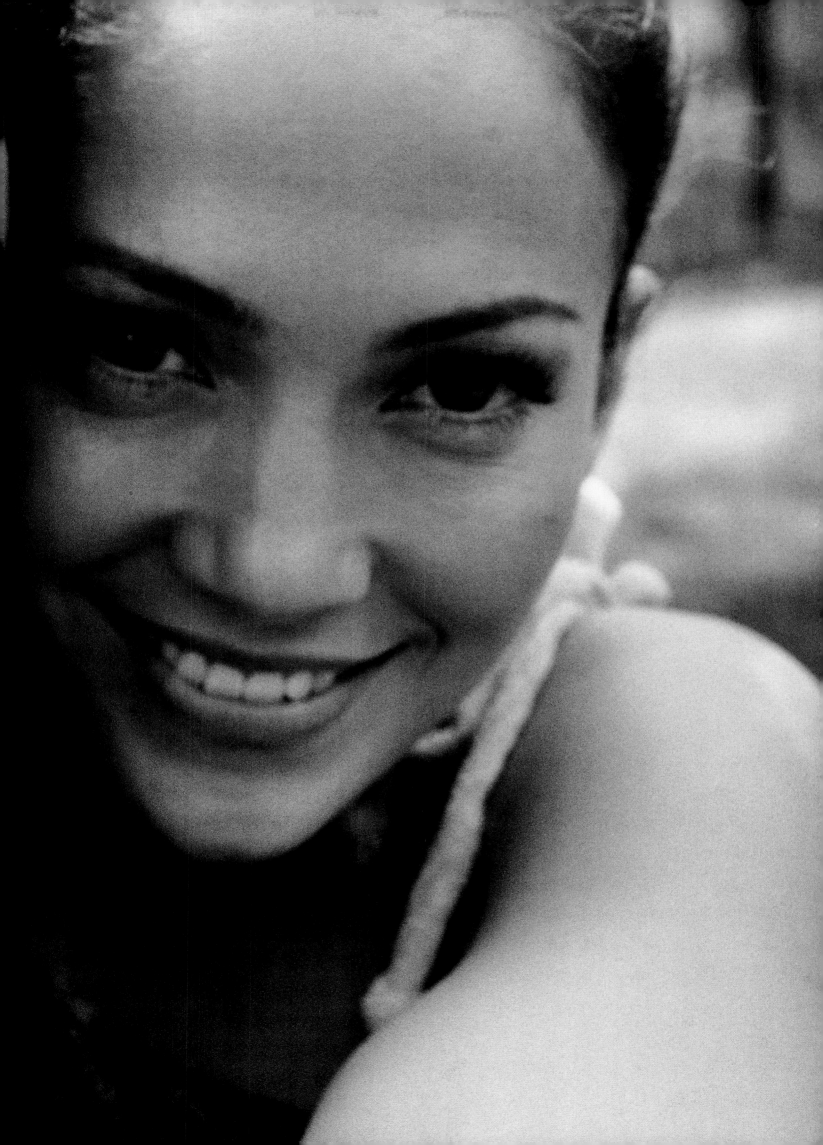

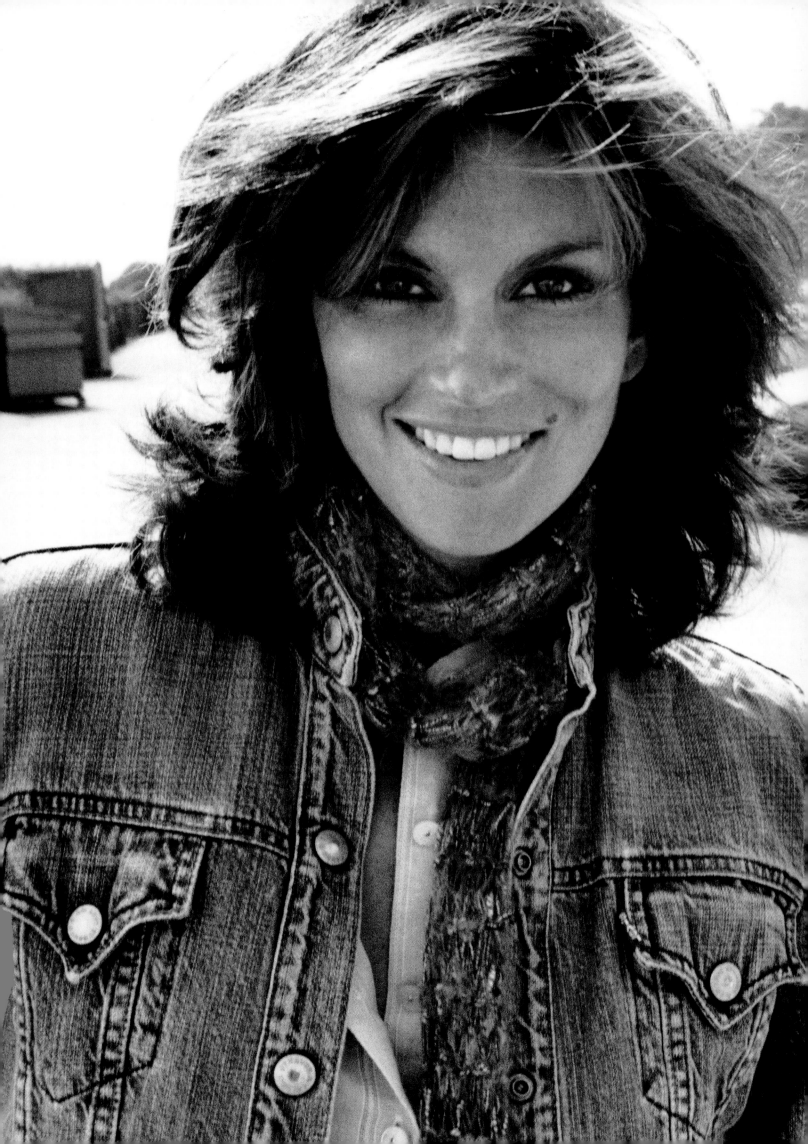

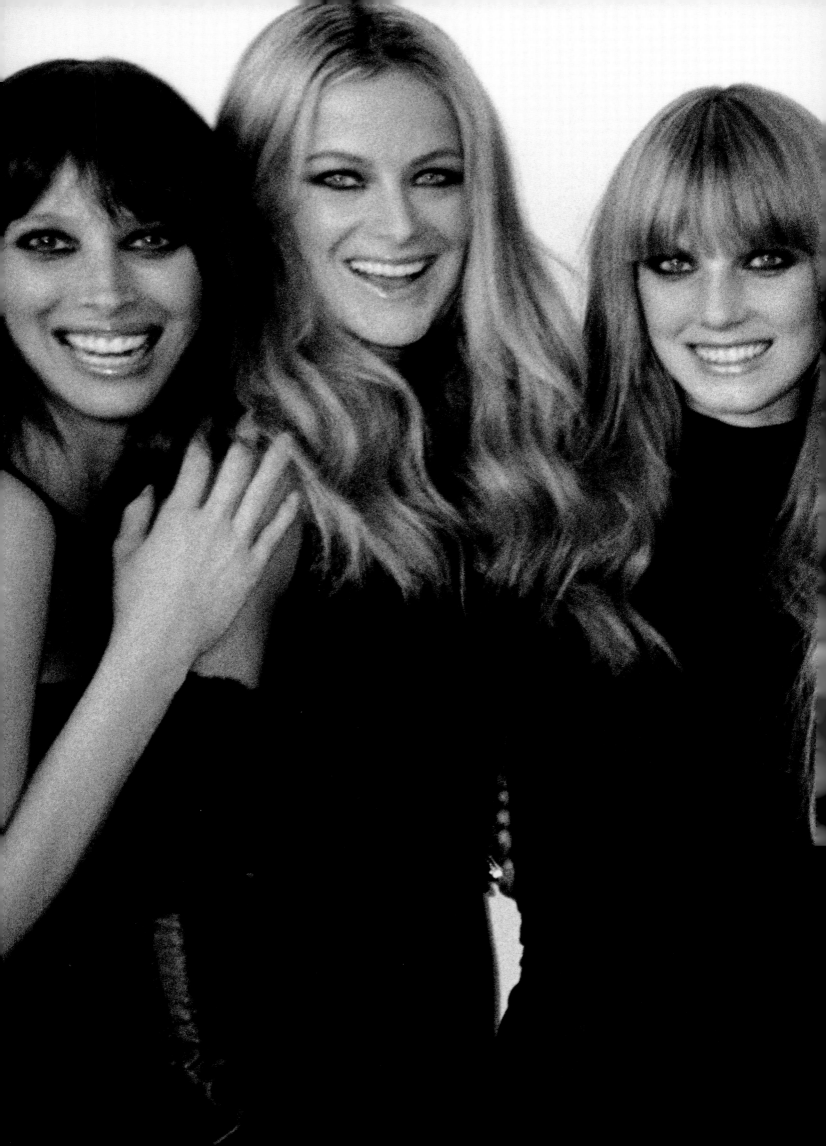

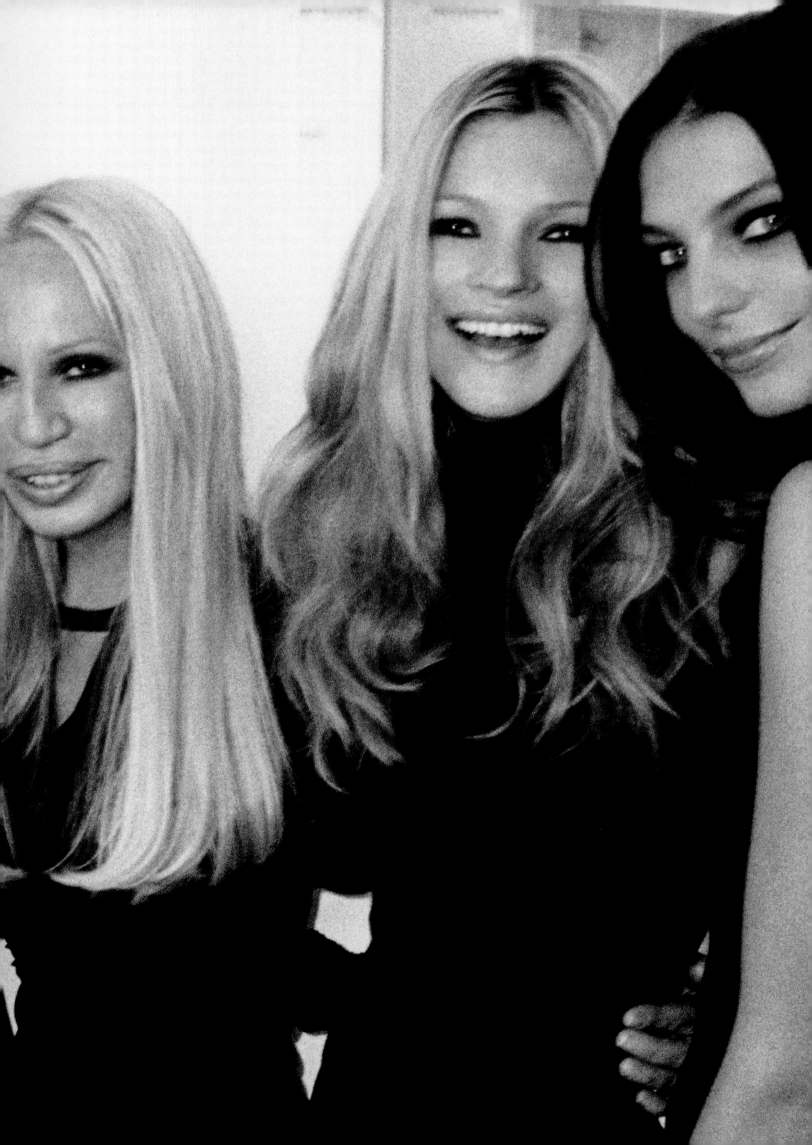

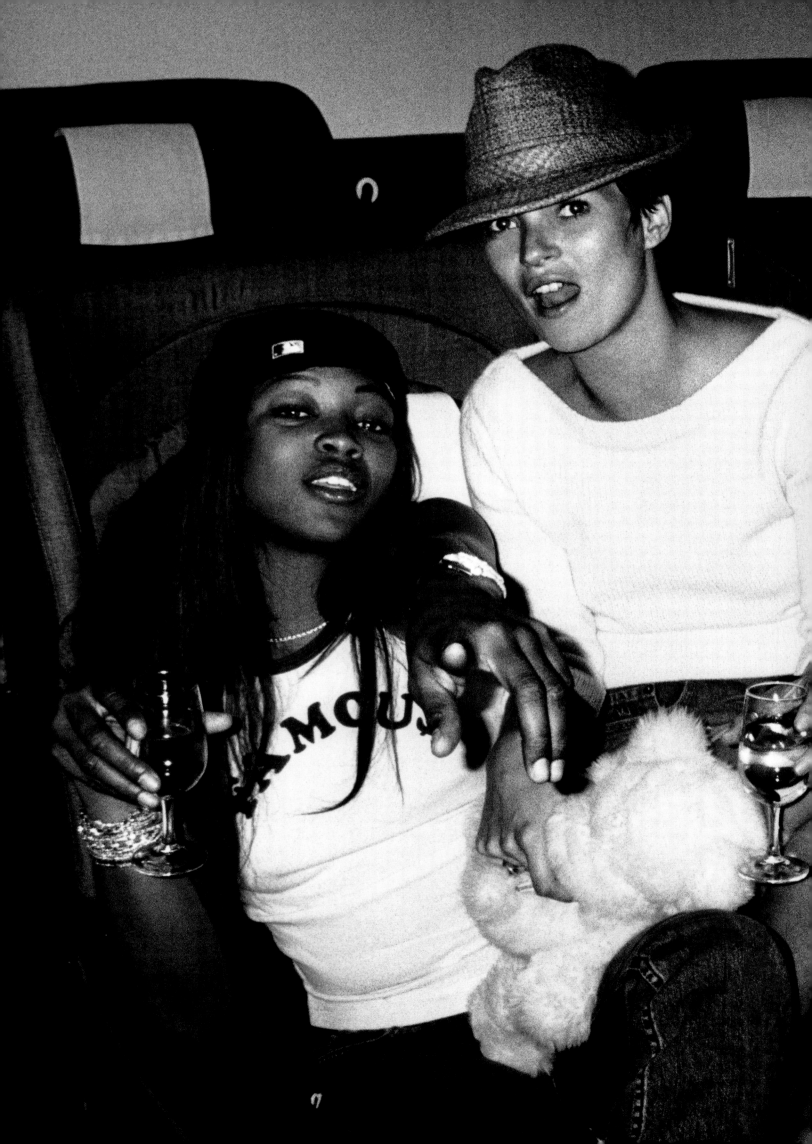

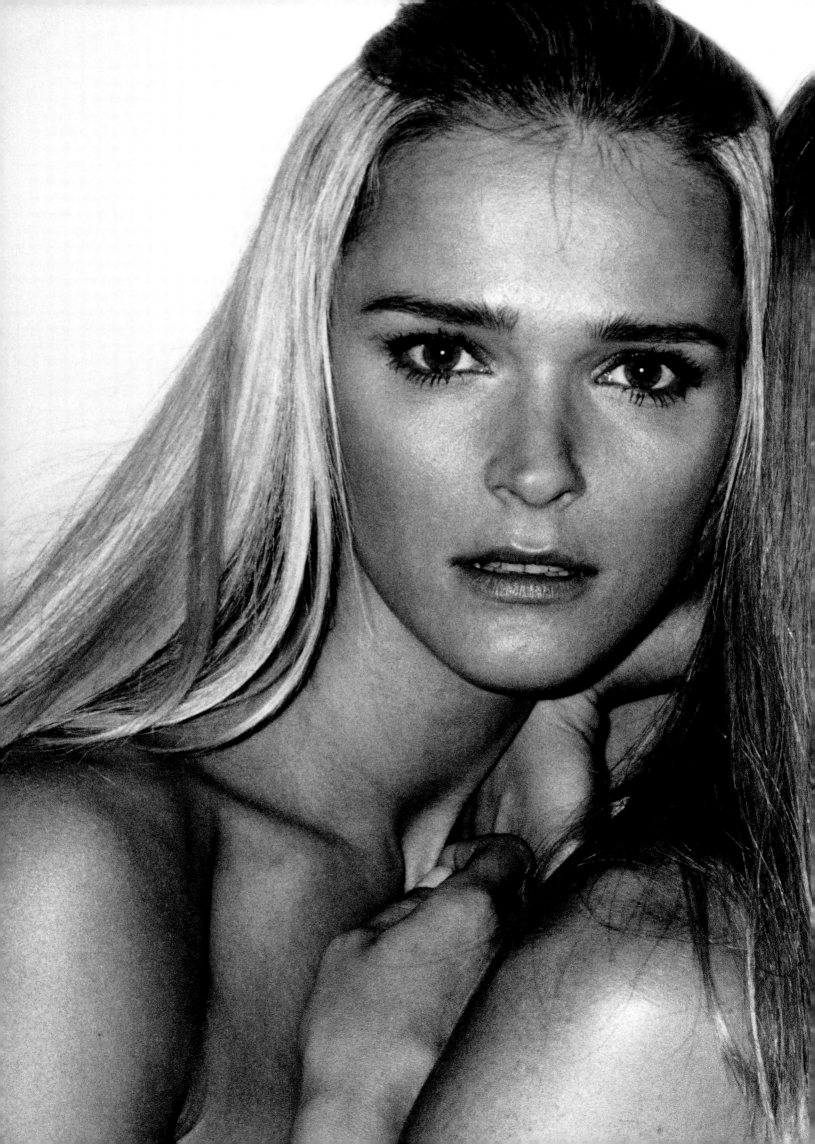

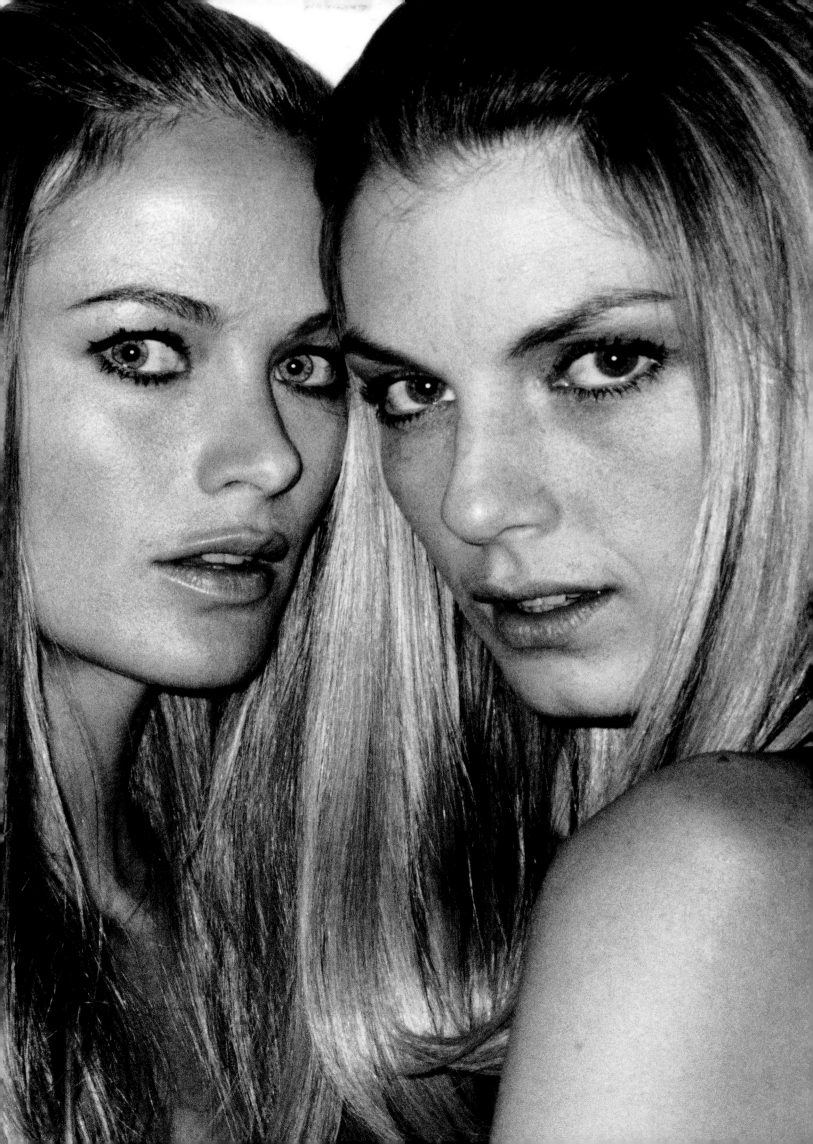

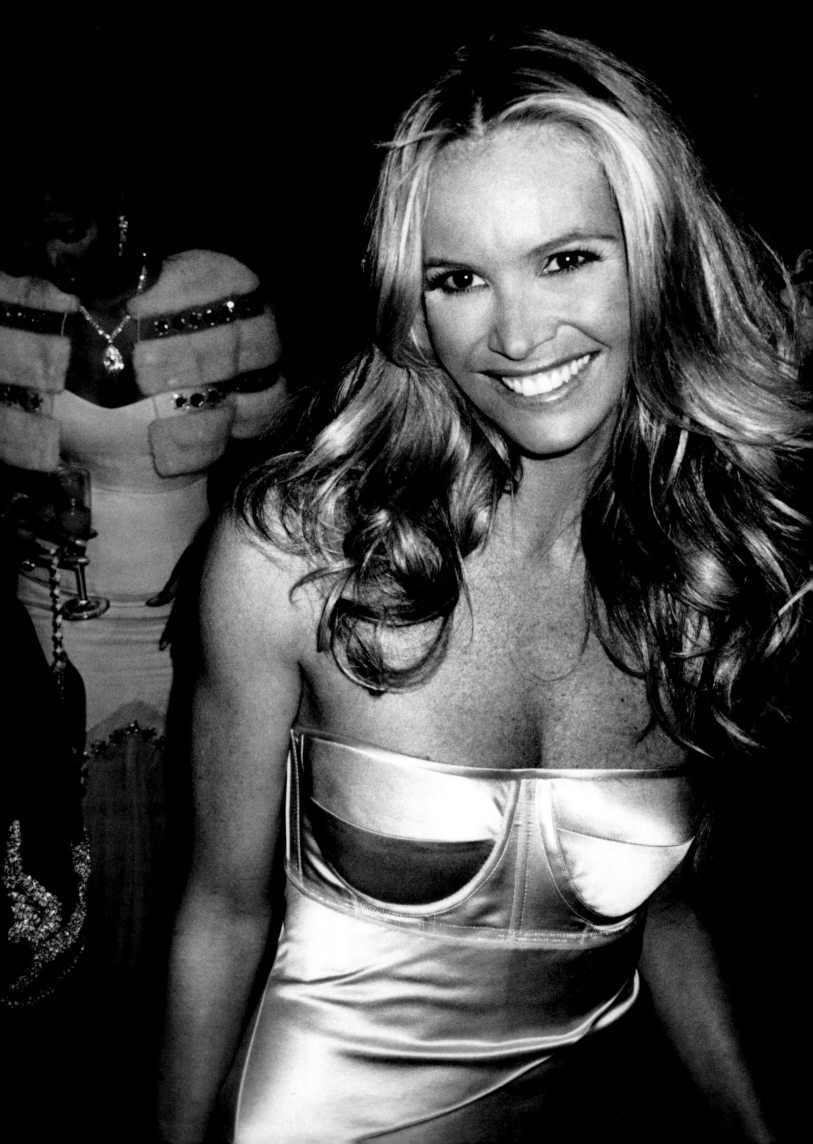

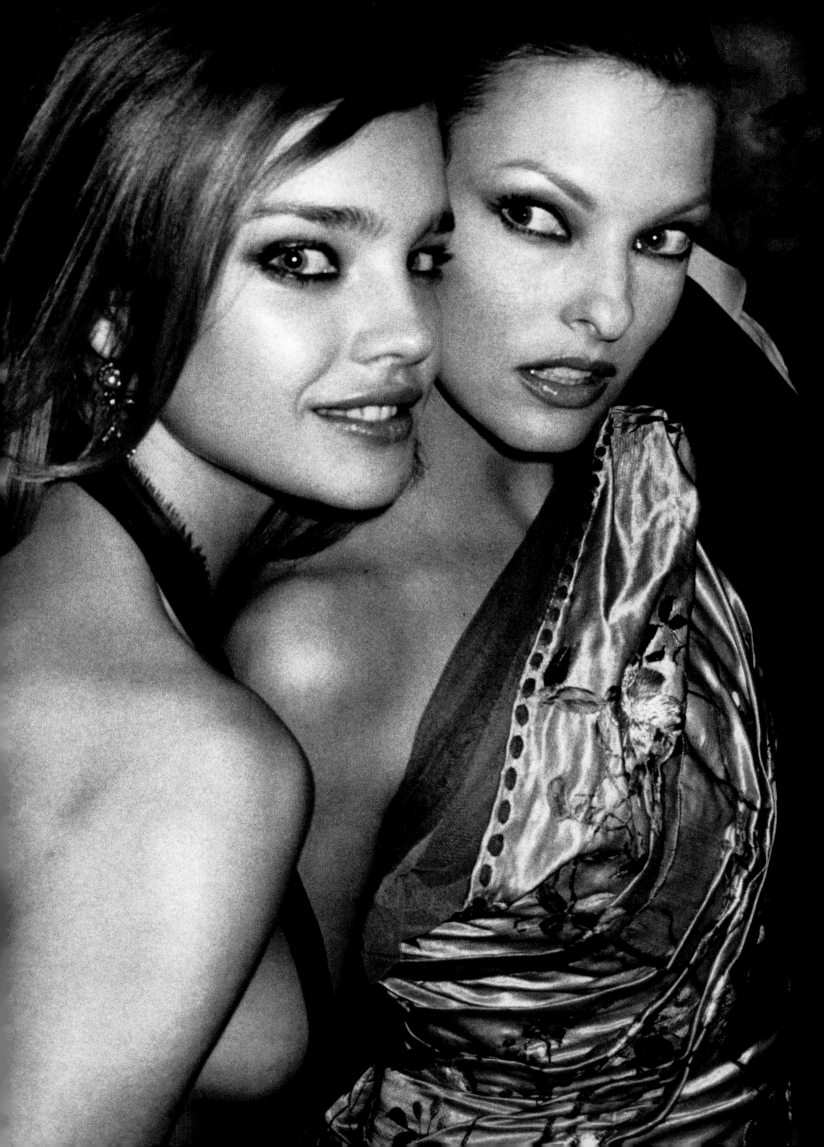

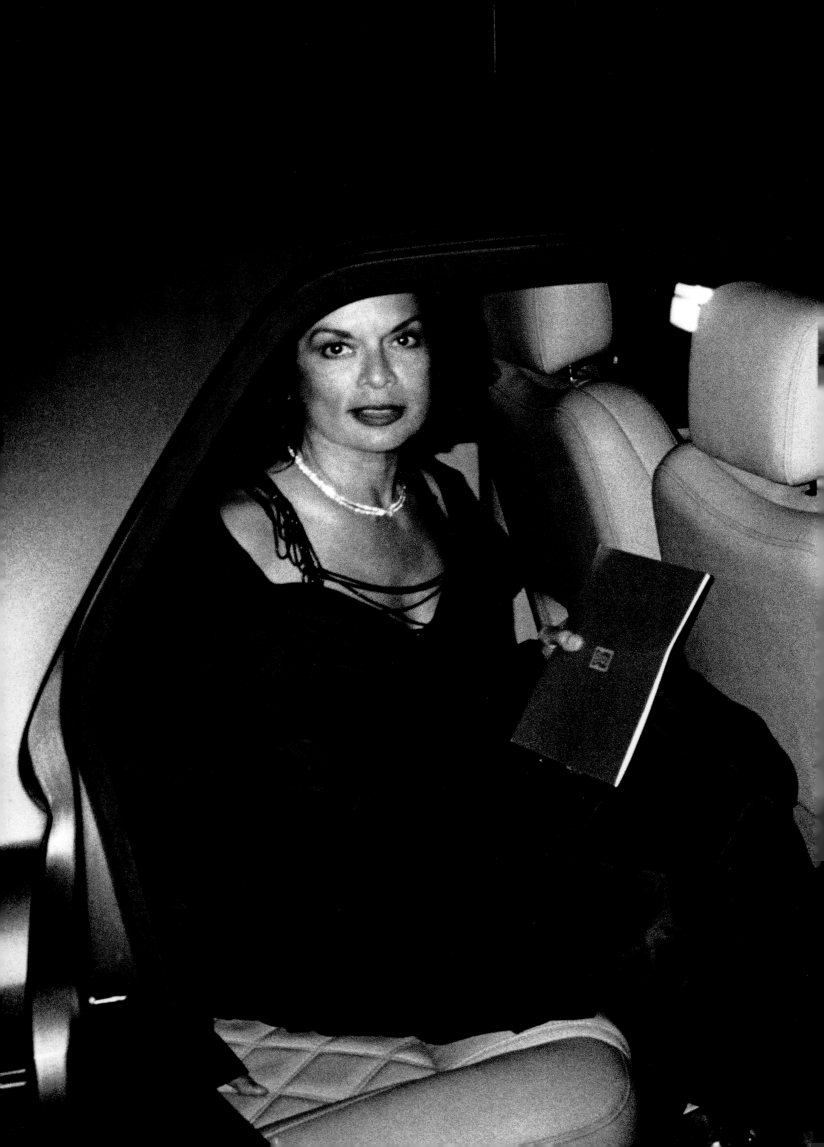

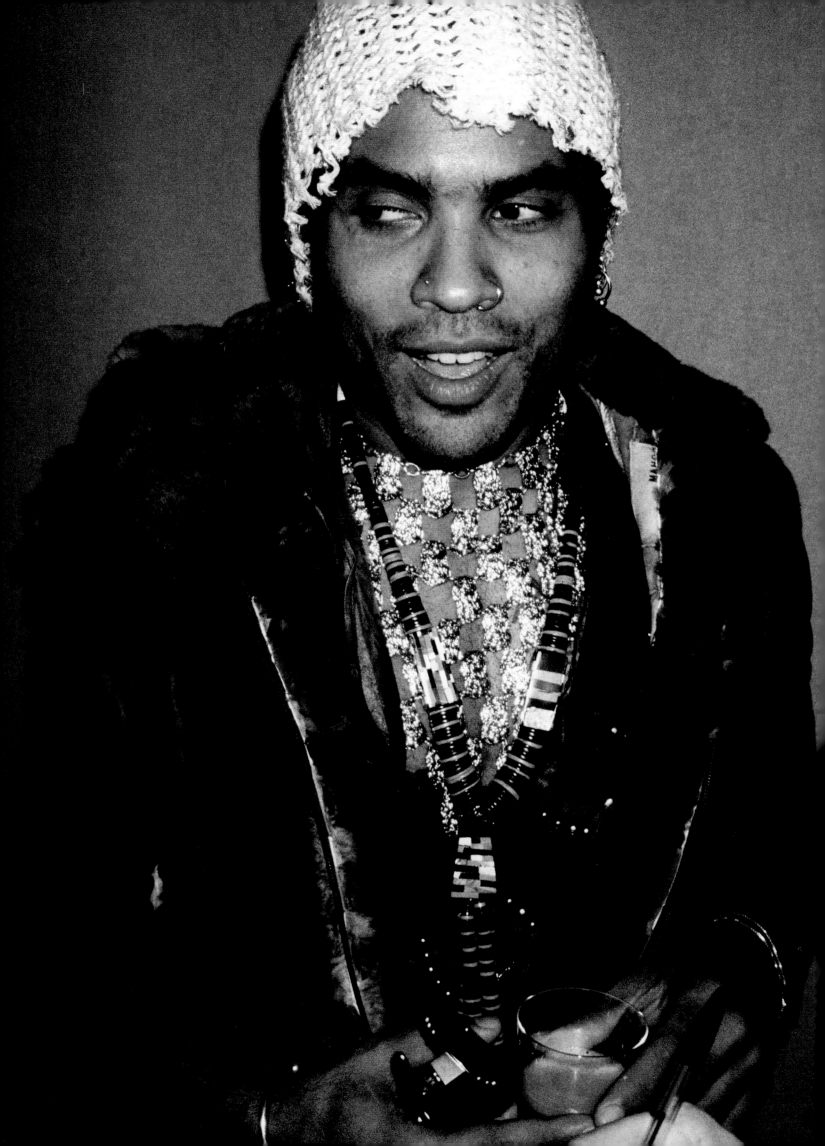

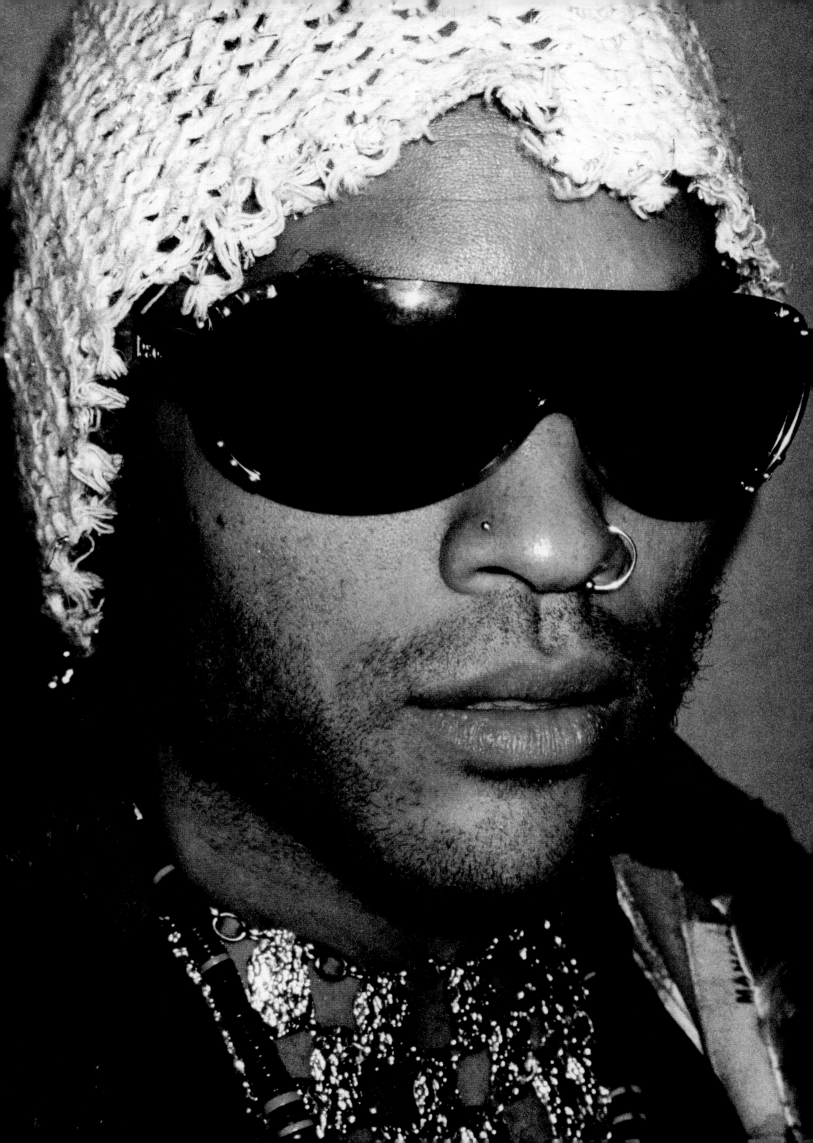

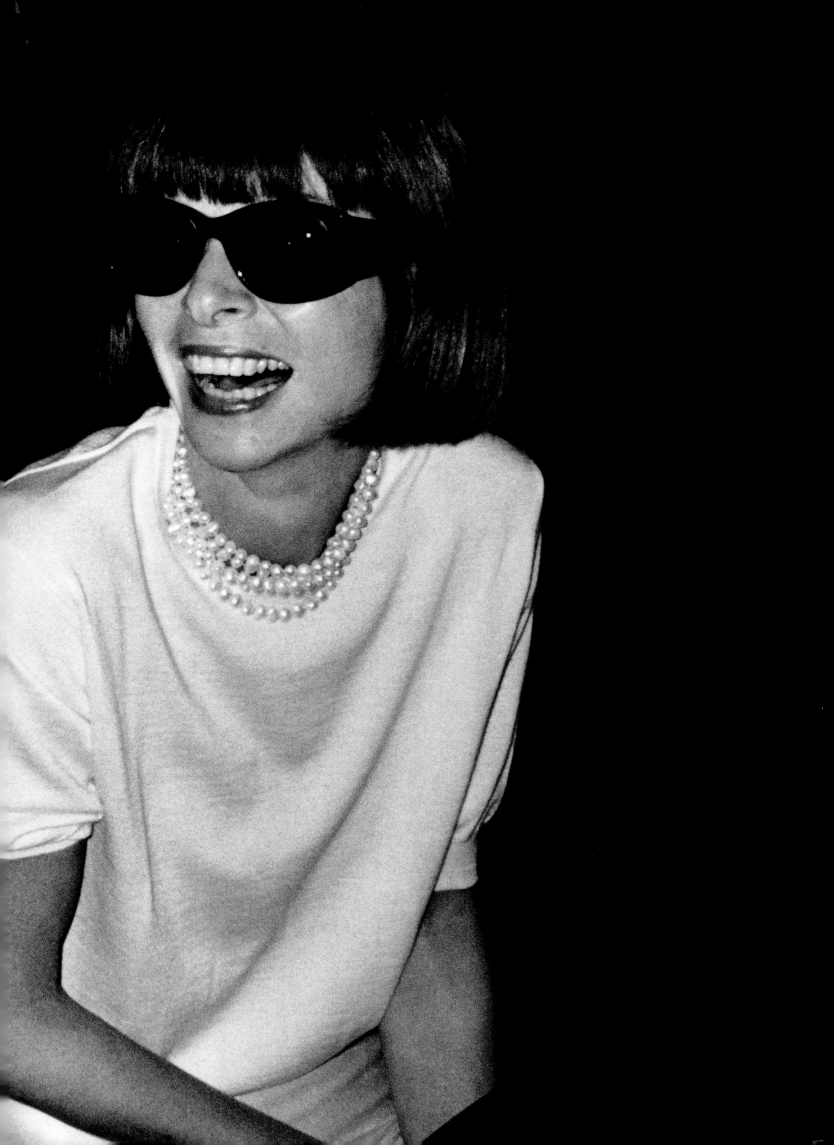

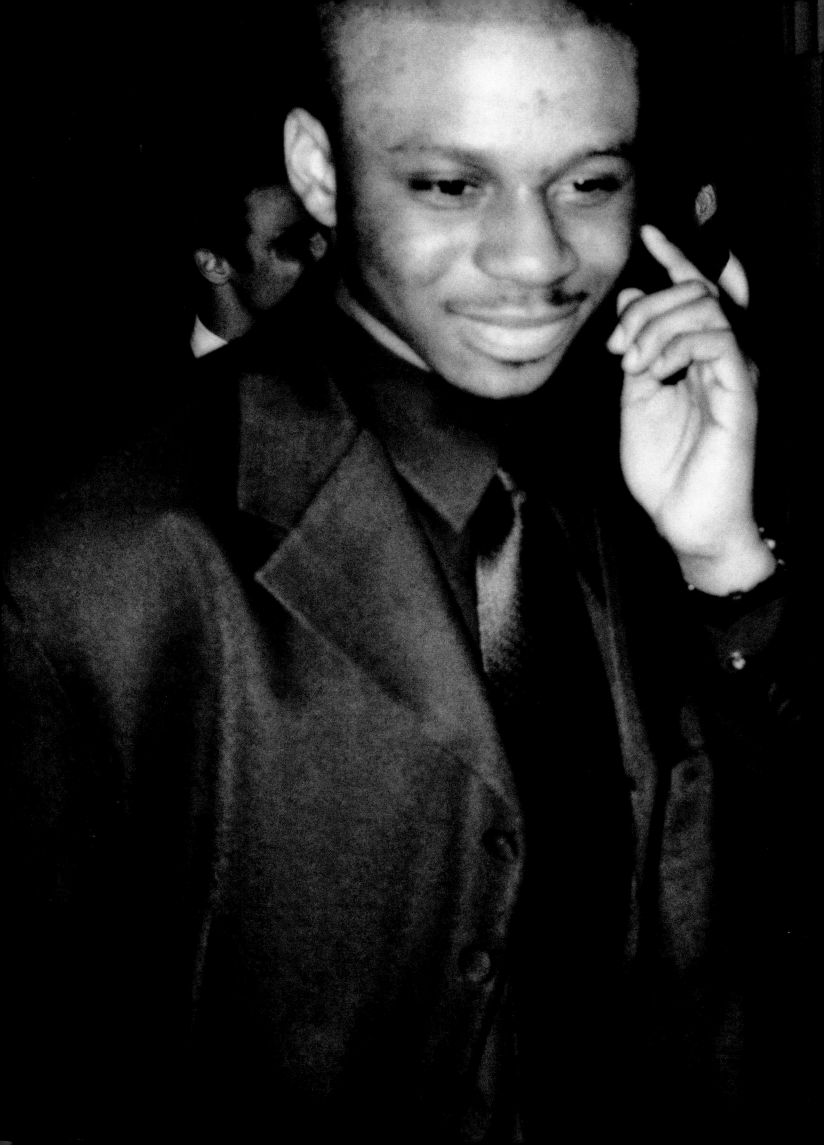

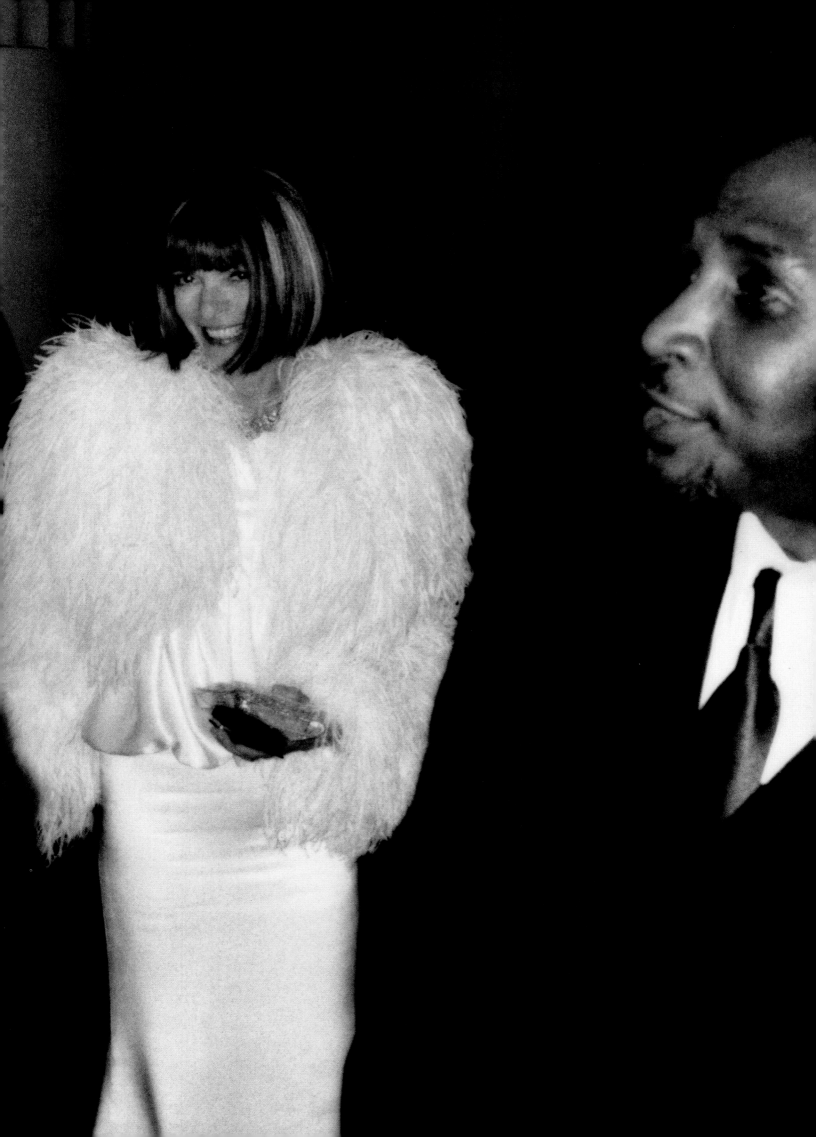

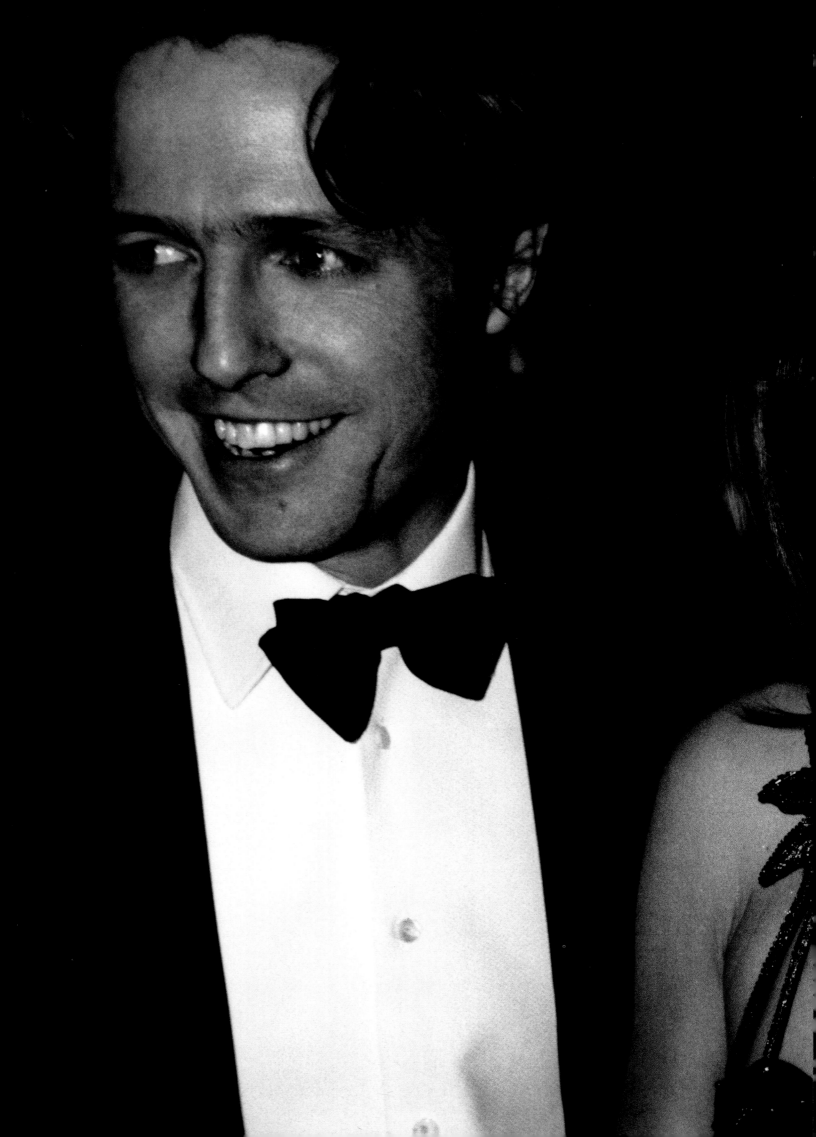

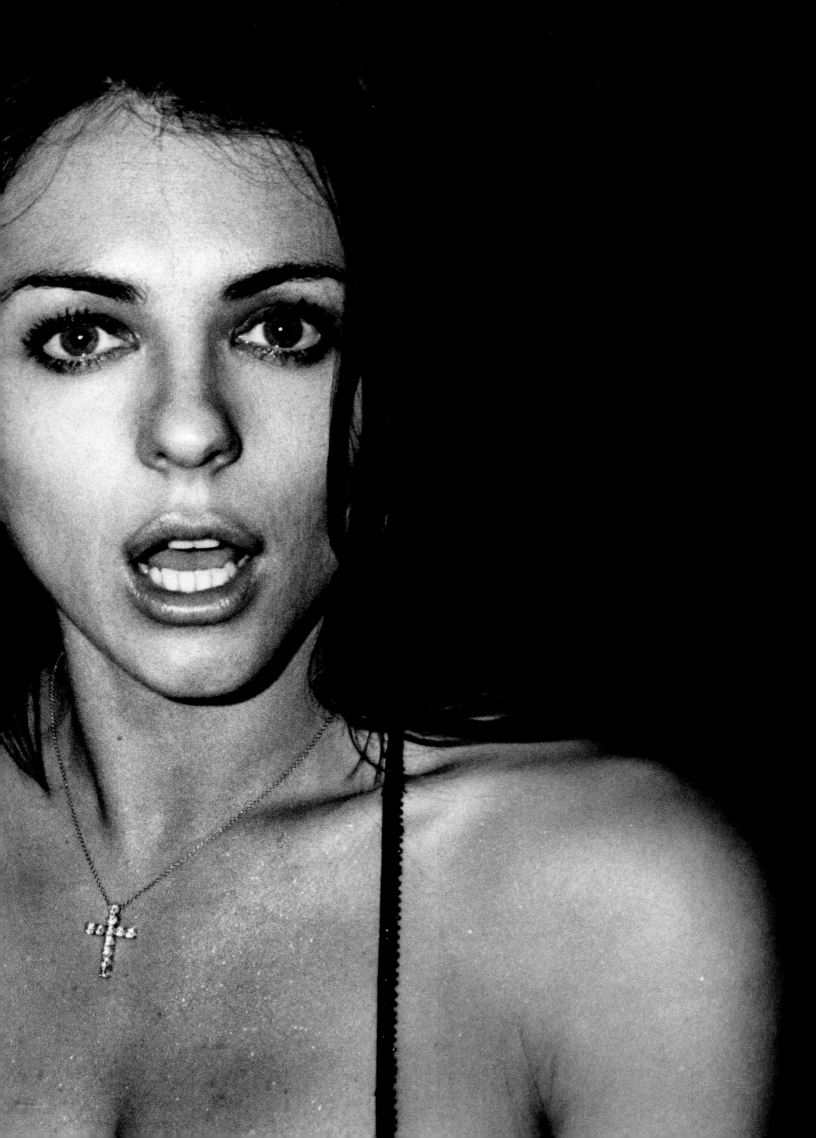

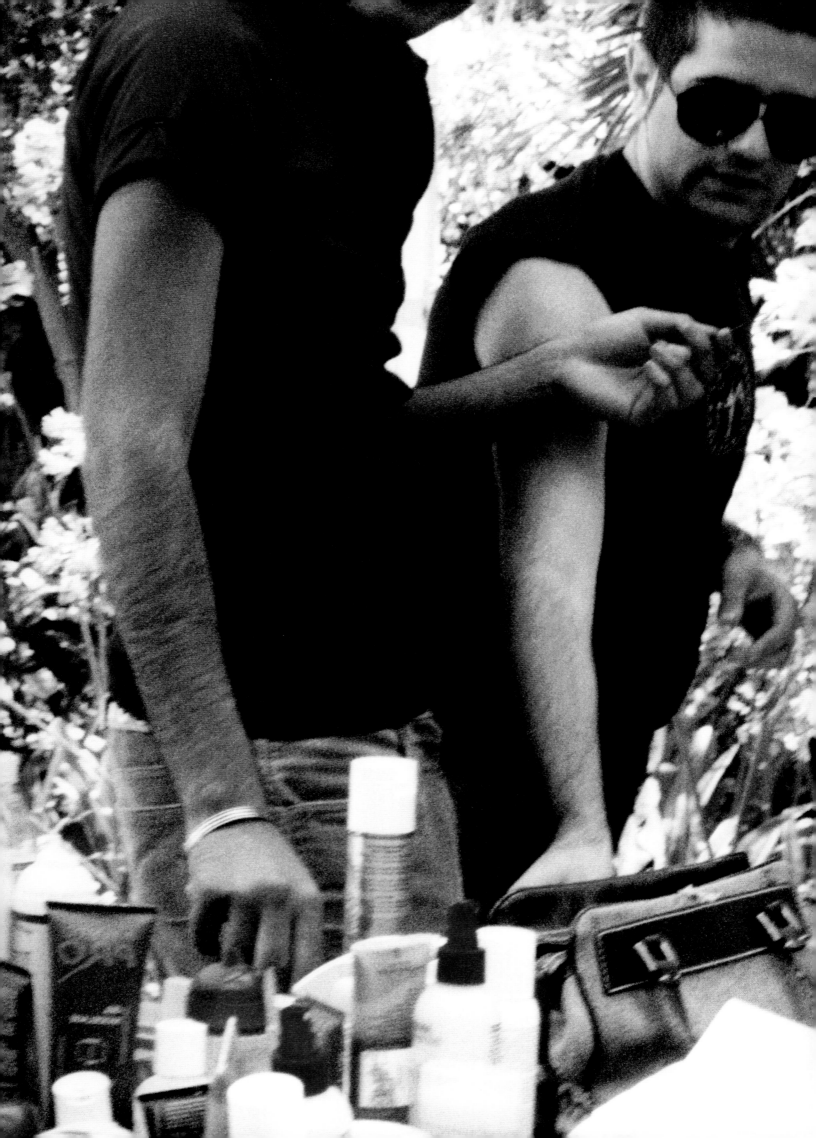

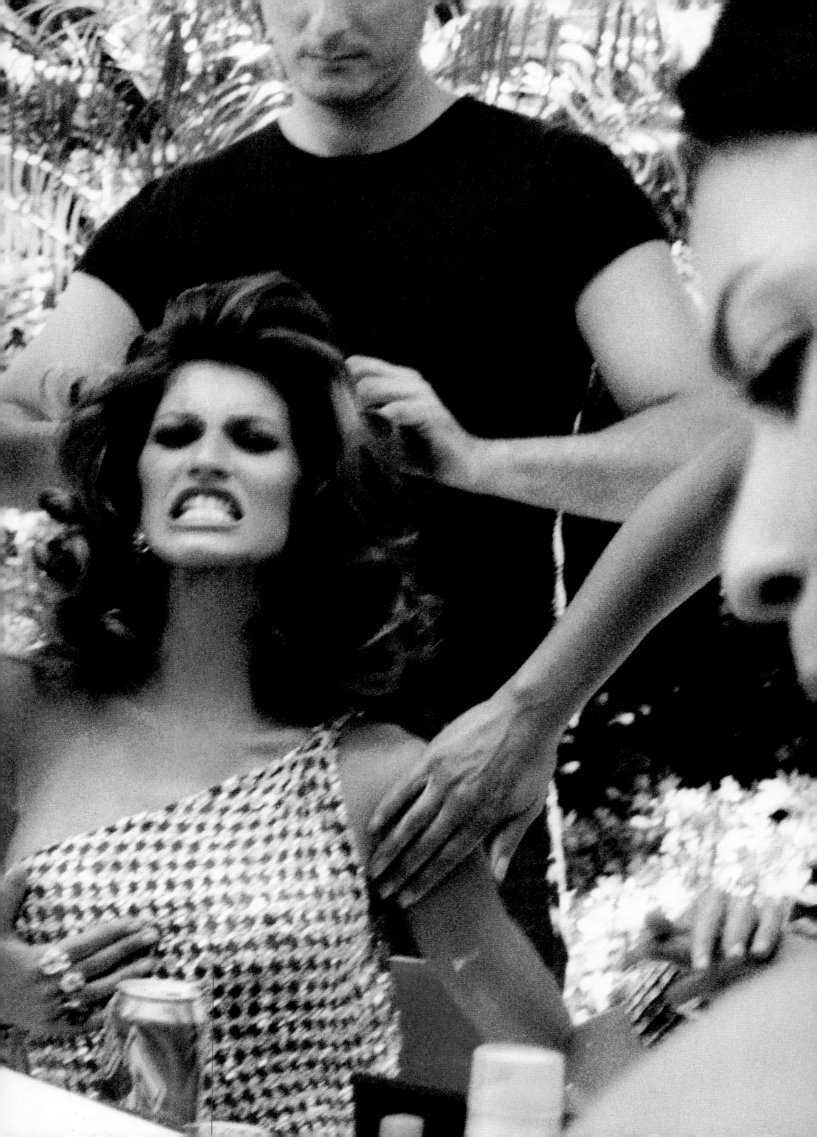

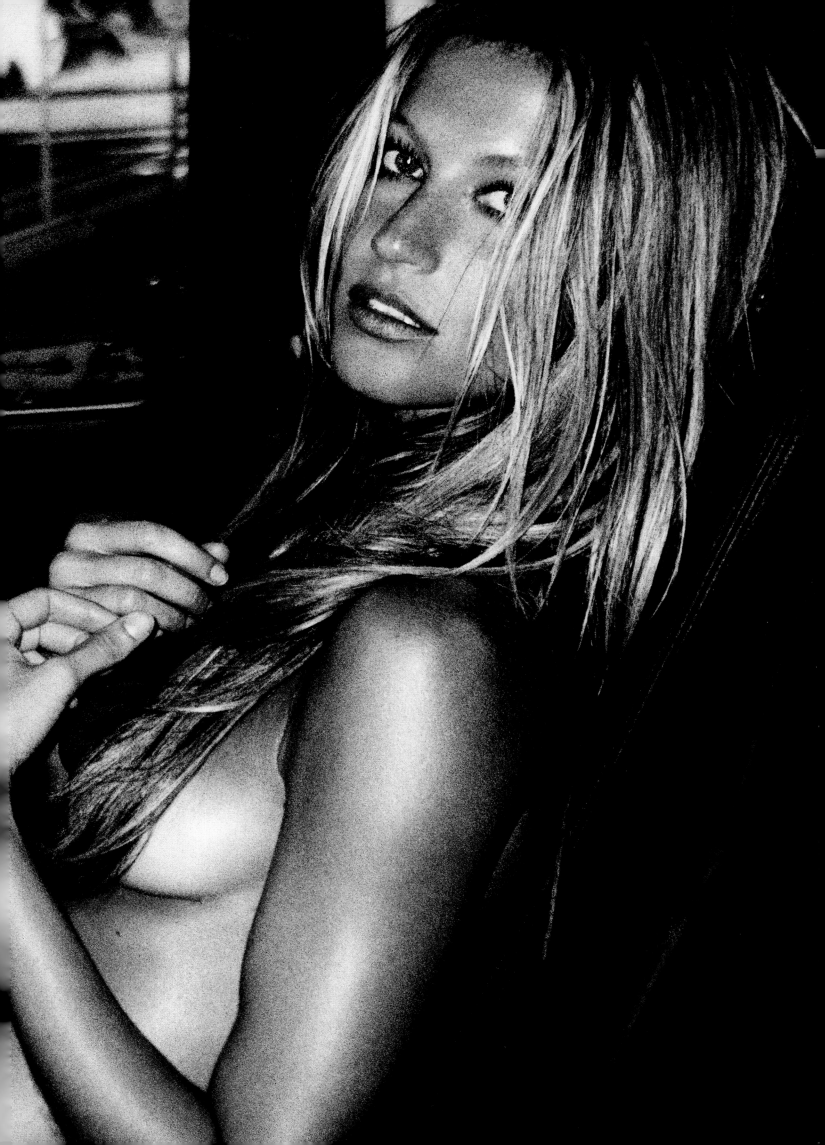

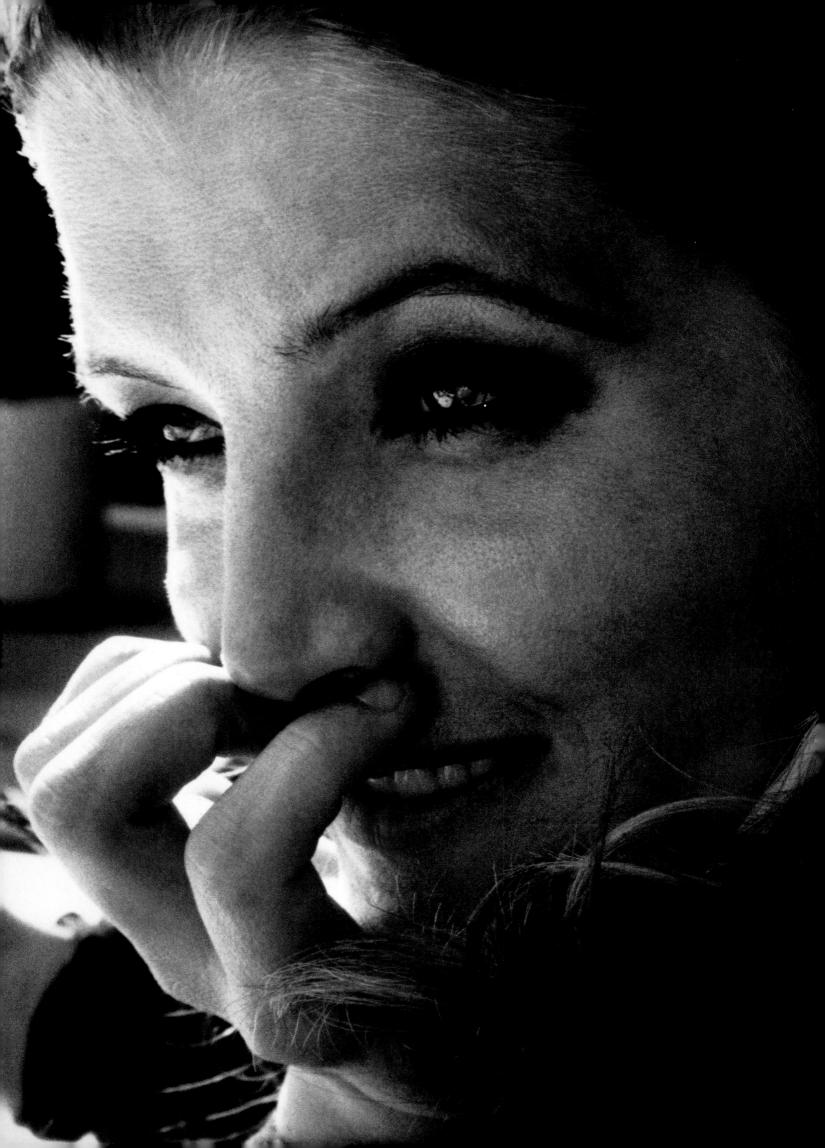

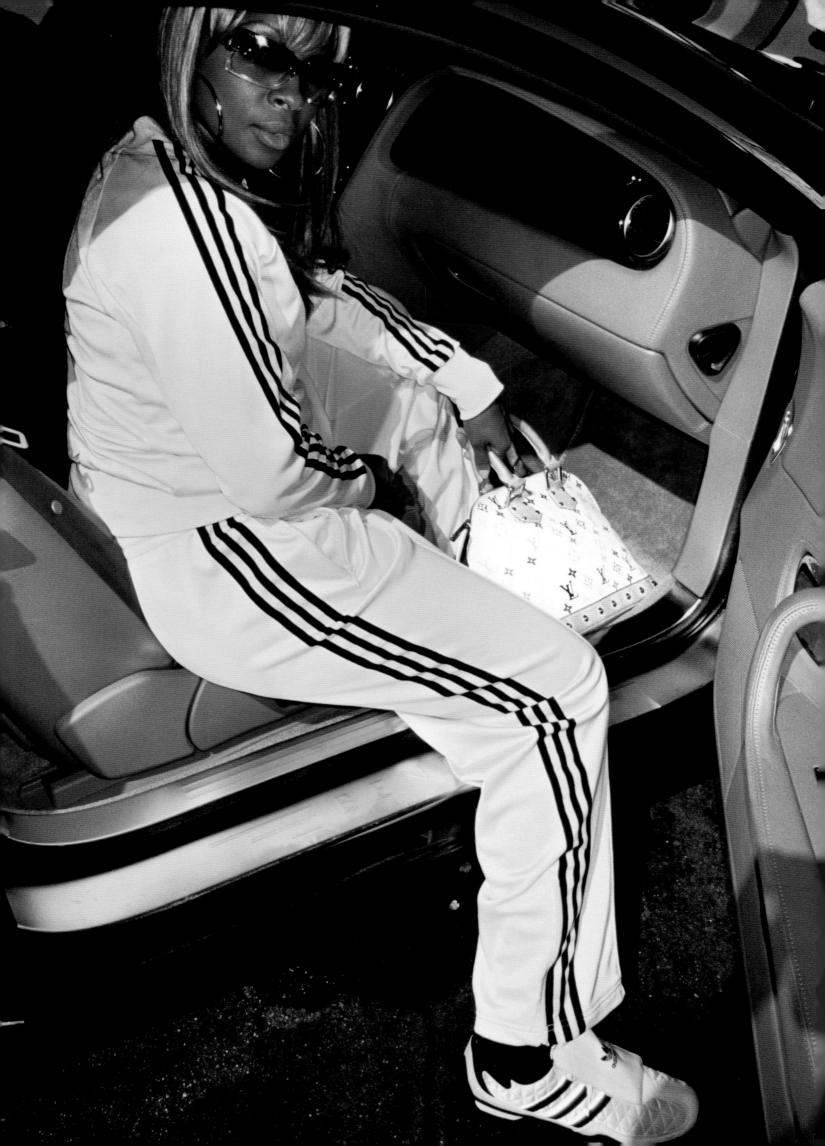

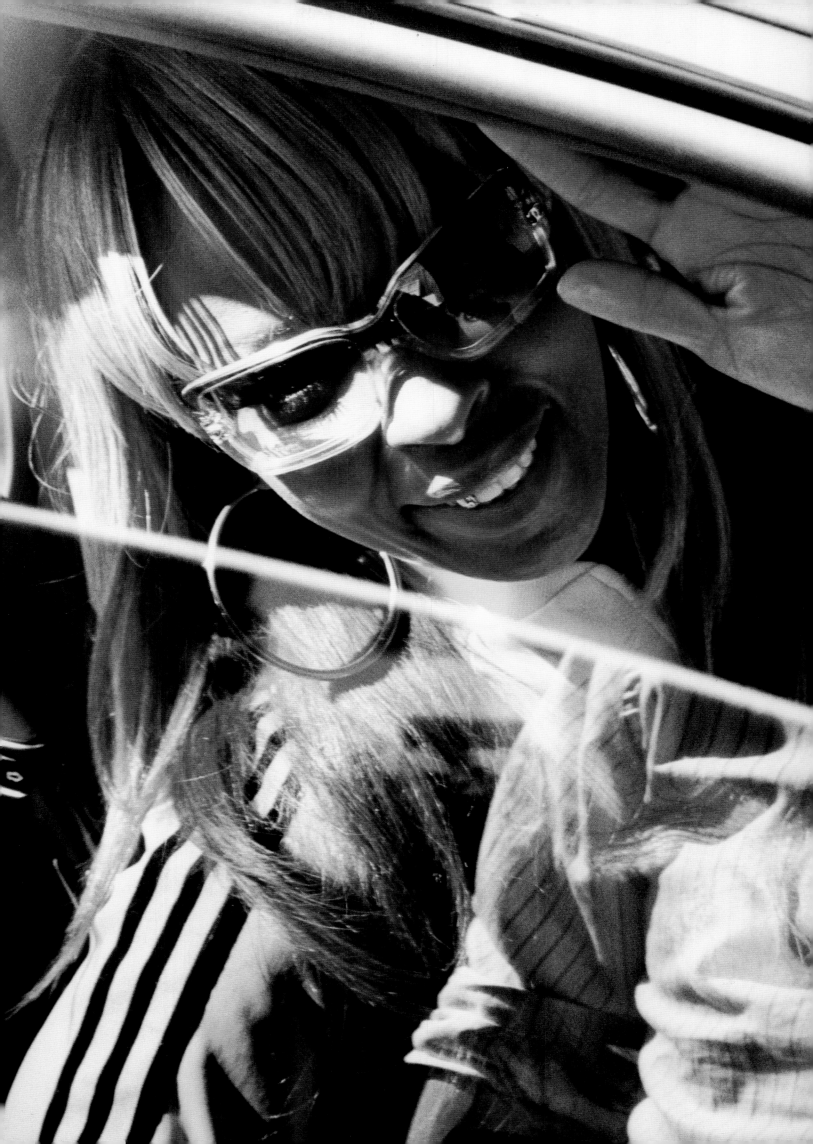

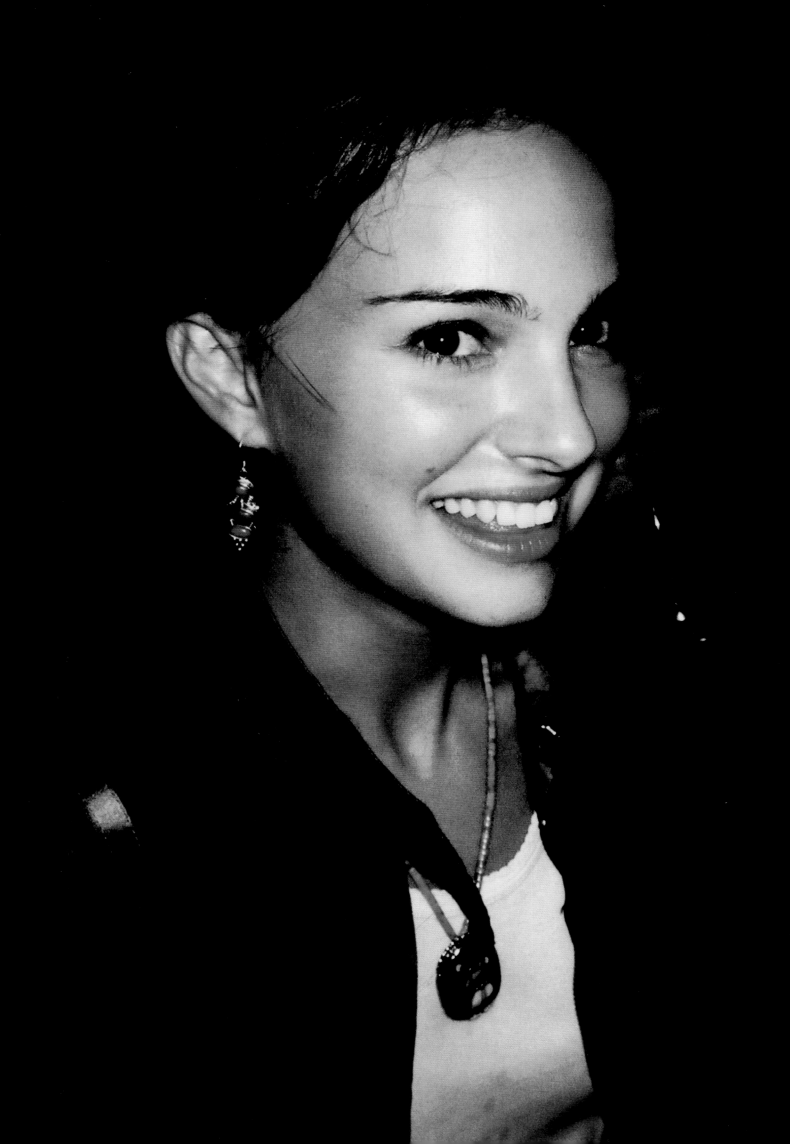

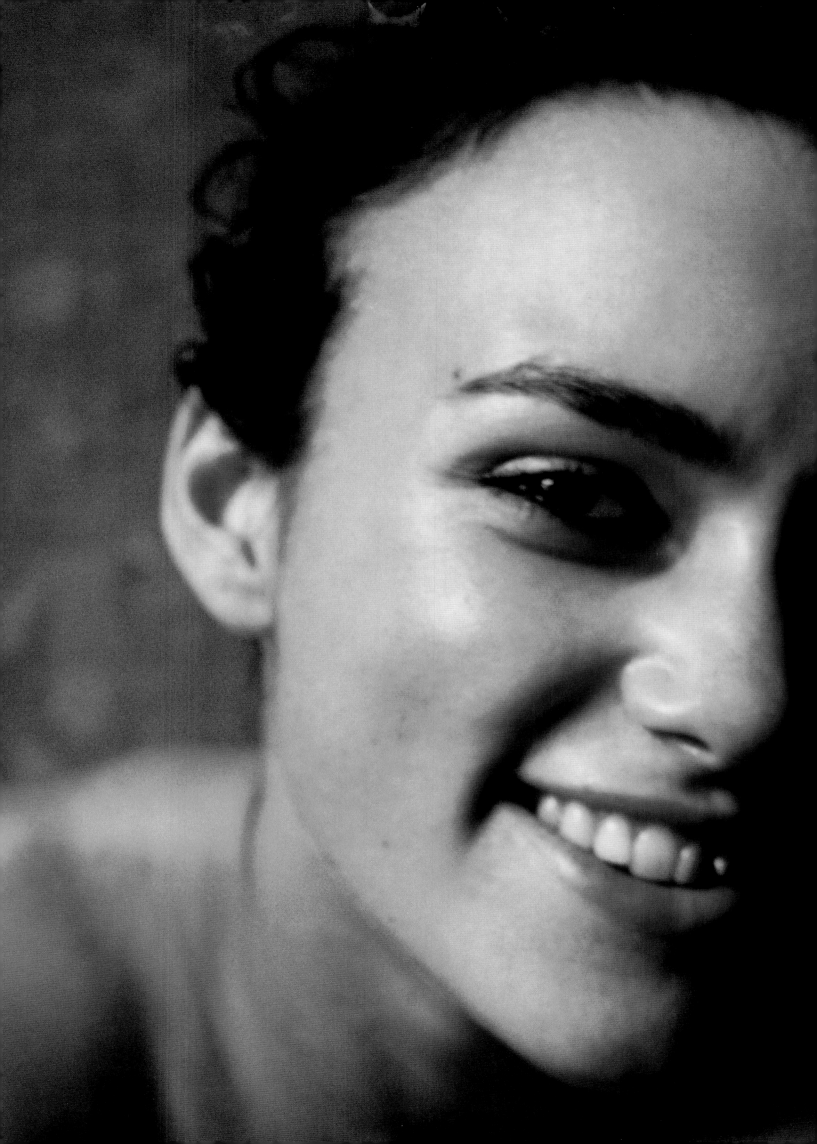

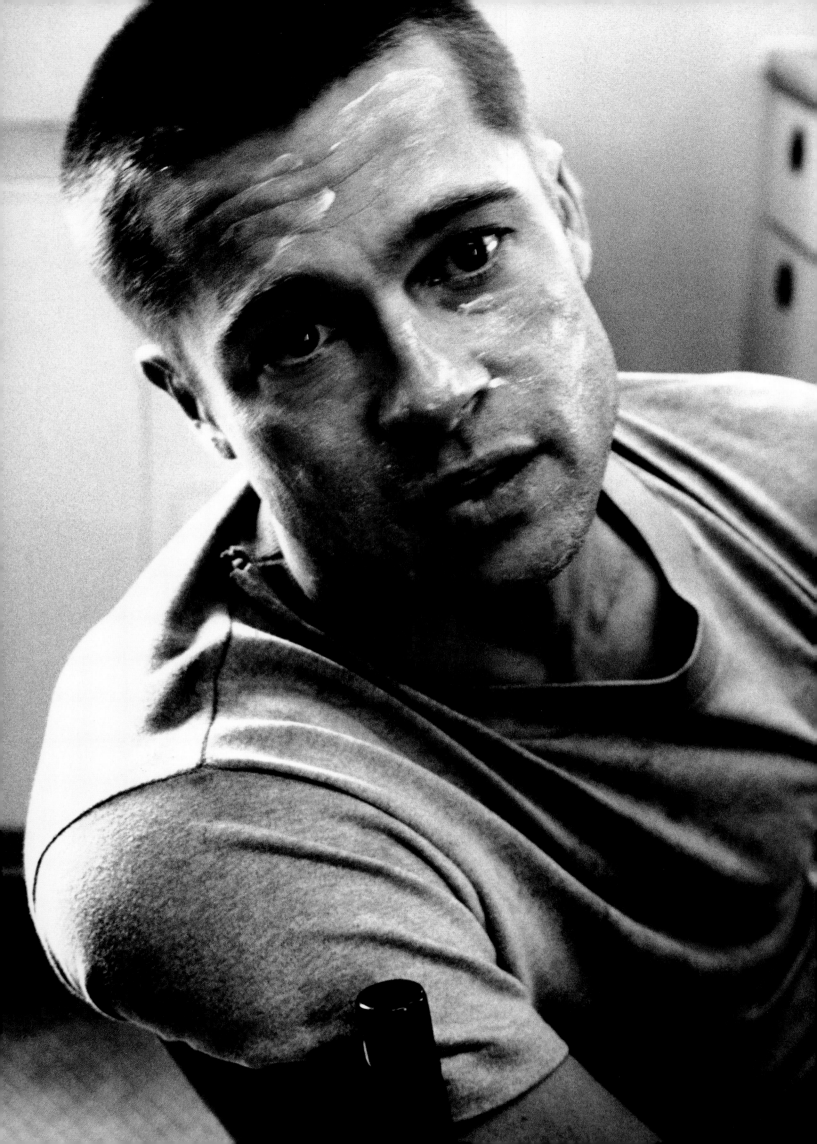

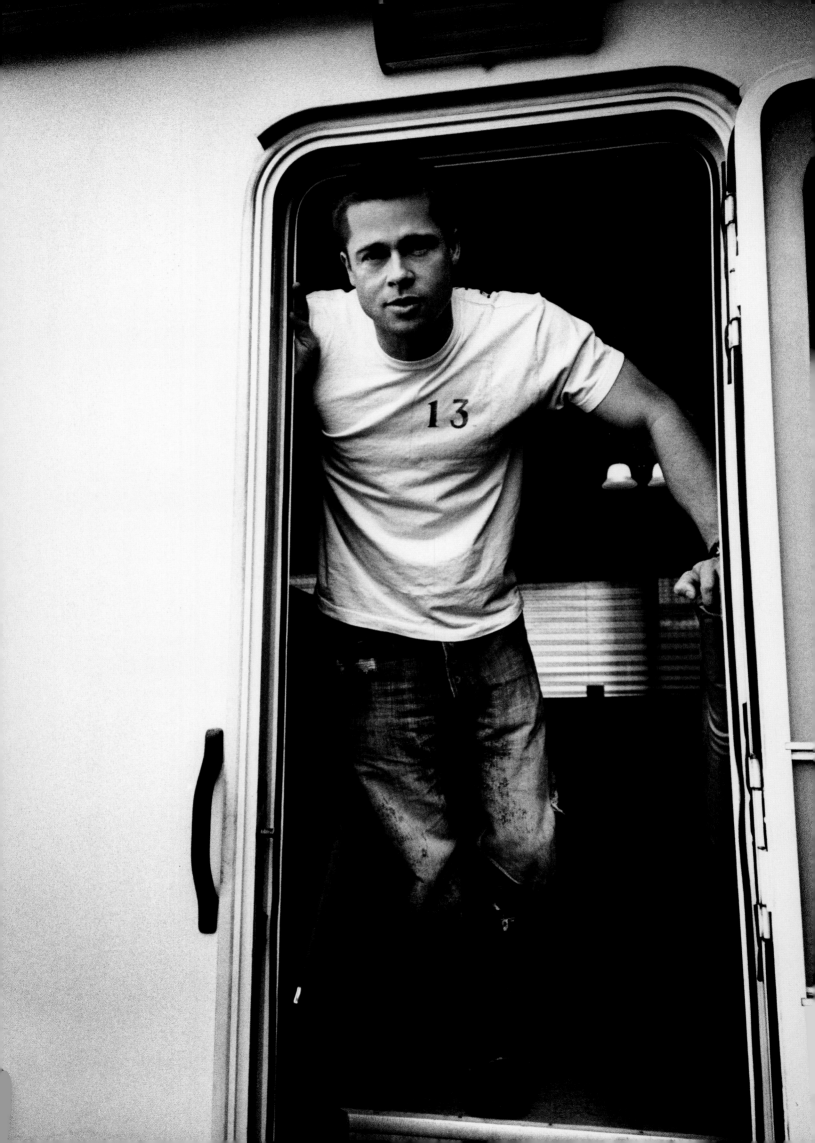

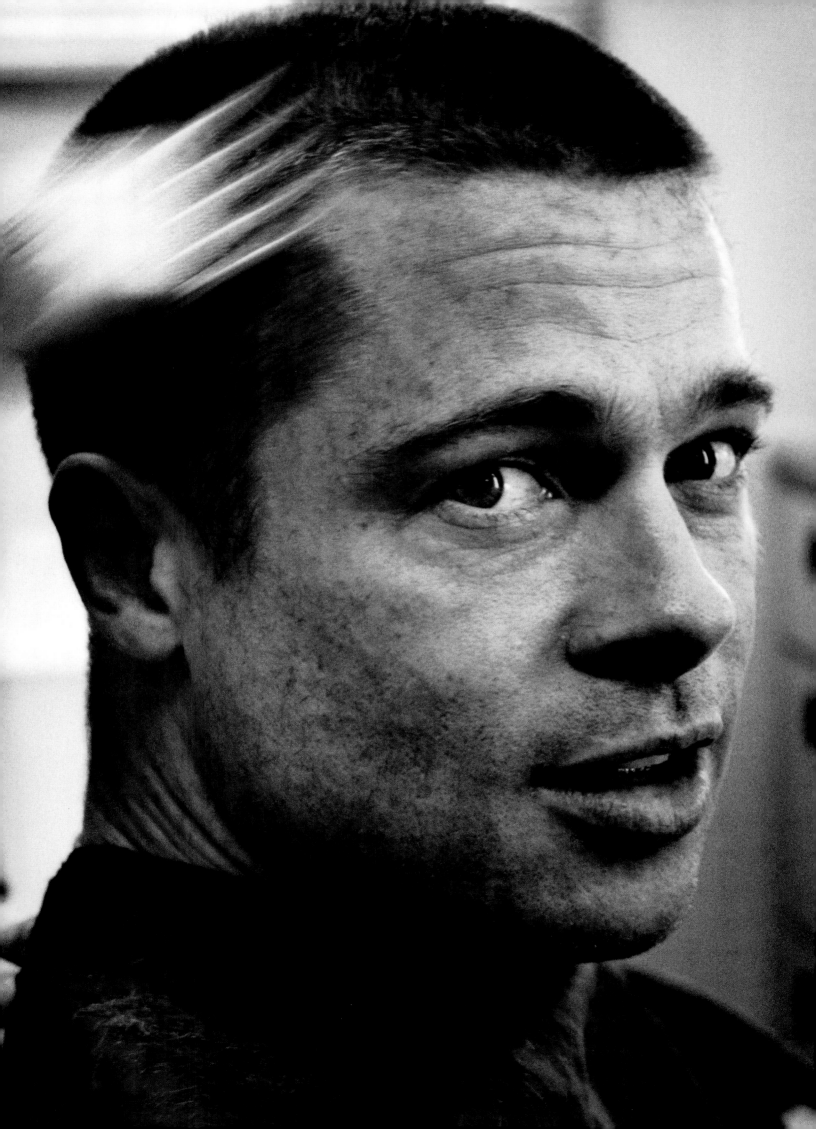

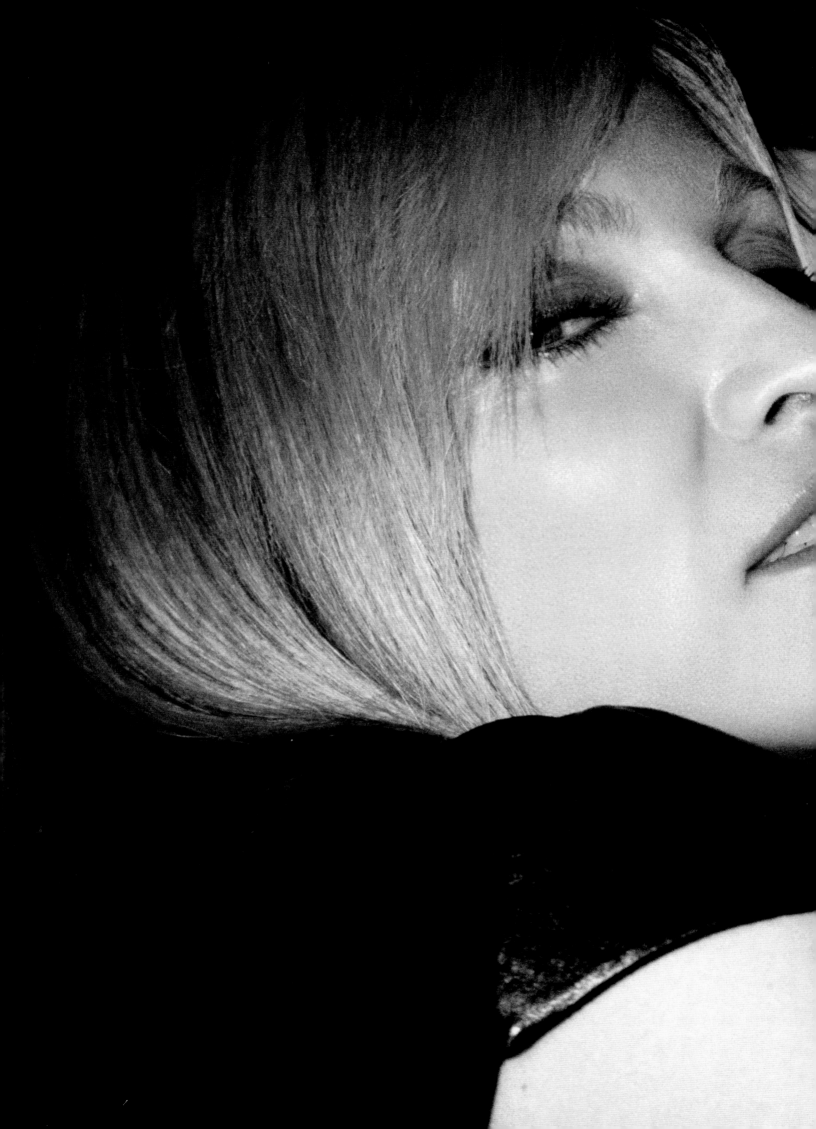

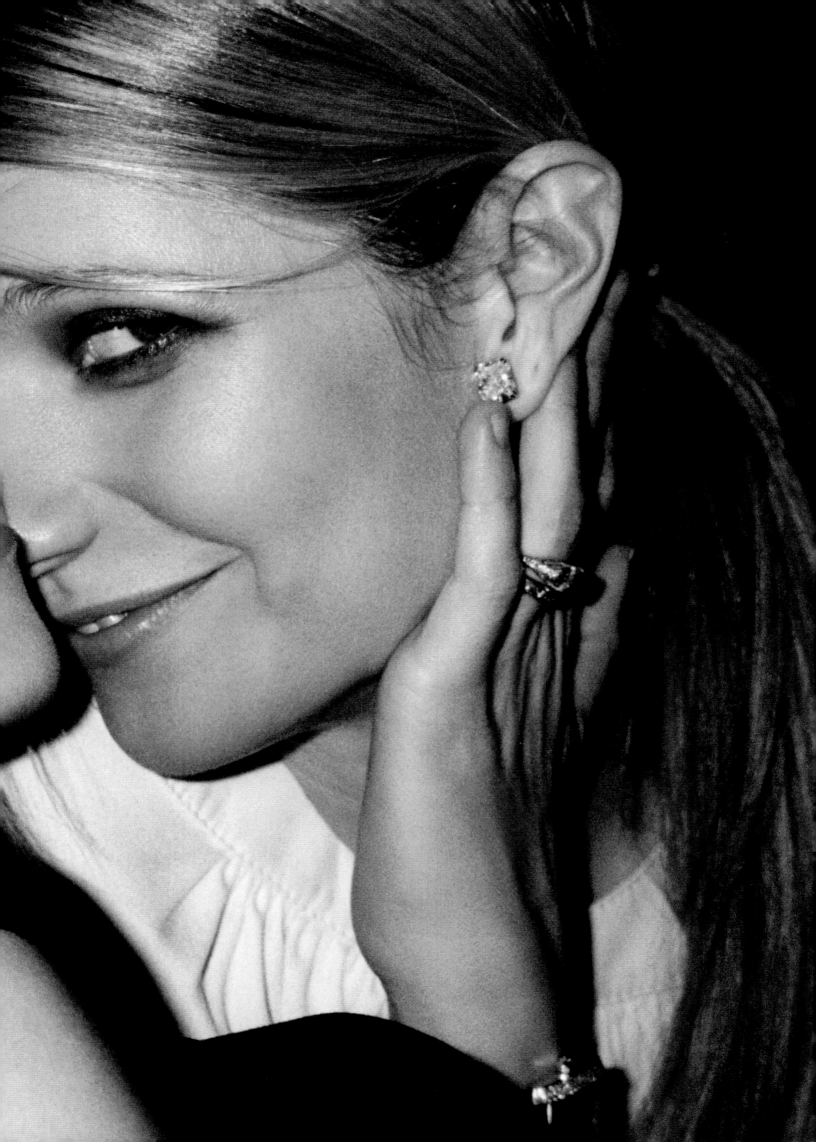

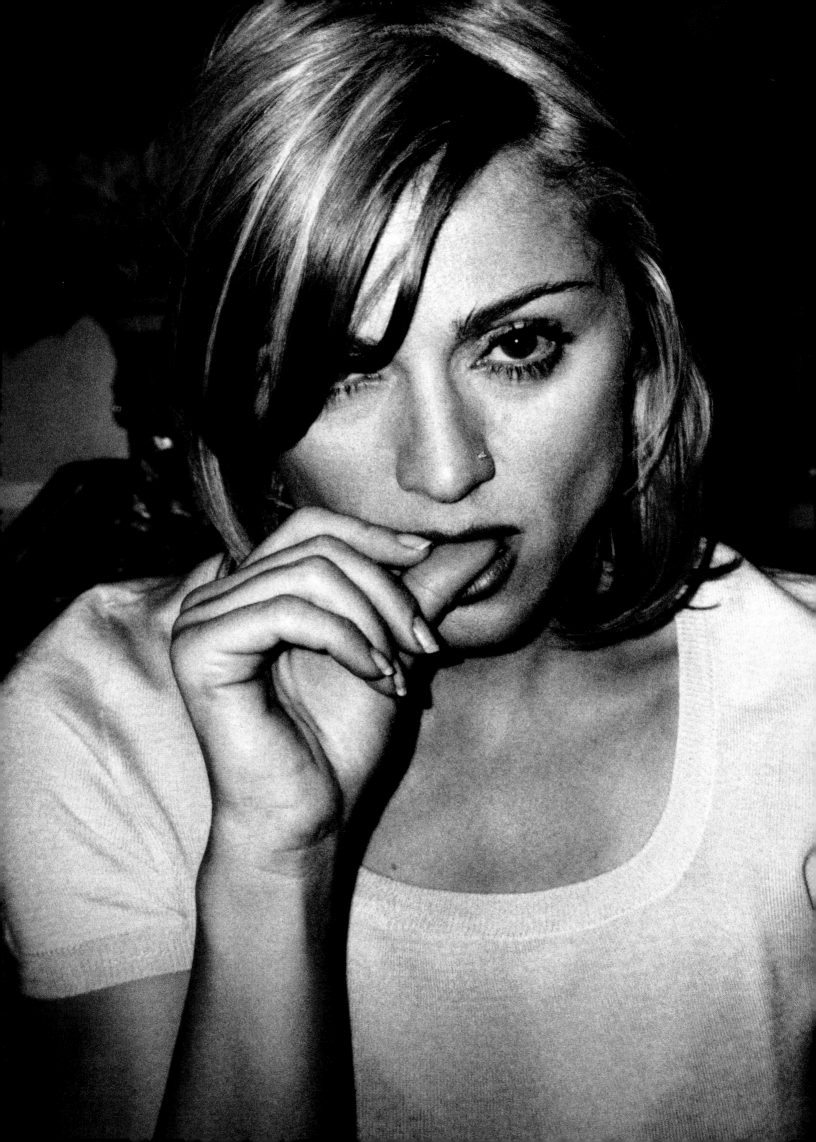

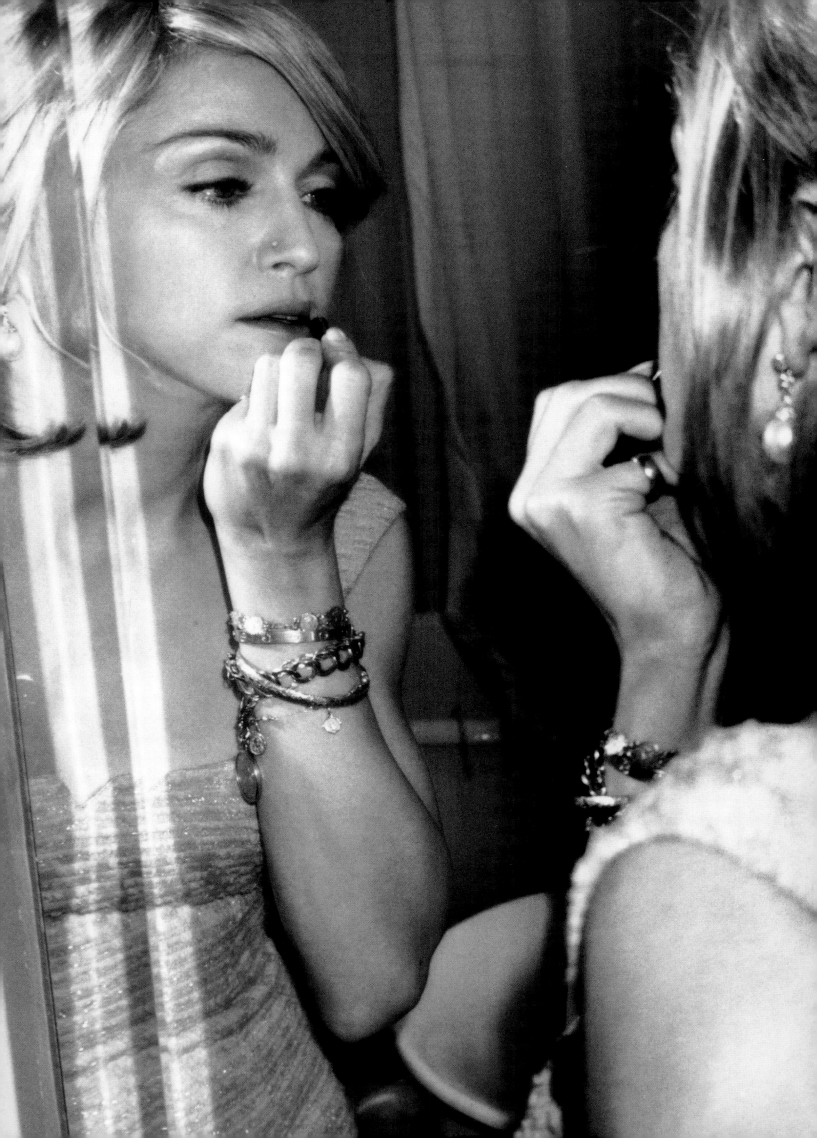

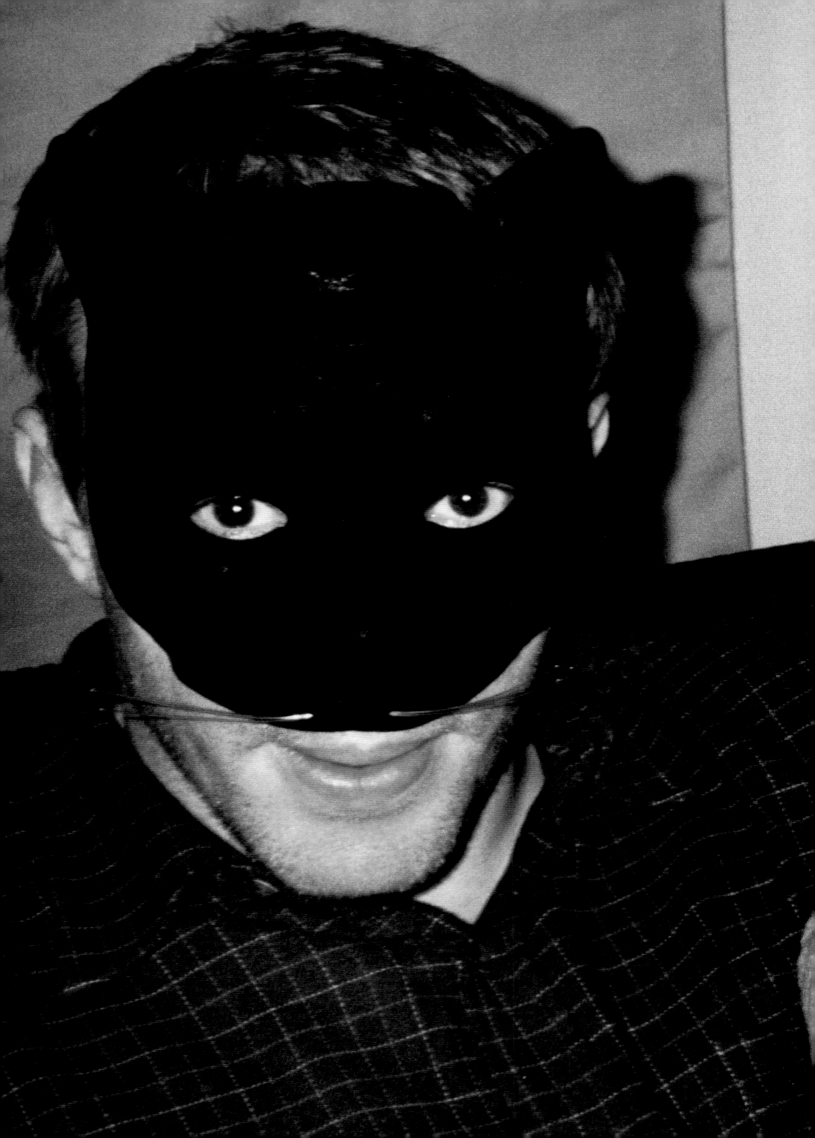

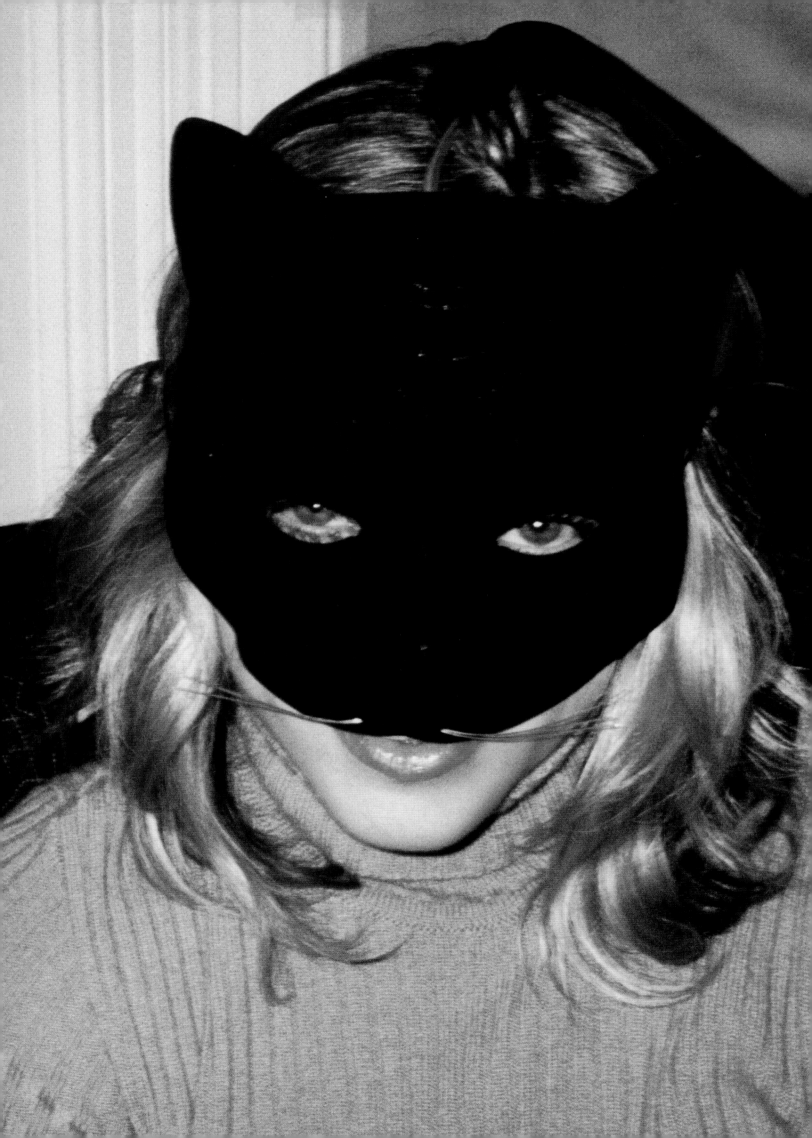

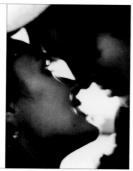
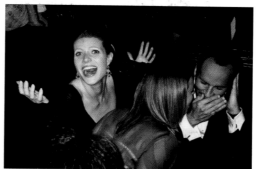
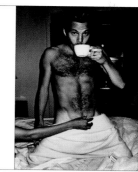

Demi Moore and Ashton Kutcher
Los Angeles
2005

Gwyneth Paltrow, Stella McCartney and Tom Ford
Milan
2002

Stephen Dorff
Los Angeles
1997

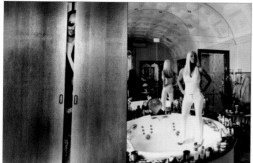
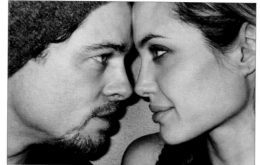
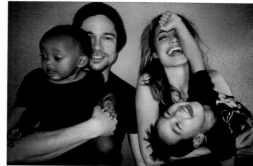

Tom Ford
Los Angeles
2003

Donatella Versace
Milan
2004

Brad Pitt and Angelina Jolie
Los Angeles
2005

Brad Pitt, Angelina Jolie, Maddox and Zahara
Los Angeles
2005

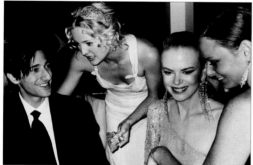
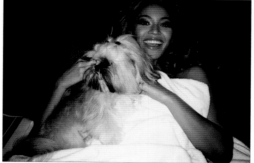
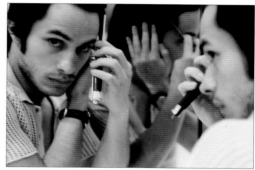

Adrian Brody, Kate Hudson, Nicole Kidman, Stella McCartney
New York
2003

Beyoncé Knowles
Los Angeles
2004

Gael García Bernal
London
2004

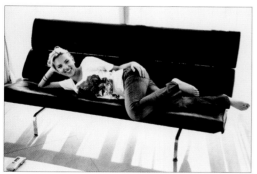
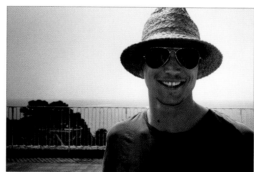
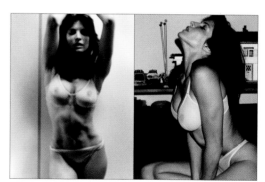

Scarlett Johansson
Los Angeles
2004

Josh Hartnett
Portofino
2005

Stephanie Seymour
Paris
2002

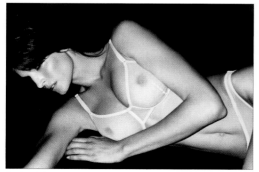
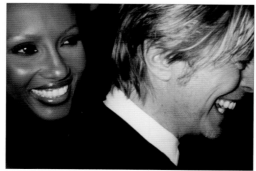
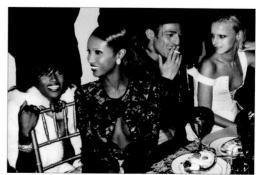

Stephanie Seymour
Paris
2002

Iman and David Bowie
New York
2002

Naomi Campbell, Iman, John Galliano and Vanessa Bellanger
New York
1999

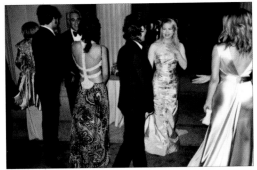

Anna Wintour, Lawrence Stroll and Renée Zellweger
New York
2004

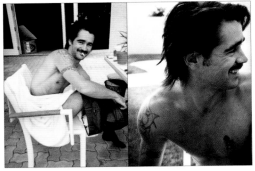

Colin Farrell
Los Angeles
2004

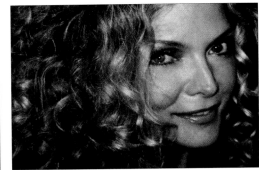

Michelle Pfeiffer
Los Angeles
2004

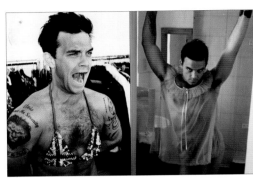

Robbie Williams
London
2000

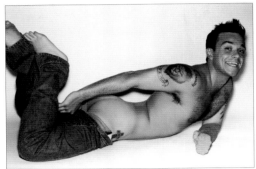

Robbie Williams
London
2000

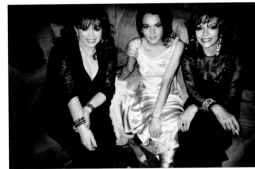

Jackie Collins, Lindsay Lohan and Joan Collins
Los Angeles
2006

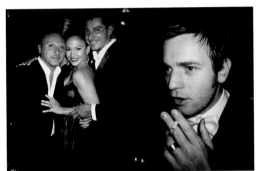

Domenico Dolce, Jennifer Lopez Ewan McGregor
and Stefano Gabbana London
New York 2002
2004

David Beckham
New York
2003

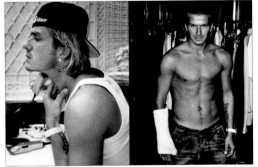

David Beckham
New York
2003

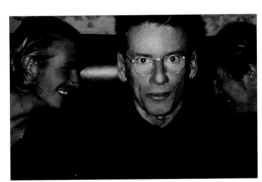

David Beckham, Calvin Klein and David Bowie
New York
2003

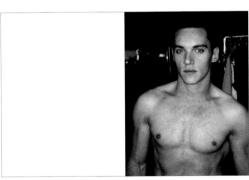

Jonathan Rhys Meyers
New York
2006

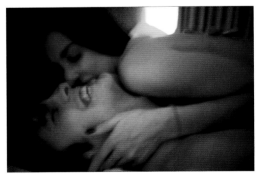

Demi Moore and Ashton Kutcher
Los Angeles
2003

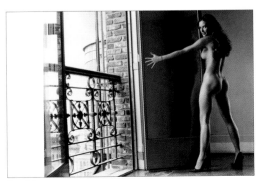

Demi Moore
New York
2003

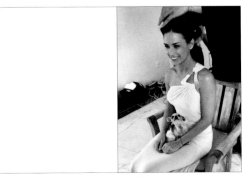

Demi Moore
New York
2003

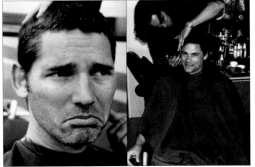

Eric Bana Rob Lowe and Orlando Pita
Los Angeles Los Angeles
2006 2000

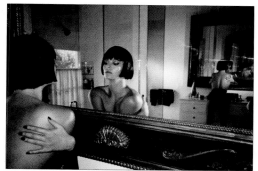

Charlize Theron
Los Angeles
2004

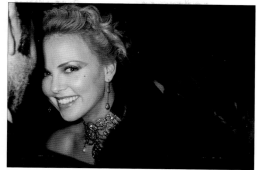

Charlize Theron
New York
2004

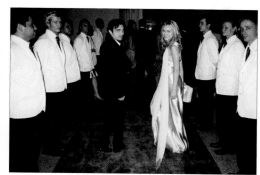

Nicolas Ghesquière and Diane Kruger
New York
2004

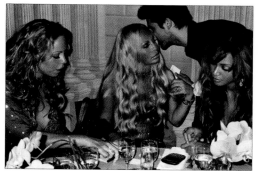

Mariah Carey, Donatella Versace and Beyoncé Knowles
Milan
2005

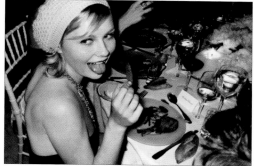

Kirsten Dunst
New York
2003

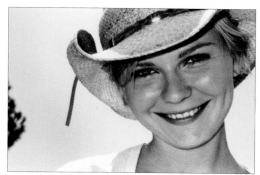

Kirsten Dunst
Los Angeles
2004

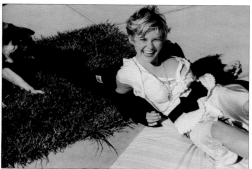

Kirsten Dunst
Los Angeles
2004

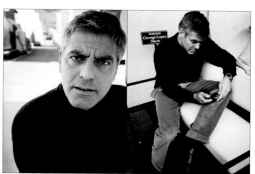

George Clooney
Los Angeles
2005

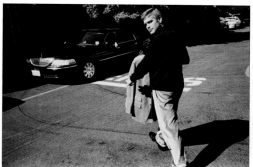

George Clooney
Los Angeles
2005

Gwyneth Paltrow
New York
2000

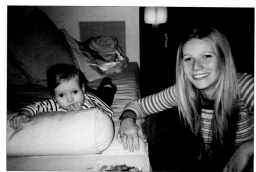

Gwyneth Paltrow and Apple
London
2005

Gwyneth Paltrow
New York
2001

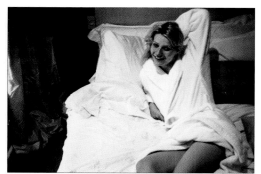

Gwyneth Paltrow
New York
2001

Gwyneth Paltrow
London
2002

Valentino
Ibiza
2003

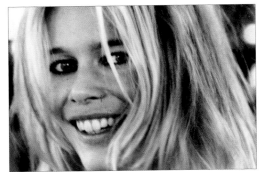

Claudia Schiffer
London
2003

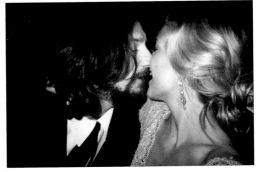

Chris Robinson and Kate Hudson
Los Angeles
2003

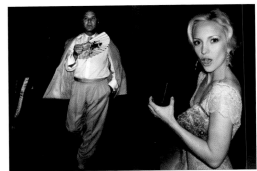

Manolo Blahnik
Paris
1998

Kate Hudson
Los Angeles
2003

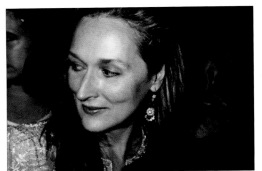

Meryl Streep
Los Angeles
2000

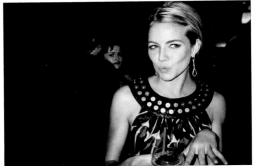

Sienna Miller
Los Angeles
2006

Cameron Diaz
Los Angeles
2003

Cameron Diaz
Los Angeles
2002

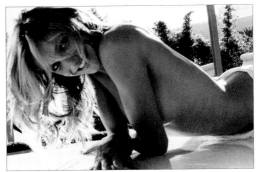

Cameron Diaz
Los Angeles
2002

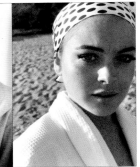

Sigourney Weaver
New York
2001

Lindsay Lohan
Los Angeles
2005

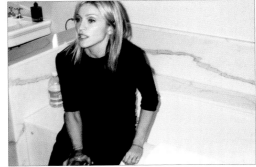

Madonna
London
2001

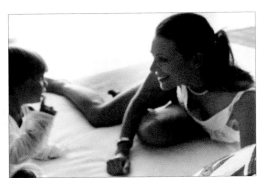

Elizabeth Hurley and Damian
Ibiza
2004

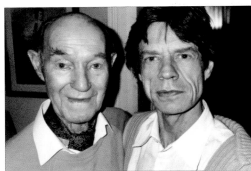

Joe Jagger and Mick Jagger
London
2000

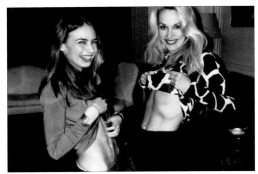

Jerry Hall and Elizabeth Jagger
London
2000

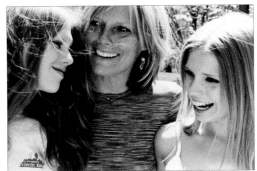

Alexandra Richards, Patti Hansen, and Theodora Richards
New York
2002

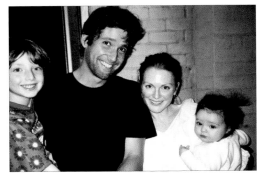

Julianne Moore, Bart Freundlich, Caleb and Liv Helen
New York
2002

Julianne Moore
Los Angeles
2000

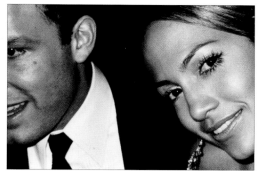

Ben Affleck and Jennifer Lopez
Los Angeles
2003

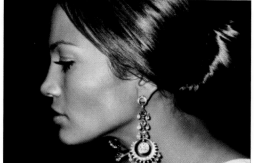

Jennifer Lopez
Los Angeles
2003

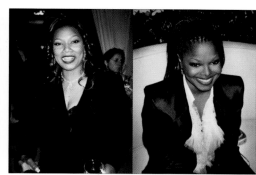

Queen Latifah
Los Angeles
2003

Janet Jackson
Los Angeles
2003

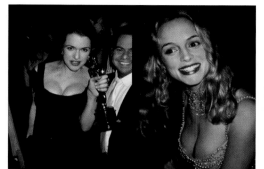

Rachel Weisz
Los Angeles
2006

Heather Graham
Los Angeles
2000

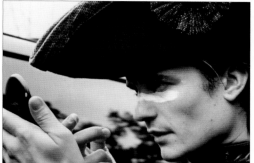

Orlando Bloom
Los Angeles
2005

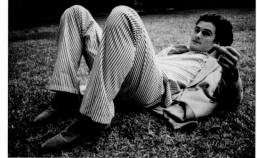

Orlando Bloom
Los Angeles
2005

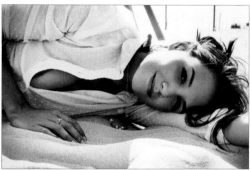

Katie Holmes
New York
2003

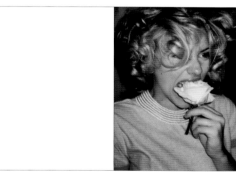

Scarlett Johansson
Los Angeles
2004

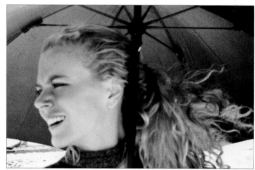

Nicole Kidman
Los Angeles
2002

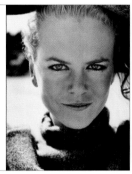

Nicole Kidman
Los Angeles
2002

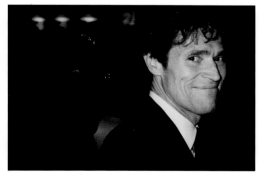

Willem Dafoe
New York
2001

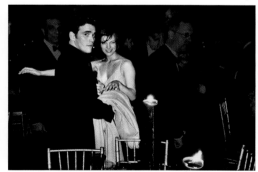

Matt Dillon & Milla Jovovich
New York
1999

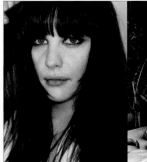

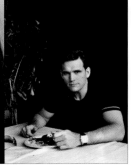

Liv Tyler
Paris
2003

Matt Dillon
Los Angeles
2006

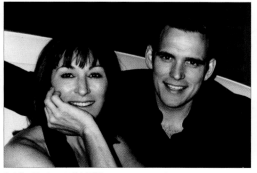

Anjelica Huston and Matt Dillon
Los Angeles
2000

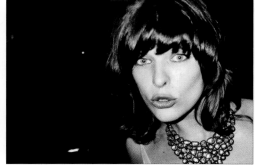

Milla Jovovich
New York
2000

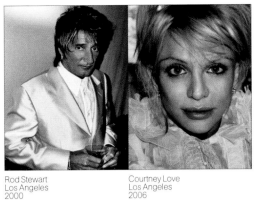

Rod Stewart
Los Angeles
2000

Courtney Love
Los Angeles
2006

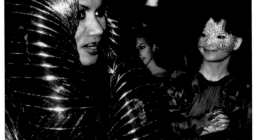

Grace Jones and Björk
London
2003

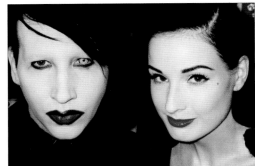

Marilyn Manson and Dita Von Teese
New York
2005

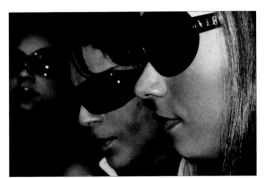

Prince
Milan
2006

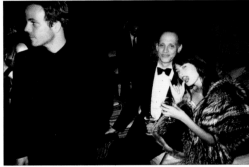

Stephen Dorff, John Waters and Rhea Durham
Los Angeles
2000

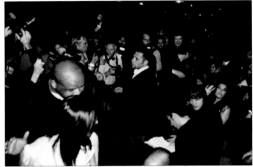

Demi Moore and Ashton Kutcher
Paris
2006

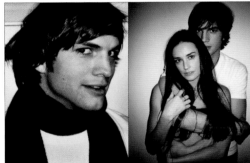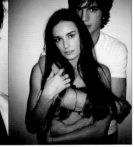

Ashton Kutcher
Los Angeles
2003

Demi Moore and Ashton Kutcher
Los Angeles
2003

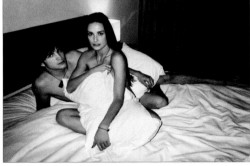

Demi Moore and Ashton Kutcher
Los Angeles
2003

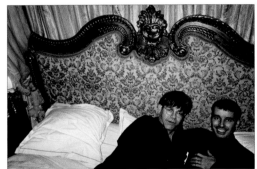

Elton John and David Furnish
Paris
1997

Kate Moss
London
2000

Kate Moss
London
2001

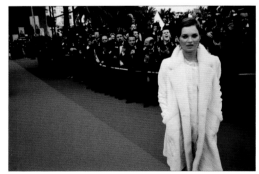

Kate Moss
Cannes
2001

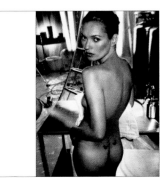

Kate Moss
London
2006

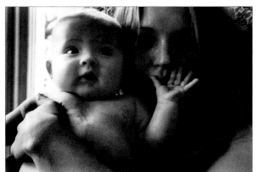

Kate Moss and Lila Grace
London
2003

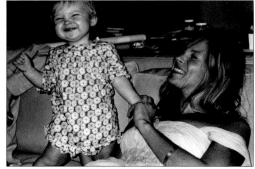

Kate Moss and Lila Grace
New York
2003

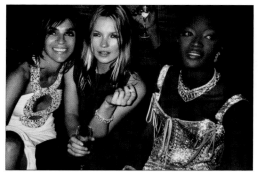

Carine Roitfeld, Kate Moss and Naomi Campbell
Paris
2003

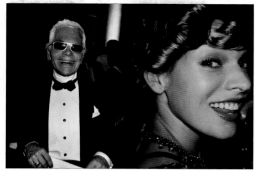

Karl Lagerfeld
New York
2002

Milla Jovovich
New York
2002

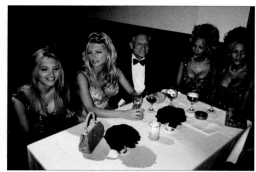

Hugh Hefner and the Bunny Girls
Los Angeles
2000

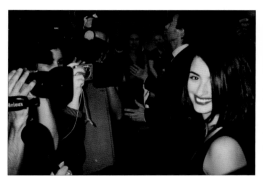

Penélope Cruz
Paris
2002

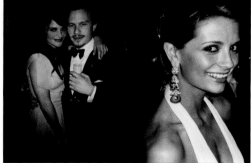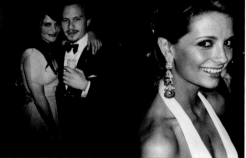

Helena Christensen
and Heath Ledger
Los Angeles
2006

Mischa Barton
Los Angeles
2006

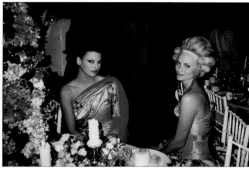

Linda Evangelista and Amber Valletta
New York
2004

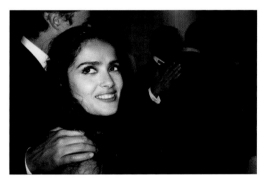

Salma Hayek
Los Angeles
2003

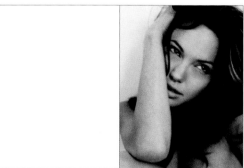

Angelina Jolie
London
2003

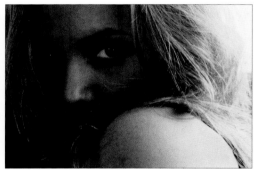

Angelina Jolie
Los Angeles
2005

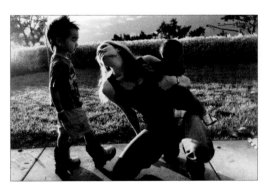

Angelina Jolie, Maddox and Zahara
Los Angeles
2005

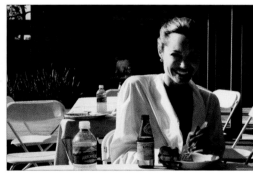

Angelina Jolie
Los Angeles
2005

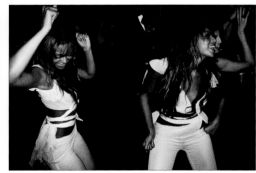

Beyoncé Knowles
Milan
2003

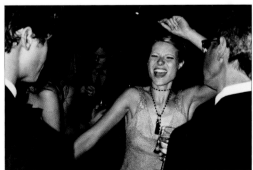

Gwyneth Paltrow
Los Angeles
2000

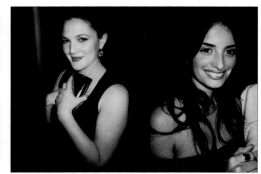

Drew Barrymore
New York
2005

Penélope Cruz
New York
2002

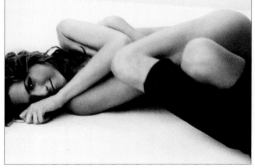

Jennifer Aniston
Los Angeles
2005

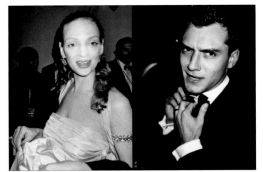

Uma Thurman
Los Angeles
1999

Jude Law
Los Angeles
2000

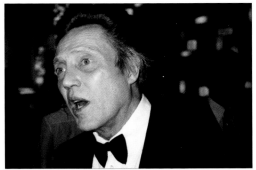

Christopher Walken
Los Angeles
2003

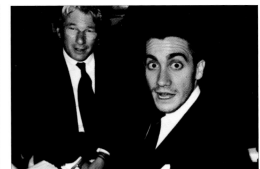

Richard Gere and Jake Gyllenhaal
Los Angeles
2005

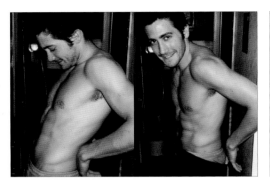

Jake Gyllenhaal
London
2003

Jake Gyllenhaal
Los Angeles
2004

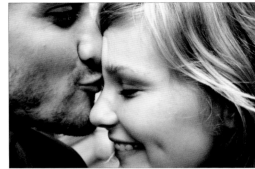

Jake Gyllenhaal and Kirsten Dunst
Los Angeles
2003

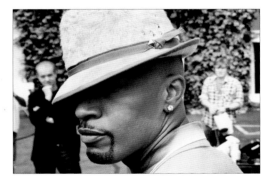

Jamie Foxx
Los Angeles
2006

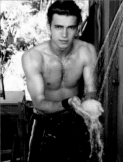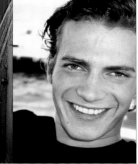

Hayden Christensen
Los Angeles
2004

Hayden Christensen
Capri
2003

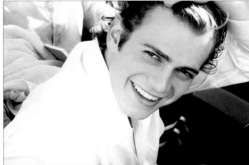

Hayden Christensen
Los Angeles
2003

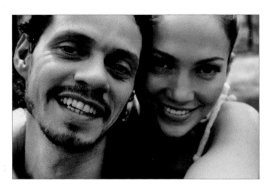

Marc Anthony and Jennifer Lopez
New York
2006

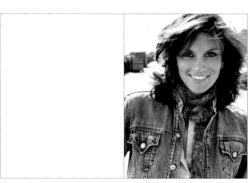

Cindy Crawford
Los Angeles
2002

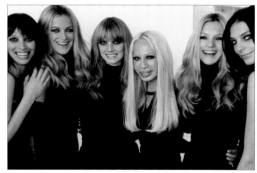

Christy Turlington, Carolyn Murphy, Angela Lindvall,
Donatella Versace, Kate Moss and Daria Werbowy
New York 2006

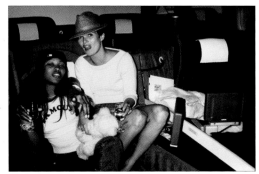

Naomi Campbell and Kate Moss
BA, New York to London
2001

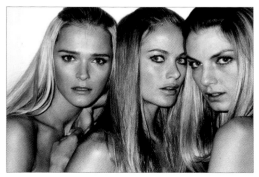

Carmen Kass, Carolyn Murphy and Angela Lindvall
New York
2006

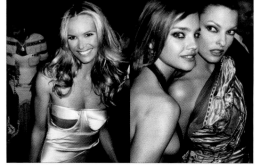

Elle Macpherson
New York
2005

Natalia Vodianova and
Linda Evangelista
New York 2004

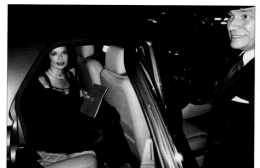

Bianca Jagger
London
2002

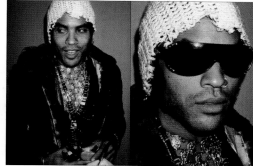

Lenny Kravitz
New York
2002

Anna Wintour
New York
1998

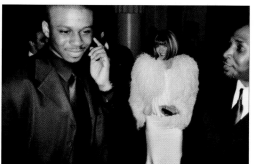

Anna Wintour
New York
2004

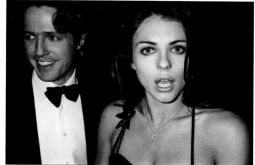

Hugh Grant and Elizabeth Hurley
Los Angeles
1999

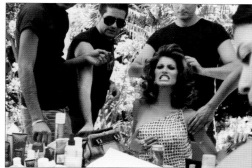

Gisele Bündchen
Los Angeles
2002

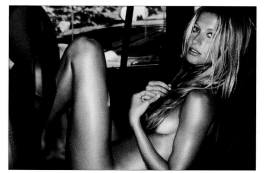

Gisele Bündchen
Los Angeles
2006

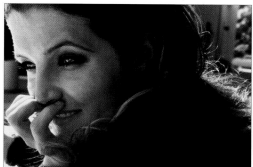

Lisa Marie Presley
Los Angeles
2002

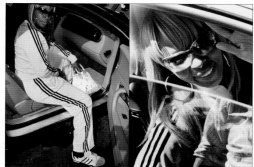

Mary J. Blige
Los Angeles
2005

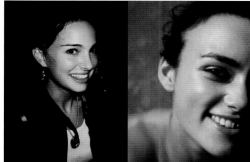

Natalie Portman
New York
2002

Keira Knightley
Ireland
2003

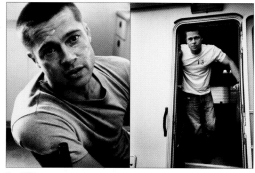

Brad Pitt
Los Angeles
2005

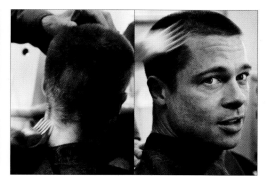

Brad Pitt
Los Angeles
2005

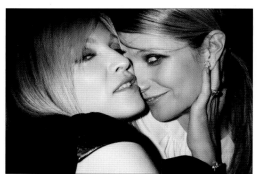

Madonna and Gwyneth Paltrow
London
2002

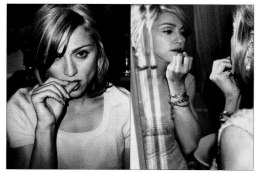

Madonna
Miami
1997

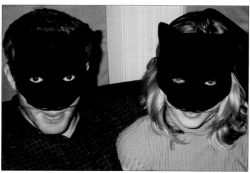

Guy Ritchie and Madonna
London
2000

Special thanks to Carine Roitfeld for preparing me for this moment and to Anna Wintour and Graydon Carter for giving me the access.

I'd like to thank my brother Giovanni for holding my hand throughout.

Teresa Testino and Jan Olesen.

Lucinda Chambers, Stephen Gan, Tonne Goodman, Eric Jussen, Patrick Kinmonth, Marc Lopez, Camilla Nickerson, Orlando Pita, Tom Pecheux and Adam Whitehead.

Chris Arvidson, Veruschka Baudo, Jean-Claude and Jocelyne Bedel, Eric Bergère, Terry Bevacqua, Pietro Birindelli, Rufina Breskin, Beau Bright, Dewitt Canon, Federica Carrion, Desmond Cheyne, Charles Churchward, Grace Coddington, Esther Davor, Federico de Angelis, Cecilia Dean, Jill Demling, Sicco Diemer, Bill Doig, Guillaume Dulermo, Sam Faulkner, Maud Faussurier, Jack Flanagan, Paul Fortune, Alex Franco, SunHee Grinnell, David Harris, Gabriel Hill, Sarajane Hoare, Jemima Hobson, Christiaan Houtenbos, Lisa Jachno, Paul Jasmin, Lilli Jussen, James Kaliardos, Robert Kent, Nicole Kidman, Philippe Kliot, Peter Koechlin, Karl Kolbitz, Marcus Kurz, Ashton Kutcher, Salim Langatta, Lisa Love, Didier Malige, Stéphane Marais, Elizabeth Mitiku, Jim Moore, Demi Moore, Jonathan Newhouse, Si Newhouse, Thomas Nutzl, Amber Olson, Keshara Parker, Jono Patrick, Jimmy Paul, George Perlman, Simon Perry, Chad Ofstedahl, Gawain Rainey, Andrew Richardson, Michael Roberts, Elizabeth Saltzman Walker, Jane Sarkin, Raja Sethurman, Ivan Shaw, Alexandra Shulman, Toby Sillence, Brigitte Sondag, Sabina Spaldi, Benedikt Taschen, Carla Testino, Elena Testino, Giuliana Testino, Thomas Thurnauer, Charlotte Tilbury, Elodie Touboul, Barverd van der Plas, Donatella Versace, Gina Viviano, Gucci Westman, Alex White, Susan White, Phillip Williams, George Yandell.

Art Partner, Argento, GQ, Icon, Chateau Marmont, Frenchway Travel, Mercer, M.PD, R&D, 60 Thompson, V, Visionaire, Vanity Fair, Vogue.

Publicists and agents for their constant support.

Picture Editor: Alex Bramall
Creative Consultants: Patrick Kinmonth and Stephen Gan
Project Coordinator: Chiara Zoppelli
Graphic Design: Tom Phillips
Art Partner: Candice Marks and Sarah Dawes

Foreword by Nicole Kidman
Essays by Michael Roberts, Mario Testino and Patrick Kinmonth

All photographs © Mario Testino
Cover Image: Demi Moore and Ashton Kutcher, Los Angeles, 2003

To stay informed about upcoming TASCHEN titles, please
request our magazine at www.taschen.com/magazine or write to
TASCHEN, Hohenzollernring 53, D-50672 Cologne, Germany,
contact@taschen.com, fax +49-221-254919.
We will be happy to send you a free copy of our magazine which
is filled with information about all of our books.

Editorial coordination: Florian Kobler, Cologne
German translation: Clara Drechsler, Cologne
French translation: Philippe Safavi, Paris
Production: Frank Goerhardt and Tina Ciborowius, Cologne

Printed in Hong Kong
ISBN 978-3-8228-4418-2